LIQUOR STORE THEATRE

BLACK OUTDOORS
INNOVATIONS IN THE
POETICS OF STUDY

A SERIES EDITED BY
J. KAMERON CARTER +
SARAH JANE CERVENAK

DUKE UNIVERSITY PRESS
DURHAM + LONDON 2020

LIQUOR STORE THEATRE

MAYA STOVALL

WITH A FOREWORD BY CHRISTOPHER Y. LEW

© 2020 DUKE UNIVERSITY PRESS All rights reserved
Printed in the United States of America on acid-free paper ∞
Designed by Aimee C. Harrison
Typeset in Garamond Premier Pro and Univers LT Std
by Copperline Book Services

Library of Congress Cataloging-in-Publication Data
Names: Stovall, Maya, [date] author. | Lew, Christopher Y.,
writer of the foreword.
Title: Liquor Store Theatre / Maya Stovall ; with a foreword
by Christopher Lew.
Other titles: Black outdoors.
Description: Durham : Duke University Press, 2020. |
Series: Black outdoors: innovations in the poetics of study |
Includes bibliographical references and index.
Identifiers: LCCN 2020014216 (print)
LCCN 2020014217 (ebook)
ISBN 9781478010098 (hardcover)
ISBN 9781478011125 (paperback)
ISBN 9781478012672 (ebook)
Subjects: LCSH: Liquor Store Theatre. | Experimental theater—
Michigan—Detroit. | Performance art—Michigan—Detroit.
| Conceptual art—Michigan—Detroit. | Political art—
Michigan—Detroit.
Classification: LCC PN2193.E86 S768 2020 (print) |
LCC PN2193.E86 (ebook) | DDC 792.9/5—dc23
LC record available at https://lccn.loc.gov/2020014216
LC ebook record available at https://lccn.loc.gov/2020014217

FOR MY FATHER, MARTIN CADWELL, ESQ.

CONTENTS

Dressed in black bodysuits, Maya Stovall and two dancers stretch their arms wide, palms facing the pavement, and bring their knees together as patrons of the liquor store come and go behind them. Todd Stovall's electronic music composition blares out of a portable speaker, competing with the rush of traffic. Because this is an unannounced performance—and an uninvited one at that—passersby may be surprised by the dance that is occurring, or perhaps they are unfazed, having already seen Stovall's choreography outside another liquor store in McDougall-Hunt.

Working on *Liquor Store Theatre* since 2014 and deliberately residing in the neighborhood, Stovall has amassed an impressive body of research and performance works that cannot be separated from one another. As William Butler Yeats famously wrote, "How can we know the dancer from the dance?" Stovall's project weaves together anthropology, geography, choreography, performance, conceptual art, and so many other disciplines in a manner that cannot be unraveled. It is useless to make such distinctions. Her performing body is inseparable from the dance itself just as the various lines of inquiry are braided together, forming a unique cord that not only addresses the contemporary conditions of the neighborhood, but also takes on Detroit's past and potential future, along with the broader scope of being black in an American city.

For Stovall, how we know is the operative question. Through such a simple act, dancing on the sidewalk before these business establishments, she sparks so much one-on-one engagement that has led to long-term dialogues.

It is through her performances that she is able to bring into relief what affects the lives of her community: the economic, racial, historical, political, and social forces that shape the area's inhabitants and the built environment that surrounds them.

—CHRISTOPHER Y. LEW / Nancy and Fred Poses Curator / Whitney Museum
of American Art / May 2019

Prologue

EXT. PALMS LIQUOR—(DAY)—LONG SHOT—It's a tropical Saturday afternoon—Detroit in July. Plastic-beanstalk palm trees loom and bracket a weathered, neon-lit party store at the corner of Gratiot Avenue and Mt. Elliott Street. The store's adjacent parking lot is a jam-up of late-model Detroit steel. Cotton-candy-melancholy hip-hop beats blare from kitted-out SUVs. Chrome rims glint. Fresh pedicures click across the lot. I take a deep breath, look up at the vibrant, cloudless sky, hold-hold-hold, I feel the instant, soak it in—and I exhale. On Detroit's east side, liquor stores sell a variety of snacks, drinks, clothing, household goods, small electronic products, and more, in addition to the obvious offerings of beer, wine, and liquor. This selection—although the products are often overpriced, inferior goods—provides the stores a sort of captive audience of customers in neighborhoods where shopping options, transportation, and disposable income are scarce.

I step into a lunge—ravenous insect, conceptual artist, ballerina—and flip my hands through a pattern of action crossing voguing, jujitsu, and finger tutting. We're in the McDougall-Hunt section of the city's east side—a storied, hard-boiled neighborhood; part of the historic Black Bottom, Paradise Valley, and Hastings Street zones; past or present home to iconic African American figures like performer Lottie "The Body" Graves Claiborne, contemporary artist Tyree Guyton, and jazz innovator John Lee Hooker; and home to the people, the streets, and the sidewalks where my *Liquor Store Theatre* (*LST*) unfolds. *Liquor Store Theatre*, where I research, and make love to, the streets and sidewalks of the city that made me who I am.

Past is prologue. History is now. *Liquor Store Theatre*, the ongoing conceptual art practice and urban anthropological research project I began in 2014, a series of video-recorded performances and conversations with people about city life on the streets and sidewalks of liquor stores in my east-side Detroit neighborhood, may come off as an abstract, uber-contemporary approach to urban ethnography. While this may be true, LST is steeped in a critical historical-materialist analysis of city life, of human existence.

With this prologue, I contextualize LST for you as it exists in my mind. In spite of its apparent whimsy, LST is part of a scholarly, artistic, and practical genealogy of documentation of, and resistance to, destruction of African American lives. What keeps me up at night, obsessively writing—and the only way I can sleep at night—is to begin this book with a walk from the sixteenth century to the present. With this walk, I launch a corrective against the poverty of thinking concerning African American lives in U.S. cities. In the case of LST, we're in Detroit—and I explore here how lives and existence connect with U.S. founding myth. Please walk with me—I promise it will be hard-core.

Political Economic Racism: The Choreographic Machine

JUMP CUT to a CLOSE-UP SHOT of my WRITING DESK, a midcentury modern, oak, little thing. An air plant rests in an itty-bitty ceramic hand; James Boggs, Kellie Jones, Karl Marx, Katherine McKittrick, Cedric J. Robinson, Kathleen C. Stewart, and Michael Taussig's books stack a writerly shrine; a cairn of luxurious, well-seasoned notebooks threatens to reveal a tormented soul. Here I sit, amid years of research, connecting past and present—writing corrective roots for LST. I cannot simply begin on the streets of McDougall-Hunt, you see. We need to go back in time. JUMP CUT from my writing desk to images of the early UNITED STATES—the colonies.

Since the 1500s, racism has been the central ingredient in making and continuing the United States of America. Rather than an issue of emotion, racism is a way to get rich without overhead, a way to kill without consequence: racism is the center of gravity of these United States. Why does this matter for *Liquor Store Theatre*? Because I trace precisely the racist U.S. historical threads that weave the fabric of contemporary Detroit. The year 1500 is in 2020. Somehow we've been in denial about this—we need to face it.

In 1526, the first known settlement in the U.S. with African American enslaved people was also the first site of a rebellion, organized by the enslaved people themselves.[1] In a present-day South Carolina town near the Pee Dee River delta, a Spanish explorer established a town with five hundred Spanish

people and one hundred African American enslaved people.[2] The settlement did not run smoothly: "Illness caused numerous deaths.... The Indians grew more hostile and dangerous. Finally, [the same year the town was established]... the slaves rebelled, killed several of their masters, and escaped to the Indians. This was a final blow and the remaining colonists—one hundred and fifty—returned to Haiti in December."[3]

With records of slavery since the early 1500s, by the 1600s, African American slavery was an economic institution. Slavery generated the first labor-sourced wealth the United States was able to accumulate. Appearing in colonial legislation by the 1660s, slavery was a legalized economic system—a system that humiliated, maimed, and destroyed African Americans to build wealth for white people. It may be a surprise that the historical record shows that African American people used the legal system to fight for their freedom from the start. The 1661 New Netherlands Petition illustrates this point.[4] The petition, written by Dorothy and Emanuel Pieterson, begins,

> To the Noble Right Honorable Director-General and Lords Councillors of New Netherlands
> Herewith very respectfully declare Emanuel Pieterson, a free Negro, and Reytory, otherwise Dorothy, Angola, a free Negro woman, together husband and wife, the very humble petitioners of your noble honors, that... the aforementioned... our son named Anthony... may be declared by your noble honors to be a free person: this being done, [the document] was signed by the mark of Anthony Pieterson.[5]

Today, the United States is largely oblivious to the fight against legal slavery that black people waged from day one. Why? Erasure and distortion, over the years, to maintain the status quo.[6] The facts remain. Within the year that slavery appeared as colonial law, African Americans were fighting—from rebellions to legal petitions. And these are just two of many strategies African American people deployed across generations of struggle against slavery and related genocidal, state-sanctioned practices and policies. Like the backstage stories I work to reveal in *LST*, I work to reveal the backstage stories in a radical African American historiography—stories that are missing from popular knowledge.

The CAMERA SURGES, pulling forward a few centuries, to the scene of the U.S. CONSTITUTIONAL CONVENTION. Contrary to popular myth, the U.S. Constitution never granted justice, defense, or liberty to all people in the United States.[7] Rather, the U.S. Constitution secured justice, defense, and liberty exclusively for white people. These benefits to European Ameri-

cans came at the direct sacrifice of African Americans. The sacrifice African Americans made was not optional—it was the law—through the framework of colonial law, the Articles of Confederation, and, later, the U.S. Constitution. Why are such assertions the opening statements of a book called *Liquor Store Theatre*? The reason is simple: racist power consolidation shapes U.S. historic and contemporary life—from genocide to gentrification. And yet, these same facts remain obscured in mainstream consciousness. I hope to clarify some facts in this book.

Cedric J. Robinson writes, "Founding myths [have been] substituted for history, providing the appearance of historical narrative to what was in actuality part fact and part class-serving rationales."[8] Because "the national government has used the Constitution in such a way as to make law the instrument for maintaining a racist status quo," the U.S. masses have been brainwashed to believe "the myths of Frontier, the paternal Plantation, the competitive capitalism of the Yankee, the courage of the Plainsman . . . the tragedy of the War between the States, the Rugged Individual, the excitement of the American Industrial Revolution, [and] the generosity of the Melting Pot."[9]

This mythical backstory matters for contemporary Detroit, because I hope to reveal how, and why, our thinking is hamstrung. Stuck between the weapons of mass destruction that are colonial, postcolonial, and contemporary political-economic-racist law and policy, American brains are pinned in a complicated vise. This vise teaches us to genuflect to a founding myth—a founding myth made possible with African American people's legislated sacrifice and destruction, a founding myth that necessarily blocks an onto-historical materialist understanding of political-economic racism. These founding myths sculpt the Detroit myths that *Liquor Store Theatre* searches out, interrogates, and documents. Remarkably, African American people have evaded outright destruction and have lived to tell the tale. They tell me the tales day in and day out, on the streets and sidewalks as I film *LST*.

The U.S. Constitution consolidated exploitation and, next, wrote exploitation and dispossession into the letter of the law.[10] The notion of the U.S. Constitution as pursuing an idealistic quest for liberty and accidentally falling short requires adjustment to reflect reality—that is, the reality that the onto-historical materialist formation of wealth, power, and law in the U.S. was sourced from, and subsequently crafted and written to, destroy African Americans. I open this book with a corrective antidote to impoverished understandings of the racist, exploitative nature of U.S. political economic and legislation formations and the way historical formation is understood today.

The U.S. Constitution's racist formation, and the associated formation of U.S. military power, police power, and racist policy across education, employment, and housing, continue to shape contemporary existence. The legislated, Americanist genocide of African Americans, documented in the historical record since the late fifteenth century, continues yet today.[11] In the case of Detroit, the 80 percent-plus African American city that centers *Liquor Store Theatre*, the genocide continues, in slow forms and in fast forms—licit and illicit substances, policing and surveillance, gentrification and displacement, education, employment, housing, erosion of the public commons, and more. These factors form widespread political-economic violence against African American people in this majority African American city.

Local application of economic conditions, perpetuating the status quo, was framed by the Articles of Confederation, in which "state governments were free to make whatever regulations they desired on slavery and the control of [black people]."[12] Moving from United States military formation to the formation of neighborhoods in this city, the historiographic and the ethnographic converge, shining light through popular myth and pressing toward empirical understanding.

The U.S. government, wedded to a political-economic model designed to destroy African American people in the service of wealth creation, bit back with additional legislation and policy. Such policy criminalized being alive; being human; being black. In the early 1700s, "militia laws were designed for slave control," and according to colonial legislation, black people "could not gather in groups, carry weapons, or travel without the permission of their masters."[13] As the nation moved toward the revolutionary period, the American Revolutionary War principles, including "[the revolution's] denunciation of aristocracy, its separation of Church and State, its espousal of a nation's right to self-determination, its overthrow of feudal hangovers, its promise of liberty and equality, its proud avowal of man's right and ability to direct his own destiny and guide his own pursuit of happiness here and now, not hereafter and in some nebulous beyond," were explicitly intended for landowning European Americans only.[14] These pursuits were to be had at the direct expense of enslaved and/or dispossessed African Americans and Native Americans—both of whom the political-economic power formation they supported was intended to destroy. Still, Native Americans and African Americans, from the start, were American patriots. The first soldier to die in the American Revolution was the African American soldier Crispus Attucks. Attucks "was the first to die challenging the rule of Britain, falling dead in Boston, his chest pierced by two bullets, five years before the Battle of Lexington."[15] The

irony: the first American patriot—an African American patriot—fought and died for a country hell-bent on destroying black and Indigenous people. These destructive policies surge to the surface in contemporary Detroit.

Moreover, African American people not only were excluded from the benefits of the U.S. but were subjected to state-sanctioned violence written into the letter of the law. This nation-building history shapes the state-imposed violence we witness today, from police brutality, to surveillance capitalism, to mass incarceration. During the war period between 1765 and 1783, state governments imposed, and increased, violent policies upon African American people. For African Americans, the hypocrisy of the American Revolution was crystal clear. African Americans continued to "make public pleas against slavery and to point out to the . . . two and a half million [European American] people the incongruity and the danger of shouting 'Liberty or Death' while enslaving 750,000 human beings."[16]

And, again, enslaved African American people continued to resist, to challenge, and to defy attempts to enslave, exploit, and destroy them. Between 1775 and 1783, at least 100,000 enslaved African Americans escaped slavery.[17] Aptheker summarizes this mass social movement: "Thomas Jefferson declared that in the one year of 1778 Virginia alone saw thirty thousand slaves flee from bondage, we know many more escaped both before and after that year. Georgians felt that from 75 to 85 percent of their slaves (who numbered about fifteen thousand in 1774) fled, and South Carolinians declared that of their total number of some one hundred ten thousand slaves at the start of the Revolution, at least twenty-five thousand made good their escape." Moreover, "if to all this one adds the slaves who escaped from North Carolina, Maryland, Delaware, and the Northern States, it appears to be conservative to say that from 1775 to 1783 some one hundred thousand slaves (i.e. about one out of every five) *succeeded* in escaping from slavery, though very often meeting death or serfdom instead of liberty."[18]

Post–American Revolution, states asserted "the continued existence of slavery as an institution by reenacting and expanding the body of colonial laws on the subject."[19] In other words, the transition from colonial rule to American independence, paradoxically, reflected increased racist, genocidal, political-economic laws and policies. In other words, state governments imposed oppressive, punitive, corporal, and genocidal forms of surveillance and policing, with "militia and citizen patrols [remaining] primarily responsible for the control of the black population."[20] African American people continued to challenge and resist such oppressive legislation and policy.

Enslaved African American people used the American Revolution to exit slavery. As Aptheker indicated, "[black people] who escaped their masters and mistresses [joined] the British forces or . . . fled to the interior, where they lived as maroons or faded into Indian communities."[21] Contra myth, enslaved African Americans were not a "contented and docile coerced labor force."[22] Rather, African American people strategized and executed "massive defections from slavery" over centuries of colonial and U.S. enslavement.[23]

Moreover, African American enslaved people contributed to the U.S. victory against the British in mass numbers, with five thousand or more African American people serving in the U.S. army and navy revolutionary forces, making up an estimated 10 percent of military forces in any given battle.[24] African Americans also exited slavery by fleeing not only to serve in war but to move to frontier life. Dating from at least 1672 through 1864 at Thirteenth Amendment Eve, thousands of formerly enslaved African Americans, historically called maroons, set up communities in frontier areas near and/or together with Native American people.[25]

As the United States moved toward the Constitutional Convention that would take place in 1787, African American "oppression through the system of slavery [survived] the Declaration of Independence and American Revolution and would now become an integral part of American constitutional law."[26] African Americans' and Native Americans' interconnected political economic oppression and genocide appeared in related and differing ways at the Constitutional Convention. A common thread was that the newly forming U.S. government acquired power on the basis of oppression, and (paradoxically) due to this oppression, considered African American people and Native American people military threats.[27] With this backdrop, the U.S. Constitution surfaced as a deliberately racist and genocidal document, designed to promote European American power and domination at any expense.

In the case of Native American people, "having engaged in numerous wars with colonial forces, tribes were seen as potential military opponents, not wholly unlike foreign powers, at the time of the Constitution's drafting."[28] In the case of African American people, the Constitutional Convention delegates discussed "the relationship between slavery and the use of national military forces," with Rufus King stating that "importing additional slaves would make national defense more difficult and costly."[29] In the case of workers and the poor, "debtor disturbances, among them Shay's Rebellion, a revolt of impoverished farmers against taxation and the judiciary, which had

threatened a federal arsenal at Springfield, Massachusetts," showed that the military powers and the central government of the U.S. must be strengthened to maintain the status quo in relation to potential uprisings of working-class, low-income people.[30] The historic uprisings people staged at nation-forming reverberate in contemporary Detroit.

Constitutional language referencing state-sanctioned policies of African American genocide, Native American genocide, and working-class domination through political-economic legislation and policy was not necessary—such hegemonic legislation and policy was built into the founding document and structured to execute the dominance of the European American majority. Moreover, the clauses of the Constitution explicitly reflected the Constitution's central goal to maintain European American political, economic, military, social, and cultural dominance.

"The Fugitive Slave Clause of the Constitution was . . . adopted with little debate," reflecting "the commitment of the national government to protect slavery" and to systematically destroy African American people through the powers of the Constitution.[31] In addition, in the case of Native Americans, the Treaty Clause and the Commerce Clause reflected the U.S. government's first step toward "development and implementation of policies meant to destroy American Indian tribes."[32]

JUMP CUT to my WRITING DESK in the CONTEMPORARY UNITED STATES, in a faculty apartment at California State Polytechnic University (Pomona), where I'm an assistant professor in the Liberal Studies Department. CUT to a MEDIUM SHOT. I'm leaning over a notebook and a laptop. I am trying to write us from the past to the present. Through this backdrop of genocide, we understand how African American people's legislated domination and oppression built the foundation and wealth of the U.S. economic system and the foundation of U.S. military power.

Moreover, we understand that the U.S. Constitution is the foundation of the constructed white supremacist dominant narrative, with African Americans configured as persons to be exploited, oppressed, and destroyed by the very military powers that their political-economic exploitation has financed. African Americans formed the template for progressive social movements from day one, providing a priceless resource to all other persons who would source this template in the future. From this reality, I zoom in on the case of Detroit, where the national racist calculus is transposed and amplified. Racism, remember, is not about preference or emotion. It's about life and death. Detroit, currently in the throes of a brutal urban process, continues the arc of racist political economic exploitation, oppression, and destruction

first documented in the U.S. centuries ago. Detroit, then, is the contested site where we continue our discussion from genocide to gentrification.

Detroit: Nineteenth Century to Present

The CAMERA PULLS IN and we're squarely in DETROIT. In many ways, the city of Detroit reflects the contradictions inherent in the United States. With its population of approximately 673,104, the 139-square-mile city feels spacious and familiar—yet big-city moving—as you push through the streets in sculpted Detroit steel, on foot, or on the city's weathered public transportation system.[33] In Detroit proper, African American people make up 80 percent of the population; European American people, 14 percent, and Latinx American people, 8 percent.[34] The area is incredibly diverse ethnically, including many, many more groups in addition to the relatively larger groups mentioned here. There is a significant Middle Eastern population (estimated around 200,000, one of the largest populations outside the Middle East itself) in the predominantly working-class suburb of Dearborn, Michigan, to the west of Detroit. Tracing state violence to Detroit, African Americans were formally enslaved in Detroit until 1837, when slavery was abolished in Michigan at statehood, and the U.S. Constitution's Fugitive Slave Clause had historic implications in Detroit.[35]

In 1833, Detroit erupted into a rebellion as an African American couple, Ruth and Thornton Blackburn, were followed there by a mob from Kentucky—a mob hoping to force the Blackburns to return to slavery in that state.[36] The Blackburns were not willing to return to slavery. They resisted, along with African Americans across the city and their allies, and staged a successful rebellion on the steps of downtown Detroit's courthouse, just two miles from the McDougall-Hunt neighborhood, right off Gratiot Avenue, close to the streets where *LST* unfolds. The Blackburns were able to flee to Canada, which, ironically, at the time was maintaining centuries of state-imposed genocidal policies toward Aboriginal Canadians. African Americans in Detroit, however, did not resist only through means of rebellion. In 1843, African Americans of Michigan hosted the Michigan Negro Convention, convening twenty-three delegates in Detroit on October 26 and 27.

William Lambert, the committee chair of the convention in Detroit, wrote the call for the 1843 meeting: "Shall we not meet together, and consult how we may better our condition? Shall we not infuse into the minds of our young men, and posterity, a disposition to be free, and leave their present low and degraded employment, and endeavor to obtain mechanical arts, and fol-

low agricultural pursuits? Shall we not meet together and endeavor to promote the cause of Education, Temperance, Industry, and Morality among our people?"[37] Lambert's focus on political-economic equity continued in Detroit and across the state of Michigan. In 1861, when the American Civil War began at Fort Sumter, African Americans around the U.S., including Detroit, began writing letters of interest to Simon Cameron, Abraham Lincoln's secretary of war.[38] G. P. Miller, an African American man in Battle Creek, Michigan, wrote to Cameron on October 30, 1861, intending to seek the "privilege of raising from five to ten thousand free men to report in sixty days to take any position that may be assigned us (sharpshooters preferred). . . . A part of us are half-breed Indians and legal voters in the State of Michigan. We are all anxious to fight for the maintenance of the Union."[39]

The abolition of slavery in the U.S. brought on more racist legislation and policy through Jim Crow laws. Jim Crow laws were directly designed to destroy African Americans through political-economic, educational, occupational, and everyday violence. Jim Crow laws—an ideal type of genocidal political-economic machinery—spread across the U.S. Meanwhile, thousands of African American people moved throughout the U.S. to cities including Detroit.

Between 1900 and 1950, Jim Crow's oppressive Southern crush, and thousands upon thousands of brutal murders known as lynchings, encouraged 1.5 million African Americans to move north.[40] What African American people found, however, was a brutal reality that Northern cities like Detroit were steeped in "more durable and immovable obstacles of de facto apartheid" across every aspect of life, including policing, housing, education, and employment.[41] From the late nineteenth century on, as African American movements worked to dismantle four hundred years of Jim Crow and predecessor law, racist police brutality and lynchings intensified across the country. Detroit was no exception. Federal, state, and local government-sanctioned and underwritten housing discrimination against African Americans continued, with real estate redlining, racially restrictive covenants, and congressional housing acts of the 1920s and 1930s converging toward economic destruction.[42]

September 1915 started Detroit's demographic transformation as African Americans rapidly began moving to the city. In "May, June, and July of 1916, one thousand blacks were arriving in the city every month," and "the United States Department of Labor estimated that during 1916–17, between 25,000 and 35,000 blacks came to Detroit. . . . By 1926, 85 percent of the black population had come to Detroit in one decade."[43] The numbers are stunning—"Detroit's [African American] population increased 611% from

1910 to 1920 and nearly 200% during the 1920s."[44] However, what is less well known is that racially restrictive real estate covenants were already in place by the end of World War I.[45] As Gotham writes, "Racially restrictive covenants were contractual agreements between property owners and neighborhood associations that prohibited the sale, occupancy or lease of property and land to certain racial groups, especially blacks. Racially restrictive covenants did not exist before 1900 and legal restrictions on the transfer and sale of property were contained in deed restrictions which covered single parcels of land. After 1910, the use of restrictive covenants became more widespread through the promotional efforts of large 'community builders,' local real estate boards and national real estate associations, especially the National Association of Real Estate Boards (NAREB), created in 1908."[46]

Between 1910 and 1920, "real estate boards in Chicago, St. Louis, Milwaukee, Detroit, and other cities had approved measures endorsing the maintenance of racial homogeneity to protect property values and neighborhood stability," normalizing racialized economic inequality in early twentieth-century city neighborhoods.[47] Racialized economic inequality was and remains a reality of the most domestic and intimate sort: racism and brutal economic exclusion are the foundation of American neighborhoods.

In 1924, the NAREB amended its code of ethics to read, "A Realtor should never be instrumental in introducing into a neighborhood . . . members of any race or nationality . . . whose presence will clearly be detrimental to the property values in that neighborhood." As Gotham writes, NAREB's views were pervasive across real estate professionals and the European American mainstream. "In one early real estate textbook," *City Growth and Values*, Gotham writes, the authors of the textbook, Stanley L. McMichael and Robert Fry Bingham, argued that "'[African American] people must recognize the economic disturbance which their presence in a [European American] neighborhood causes and forego their desire to split off from the established district where the rest of their race lives.'"[48] Across mainstream textbooks, "segregationist real estate ideology" gained momentum and authority, pinning Americans' thinking about space, place, and culture into mystified, naturalized, hierarchical strata. Not only did textbooks reflect such thinking, but the politics and grind of the day-to-day did, as well.

In June 1925, Ossian Sweet, a black physician, bought a home in northeast Detroit. This neighborhood was majority European American, although the prior owners of the new home of Dr. Sweet and his family were more ethnically diverse than was known at the time. (Edward Smith, the previous owner, was a fair-skinned African American whom neighbors assumed was

European, and Smith's wife was European American.)[49] After learning that the Sweet family was moving in, hostile residents formed a neighborhood improvement association (code for racist mob) called the Waterworks Improvement Association.

In September of the same year, the Sweets moved into their new home. They were not met with casserole and champagne. Rather, they were met with rocks, guns, and hostile white mobs. Noticing a hostile mob forming, friends and family joined Dr. Sweet and his wife, Gladys, including Sweet's brother (a dentist), seven friends, and a local college student. With a modest group of eleven people protecting their home, the Sweets were vastly outnumbered.

A *Detroit News* reporter, Philip A. Adler, testified for the defense at the subsequent trial. He was at the scene of the shooting and told of a "considerable mob" of between "400 and 500," and stones hitting the house "like hail." "I heard someone say, 'A Negro family has moved in here and we're going to get them out,'" Adler testified. "I asked a policeman what the trouble was and he told me it was none of my business."[50]

Four to five hundred hostile neighbors waged an assault on the Sweet home. As Dr. Sweet's brother entered the home, the mob intensified. People threw rocks, shouted slurs, broke glass, and advanced closer and closer to Dr. Sweet's family home.[51] Gunshots surged from the mob, the police, and the home. The Sweets defended themselves. Two members of the hostile mob were shot, and one was killed. Everyone in the Sweet home was arrested and charged with murder. A long trial followed. Clarence Darrow defended Henry Sweet, Ossian Sweet's brother. Darrow's defense and the Sweets' determination ultimately resulted in a self-defense ruling.[52] Although the Sweet case had a relatively just ending, many more similar cases did not, with police brutality, mob violence, and Ku Klux Klan organizing intensifying across the city from the 1920s through the 1940s.[53]

During African Americans' continued mass migration to northern cities like Detroit, segregationist residential policies and practices were intensified and complemented by egregious employment discrimination. Accumulation by dispossession practices remain in contemporary Detroit, and the history runs deep. Moreover, the structures and practices of accumulation by dispossession are wide ranging and viral over time. David Harvey describes the practices as follows: "Commodification and privatization of land and the forceful expulsion of peasant populations; conversion of various forms of property rights—common, collective, state, etc.—into exclusive private property rights; suppression of rights to the commons; commodification of

labor power and the suppression of alternative, indigenous, forms of production and consumption; colonial, neo-colonial and imperial processes of appropriation of assets, including natural resources; monetization of exchange and taxation, particularly of land; slave trade; and usury, the national debt and ultimately the credit system.[54] In the Detroit case, the early twentieth-century "labor market favored white workers over black workers regardless of the skill of the latter or their longevity in the city. Black workers discovered that European immigrants could arrive in Detroit without jobs or skills and without a knowledge of English use white-skin privileges to secure better housing and better jobs than blacks."[55]

In midcentury Detroit, the city's increasingly decentralized manufacturing economy was already hemorrhaging jobs—with 130,000 manufacturing jobs lost between 1948 and 1967.[56] Meanwhile, racism intensified in Detroit labor markets as "war production policies" allowed African Americans to begin to enter "so-called white jobs" previously open only to European Americans.[57] European American workers responded with "hate strikes." Such hate strikes explicitly protested "the upgrading and transferring of black workers to jobs from which they had been excluded by tradition."[58]

As the automotive manufacturing industry drained jobs and shop floors oozed racism, racialized disparities deepened across realms of social life including policing, housing, and education. In 1943, there were just forty-three African American officers on Detroit's 3,400-member force.[59] Racist disparities were part of everyday life, and African Americans found themselves profiled, harassed, and brutalized in disproportionate numbers: "White policemen were not infrequently the source of many racial problems in Detroit during the post-war period. Operating much like foreign soldiers occupying colonies, they appeared to many as being concerned only with protecting the rights of the white majority against the black minority. In the period between 1943 and 1953, police brutality was a symbol of everything that was wrong with Detroit."[60]

Complaints to the NAACP reflect such conditions.[61] "The NAACP, along with other groups, spent much of their time processing complaints against the police department. The black community found itself using the courts to clarify the use of firearms by white police officers in apprehending persons suspected of crime. Unfortunately, the issue was never resolved and continues to the present day."[62] As Darden writes, "historically, such patterns of uneven economic and social development have contributed to protracted racial estrangement and conflicts in Detroit—for example, the 1942 Sojourner Truth housing riot, the 1943 riot, and the 1967 rebellion."[63] After the 1942

Sojourner Truth Housing Project Rebellion, in which white mobs protested the presence of black people in a new government housing initiative, Detroit's 1943 Rebellion, again, was about economic violence.[64] Often misrepresented as about emotional race relations, and often described as a race riot, the 1943 Rebellion wasn't that simple. The reality is, the 1943 Rebellion resisted government-legislated and state-sanctioned discriminatory policies such as racially restrictive covenants, racialized police brutality, and discriminatory employment practices. The months and weeks leading up to the 1943 Rebellion, on the shop floors of Detroit automotive factories, tell the story.

In February 1943, three African American women workers were promoted to semiskilled trade jobs at Detroit's Packard Automotive Manufacturing Plant. Previously, African American women were relegated to janitorial jobs only—and were not allowed to apply for any other jobs. Soon after the workers were promoted, all hell broke loose. After months of hate strikes and union meetings, in the weeks leading up to the 1943 Rebellion, 39,000 European American workers walked out of the Packard Plant to protest African American people accessing better employment options.[65]

In June 1943, the Rebellion opened up, following the massive Packard Plant hate strike. The 1943 Rebellion emerged in Detroit's Paradise Valley neighborhood, following an incident on Belle Isle. Different versions of the story reflect confrontations between young European Americans and African Americans. The grossly unequal conditions endured by African Americans, and European American hostility toward progress, were at the center of the 1943 Rebellion. Employment discrimination, housing discrimination, educational discrimination, and police brutality laid the groundwork for resistance. Thirty-four people died in the 1943 Rebellion; twenty-five of them were African American.

The majority of the people arrested for property damage were African American, although accounts report that both white and black people participated in property damage and looting.[66] Just like the U.S. founding myths, the Detroit myths were created by those in power, with the "official riot report . . . charging [African Americans] for inciting the riot."[67] Today, I write to clarify those myths. Weeks earlier, 39,000 hostile European Americans shut down the Packard Plant to protest the promotion of three African American women. The facts speak for themselves. The attorney Thurgood Marshall and NAACP president Walter White prepared a rebuttal to the report, collecting evidence through historical and political-economic context and interviews, demonstrating that the rebellion was an act of resistance to long-term inequality, and that whites were equally involved.[68]

As the 1940s wore on in Detroit, entrenched, legislated, and structuralist racism intensified. In 1948, "65 percent of all job openings in Detroit contained written discriminatory specifications" against African Americans in particular.[69] In 1953, conditions were even worse: 83 percent of 417 surveyed Detroit manufacturing jobs were designated for European American workers only.[70] Hurtling through midcentury Detroit, labor and political-economic progress were inextricably linked. Perhaps no one represented the consolidation of these forces more than the labor organizer and World War II veteran Coleman Young.

In 1952, Coleman Young spoke on behalf of Detroit's African American leaders before the House Committee on Un-American Activities (HUAC).[71] The HUAC, investigating suspicions of "communism in defense industries," was chaired by John Wood of Georgia.[72] Coleman Young "denounced segregation and pointed out that in Georgia, 'Negro people are prevented from voting by virtue of terror, intimidation, and lynchings.'"[73] Moreover, Young pointed out the paradox of the HUAC's claim of un-American activities, given the un-American treatment of African Americans writ large throughout the U.S., as de facto and de jure legislation and practice converged to destroy African American lives. In response to HUAC's question of whether Young would serve in the U.S. armed forces should Soviet forces attack the U.S., Young replied, "I fought in the last war and I would unhesitatingly take up arms against anybody that attacks this country. In the same manner I am now in the process of fighting discrimination against my people. I am fighting against un-American activities such as lynching and denial of the vote. I am dedicated to that fight and I don't think I have to apologize or explain it to anybody."[74]

The nuance of Young's critique—that racist, un-American activities were part of the fabric of U.S. political-economic and social life—was lost on most people at the time. While African Americans on the streets of Detroit embraced Young's testimony for its honesty, European American vigilantes in Detroit "were determined to reassert racial hierarchy and punish anyone who undermined segregation."[75] European American workers at the "Chrysler and Midland plants used traditional racial epithets and scare tactics like lynching and hanging in effigy" to intimidate persons supposedly associated with the Communist Party.[76]

However, European Americans were not so much concerned with communism as they were with communism's association—scaffolded by Young in part at the HUAC hearing—with civil rights.[77] Moreover, although the vigilantes' actions were extreme, their views represented the European Ameri-

can mainstream. In 1952, "68 percent of respondents in a survey of whites in Detroit proposed that the city deal with its racial problems through some form of segregation."[78] The connection between political-economic racism, legislation, and policy, again, is crystal clear, from the sixteenth century to the twentieth century.

Meanwhile, in concert with the four-hundred-year peak and crescendo of legalized human trafficking and genocide, Jim Crow legislation, lynchings, and the gradual overturn of segregation vis-à-vis the African American civil rights movement, a new, equally deadly form of segregation emerged—geographic apartheid, often referred to in code as "suburbanization."[79] In Detroit, geographic apartheid was expressed in residential and commercial terms— with both manufacturing plants and residential real estate. As Detroit was sucked dry, wealth and capital were consolidated in distant suburbs that were legislated, configured, and practically designated *white only*.[80]

Racialized, geographic apartheid across employment, education, and housing economically debilitated African American people during the 1950s and 1960s. Detroit's government-underwritten suburbanization, or geographic apartheid, secured and isolated superior employment, education, and housing for European Americans only.[81] Between 1950 and 1980, "the number of city residents employed in manufacturing jobs dropped 68 percent, from 349,000 jobs to 113,000 jobs," converging with the city's "dramatic white out-migration during the 1970s."[82] Contra the myth that European Americans were fleeing African Americans, a myth supported by the linguistic term "white flight," European Americans were actually moving to align with superior, white-only employment, education, and housing opportunities. African American people were disproportionately negatively impacted by the resulting racist, segregationist housing, education, and employment disparities.[83]

Massive European American out-migration from central cities alongside industrial suburbanization, manufacturing deindustrialization, and/or manufacturing reindustrialization were not unique to Detroit—across the U.S., sun-belt cities like Los Angeles, frost-belt cities like Cleveland, and rust-belt cities like Pittsburgh reflected similar geographic apartheid trends.[84] In the Detroit case, the people's choreography between city and suburbs—and the demography of the people moving—continues to be marked with accumulation by dispossession central to geographic apartheid.

Efforts to redevelop were, ironically and bitterly, steeped in the racism that initiated the reverse choreography in the 1950s so that "close examination of the urban renewal plan in Detroit, with a special focus on redevelop-

ment at the Gratiot site, demonstrate[d] the early tendency of the city to clear low-income, black residents from central-city land in order to try to attract white, middle-income people back to the city as well as to keep medical and educational institutions."[85]

Between 1946 and 1958, for instance, Gratiot and Lafayette Park redevelopment resulted in the condemnation of "129 acres" and "relocation of 1,950" African American families while a brand-new, twenty-two-story apartment building with luxury-rental price tags, intended for new European American renters, was finally built.[86] Lafayette Park, today, remains an upscale downtown Detroit neighborhood. Unbeknownst to many, however, the neighborhood also continues to symbolize redevelopment and urban process "in a societal context of racial prejudice and segregation."[87] Amid founding myth and Detroit narrative myth, historicizing key events to account for the reality—that legislated racism is the root cause of tremendous challenges— is critical. Detroit's 1967 Rebellion is such an event.

In July 1967, African Americans made up just 5 percent of Detroit's police department; were economically hamstrung by racist housing, employment, and education legislation; and were subjected to everyday racist practices of fellow Detroiters, police, and the national government alike.[88] The injustices between 1526 and 1967 wove a long, tense thread as Detroit police raided an African American after-hours club, initiating what would be the "bloodiest rebellion in a half-century and the costliest, in terms of property damage, in U.S. history."[89] All in all, at the end of the rebellion, "34 people were dead, 347 people were injured, 3,800 people were arrested," and "5,000 people were homeless, most of them black."[90] The majority of the people killed, injured, and arrested were also African American.[91] The estimated $50 million in property damage was the result of 1,000 burned buildings and 2,700 businesses subjected to property damage.[92]

The 1967 Rebellion, contemporary scholars agree, "stemmed from a long train of racial abuses heaped upon the black community over the years."[93] African Americans present at the time, however young, were aware of this as well. One Thanksgiving evening, at Todd Stovall's father's house, I spoke with a family friend, Leon Verble, who was an eyewitness to the 1967 Rebellion. Over Thanksgiving collard greens and yams, Verble reflected.

"What was the cause of the '67 Rebellion?" I asked Verble.

"Police brutality," Verble responded immediately. A beat. "The same thing that's going to lead to it again if they don't do something about these police killing people—both black and whites," he continued. "In the inner city, like the president is talking about bringing back that stop and frisk, and

all that. . . . Won't work. It didn't work then, and it's not going to work now. People are tired of being abused by the authority. And that's what brought it about. Frustration. It was a hot summer. And it just boiled over. I don't condone any killings. I don't condone it on either side. Police or civilian."

Verble paused and thought for a moment. "But basically," he continued, "the curfew was at nine o'clock. And I wasn't coming home at nine o'clock! At nine o'clock I'd be way up on the east side somewhere partying with some friends." He chuckled. "All the major action was Twelfth Street and Linwood. It was really . . . The saddest thing I saw was when Hazelwood was on fire," Verble mused. "This was into the third day of the riots, as they want to call them. . . . The police were shooting up houses. . . . It was the police. And later on, they called in the 101st Airborne Division to help police the city. Which I had just gotten home from the 101st Airborne Division. I had just got out of the service . . ." Verble's voice trailed off.

Further reflecting on the personal irony of police brutality, Verble recalled a personal incident with the Detroit police. "We knew internally, that we were being abused," Verble said. "It was like I said—it was frustration. People were tired of being abused. I'll tell you an incident that happened before this. My wife and I were coming home. About three o'clock in the morning. We lived right off of Linwood Street. And that was when the STRESS officers were out covering the streets of Detroit."[94]

"What were the STRESS officers?" I asked.

"STRESS was a violent group of the Detroit Police Department," Verble replied. "They were like a tactical force, and they called them the STRESS officers." A beat. "So, we were walking. I had just parked my car in the parking lot, and we were walking around to the front of the building, and they were coming down the street. And this one black cop jumps out of the car and says, "'Nig***, you and that bi*** come here.'

"And I'm like, 'Hey man, this is my wife. And we're on our way home. We live here.' And he asked me, 'What you got in your pockets?' and all this.

"And I'm like, 'I don't have anything in my pockets.'

"And he asks me, 'You got any ID?'

"And I'm like, 'Yeah, I got ID but I'm not going to pull it out until you frisk me because I don't want to get shot in front of my house.' I've had some bad experiences with those people," Verble concluded. The warm and cozy smells of Thanksgiving dinner, and the soft buzz of holiday football behind us, contrasted with the stark discussion.

"Another thing . . ." he continued. "Well, as a young man, I called myself a nice dresser. And I had a brand-new car. But I was working eleven and

a half hours a day, seven days a week, at Ford Motor Company, to pay for it. And every time I would cross Woodward Avenue going east, the police would stop me for no reason. See, that was the kind of stuff that brought on the '67 riot. That happened before the riot. It was the cause. Although it made me angry at the time, I didn't act on my anger. But it was based on police brutality. They want to call '67 a riot. I don't call it a riot, because it was a response to years of violence. It was a rebellion," Verble concluded.

I sat in Todd Stovall's father's living room, considering the perfect alignment of scholarly accounts and Verble's account of the 1967 Rebellion. The '67 Rebellion was an act of resistance to geographic apartheid, police brutality, and legislated discrimination across every aspect of daily life. The '67 Rebellion was a loud, bold statement that business as usual, where African American lives were destroyed every day, would not continue. However, the destructive economic policies did continue, in the form of racist urban renewal programs in the late 1960s, with the continued goal to accumulate wealth by dispossessing others of resources.

Meanwhile, during the mid- to late 1960s, African American liberation and power movements continued to multiply in Detroit. Such movements took a variety of forms, from the shop floor, to the church, to the streets. In 1967, Rev. Albert B. Cleage Jr. renamed Detroit's Central Congregational Church as the Shrine of the Black Madonna, with the goal of "redefining Christianity and bringing the church in line with the political logic of black nationalism."[95] Whether or not a nationalist approach was reactionary, Rev. Cleage's rationales were—and remain—empirically sound. "Calling for community control of institutions in the inner city, as well as for self-determination in economics, politics, and, above all, religion, Cleage and his cohorts offered what they claimed was the only viable alternative to the 'moribund' framework of the post-WWII and Southern-based civil rights movement."[96]

At the center of Cleage's efforts in Detroit was a profound and necessary call for an African American liberation movement. Reverend Cleage's efforts vis-à-vis a radical church movement were mirrored on the shop floor. In May 1968, an African American organization of unified workers was formed at Chrysler Corporation's Hamtramck, Michigan, assembly plant, formerly known as Dodge Main.[97] The group was known as the Dodge Revolutionary Union Movement, or DRUM, and was focused on addressing, "in addition to the specific issues of [production] speedup and discrimination . . . black control of the local union and black control of Management, from the lowest to the highest echelons."[98] The Shrine of the Black Madonna and DRUM's sus-

tained efforts demonstrate African American Detroiters' relentless efforts to challenge destructive policy and legislation.

In the mid- to late twentieth century, the echoes of racist urban renewal, suburbanization of the automotive industry, racially restrictive real estate policies, and employment discrimination aligned with expansion of both licit and illicit pharmacological and psychoactive drug markets. Moreover, this expansion was also a direct result of simultaneous urban re/deindustrialization and geographic apartheid. Detroit became a textbook example of the phenomenon sweeping cities across the U.S., in which "urbanites dwell in troubled, often forgotten outposts, where the 1950s promise of industrialization became a 1980s 'junkyard of dreams' as Mike Davis calls it. In this wasteland, gangs package narcotics to stimulate the local economy, Sudhir Venkatesh has shown, taking it on themselves to bear the responsibility of job growth in government-neglected streets."[99]

In the case of Detroit, crack cocaine was the illicit drug of popular concern in the 1980s and 1990s. Crack cocaine's popularity—and status as epidemic—in majority African American neighborhoods across cities like Detroit, Los Angeles, Philadelphia, and New York aligned with mass media obsession with the drug and its racist criminalization.[100] Moreover, the political-economic consequences of criminalizing crack cocaine use devastated people across low-income African American Detroit neighborhoods through familial destruction, punitive criminalization, explosive mass incarceration, violence, and death.[101]

The War on Drugs, first declared by Richard Nixon in a 1971 press conference in which he called drug use "public enemy number one," criminalized drug addiction and, in particular, criminalized people already in precarious geographic, racialized, political-economic positions versus the apparatus of the U.S. government.[102] The War on Drugs would continue through the Ronald Reagan and George H. W. Bush years, with devastating consequences to the people the War on Drugs was designed to destroy: "By 1992, one in four young African-American males was in jail or prison or on probation or parole—more than were in higher education. . . . During the crack scare, the prison population more than doubled, largely because of the arrests of drug users and small dealers."[103]

The result of the War on Drugs? By 1992, the U.S. achieved an unfortunate title befitting a country built upon destruction and racist policing of African Americans and Native Americans during the Constitution's drafting— the highest incarceration rate in the world.[104] The glaring paradox of the crack cocaine epidemic and the War on Drugs was an

ironic mixing of metaphors, or of diagnoses and remedies, when advocates for the War on Drugs described crack use as an epidemic or plague. Although such disease terminology was used to call attention to the consequences of crack use, most of the federal government's domestic responses have centered on using police to arrest users. Treatment and prevention have always received a far smaller proportion of total federal antidrug funding than police and prisons do as a means of handling the "epidemic." If crack use is primarily a crime problem, then terms like "wave" (as in crime wave) would be more fitting. But if this truly is an "epidemic"—a widespread disease—then police and prisons are the wrong remedy, and the victims of the epidemic should be offered treatment, public health programs, and social services.[105]

In the realm of licit drug markets, aggressive liquor marketing campaigns and geographic apartheid-suffocated commerce asserted the neighborhood liquor store and alcoholism as facts of everyday life.[106] Liquor stores and their proxies serve as hubs for licit and illicit drug transactions that enrich business owners.[107] In addition, the stores are reimagined as plazas by people in neighborhoods with no formal public plazas or squares.[108] Flashing forward through the War on Drugs' destruction of African American neighborhoods: mandatory minimums cause neighborhoods to be gutted and create a Prisocracy where millions of African Americans are incarcerated as companies profit from their destruction.[109]

In addition to illicit and licit drug markets, Detroit's racist urban renewal projects of the 1980s and 1990s gave way to waves of predatory residential mortgage loans—Detroit's residential foreclosure crisis—of the 2000s to the present.[110] In 2007, Detroit and Cleveland were tied for an unwanted title: the highest home loss rate in the country for subprime (typically low-income, working-class, African American and additional people of color) borrowers.[111] In 2015 it was reported that since 2005, more than one out of every three homes in Detroit had been foreclosed upon—139,699 of Detroit's 384,672 homes—due to mortgage defaults or unpaid taxes.[112]

African Americans were disproportionately harmed economically in the foreclosure crisis, with African American net wealth falling by 53 percent, to $12,124 as a result, versus a drop of 16 percent in European American median net wealth to $113,149.[113] The vast wealth gap—the consequence of economic disparities, fashioned and multiplied from the year 1526 to present, without redress to date—is only growing. Low-income African American Detroiters were pushed out of their homes and their wealth not only due

to foreclosures, but also due to threats upon a resource elemental to human life—water. Between March 1 and August 22, 2014, close to 20,000 Detroit households experienced an interruption in their water service.[114] In 2014 in total, 33,000 households had their water shut off. Detroit's Water and Sewerage Department, amid a municipal bankruptcy process and cash-strapped to cover $90 million in bad debt expense, devised a plan to generate cash. The plan: shut off the water in households owing $150 or more.[115]

The city's cash-generating strategies caused the most pain to its most vulnerable residents—children, elderly, and disabled people—while corporations and public entities owing six figures (including the city itself) in back bills failed to pay and the water continued to flow.[116] Since the 2014 mass shutoffs, Detroit's water crisis continues to unfold. In 2015, water shutoffs continued at a remarkable clip, with 23,200 new shutoffs. In 2016, 27,552 households lost water access, and in 2017, at least 17,665. In 2018, the city added 16,295 shutoffs, and in 2019, 23,473. All told, between 2014 and 2019, 141,000 Detroit households lost water access, nearly all of them black and low-income.[117] In March 2020, as the COVID-19 (novel coronavirus) pandemic reached Michigan, under pressure from grassroots activists and church leaders, Michigan's governor Gretchen Whitmer announced plans to temporarily restore water services to all residents and to temporarily stop new shutoffs. However, the timing and the impact on the most vulnerable people is unclear.[118]

This long-overdue action seems late and self-interested. At least 141,000 black and low-income households have been at grave health risk due to lack of water services since 2014. This is a human rights crisis and a genocidal situation. However, antiblack violence in Detroit is so entrenched, and poor people's suffering so banalized, that it takes a viral pandemic for households to receive water. The insidious logic behind the public health pivot can't be ignored—now that sickness may travel unencumbered amid a pandemic, we suddenly find concern for a long-egregious situation.

Longtime grassroots activists in this city continue to advocate for the city's most vulnerable people, with groups like the Detroit Water Brigade, the Poor People's Campaign, and the Michigan Welfare Rights Organization, dedicated grit-and-sweat-run groups, working against unjust policy ultimately designed to remove low-income African Americans from now-coveted real estate. Today, Detroit is over 82 percent African American, over 40 percent of households live below the poverty level, and outsized economic benefits flow to a small number of white and wealthy newcomers. Meanwhile, low-income Detroiters and African American Detroiters continue to be dis-

proportionately harmed by antiblack political and economic policy across education, housing, jobs, the legal system, food access, water access, and credit markets. In 1999, the first state takeover of Detroit Public Schools initiated the closing of more than two hundred public schools. During 2009–2011, under state-appointed emergency financial management, the school district lost more than twenty thousand students and closed fifty-nine schools, and its deficit ballooned to more than $284 million.[119] Today, the remaining 49,276 students try to learn in substandard conditions including derelict buildings, freezing temperatures, vermin infestations, teacher shortages, book shortages, and associated lack of engaging curricula.[120]

In 2017, white people constituted 10 percent of Detroit's population yet received disproportionate access to credit markets. Of 1,072 mortgages issued that year, the mathematical majority went to whites, in spite of the city's demographics. Moreover, in many city neighborhoods (139 census tracts in 2017) there were no mortgages issued at all.[121] Yet where black people did own homes, mortgage foreclosure rates across the nation were highest. Detroit was unfortunately emblematic of mortgage foreclosure's disproportionate impact on black people. Between 2013 and 2017, Detroit led the nation in reverse mortgage foreclosures (Chicago trailed in second place, even with four times Detroit's population).

A reverse mortgage allows borrowers to borrow money against their home at market value and to suspend mortgage payments temporarily. When the loan comes due, however, as a result of moving, a death, or a default, the entire balance becomes due, plus fees and interest. Of Detroit's 1,884 reverse mortgage foreclosures during that time frame, the foreclosure rate was six times higher in black neighborhoods than in predominately white ones, even at the same income level.[122] In 2020, a *Detroit News* investigation revealed that black Detroit homeowners were overtaxed at least $600 million after the city failed to adjust property values after the Great Recession.[123] Almost zero convenience and grocery stores are owned by black people, over 140,000 low-income and black households lost water services between 2014 and 2019, and between 2005 and 2015, there were at least 65,000 mortgage foreclosures completed in the city out of hundreds of thousands initiated, disproportionately impacting black households.[124]

In *LST*, my ethnographic and artistic agenda works to collapse (imagined) distance between onto-historical materialist formation of power, law, oppression, domination, and destruction. I work to reveal that "space, social justice, and urbanism are all initially viewed as topics in themselves which can be explored in abstraction—once it has been established what space is, once

it has been established what social justice is, then . . . we can proceed to the analysis of urbanism. . . . The recognition that these topics cannot be understood in isolation from each other and that the pervasive dualisms implicit in western thought cannot be bridged, only collapsed, leads to a simultaneous evolution of thought on all fronts."[125]

These days, you can smell money in downtown Detroit. The smell of money—the electric smell of filet mignon, the dank waft of craft cocktails blowing in your face with the frost-belt cold as you walk by a newly renovated downtown bar. Downtown Detroit smells like money. But just a few miles away, in McDougall-Hunt, the east-side neighborhood where Liquor Store Theatre unfolds, there is an odd smell of money.

On the scene of the liquor stores of McDougall-Hunt, as I film and hang out, I find that these stores are ATMs for the proprietors—and sites of gross inequality for neighborhood residents.

Spinning back to the present moment—let me bring you to the streets of Detroit's east side, to McDougall-Hunt. From 1526, we move to contemporary Detroit, where African Americans continue to live and to work against political-economic racism and legislation designed to destroy them. In *Liquor Store Theatre*, I'm toggling between the abstract, the smooth, the gritty, and the material in order to document, to historicize, and ultimately, to transform.

Introduction

FADE IN FROM WHITE:

EXT. GRATIOT LIQUOR—(DAY)—MEDIUM SHOT—A weathered, well-seasoned liquor store. It's steamy and sultry. The swirling air sings the promise of a months-long Detroit summer. My mind winds through the series of films I hope to make this summer, where I plan on coursing through this tiny little sliver of the United States in a neighborhood on Detroit's east side called McDougall-Hunt, staging performances and talking to people about city life. This thing will be called *Liquor Store Theatre*. This is all, at the moment, a forward-facing dream. I'm dreaming forward, willing concrete investigations to the surface of the street as I move. But today, warm sun presses down on a city scene.

The CAMERA PULLS BACK to a HANDHELD SHOT across a weather-faded, indigo-and-lemon façade with GRATIOT LIQUOR emblazoned in all caps across the store's awning. People walk across the streets and sidewalks around the small, modest liquor store; it's a typical midday on a summer Saturday, with soft, city bustle. The McDougall-Hunt neighborhood's bizarre blend of abundant nature, postindustrial buildings, and well-worn modernist architecture grabs you with its surreal swooshes of then, now, and future. In a quick PANNING MEDIUM SHOT, we get a sense of all these movements at once. Right away, the CAMERA PULLS BACK to a fatter ESTABLISHING SHOT of GRATIOT AVENUE in front of GRATIOT LIQUOR.

We're staring down the wings, into the backstage of Detroit, a Midwestern, postindustrial city with a population of approximately 700,000 people. Imagine a grit-shaded, broad city sidewalk, just at the edges of four lanes of traffic, streaming down either side of the street. In front of the store, here I

am, trembling-hot in the sunlight, eager to start this *Liquor Store Theatre*. All at once, I'm feeling the whirling of theory and thinking up against the rolling hum of practice under my feet.

The Moves

In *Liquor Store Theatre* (2014–ongoing), I stage and video record performances and conversations about city life in the streets, sidewalks, and parking lots surrounding the eight liquor stores in a neighborhood called McDougall-Hunt on Detroit's near east side. The resulting videos, equally depicting ethnographic encounters and contemporary art unfolding on the surface of the street, form a multivolume, thirty-plus-episode series. But the truth is that this book is all about the action before the *LST* cameras showed up and the action after the *LST* cameras were turned off, far beyond the scene of the liquor store and into everyday life in the zone.

After the cameras were turned off, I followed four of my willing neighbors into their lives in the McDougall-Hunt zone. These four individuals became what we call, in anthropological research, key informants. They included Greg Winters, a former long-haul truck driver whose family had owned a block of homes in the zone since the 1950s; Faygo Wolfson, an artist and sidewalk philosopher; Hector McGhee, a retired manufacturing worker and organic intellectual; and his nephew Zander McGhee, an aspiring college student.

During the time frame discussed in this book, in front of the *LST* cameras and beyond, my time with these four informants, and in particular Winters and Wolfson, modulated between deliberately thin-description encounters, scaffolded by anthropologist John Jackson in that "thick description, in a sense, has always been thin," and an affective approach to classical neighborhood ethnography, which anthropologist Kathleen C. Stewart described as locating "circuits and flows" of everyday life.[1]

Bracketing thick description with awareness of limits of knowing, I search out what anthropologist Clifford Geertz called the "informal logic of actual life."[2] Over the course of the many years discussed in this book, my key informants and I drank coffee together, smoked a square or two in the midst of heady conversations, talked and did math at kitchen tables, shot the breeze at bus stops, took photographs together, walked McDougall-Hunt countless times, went to performances and art openings, gardened, went to neighborhood meetings, made things, laughed, and cried, as they shared glimpses of their lives, and me of mine, in our own different ways.[3] It might come as a

surprise to those familiar with the *LST* video project that most of the ethnographic action occurred after the cameras were clicked off, and I orbited from the scene of the liquor store back into the neighborhood where I also lived and started collecting anthropological field notes in 2012.

The films and the fieldwork that followed after the *LST* cameras were switched off center on questions of contemporary cities and social life. What is the struggle for the city in Detroit? The right to the city, described by critical geographer David Harvey as the right to participate in the experiences, the resources, and the shaping of city life, is a poignant description of what it means to participate in city life.[4] But such participation isn't simply voluntary—it is structured, controlled, mediated, contingent, and offered or not, according to a society's policies, legislation, consolidation of wealth and resources, and practices. How, in Detroit, do people struggle for access to key resources, like quality education and employment opportunities, affordable housing, clean air, clean water, fresh produce and adequate nutrition, reliable public transit, and leisure, recreation, and green space amid the concrete grids and inequities of city life? How do people view, experience, shape, and reshape urban process? How do people shape their day-to-day, and through this, the city as a whole? McDougall-Hunt had much to say to all of these questions.

The Backdrop

McDougall-Hunt, a tiny little slice of Americana, just under half a square mile, with a population of approximately 1,000 people, is 95 percent African American and has a median per capita income estimated at $13,000.[5] The zone, bounded by Gratiot Avenue, Mack Avenue, Mt. Elliott Street, McDougall Street, and Vernor Highway, is two miles from downtown Detroit and the Detroit riverfront, and less than a mile from the Eastern Market neighborhood.

It's a precious little slice of the city that, at the time of this writing, seemed to float under the radar of glitz, redevelopment, and reindustrialization. It's a sprawling, postindustrial landscape of weather-faded modernist architecture, wide city sidewalks, funky urban cottages, and—above all— people who never ceased to challenge my assumptions. McDougall-Hunt is also the site of the Heidelberg Project, contemporary artist Tyree Guyton's sprawling installation of abandoned homes festooned with everyday objects like teddy bears, televisions, Barbie dolls, AM-FM radios, toilets, tires, and more (such objects are known as *readymades* in the art world). Since the late

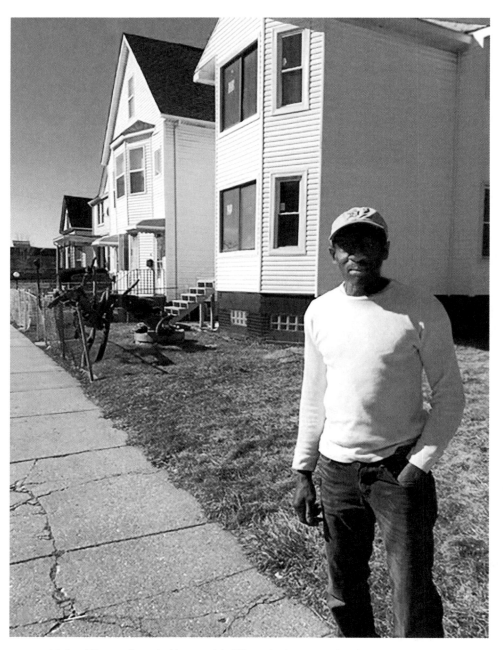

I.1 Greg Winters, pictured with some of the Winters family property (2017).

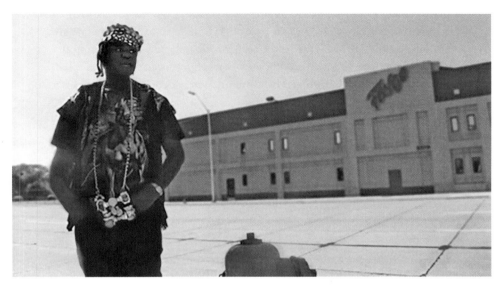

I.2 Faygo Wolfson, pictured at *Liquor Store Theatre, Vol. 4, No. 7* (2017).

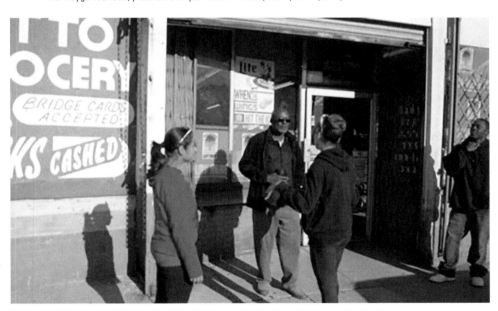

I.3 Hector McGhee and Zander McGhee, pictured with Fabiola Torralba and Maya Stovall, at *Liquor Store Theatre, Vol. 3, No. 5* (2016).

1980s, Guyton had been covering homes, including the home in which he grew up, with readymades and his paintings. Still, in spite of the rich neighborhood cultural life that the Heidelberg Project reflected, the economic figures of the zone were dire. And, while economic figures can't begin to explain the complexities of the people, the economics are, of course, worth a closer look.

At the latest census, at least 48 percent of citizens were living in poverty, and the rate of residents with mortgages was 19.4 percent, versus 36.1 percent across the city, indicating an even more stark economic picture in McDougall-Hunt. With a population density of 2,550 persons per square mile, McDougall-Hunt's density was far below Detroit proper's average of 4,878 persons per square mile. Think of New York City, with 28,256 per square mile, and San Francisco, with 18,440 per square mile.[6] It was clear that post–Rust Belt poverty had its arms around this slice of the city.[7] And yet the zone sang with complexities—for me, a salient approach to urban anthropological research needed to sing back with equal complexity.

Urban anthropological research has shifted considerably over the three centuries in which it has emerged formally through the disciplines of sociology and anthropology. From sociologist W. E. B. Du Bois's groundbreaking nineteenth-century mixed-methods study of urban African American life in Philadelphia, to anthropologists St. Clair Drake and Horace Cayton's analysis of raced and classed communities in Chicago on the heels of the Great Migration, to political philosopher Frantz Fanon's postcolonial analysis of revolution, psychoanalysis, dynamic psychiatry, anthropology, and ideology across France and Algeria, to anthropologist and writer Zora Neale Hurston's luxurious ethnography of African American folkloric traditions of her hometown of Eatonville, Florida, to anthropologist and choreographer Katherine Dunham's combination of praxis and ethnographic study of Haitian Vaudun, to poet Audre Lorde's gracefully painful poetry marking the feminist civil rights movements of 1960s New York City and beyond, to playwright August Wilson's works tracing contours of African American cultures across geographies, classes, and decades in the United States, an interest in performance and place imprints genealogies of urban anthropological research, as well as understandings of African diasporic cultural traditions and aesthetics.[8]

Building on this literature, I placed performance—in this case, a particular approach to the public making of conceptual art through choreography, ethnography, and moving image—in direct dialogue with the city. I was in search, as well, of a nuanced dialogue. I built upon works like anthropologist Laurence Ralph's urban ethnographic inquiry. On synthesis of theory and

method in fieldwork among gang groups and communities in urban Chicago, Ralph wrote, "After years of grappling with the sociology and anthropology literature on gang and community life, I decided that the most tenable approach was a concept of the past as an ambiguous space, as somewhere between history-as-registered and history-as-lived."[9]

Ralph's phenomenological interest in history's claims links to a critical question concerning Detroit—"Who decides which version of history will be told?"[10] Ralph's philosophical approach offers a point of departure. In deploying a contemporary, in-the-moment performance as prompt for conversation, I visually prioritized "history-as-lived" and invited people to respond to my visual prompt with their thoughts. In situating the conceptual art project on the street with a historiographic, political-economically contextualized rendering of the city, I offered "history-as-registered" as a necessary backdrop in an ethnographic analysis of the present. Ralph wrote, "The very composition of urban cities shifted, with increasing vehemence, starting in the 1960s, as businesses moved their investments from urban centers to the suburbs, and eventually overseas. Opportunities for illicit revenue blossomed just as opportunities in the legal labor market wilted."[11]

Spinning to conversations with people at *Liquor Store Theatre, Vol. 1, No. 3* (2014), Ralph's discussion of political-economic structure and its implications for social life rang particularly relevant. The CAMERA CUTS to a TIGHT SHOT of an attractive older woman, Fran Harper. Harper is wearing a mud-cloth African print dress, has smooth, gray hair, and a gentle smile. She's kind and witty, with punchlines at the ready. After viewing two takes of dance performances, she asks, "What are you doing here, sweetie?" After some explanation, Harper agreed to an interview and proceeded to give one of the most quoted and fascinating interviews of all of the films.

"My father bought the house in 1945. Right there on McDougall. You see, back then, the men, they basically worked in the factory. When your father worked in the factory, you didn't think you were poor, you see. I didn't think I was missing anything until I got to Cass Tech. . . . There, I met the children of doctors and lawyers."[12] Harper smiled. The CAMERA PULLS BACK and we see a summer late afternoon in full swing going on behind her. There are people of all ages, but mostly in their twenties and thirties, appearing to stock up on supplies for a party.

"My father said, 'What do they have?' I said, 'They got steak on the grill, Dad—and we have barbecue on the grill.' . . . My father said, 'Okay then . . . let's get some steak, and put it on the grill!'" Harper continued to describe her experiences in the McDougall-Hunt neighborhood over the years. "I went to

the University of Michigan and graduated in 1965. . . . One of my daughters moved out to California, one of them moved to Warren, Michigan, they're both good; and my son didn't do anything... because he didn't want to do anything." Harper's stoic demeanor wavered just a hair as she mentioned her son. She quickly righted herself and offered another signature, impeccably timed quip. "Now, what else do you want to ask me?" she volleyed. Harper's comments not only confirmed Ralph's historiographic analysis of the difficulties faced by urban African Americans across post-1960s U.S. cities, but Harper also cemented the structural supports of Ralph's interest in history-as-lived.

Harper's descriptions of her family's complex choreography in the neighborhood included fine-grained awareness of intracultural classed, political-economic differences, generations of property ownership, attendance at an elite public university, and a wide range of third-generation outcomes, including her adult children who were doing well and one who seemed to be struggling. Fran Harper's interview and Ralph's interest in who gets to tell the stories set the ethnographic and theoretical stage for my approach to urban anthropological research in this work. In the years after Harper's poignant conversation, Ralph's claim continued to resonate—it turned out that people were interested in telling their own stories on camera, and that many people (both in the neighborhood and around the world) were interested in hearing these stories. More and more, as I spoke to people on the streets and sidewalks, it seemed that after the cameras were clicked off, curious people would ask me a particular question.

People wanted to know—what was the typical conversation with someone on the street like? The answer was, there was no typical conversation. In fact, if anything was typical, it was surprise. Harper, for instance, shared in a few moments just a few of her family's connections and contradictions across generations. The desire to know what the typical conversation with one of my informants looked like, I considered, was a desire to get to what Jackson called "*the real* in (and in the intentions of) everyone around us."[13]

As Jackson theorized, one of the problems with our desire to get to a so-called real was the series of shortcuts it recruited and required. Jackson's "racial sincerity," rather, offered a revision to the flat notion of "authenticity . . . as an unbalanced relationship between the powerful seer and the impotently seen."[14] Racial sincerity, then, consolidated both a critique of racial authenticity and a critique of racial authenticity's critique, given that "critiques of racial authenticity may be anchored in the very same kind of objectifying and thingifying that they attempt to debunk."[15]

The CAMERA PULLS BACK to a MEDIUM SHOT of Fran Harper. The plastic palm trees and the persistent neon signs flicker in the bright midday sun as Harper describes her opinions on graffiti art in the city: "Some of the graffiti art is good, and some of it is not so good," she reflects. Moments later, Harper pivots seamlessly from art on the street to art in a white cube, expressing her hopes that the Detroit Institute of Arts would not be closing due to Detroit's municipal bankruptcy, from which the city had yet to emerge at the time.[16] Harper's nuanced discussions, and similar discussions that followed, reflected the complex subjectivity ethnographically and theoretically mined by Ralph and by Jackson. The racial sincerity analytic foregrounded an anthropological reality of confessing to not-knowing, as an essential element to knowing more.

Racial sincerity, then, offered a necessary speed bump to those seductive assumptions of which we're all guilty—think of a rhythm of banger; thug; queen; transient person; stoner. Of course, McDougall-Hunt's residents and passersby did not fit these seductive assumptions; there was no typical person nor typical interview. The analytic also presented a model for reading and understanding both subjective particularity and generality. From brief ethnographic encounters with informants such as Harper to extended ethnographic relationships with Winters, Wolfson, and the McGhees, this "granting of autonomy and interiorized validity" proved necessary as I listened to and documented the complexity of the day-to-day.[17]

The Contributions

This work is a critical theoretical and methodological intervention across disciplines including conceptual art, critical geography, critical race theory, political economy, and urban anthropology. Complicating an assumed hierarchy between artist/ethnographer and subject is at the center of these efforts. I began with performance as prompt—what I call a dancerly prompt—at the scene of the liquor store. With this prompt, I posed the question—how might I challenge what cultural theorist Stuart Hall called the received and rehearsed roles of people on the scene, including the anthropologist/artist and the informant/subject?[18]

That is, how might I trouble the assumption of a hierarchical relation between the anthropologist and the informant, where the anthropologist is the gazer and the informant is gazed upon? How might I challenge where contemporary art exists for viewing, who gets to view it, and who is

or isn't invited? How might I challenge power dynamics between artist/ethnographer and subjects?

Foregrounding the anthropologist's encounter with what feminist theorist Sarah Jane Cervenak named "philosophical wanderings," I prioritized the affect and desire of the day-to-day, the interiors of people's lives.[19] At the same time, I sought an ethnographic approach that could bridge the philosophical and the materialist, by uncovering the coded insights of daily life that pointed to political-economic, historical, legislated realities.[20] By beginning with perhaps bizarre, surreal performances outside liquor stores in the reportedly second most dangerous neighborhood in the United States, I challenged reductive ideas of low-income and black lives. I laid bare the question and investigated why, as critical geographer Katherine McKittrick wrote, "black bodies, rather than black people, are informing how we understand the production of space."[21] In the course of my meditation on life in the neighborhood, I came to some conclusions.

First, I developed an ontology for analyzing space and place, called the paradox of place. The paradox of place is an analytic consolidating the metaphysical, philosophical, and historical-materialist registers of places and spaces. In my approach to anthropological research and making art, I wanted to find new ways of thinking about space and place.

In other words, I wanted to touch and meditate on the contemporary; even shift it, while I documented and analyzed the subtlety, complexity, and the intricacies of human existence. The paradox of place, which ascended to the front of the camera and landed in my notebooks, is to be deployed as a way of thinking through personhood, power, access, resources, and nuance of urban process, centering the unseen, the subtle, and the insides of places and spaces. In addition to the theoretical intervention of paradox of place, I located particular findings in the McDougall-Hunt neighborhood.

I found that art, labor, and movement were the central forces people in the neighborhood deployed to move forward, to exist, and to meditate on the past, present, and future of city life. One day, a willowy, fresh-faced woman named Charlene Athens told me, "My art is black culture—I do hair. It's how I live." My theory of art in McDougall-Hunt was built on the foundational supports of Charlene Athens's words—her art was the black culture she drew upon, shaped, and reshaped each day, in her everyday life, as she worked to pay her bills and earn a fulfilling living doing hair. Faygo Wolfson, the artist and sidewalk philosopher, told me, "Someone has to stay here and do this work," as he described running errands for his older family members and making his art from items salvaged from the streets and sidewalks.

My theory of labor was supported by a Boggsist intersectional conception of philosophers Michael Hardt and Antonio Negri's affective labor, reflected in Wolfson's commentary. I synthesized this intersectional affective labor as labor that landed beyond formalistic political-economic structures and labor that was inflected and/or attuned to classed, racialized, gendered, and sexualized structures.[22] In Wolfson's labor, there isn't formal capital structure, nor is money exchanged, yet Wolfson's labor is critical to life in the neighborhood—he helps family members and friends live another day. Likewise, Greg Winters had a mantra that resonated across the neighborhood—"keep it moving."

My theory of movement was built on the critical platform of Winters's mantra. I stitched the philosophers Deleuze and Guattari's notion of movement as an interrelated project of "becomings," "affects," and "perceptions" together with Greg Winters's words.[23] The resulting theory of movement is both visceral and wide-ranging. Whether it was moving a residence, moving to a new job, moving on to the next lawn to mow, moving to the next art project, or moving one's thinking, the people in the neighborhood, I found, were constantly moving. Although the people's apparent economic, housing, or educational status may not have moved, people were moving, always, to keep going forward, and to reshape their own subjectivities.

In other words, McDougall-Hunt was not what stereotypical assumptions might have held—it was not a place that could be boiled down to drug trade, gang affiliation, and late-capitalist, neoliberal decadence and decay. McDougall-Hunt was a glittering, contradictory, fascinating place of ideas, thoughts, words, hopes, and dreams. McDougall-Hunt emerged in this fieldwork as an artsy, postindustrial, funky urban neighborhood, and the people who made McDougall-Hunt move were equally complex.

McDougall-Hunt also emerged as economically distressed area in which people worked to mitigate monumental destructive economic forces like the residential housing tax foreclosure crisis, the mass water shutoff crisis, and forces of brutal urban process like escalating rents, evaporating jobs, and inadequate public transportation bus routes.[24] The people that studded this story were as complicated as anyone walking the planet, and their uses of art, labor, and movement as strategic forces in city life, to be described and analyzed in the pages that follow, evidenced their complexity. The McGhees, Winters, and Wolfson each provided ways of knowing art, labor, and movement in the zone, and beyond. I was interested in encircling the neighborhood and my informants in a global discussion of the politics of cities and the complexities of urban existence. My informants, with their stories and

ideas, made this easy—what they were theorizing and doing was in dialogue with the world.

From Performance to Choreography to Ethnography to Conceptual Art

When I refer to the term "performance," I am referring to conscious and unconscious actions happening from the sidewalk to the stage. In other words, I refer to performance as a broad concept, both consolidating and expanding notions of performance as art or performance as the actions of the everyday. My wide-ranging approach to theorizing and making performance rises from genealogies of critical anthropological performance studies and conceptual art frameworks.

Performance, in conceptual art frameworks, often deploys ethnographic method as a mode of researching and making. However, the location of ethnography in art world contexts, by anthropology's standards, including rigor, duration, and ethics, remains largely undefined. Simultaneously, anthropologists have a rich tradition of conducting ethnography in performance communities, as well as deploying performance as analytic toward investigating the everyday.

Ethnographer Marlon Bailey, for instance, deployed performance as ethnographic framework in his monograph, *Butch Queens Up in Pumps: Gender, Performance, and Ballroom Culture in Detroit.*[25] In part drawing on performance theorist Dwight D. Conquergood's coperformative witnessing, Bailey's ethnography of the Detroit drag ball scene over the early to mid-2000s documented ballroom culture, and complex subjectivities, of people with a variety of racialized, classed, gendered, sexed, and sexualized social positionings in the drag ball scene.[26] Bailey was also concerned with the interiors of queer ballroom culture, ultimately producing a nuanced kinship analysis.

Bailey meditated on kinship in the drag ball scene, but in doing so he destabilized dominant narratives of what patriarchal, biological kinship structures can and should look like. Bailey didn't stop there. He also destabilized notions that alternative kinship structures were, a priori, free from oppressive ways of thinking, knowing, and being. Bailey could build an insider's ethnographic account of the drag ball scene because of his approach as an emic participant-observer ethnographer. In other words, Bailey extended and challenged coperformative witnessing, joining the scene, walking, talking, and listening alongside a variety of informants over the years. Anthropologist Deborah A. Thomas's ethnography of a Jamaican village just outside Kings-

ton likewise demonstrated an attention to performance. In Thomas's mono-graph, the performance of cultural identity was of particular importance.

Thomas, who in addition to her location as ethnographer was a dance artist and former performer with the acclaimed contemporary dance com-pany Urban Bush Women, conducted fieldwork attuned to "popular cultural production and modern blackness in Jamaica."[27] Thomas's work reflected a sensitivity to the connection between "publicly hegemonic ideologies" of nation-states and institutions, and ways Jamaican people chose to per-form their cultures and subjectivities.[28] Writing against an Enlightenment-kindled, nineteenth-century-sustained, and neoliberalism-fueled expectation of racialized respectability, Thomas documented critical, resistant perfor-mances across her fieldwork. Such critical performances are what Thomas called "modern blackness."[29]

Thomas wrote, "The modern blackness of late-twentieth century youth, then, is urban, migratory, based in youth-oriented popular culture and influ-enced by African American popular style. It is individualistic, radically con-sumerist, and 'ghetto feminist.'"[30]

Thomas's particular attention to the expression of complicated politi-cal-historical ideology through "cultural idioms and innovations" of "lower-class black Jamaicans" resulted in an ethnography requiring attention to the connection between popular culture, everyday life, and broad political-economic, sociocultural stances and structures.[31] From cultural festivals, to dance studios, to transnational migration, to collective and individual memo-ries, to local and national policy and legislation, a particularly "unapologetic blackness" emerged from the performances, actions, speech acts, and musings of Thomas's informants.[32] Thomas's monograph contributes to the geneal-ogy of performance-attuned anthropological and sociological research, and to this work in particular, through its dialogic attention to both the complex subjectivity of broad-spectrum black performances and the significance of broad-spectrum performances themselves in analyzing contemporary social life.

Shifting to the United States, anthropologist Elizabeth Chin's per-formance-sensitive ethnography of low-income and working-class African American youth is likewise attuned to a particular sort of consumerism that figured critically in Thomas's monograph. Chin's perspective as an anthro-pologist and a performing artist manifests in her critical, sophisticated analy-sis of her informant's formal and informal performances. Chin, at times, acts as what I shall call an ethnographic dramaturge, in complicated readings of her interlocutors' actions.

Chin's young girl informant, Tionna, implores from inside a car while driving with Chin, to another passing car (which was driven by a "blue-haired" white woman), "What are you looking at, white people?"[33] Chin deploys this statement as an analytic of positionality. Rather than a flat statement reflecting racialized binaries, Tionna's statement was meant for Chin, and meant as a support in Tionna's assertion of her own personhood. Chin proceeded with an ethnographic dramaturgical analysis of Tionna's prompt, writing, "'I know what you're thinking,' Tionna seemed to say, 'and I can be that person, but if you think that's me, you don't know what you're really looking at.' The challenge Tionna offered was to see beyond the act, to recognize her performance for what it was, an imitation of stereotypes held by others."[34]

Chin's analysis wasn't simply ethnographically dramaturgical but was also foregrounded with ethnographic subjectivity. Chin didn't assume she could accept her informant's actions at face value; moreover, Chin sought nuance and irony in everyday performances that produce and reproduce social life. Her work offers an invitation for ethnographers to consider their own location and extend such criticality to their ethnographic interlocutors. Chin also reflected on the limits of such a nuanced approach—from Tionna's prompt, to the responses of passersby, to ethnographer's participant observation. Chin mused, "The catch is, Tionna could be reasonably sure that only those familiar with her neighborhood as a community would be able to see through the put-on: people passing by in cars at thirty-five miles an hour are hardly likely to get the joke."[35]

Chin's car ride with Tionna and the motorist passing by are a metaphor for the possibilities, and challenges, of performance-attuned ethnographic research. Chin, in the driver's seat, has a particular location and view. Chin self-reflexively analyzes herself, her informants, and other people, including the woman driving by. Chin has a view that offers subjectivity to all on the scene—including the motorist who was thought by Tionna, perhaps, to represent a broader tone-deafness to complexities of black youth.

Broad-spectrum performance-attuned ethnographic research allows us to slow down the cars—continuing Chin and Tionna's drive—perhaps to pull up alongside the woman in the other car, perhaps asking Tionna to elaborate more on her "homey-er than thou" riff, perhaps pulling over, abandoning the cars altogether, and exploring these meanings.[36] Enriched by such performance-attuned sociological and anthropological research, I developed a theory of choreography as strategy.

When I use the word "choreography" in this work, I am referring to a theory of choreography as strategy—first, choreography as a way of making and analyzing sequences of actions and events. And second, choreography as a mode of making and analyzing all of the cultural, political-economic, and social movements contributing to continuous shifts the world over. Choreography as strategy, then, is both "the extension of Marx's concept of socialization to a widening range of practices" as well as a way of "find(ing) an analytical ground between incorporation and inscription, the bodily and the linguistic, historical subject, and agency."[37] In other words, choreography as strategy is a particular way of understanding sequences of choreographed actions within the scope of contemporary social life, contemporary art, urban anthropological research, political economy, and critical geography.

Classical critical geography theory refers frequently to art, dance, and performance metaphorically in discussions of city life.[38] Geographer Jane Jacobs described neighborhood life on New York City's Hudson Street as a "daily ballet"; geographer Henri Lefebvre described city spaces as contesting "the division between the everyday and the out-of-the-ordinary"; and geographer David Harvey described walking down a street as locating "works of art that ultimately have a mundane presence in absolute space and time."[39] Taking this to task, what might performance as prompt, what might conceptual art bring to studies of space, place, and cities? How might this approach expand on the work of ethnographers studying cities? How might this approach meditate on, and press into, contemporary artists' embrace and critique of studio practice, post–studio practice, white cube, and street?

Reflecting the large-scale questions looming here, performance theorists Thomas DeFrantz and Anita Gonzalez note that "black performance theory is high stakes because it excavates the coded nuances as well as the complex spectacles within everyday acts."[40] In other words, as performance theorist André Lepecki writes, choreography as strategy refracts "political ontology . . . in relationship to representation and subjectivity."[41] I also took an interest in positionings of dance within performance studies, anthropology, and contemporary art.

Dance studies draws metaphors between the politics of concert dance and the relational politics of social life.[42] In the words of performance theorist Barbara Browning, the deeper meanings of performance are excavated through attention to, in addition to control of, musicality through syncopation, "another kind of suppression, which is racial, cultural, and political."[43] This way of reading dance as social-life analytic required specificity

and context, as Browning noted. Dance theorist Randy Martin described the complexity of dance as frame, writing, "the question of what dance does for politics cannot be answered a priori; its effects need to be specified in any given instance."[44] In other words, Martin argued that as context is articulated, "dance can be specified as that cultural practice which most forcefully displays how the body gets mobilized."[45]

Shifting from argument to philosophical inquiry, dance theorist Brenda Dixon Gottschild asked the billion-dollar art world question, "How much is the world of art beholden to acknowledge and deal with history and culture?"[46] I built on this analytical frame, casting postminimalist performance as prompt, beyond dance-specific proscenium and post-proscenium contexts, into the realm of the everyday, bracketed by the making of conceptual art and the ethnography of a neighborhood.

In this work, acts of performance and acts of dance were not modes of entertainment. Acts of performance and acts of dance, rather, were modes of thinking, modes of conceptualization, modes of inquiry, modes of theory and praxis, like a brushstroke across a canvas or an acrylic glass cube in the middle of a public square. And still, this way of working and thinking of medium in contemporary art contexts didn't obliterate medium itself. Rather, I worked in the space that art critic Rosalind E. Krauss described: "If such artists are 'inventing' their medium, they are resisting contemporary art's forgetting of how the medium undergirds the very possibilities of art."[47]

From Detroit to the World and Back

I wanted an analysis of Detroit to sing around the world for its ability to dialogue with the politics of space, place, and contemporary life. For anthropologist Li Zhang, questions of ownership and belonging bubbled up in her study of the regional city of Kunming, China.[48] Connections and contested figurings of space and place came into relief as Zhang traced dislocation and dispossession of Chinese construction laborers versus a burgeoning, gated-community Chinese middle class. With such political-economic forces at play, I considered Kunming, China, an interlocutor in my analysis of Detroit.

Zhang wrote of an after-the-rain morning in which she ventured along with her informants Mrs. Fong and Fong's son Fong Nian to see their soon-to-be-demolished family home. The home was to be replaced with brand-new commercial construction. The Fong family resisted. The Fongs were forced out after a months-long court battle, bracketed by encroaching con-

struction grit and relentless noise from the nearby construction sites. Zhang wrote, "The Fong case is just one of numerous conflicts over eviction, property rights, and relocation that have occurred during the spatial and social restructuring of Chinese cities."[49] It sounds as though Zhang is writing about Detroit, as much as Kunming. In Detroit, property rights loom large. As mentioned earlier, a *Detroit News* investigation in 2020 found that the city of Detroit overtaxed black homeowners by at least $600 million between 2010 and 2016 as a result of incorrect property assessments following the Great Recession. Many black homeowners are deeply in debt and/or have lost their homes as a result.

Back in China, for Zhang, across cities, "the rapid expansion of the real estate industry and the rise of the new middle class is not simply a matter of successful entrepreneurial endeavors or innocent consumption practices. It is also a matter of remaking urban spatial order and cultural distinctions between the relatively affluent and the less affluent through massive displacement."[50]

The question of spatial order continued its global tour, zooming back across the ocean to Los Angeles, California. Geographer Edward Soja's work in Los Angeles reflected, as Zhang's did in Kunming, the "obverse and perverse" interaction of developed and underdeveloped city spaces.[51] Soja described the situation of Los Angeles's marginalized populations as they were ideologically and materially erased from the city center. For Soja's Los Angeles, "underneath this semiotic blanket there remains an economic order, an instrumental nodal structure, an essentially exploitative spatial division of labor."[52] Soja's semiotic blanket was an obscuring force—a force that limited vision. A choreography as strategy that objectified and erased low-income people. For Soja, this blanket represented Los Angeles's brand as site of pure pleasure. For unadulterated pleasure to exist, as in the Detroit case, pain had to be administered, and then erased and dislocated. In other words, pain—or rather, the people who endured it for decades and more—had to be moved.

A collective forgetting or dislocation of pain shouldered by low-income Detroiters required a variety of strategies. Such strategies were distilled clearly by cultural theorist Rebecca Kinney. In *Beautiful Wasteland*, Kinney situated demography, cultural histories, political economy, and historiography that, together, mapped the city's shifts over the past half-century. One of the reports Kinney discussed was the *7.2 SQ MI* report, produced jointly in 2013 by certain nongovernmental organizations, companies, foundations, and quasi-private governmental groups.[53] This report concerned the area of downtown Detroit known as Greater Downtown. Greater Downtown re-

ferred to the 7.2-square-mile land area including neighborhoods surrounding downtown Detroit and downtown itself. The surrounding neighborhoods included New Center to the north, Rivertown to the south, Corktown to the west, and Belle Isle Park to the east. The 7.2-square-mile land area was just over 5 percent of the 139-square-mile land area of the city. However, the economic and ideological significance far outweighed the geographical. And so, the politics of demography, capital, and urban process were crystallized in this report.

Overall, the 7.2-square-mile report attempted to rebrand Detroit with an urban-corporate-light image. The report called the area diverse. However, the report celebrated African American people's departure and the demographic stagnation of Asian American, Hispanic American, and Latinx American people. Finally, the report celebrated European American people's increased numbers in Greater Downtown.

Kinney indicted the pathology of this logic, writing that the 7.2-square-mile report "plays on the prior narrative of Detroit's fall, to suggest that its rise will be possible when the population shift reverses, and the balance is tipped back toward a decrease of black people."[54]

The Detroitness of it all may seem to stud my writing here, but such ideological displacement was a global phenomenon. The ideological and material dispossession that Kinney analyzed in the 7.2-square-mile report jolted me daily as I read the news and sipped coffee. This ideological and material displacement assaulted my senses. Whether the ideas and actions were naive or deliberately racist did not make much difference.[55]

I continued to read such newspaper articles more and more, year after year as I documented on the streets and talked to people, and followed the lives of people of the zone, into people's homes and neighborhood meetings. I also analyzed and wrote about these newspaper articles that kept breaking my heart. I pushed through the extreme discomfort I felt in reading dehumanizing narratives about the people who I knew made the city tick every day.

Were we furthering inequality with projects that fail to reflect the historical context? Were we contributing to disparities by adding disparities onto an already economically distressed city? Were we furthering a mythical exoticism of low-income and black people, by sourcing cultural aesthetics from people excluded from funding opportunities? These were questions I asked through *Liquor Store Theatre* events, and that more broadly I asked concerning cities around the world. Detroit was a powerful case—but Detroit was not alone.

Because of the centrality of Detroit's mirror of underdevelopment and the reverse, I did not need theories specific to Detroit to think through my ideas; urban anthropological research around the country and the world was interested in documenting and analyzing political-economic, sociocultural struggle. Anthropologist Ida Susser condensed tensions of working-class people across Brooklyn's Greenpoint/Williamsburg zone during New York City's 1975–1978 fiscal crisis; Mitch Duneier traced masculinity, friendship, and racialized, classed tensions among people at Valois Restaurant in the shadows of the University of Chicago's Southside campus; Steven Gregory traced resistance among working-class and middle-class people of New York City's Queens County Corona neighborhood; Mary Patillo followed generations of working- and middle-class people through labor, kinship, and political economy, tracing upward and downward mobility in Chicago's Hyde Park zone; and Andrew D. Newman followed the lives of immigrant people of primarily African and Middle Eastern descent in suburban Paris as they worked to organize, resist, and create movements around a public park, Jardins d'Eole.[56]

I was stopped in my tracks by the works of anthropologists Zora Neale Hurston and Kathleen C. Stewart.[57] Both ethnographers traced affect and desire across the southern United States, meditating on the contours of place through political economy and cultural aesthetics. Both Stewart and Hurston wrote through and with culture—each anthropologist shook the complexities of their world into existence with words so rich that you could understand a pressing moment and centuries of history, and the irony of it all with a single image. Hurston and Stewart were ethnographers, and they were also artists, searching out old questions, while expressing those old questions in new forms.

For Hurston, in *Mules and Men*, the rich cultural traditions and aesthetics of her hometown were worth documenting. Hurston wrote, "I hurried back to Eatonville because I knew the town was full of material and I could get it without hurt, harm, or danger. As early as I could remember it was the habit of men folks particularly to gather on the store porch on evenings and swap stories. Even the women folks would stop and break a breath with them at times. As a child when I was sent down to Joe Clarke's store, I'd drag my leaving out as long as possible in order to hear more."[58]

Hurston, in the early 1930s, a freshly minted anthropologist and a writer, hung out in the spaces surrounding the convenience store in her neighborhood—populated by mostly men. In the throes of an early twentieth-century

world where most people did not have human rights, Hurston wrote her own path and documented her own culture with a stark brilliance. For Hurston, poetics of the streets and sidewalks were critical cultural documents to be observed, touched, documented, and launched for future generations to write their own freedom. I extend Hurston's work here.

In *Ordinary Affects*, Stewart traced social theory through the memories and the moments of the everyday across Appalachia and, at the same time, removed clumsy argument and bossy theorizing altogether from her decisive book. With writing so elegant that it forced theory into a corner and moved into the core of the reader's heart, Stewart, like Hurston, could gesture cultural revelations and stunning prose at once. On touching the everyday, Stewart wrote, "For some, the everyday is a process of going on until something happens, and then back to the going on. For others, one wrong move is all it takes. Worries swirl around bodies in the dark. People bottom out watching daytime television. Schedules are thrown up like scaffolding to handle work schedules and soccer practice or a husband quietly drinking himself to death in the living room."[59]

Like Hurston and Stewart, I wanted to connect the historical with glittering and fraught possibilities of the now. Aimee Meredith Cox's work brings us back to Detroit and the now. In Cox's ethnography of adolescent girls and young women in the twenty-first century, Cox traced racialized, gendered, and classed personhood as lived by her key informants at a Detroit shelter for young women.[60] An anthropologist and a previous member of Alvin Ailey's Ailey II dance company, Cox lived and worked at the shelter for years while conducting her research.

While Cox wrote that she did not begin with the intention of using dance as part of her ethnographic practice, ultimately performance broadly and dance in particular figured critically in her work. Where Cox began with a classical approach to unit-of-analysis Chicago School ethnography, her method became increasingly inflected with her perspective as a dance artist. The performance projects Cox initiated with her informants allowed a recentering of young women as complex subjects, spinning their personhood into brilliant relief.

Ultimately, making conceptual art on the streets spun me back into the neighborhood—back into the everyday, with people including Greg Winters, Faygo Wolfson, Hector McGhee, and Zander McGhee leading the way. My fascination with the everyday required a continuation of the ethnographic project after the *LST* cameras were turned off. *Liquor Store Theatre* consoli-

dated swirling streams of philosophy, history, contingency, and the real. In the chapters that follow, I work to locate the how in knowing and the how in making as key questions in anthropological and contemporary art theory, method, and practice. In the chapters that follow, I trace city life—pushing and meditating across streets, sidewalks, and frames. Let's go.

FADE TO WHITE

Liquor Store Theatre, Vol. 1, No. 1 (2014)

FADE IN FROM WHITE:

EXT. GRATIOT LIQUOR—(DAY)—ESTABLISHING SHOT—A well-weathered liquor store that has seen better days. Dusty sunbeams slide through the frame; summer in the city is just starting to moonwalk across the sidewalks.

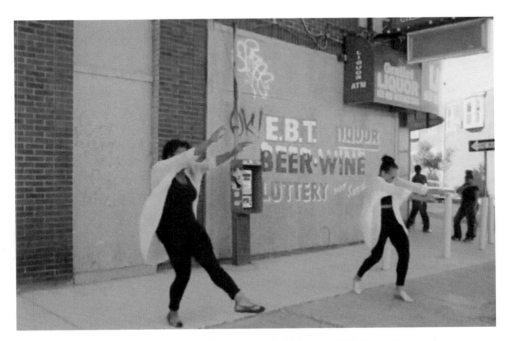

1.1 *Liquor Store Theatre, Vol. 1, No. 1* (2014). Pictured with Seycon-Nadia Chea and passersby.

Here we are—day one. A MEDIUM SHOT takes in the scene of the summertime-drenched storefront, along with the passersby who form the theatre of the everyday here in the first place. There's a woman speeding by in the frame, sinewy and Detroit-fresh, wearing white-hot jeans, sky-high pumps, and dark sunglasses. Other passersby are less fashionably dressed. A man and a woman carry large plastic bags branded with the nearby Save A Lot budget grocery store's logo, and people's clothing seems excessive for the already-pressing heat. As the minutes and seconds tick by, CAMERA TWO PULLS BACK from the MEDIUM SHOT to a WIDE-ANGLE SHOT in which you see all of my collaborators and CAMERA ONE. Here you can get a sense of what's going on: you can see my method.

There's a camera on the sidewalk. B-roll is gathered. After a few takes of choreographic sequences including a mixture of contemporary movement, voguing, finger tutting, martial arts, classical ballet, and butoh, people on the street slowly start to gather around. Curiosity builds. We pause for a moment, so that I can let people approach me and, if they wish, participate in an interview on or off camera. I have consent forms on hand, my notebook is nearby; I'm sliding between artist on the street and ethnographer in the neighborhood. Imagine someone going into the store, making a purchase or meeting a friend, then watching a few takes of the performances. The person gets curious. They approach me, and I take a break from performing to explain the project. The person agrees to be interviewed, signs a consent form, is miked, and has a conversation with me on camera.

Many people walk by without interaction—they're taking in the scene of the city, and me and my crew are just part of it. But for now, the most important thing to know is that the performances and the conversations with people in the neighborhood afterward are a call and response of some sort. A kind of alien call and response, with different languages being spoken on either side, but communication happening nonetheless. Later I'll discuss more of the choreographic method, but for now, I want to get you on the scene. Speaking of the scene, that day as I begin filming at GRATIOT LIQUOR for the first time ever, it seems oddly calm and serene. And yet the politics and sensations that got me to this spot in the first place are anything but serene.

The intersectional calculus of racialized, sexualized, and gendered identification tensions, alongside a calculus of power and money, streamed together and landed squarely at the liquor store. In 2012, when I moved into the zone, I noticed a strange sinking feeling and a bizarre ringing in my ears when I thought about entering liquor stores in the neighborhood. For the first two years I lived in the zone, I deliberately did not set foot in Gratiot Liquor,

known by locals as the Blue Store, right across the street from my studio-loft. And then I started to ask myself why.

This asking of why led to my decision to stage dance performances and conversations in front of the stores. Toward exploration of the struggle for the city on Detroit's east side, I took the path of more resistance. I felt the press of men's eyes sizing me up when I entered the scene. Store clerk, passersby, it didn't matter. I felt eyes that wondered why I was there, what my status was in the adjacent axes of race, gender, and sexuality; power and money. I felt the store clerk's slightly surprised eyes when I walked up to a counter and spoke; were they wondering what I was doing there, or why my register of USA English was devoid of linguistic cues associated with African American Vernacular English (AAVE)? Or was it something else?

Or was I imagining it? The way that men looked at women, however, was not imagined. The anecdotal evidence I noticed over the first two years in the neighborhood, before *LST*, was enough to shake itself clear in front of me. I noticed that women who drove to stores in the neighborhood with another person would often wait in the car while a man would usually venture inside to make a purchase. I noticed that women would often move more quickly through the streets and sidewalks surrounding the stores, with less interest in hanging out and talking and more interest in errand running. I felt the need to move quickly around the stores, as well, and even perhaps not to move around the stores at all.

In truth, in the beginning, I didn't want to enter these stores at all. I was surprised and disappointed in myself for feeling this way. As a self-described feminist, how could this be? I wanted to know why I felt like this. Along with a desire to study the corners of a shifting city, my personal conflicts and questions around the intersectional politics of racialized, gendered, and sexualized inscriptions shaped this work. As I moved into and through my aversion to the liquor stores in the zone, I centered my approach with critical, queer, and black feminist theory. Roderick A. Ferguson writes, "Low-income and African American neighborhoods, popularized as the terrain of prostitutes, homosexuals, rent parties, black and tans, interracial liaisons, speakeasies, and juvenile delinquency, epitomized moral degeneracy and the perverse results of industrialization."[1]

Ferguson's juxtaposition of the repulsions of postindustrial economic decline with exoticized sexualization of low-income and African American neighborhoods resonated in the Detroit case in particular. Detroit's rendering as economically perverse—its historical figuring as a disastrous, alien mutation of failed industry—was directly connected to the racist, mythical

conception of black people and low-income people as perversely gendered and sexualized. In other words, the perversion of an imagined place was necessarily tied to sexist, racist, classed, and heteronormative visions of vice and virtue. Much of the perceived unworthiness of the neighborhood was bound up in economic oppression. And economic oppression depended upon racialized and gendered subordination to maintain its hungry existence. Saidiya Hartman's histori-ethnography of Venus, a girl who was subjected to gendered, sexualized, and racialized violence during the transatlantic slave trade, illustrates specific ways that political economy and sexual domination connected to the politics of representation. Hartman's chilling words force a grappling with the conditions and requisites of representation itself, declaring, "The archive yields no exhaustive account of the girl's life, but catalogues the statements that licensed her death. All the rest is a kind of fiction: sprightly maiden, sulky bitch, Venus, girl. The economy of theft and the power over life, which defined the slave trade, fabricated commodities and corpses. But cargo, inert masses, and things don't lend themselves to representation, at least not easily."[2]

Further complicating the politics of representation under conditions of genocide Hartman chronicled, the vicious nature of slavery obfuscated the intersectional nature of oppression itself. As political philosopher Manning Marable theorized, "during the entire slavery period of the U.S., a brutal kind of equality was thrust upon both sexes."[3] Of course, equality by shared dehumanization is not equality at all. Acknowledging nuances of racialized, gendered, and sexualized oppression, bell hooks writes, "Men who oppressed women did not do so because they acted simply from a space of free will; they were in their own way agents of a system they had not put into place."[4]

Here, hooks foregrounds structure, reminding us that gendered, sexed, and sexualized systems of subjugation and oppression shape the lives of women and men. Further, hooks critiques a faulty assumption that low-income men and men of color received benefits from the patriarchal structure equal to those of men of European descent. In other words, as Judith Butler writes, to challenge dominant norms is to cause trouble.[5] Fundamentally, as Sara Ahmed wrote, "we trouble gender when we do not follow conventional routes."[6] The idea of trouble—that is, what was being troubled on the street, what was not, and why—kept causing me conceptual problems.

There was something I noticed that was troubling from the start, and I realized that it was both cause and effect of what Butler called gender trouble and Ahmed deemed troubling gender. On that first day at the Blue Store,

most of the on-camera interview participants were men. While women were present in the spaces, and women would often hang out and talk with me, for every three men who would consent to participate, about one woman consented. Why was this? Demographics played a role, for starters. First, we'll talk about demography, but there was something more there, something that took me years to admit and that made me quite uncomfortable—troubled, in fact.

In terms of demography, in McDougall-Hunt, men made up over 60 percent of the population. On top of this, the average age of male residents in the zone was thirty-seven, while the average age of female residents was forty-eight.[7] These demographics, from the start, contributed to a larger number of men being present in the zone and, accordingly, in the spaces surrounding party stores. But there was more to it than demographics. For starters, the politics of what Laura Mulvey theorized as the oppressive male gaze (that the presence of a big-lens camera connoted) did not work in my favor.[8] While women hung out with me equally and contributed equally to my fieldwork, fewer women than men wanted to be video recorded. It was clear that the social vulnerability women felt in the spaces of the liquor stores—the vulnerability I had felt, as well, with my initial aversion to the spaces—was a deterrent from consenting to video-recorded interviews.

Across LST events, roughly one-third of on-camera interviewees were women. Although I wished to have the greater and more varied representation of women that higher numbers of women participants would bring, this observation underlined the importance of gender in low-income and black neighborhoods. Were these flaws of LST events, that the twisting forces of race, class, gender, sex, sexuality, social vulnerability, and the presence of a camera were barriers to entry for more women informants in the zone? I thought the answer was yes—these were some of the problems with the work. But there were even more questions to be raised.

The CAMERA ZOOMS IN from the previous WIDE ANGLE a bit to a MEDIUM SHOT of one of the performance takes at *Vol. 1, No. 1*. Seycon-Nadia Chea and I stand together silently before beginning a choreographic sequence. She's wearing black riding pants, a black tank top, a billowing pink cape, and black sunglasses; I'm wearing the same with a sheer white cape. My performance collaborator that day, Chea, is statuesque and tall, with long lines and expressive, almond-shaped eyes that seem to move with as much musicality as her gorgeous feet. We cut a particular figure on the street, and Chea's beauty attracted attention.

As my performance collaborators shifted over the course of the project, I was the one person who appeared in all of the videos. Because of this, the fact is, I was forced to evaluate what it was that my particular type of body, and the particular figure that I and my body cut, did to the scene and what it meant for the project. I was forced to evaluate what it meant that although women were present and engaged in the work, I predominantly attracted the interest of men at the scene of the store.

The way that I was racialized as a multiethnic woman with a fair complexion and long wavy hair, performing abstract contemporary choreography and directing my videography collaborators, was a particular sort of racialization. Detroiters widely range in skin tone, body size, and hairstyle; my variation in this continuum was not precious or novel. However, the fact was, at the scene of the liquor store, in a neighborhood that was over 60 percent men, the figure that I cut stood out. The way that I was gendered was also particular.

I was a heterosexual, cisgendered woman, in my early to midthirties, dressed in visibly feminine clothing, in a neighborhood where the average man was slightly older than I was, and the average woman was approximately ten years older. Building on a foundational support of Butler's gender trouble analytic, I was myself troubled as I reflected on the videos and came to terms with the fact that my particular feminine, cis-woman presence and body wasn't actually troubling anything at all. However, after the structural scaffolding of Ahmed's notion of troubling gender, the videos disrupted the assumptions of what a cisgendered, normatively attractive woman might do with the figure that she cut. The abstract, contemporary choreography I developed for the videos was asexual; deliberately androgynous. I was not there to entertain; rather, I was there to ask questions (literally and metaphorically).

The way that I was sexualized, likewise, was particular and connected to the gender questions. As a heterosexual, cisgendered woman, my presence wasn't challenging to dominant narratives of how women should behave or whom they should love. With a body that was sculpted by years of vegetarian lifestyle, ballet, coffee, and obsession, my bodily presence wasn't challenging notions of whose bodies should matter and why. Although body positivity was at the core of my thinking of what mattered in the world, my own bodily presence on the scene was contentious—it was even problematic. The fact was, there was nothing radical about my body, insofar as it was demonstrative of an effort to attain a particular ideal type. At the scene of a store in a neighborhood with a predominance of men and a shortage of women in my

age range, my sexualized and gendered demography was a relatively scarce resource. I used this to my advantage—I'm fully aware of this.

Speaking of resources, the way that I was classed was significant in the calculus of looks, power, and money. With my mainstream Midwestern USA register of English, the linguistic cues I gave off were, on average, somewhat differentiated from those of the majority of people I spoke with. While it's important to note that there's tremendous linguistic variation among African American people, the majority of African Americans in McDougall-Hunt spoke a variety of Midwestern AAVE, a regional dialect. The fact that AAVE is not my first or most comfortably used dialect quickly becomes clear to most people I speak with. I was on the scene of the liquor store with a big camera, and while I lived in the neighborhood, it was in a nontraditional space.

The studio-loft I lived in was in a former regional bank, and I had chosen to live there to do fieldwork. While living in the neighborhood allowed me a degree of understanding and shared, lived experience that was necessary for this particular project to work, choosing to live in McDougall-Hunt was quite different from living there by default. I drove to the liquor store with my gear; most locals walked.

Part of why a largely man-identified audience would be intrigued by and would respond to me was the interaction of demographics alongside my particularly classed, racialized, gendered, and sexualized form. One of the motivations behind the videos was the desire to reclaim the scene of the liquor store as a space where women could move freely. The reason I was able to pursue this aim, paradoxically, was because of the normative structures of gendered, racialized, classed, and sexualized notions of value that rendered my bizarre presence acceptable.

This was beyond constructions of race, gender, and sexuality and into a realm of beauty standards, in which the notions of inclusion and exclusion become equally vicious and fine-grained. Which bodies, and people, would be excluded? I tried to include a variety of performers with a variety of bodies, but still, all of the performers with whom I worked would be read as attractive by mainstream standards, and ultimately, they all had great bodies in different ways. In an attempt to channel "the many spirits of the city unseen," the particular figure that I and my performers cut on the scene was paradoxically exclusive.[9] Yet these positionings and their problems and complexities can be theoretical grease for the gears of transformation.

The flex and wane of absence and restraint highlighted gender's complex figurings in the zone. In spite of my particular situation, by bringing

my camera and myself, I worked to challenge the male gaze a big-lens camera might connote, in and of itself. Women, myself included, still felt the male gaze. Through *LST*, I worked to challenge it. There was nothing biologically determinist about this—it was the doing of gender. I wished during *LST* events that I could've broken through this barrier more and included more women in the *LST* videos. Still, the work accomplished something in raising this question and in revealing the gender, sex, and sexuality politics that did exist on the streets and sidewalks alongside the overarching racist/capitalist superstructure. Patricia Hill Collins wrote, "Black women's social location in the United States provides one specific site for examining these cross-cutting relationships among race, class, and gender as categories of analysis. Its particularity may also shed light on how rethinking the connections between social group formation and intersectionality points to the potential relevance of standpoint theory for Black feminist praxis."[10]

Collins's reflections are a reminder of intersectionality theory's initial purpose—to clarify the exponential, interlocking systems of oppression faced by black women in particular and black people in general. The passage demonstrated the possibilities for intersectionality as point of critical inquiry and praxis. Collins also raised questions of theoretical visibility, problematizing the idea that black feminisms might only exist within explicitly framed discussions of gender. Such a positioning would be too simple. For Collins, intersectionality existed and feminisms were present, laboring long before academic disciplines were named as such. In other words, as Terrion Williamson quoted Hortense Spillers, black feminism lived "in the politics of the everyday, the places where the subject lives as theorist, consumer, grocery shopper, got-to-pick-up-the-mail-now, let's go to the bank."[11] Black feminisms, then, lived at the liquor stores in McDougall-Hunt.

Centered by Ferguson, Williamson, Collins, hooks, and Marable, with *LST* events, I spun together questions of quotidian black life, black political economy, and feminist movements. My corporeal movements with *LST* participants traversed a socially produced space (inevitably, gendered, racialized, classed, and sexualized) and the embodied experiences that emerged as a result.[12] In critical geography theory, space does not simply exist; rather, it is produced. Space is "the outcome of a sequence and set of operations, and thus cannot be reduced to the rank of a simple object."[13] Yet the rootedness of space in historical context did not make it fixed. Instead, space, "itself the outcome of past actions . . . permits fresh actions to occur, while suggesting some and prohibiting yet others."[14] I located a potential point of contact between space as historic choreography (read, as strategy and sequence of

events) alongside space as present and future possibility. The LST events that became videos, or "fresh actions," as Lefebvre suggests, allowed a meditation on what was on the scene, and what might be on the scene, in a single moment in time.[15]

The ways that gender, sex, and sexuality were inscribed on bodies at the scene of the liquor store was not natural.[16] Rather, such inscriptions were a result of Enlightenment-sourced conceptualizations of binary and normative gender, sex, and sexuality. For Low and Lawrence-Zúñiga, "It is the inscription of sociopolitical and cultural relations on the body, not biology/psychology, that produces gendered body spaces and their representations."[17] McKittrick theorizes gendered spaces as dialogic, inscribed both on people's actual bodies and upon the spaces in which people's bodies moved, writing, "meaningful geographic processes were interconnected with the category of 'black woman.' . . . Visually and socially represent[ing] a particular kind of gendered servitude, it was embedded in the landscape."[18] In other words, historical-materialist events—empirical realities—shaped the ways in which spaces and people were gendered. Challenging gendered and racialized spaces' analytical separation, McKittrick's theory of gendered space demonstrated how racialized, classed, sexualized, and gendered domination existed in conjunction with, and because of, the totality of historical realities. Traversing socially produced space, the scene of philosophy looms in gendered space. Questions may emerge from this way of theorizing space. If I staged LST events on the grounds that gendered domination was "embedded in the landscape," was I proposing, then, a deterministic notion of group identification (in other words, a so-called identity)?[19] As Grosz theorized, how might I, as an artist and anthropologist, combine differing analytics to "overcome, somehow, the overwhelming dominance of identity politics . . . the overriding concern with questions of who the subject is and how its categorical inclusion in various types of oppression is conceived"?[20]

While gendered space was a social fact, and was defined variously by Low, McKittrick, Lefebvre, and many others, I continued to question domination and subordination as markers of identifications and categories. I challenged and problematized Identity (with a capital I) itself—while knowing that my "fresh actions" did not erase what was, like it or not, "embedded in the landscape."[21]

Detroit's landscape was, and remains, a place of contradictions, complexities, inequalities, stories, nuances, and questions. Real estate speculators, artists, gallerists, entrepreneurs, young urban professionals, NGO workers, and students from around the world took a new interest in this city dur-

ing my fieldwork, at a time when many longtime residents were so frustrated with decades-long local lack of opportunity that movement to neighboring lower-income suburbs continued to be an economic necessity. For all its international publicity, its grit, and its mystique as a site of postindustrial determination and perseverance, Detroit was a complicated place that had much to contribute to global discussions of the politics of contemporary art, ethnography, cities, and urban process. In other words, the situation of Detroit was inextricably associated with questions of economics, art, equity, and justice.

Detroit's stunning demographic transformation, coperformed with the dissolution of urban manufacturing centers between 1950 and 2010, merits mention. In 1950, 16 percent of its residents were African American; in 2010, over 82 percent. This fact, alongside the dovetailing economic transition from industrial to postindustrial, made Detroit a racially marked place, in which global political-economic transformations such as the worldwide compression of the manufacturing sector, for instance, were inappropriately linked to the blackness of the city. For Ferguson, "in the case of African Americans and other nonwhite racial groups whose corporeal difference stands as the conduit for racial discourses, the body became the site upon which the racialized meanings of African American culture, in particular, and minority culture, in general, were legible."[22]

Of the connection between broad, economic transformation and those closest to the fallout, Ferguson, further, wrote, "The nonwhite body, therefore, was not simply skin and bone, but the screen upon which images of neighborhoods, housing conditions, and sexual and gender practices could be seen."[23]

Detroit was an ideal location to meditate on the intersection of neighborhoods and political-economic conditions of housing, education, and city resources—and the screen of LST films, channeling Ferguson's use of the word "screen," was a way to acknowledge and tease apart registers of fantasy and reality. *Liquor Store Theatre* in its entirety—from the scene of the liquor stores and into the neighborhood—worked to investigate a fundamental burning question: What was the struggle for the city in Detroit? Meaning, how did people struggle for access to resources, like quality education, decent housing conditions, clean water, employment and business opportunities, and other amenities like leisure, parks, and quality food? Did people have a say or an ability to shape the city? How did people understand the process of urban transformation? The questions of access to a city's resources and its momentum mattered to understanding the status of cities and global urban process. The words of the people on the street shook and moved me.

The CAMERA ZOOMS to a CLOSE-UP shot of ST. MARTIN, a tall, whip-thin, middle-aged man wearing glasses, jeans, and sneakers. ST. MARTIN is one of McDougall-Hunt's sidewalk philosophers I came to know that summer. He was regularly found holding court in front of the Blue Store, the nearby bus stops, and my studio-loft. Gaunt, with chiseled cheekbones and a limp in his gait, his wit matched the sharpness of his features. "Can you tell me about this neighborhood?" I asked.

"This neighborhood has a whole lot of potential," St. Martin starts. "It's a beautiful area, near the water, near the park. . . . During the day, it's pretty safe . . . but at night, you've got some young thugs with nothing to do. . . . To be honest, I haven't really seen any significant changes."

"What do you mean, you haven't seen any changes?" I was struck by the break in the usual platitudes.

"Drugs are a problem here. . . . When you take away the jobs, here come the drugs. And people, people . . . people will do their drugs. People will do their drugs." St. Martin leans back thoughtfully and we FADE TO WHITE.

Liquor Store Theatre, Vol. 1, No. 2 (2014)

FADE IN FROM WHITE:

EXT. MOTOR CITY LIQUOR—(DAY)—WIDE-ANGLE SHOT—A bustling city store in full swing, with people coming, going, and hanging out in front.

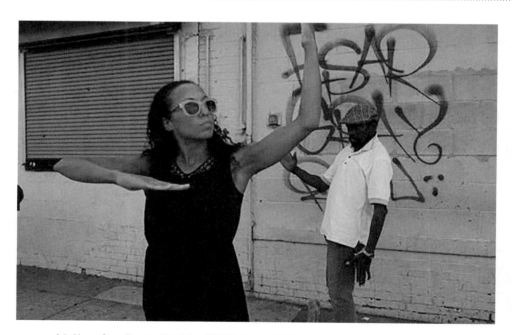

2.1 *Liquor Store Theatre, Vol. 1, No. 2* (2014). Pictured with Paul Mayfield.

Today, it's hot, we're running late, and I feel quite anxious about the shoot. We're at MOTOR CITY LIQUOR, what some locals sarcastically called the Yellow Store, for its somewhat garish awnings of the same color. The CAMERA ZOOMS IN and we see the intersecting street signs of Chene Street and Gratiot Avenue at the edge of the McDougall-Hunt zone. With the nearby major intersections, streaming traffic, and a large parking lot, Motor City Liquor felt like a spectacle. The CAMERA PULLS BACK and we see the Detroit skyline looming over McDougall-Hunt. There are people everywhere, and the scene reminds you of a public plaza or a square. People have used the space of the parking lot and the surrounding sidewalks to create their own public square, and there are people of all ages, wearing all sorts of different attire, coming and going. There's a hustle-and-bustle feel. And as the people on the streets and sidewalks were hustling and bustling with Saturday late-morning shopping and socializing, I was hustling to figure out the moves of this fieldwork—in more ways than one. Questions of what to wear, what times of the day to stage and document performances and conversations, and with whom to collaborate in terms of performances and videography swirled around these early days. A central question—what sort of choreography and performances I'd be doing in the first place—was one that I had started to investigate when I moved to the neighborhood two years before.

Isn't ethnography always choreographed? Meaning, the anthropologist must create some structure—some form—within which to interact with informants. There is no completely random anthropological ethnography. By nature of its existence as formalist, social sciences research, there would be method, frame, and human research subjects standards to maintain. This was deliberate, orchestrated, choreographed stuff. Further, choreography and ethnography were already in dialogue. Dance studies drew metaphors between the tensions and politics of concert dance and the politics of society writ large.[1] My understanding of choreography as strategy in this work brought choreo-ethnographic inquiry into the project itself. With performance as prompt, a philosophical and theoretical intervention lands beyond dance-specific contexts.[2]

In *Wandering: Philosophical Performances of Racial and Sexual Freedom*, Sarah Jane Cervenak describes what I theorize as choreography as strategy, in the work of artists Carrie May Weems, William Pope.L and Adrian Piper, writing, "For Piper and Pope.L, the elusive movement of black life swirls around the stagnant scenes of death, occurring on another plane. So too does Weems's Roaming series figure an abundance of movement, sublime

and sacred, on the other side of dwarfed agentic possibilities and narrow *visions* of freedom."[3]

In other words, in Weems's, Piper's, and Pope.L's works, choreography as strategy served the dual purpose of daylighting "privately inspired philosophical acts" and meditating on the "roaming shadow of the state" silently orbiting "black worlds" and contemporary human existence itself.[4] My process and method built on what I read as Weems's, Piper's, and Pope.L's use of abstracted choreography as strategy. In this case, part of the strategy was a dancerly prompt. This dancerly prompt was not so much interested in entertainment or spectacle as it was interested in locating a strategy that would allow viewers, informants, and performers to ask questions of what might "become possible in wandering."[5] This wandering ultimately landed in the streets, where the intrigue and excitement of the moment itself imbued my choreography with more force than any particular technique could.

In terms of codified dance technique, from a dance studies perspective, the choreographic work streaming through this project would be described most easily with the word "contemporary." Contemporary technique, in short, included all possibilities of movement, across well-known Western concert dance genres such as classical ballet, modern, and jazz, as well as emerging modern and contemporary genres such as hip-hop, and any number of cultural dance forms such as butoh, flamenco, and so much more. While modern dance techniques (there are many major schools) tend to be more specific and adhere to a more limited movement vocabulary, contemporary was more broad and conceptual. The particular sort of contemporary technique (if you could use the word "technique" to describe a broad range of material being synthesized into a style) that I developed in this work combined everyday movement, classical ballet, Japanese butoh, and voguing with what I thought of as an abstract, minimalist, conceptual approach to choreography. This combination of movement, quickly strung together here, took years to develop and perfect. It started in the stars and in the dirt.

Before *LST* was *LST*, *LST* was fruits, vegetables, sky-scraping sunflowers, gravel, dirt, and sweat. In 2013, with the help of neighborhood volunteers, friends, and a few people from the local NGO Greening of Detroit, I started a public garden in an approximately 1,000-square-foot open plot of land across from my studio-loft. It was during this time that I started to write field notes and to observe the movements and happenings—the choreography—of the McDougall-Hunt zone. As I reflected on the eight liquor stores in the 0.39 square miles of the neighborhood, I gardened, and as I gardened, people

walked by, waited at the nearby bus stop, and they talked. One afternoon, as I trellised abundant green tomatoes, I spoke with a man named Greg Winters.

Greg Winters, who over time became my key informant, lived midway down the street from both the public garden and the studio-loft Todd Stovall and I shared. Greg Winters, a tall, whip-thin, middle-aged man with a dry sense of humor and chestnut skin, consolidated some of the complexities and contradictions of life in the neighborhood. Whether discussing Winters's plans for the properties he and his family owned for generations, his future educational plans, his thoughts on art in the zone, his own life and labor, or his idea of "keeping it moving," as he relentlessly said, the notion of choreography as strategy was critical in the neighborhood. Winters's urging to "keep it moving" framed a particular theorizing of choreography. Winters, with his constant reference to motion-in-progress, condensed Deleuze and Guattari's assertion that choreography worked both "below and above the threshold of perception."[6] If movement was constant, it was, by definition, subtle. The way this subtlety hit the street was in the ways my choreographic process was informed by philosophy, ethnography, and the conceptual, contemporary, and historical-materialist landscapes of the zone.

Notebooks filled with field notes were the raw material for the choreographic sequences that eventually became the choreographed performances that I staged across the streets and sidewalks of liquor stores. These notebooks were filled with things like conversations with Greg Winters, people's movements as they coursed through the neighborhood, and the experience of gardening, walking, talking, and living. When the choreography hit the streets for filmed events, it was choreography that had been shaped by the neighborhood in which I lived. It was really choreography informed by ethnography—being used as ethnographic prompt. It was some kind of alien-movement feedback loop. Over time, I developed twenty choreographed performances, what I'll call pieces here, that were used in the films. During the first year, these pieces were heavily influenced by people in the neighborhood—sometimes they were named for them. There is a piece known as *Faygo* (2014) that was directly inspired by a person who became a key informant, Faygo Wolfson.

Like Winters, Faygo Wolfson, a tall, handsome artist who handcrafted his own haute couture hats, wrote poetry, and lived in a candy-cane-pink-and-white house, was an intriguing, complex person. The piece called *Faygo* consolidated dance techniques including voguing, classical ballet, Dunham modern technique, and hip-hop. It was interested in the space between, what

anthropologists call a liminal space—between private life and public life. In developing the piece, I meditated on hours of conversations with Wolfson at the bus stop and in the garden, on his creative process and on mine, and on the shifts in the neighborhood he described to me over the course of living there for decades. My choreographic process was steeped in the study of the neighborhood—it was steeped in the meeting of the abstract and the material.

Over time, the choreographed pieces became increasingly abstract and conceptual. A piece called *Dance of the Chip Bagger* (2015) channeled the feeling of waiting two hours for a bus. A piece called *Untitled 3* (2017) meditated on the loneliness and excitement of city life. A piece called *Maya Praising Quaint* (2017) investigated affective labor. In 2017, I began making conceptual sculptures that would appear in the films and still images I captured. While my practice of making work shifted during and because of the ethnographic investigations I undertook, the driving forces of theory and method were firmly present. Once the choreography hit the street, there was more ethnographic method to unfold and consider. After field notes and conversations informed the choreographed pieces that hit the street, those pieces hit the streets and sidewalks in a particular way. When I arrived on the scene, as on this bright and sunny day of *Vol. 1, No. 2*, I was obsessively, utterly, focused.

The CAMERA PULLS BACK and I'm jumping out of the back of a Detroit-made SUV. In a HANDHELD MEDIUM SHOT, I'm alongside MOTOR CITY LIQUOR, exiting the parking lot with my collaborators of the day, Seycon-Nadia Chea, Eric Johnston, Martha Johnston, and Todd Stovall. The sidewalk steams with summer heat, the air is aflutter, and people are everywhere going about their day. The method that I began asserting in earnest on this day became a central, critical aspect of the process. In spite of the necessarily spontaneous nature of performing and talking with people on the streets and sidewalks, there were two rubrics that I followed religiously.

The first was that immediately, upon arrival, I set up a camera shot and began the performances in front of the camera, with the collaborators of the day or solo. This was an essential protocol, and there was no negotiation on this. It was a setting of intentions that worked in several ways—practical and theoretical. In theoretical terms, I was interested in framing the spaces around the liquor store as "smooth spaces."[7] To Deleuze and Guattari, smooth space was the opposite of state-controlled, structured, hierarchical, "striated" space. Smooth space was "abstract line" rather than "organic representation."[8] The smooth space that I sought and cocreated in the zone worked to exist beyond formal definitions that assumed categories could

offer. In addition to the smoothing of the space, there was the start of the conversation—the dancerly prompt—that the choreography introduced. I viewed the performances as my way of speaking with potential informants, in a way that potential informants could choose to take or to leave. The performances were the first words I spoke to people. By doing so, I hoped to enter a register of discussion beyond expectations and structure, and to enter into a dialogic exchange that penetrated the affect of the day-to-day. The dancerly prompt, in addition to being a gesture of vulnerability, was a cognitive point of departure for the ethnographic encounters that were to follow. I worked to protect this prompt and to keep it as focused as possible.

Protecting performance as prompt also meant that a degree of secrecy was associated with the staging and documenting of the performances. The events were what I called "the anti-pop-up." There was zero promotion, zero social media, zero heads-up provided to anyone. The performance events were meant for whoever happened to be in the neighborhood, in the space and the place, at that moment. This meant that I didn't mention the location to anyone, including collaborators, until the day of the event after we met up at the studio. If performance of the choreography immediately upon arrival was a theoretical smoothing of space that worked to destabilize the classed, racialized, gendered, sexualized, and otherwise stratified space, at the same time, the action was practically driven and critical to the success of the project.

I was well aware that the liquor stores in the neighborhood (and most places of business in major U.S. cities, to be fair) had extensive video-camera surveillance systems. Through observation, in the case of the eight stores in the neighborhood, I observed that all of the stores had surveillance cameras positioned around the public spaces of the store, including parking lots, walkways, and sidewalks. When I arrived on the scene to make a film, I knew I was immediately being filmed as well. The smoothing of the space created by an immediate focus on performances of abstract, minimalist, contemporary choreography was not just theoretical but a calculated, strategic presentation directed to the store management as well. With the performances of this surreal choreography, the playing of Todd Stovall's ambient electronica through our portable sound system, and our contemporary all-black attire and sunglasses, I telegraphed our presence as harmless—as making art on the street, and beyond reproach. I telegraphed our presence as weird, as artistic, and—most importantly—as legitimate. While I moved in the space with respect and care for my surroundings and the people there—store management, patrons, passersby—I never asked permission to film, and I was repeat-

edly making this deliberate decision never to ask permission to perform or to film. I got on the scene and made it happen.

The theoretical and practical smoothing of the space was more important to me—rather than announcing my presence as benign and well-intentioned, I preferred to demonstrate it. Rather than saying what I was going to do, I preferred to go forth. Having pored over institutional review board materials and city law, I knew that I was able to work in the public spaces of the city without permission, provided I was not blocking egress, and that I had a limited number of people in my film crew. I knew the limits and I knew how to push, and it was essential to push these limits to execute the methods I chose. After the stage was set with the initial performances and the smoothing of the space, there was the question of the ethnographic encounter. As I deployed a specific method to protect the working of performance as prompt, I did so in terms of the ways I engaged spectators.

The rhythm was a delicate balance of push and pull, giving and taking. As a reserved, quiet person, I didn't want to disturb people in their daily work of going about the city. I wanted the performances to speak to people who were curious and interested in speaking back, and to melt into the scene of the city for the people who just wanted to go about their day. A sensitive, nonobtrusive presence was important to me. Part of achieving this sensitive presence was the way that I introduced collaborators to the project. Over the course of the project, I enlisted a number of professional performers to dance with me on the streets and sidewalks surrounding liquor stores. For this to work, performers didn't simply learn the choreography of the dance performances—performers were also introduced to the choreography of the ethnographic project.

The LST performers were professional dancers, technically trained in studio, conservatory, or both environments, and also seasoned performers. But this wasn't the most important deciding factor in casting decisions. Nor was physical appearance central in my casting decisions, although all of the performers, again, were indeed particularly physically attractive in their own ways. But there was something else I searched for in people—way beyond technical training or phenotype. It was the factor of presence. Presence, for me, was twofold. First, someone was present to the project. They were not put off, taken aback, or repulsed by the idea of turning formal proscenium performance on its head and dancing for passersby and locals in the spaces of a liquor store. They were not scared to perform in what had been labeled the second most dangerous neighborhood in the United States. They were not bothered by the idea of hanging around, watching, holding court, and being

there while I interviewed people in between dance performances. In short, I searched for people who would be present to what might be unusual ideas of method and practice. The performers I selected were present to these ideas, and I discussed my ideas with them in detail in preparation for their participation. The other kind of presence I looked for was the impact someone had when they set foot on a scene.

I wasn't interested in phenotype; I wasn't interested in eye shape, hair form, or skin tone—the presence I searched for in people was a sort of beating of their heart on the outside of their body that I could somehow sense. It was the way that the room moved when a person entered it. It was how someone listened to people, how they talked to people, how they moved in a space, and how the space moved around them. This kind of presence was what people have described as some kind of *it* factor—I prefer to name it presence to avoid confusion with some kind of normative beauty standard. It really wasn't that. I cast performers whose presence had the power to shape a scene—over the course of the project, performers ranged in technical and artistic focus, age, height, culture, language, phenotype—but shared the commonality of presence. Both kinds of presence made working with performers relatively smooth.

Early on, in the first year, we would rehearse together regularly at my studio-loft. Later, I'd send choreography videos to performers so that we could rehearse independently and come together the day of the performance. Sometimes, when I performed with people I hadn't had the opportunity to rehearse with, we would set choreography on the scene. Most importantly, we would talk extensively about the choreography of the ethnographic encounter, and when this all unfolded, the performers would sit back, calmly observing. When you perform at the same eight stores repeatedly year after year, you start to see many permutations of what's possible. On days when I had a full cast, I liked how the performers added another layer of audience when people shared their ideas on camera. Sometimes it was incredibly lonely on days when it was just me and my camera. Gradually, my choreography shifted from being driven by the ethnographic observations I was making in the neighborhood to being more and more conceptual and abstracted. Although the fieldwork and the research I was doing were informing my work, it was becoming coded.

And yet, as abstract and conceptual as my performances became over time, the strict protocol of method became perhaps more and more regimented as my facility with the method grew. The protocol for engaging spectators was strict—potential informants had to view some of the performances, stand around a bit in doing so, and approach us with interest.

This required a keen sense of awareness of what was going on. There was a rhythm and a choreography to this part of the interaction, as well. Typically, the rhythm would be like so:

> People pull up to store in car or walk up. People walk into store, noticing performance as they go. Some people go about their day and on their way. Some people are captivated and curious. People do their shopping, perhaps take bags to car, or stand around watching for a few minutes. After a person or a group of people start to gather and have seen performance of a few minutes of choreography, I stop the scene. I gather my gear to conduct an interview (mic, sound processor, change up the camera shot). Then, curious people approach me and ask, "What are you doing?" This is the moment where I tell them, "I'm making a series of art films about city life—want to talk?"

After some chatting with participants, I would explain the research project. I would explain the effort to make an art film series while learning about the city—centering people's thoughts on the city, people's hopes and dreams, as subject. Right there on the scene, I would shift from abstract and conceptual to pragmatic and practical. I'd pull out my little binder where I stored informed consent forms. Some people would consent; some people would be put off by the paperwork and move along. Some people would agree to be part of the project's written works but not video. Regardless of the outcome of our exchange, I'd always learn a lot.

This was a moment when contemporary art and anthropology existed in a bizarre choreography unto themselves. Could contemporary art and anthropology exist equally, and ethically, in a single project? Could this choreography (of both ethnography and contemporary art) build on and beyond what art critic and historian Hal Foster described as "quasi-anthropological art of primitivist fantasy" of the mid-nineteenth and early twentieth centuries?[9] The amount of participation and discussion that the dancerly prompt generated, and the amount of engagement and discussion that the resulting films generated, spoke for themselves. Tens of times, I met interesting people who shared stories about city life. On four occasions over the years, I met people whose lives I ended up following for years back into the neighborhood— Hector McGhee, Zander McGhee, Greg Winters, and Faygo Wolfson. But back to MOTOR CITY LIQUOR.

As I performed at Motor City Liquor that day, the Detroit-strong June sun was beaming down and the news headlines screamed of mass water shut-

offs across the city's 139 square miles. Detroit's mass water shutoff crisis was in full swing. The Detroit mass water shutoff crisis of 2014, in which tens of thousands of people, including elderly people, people with chronic illness, children, infants, and pregnant women, were to be deprived of water access on account of pedantic, inhumane shutoffs, was particularly painfully ironic in that Detroit sat next to one-fifth of the earth's fresh surface water. The Detroit Water and Sewerage Department, in trying to meet its $149 million operation costs for water ($217 million for sewage), predicted an estimated three thousand household water shutoffs per week over the summer.[10] In the coming months, over thirty thousand Detroit families were subjected to water rate increases and shutoffs.[11] Critics as wide ranging as *The Daily Show* and the United Nations chided the city of Detroit's Water Department for the structural violence it produced in denying water to low-income people, infants, pregnant women, and seniors.

The city felt like it was under pressure, like the streets might explode right there. As my long black dress blew in the steamy breeze and my shoes traced the concrete under the dance-smoothed soles, I thought. And the repeated question—were we shooting a rap video? After passersby came and stayed for a few moments, they realized we were not shooting a mainstream rap video. But the male gaze in the space of the liquor store was undeniable.

On that steamy day, a number of men and a lone woman discussed their ideas of the neighborhood. A well-heeled man with bright hazel eyes, John Harrison, riding an expensive bike, stopped and spoke with me at length about Detroit's future, saying that he thought it was yet to be determined. A slender man wearing a white golf shirt and jeans, Dave Ellis, with a powerful voice spoke about the neighborhood being a reflection of "the people's minds: torn, broken."

A slim woman with a stylish headband and dark sunglasses, Chloe Dennis, stopped and spoke with me. Dennis had a quick sense of humor and gorgeous, high cheekbones. Her smooth, slim legs emerged from jean shorts. Dennis spoke about the convenience of that liquor store and the role it played in the neighborhood as a walkable watering hole. Dennis also expressed that Detroit was moving in a positive direction overall. "I'm smiling because the future is bright," she said. Dennis left quickly after our interview, striding across Gratiot Avenue with confidence, her elegant frame slicing the street toward the slash of wood-frame urban cottages peeking out from the adjacent side street. As Dennis left, another person came on the scene, and choreography and ethnography actually blurred together until I was dizzy.

CUT to a CLOSE-UP of Paul Mayfield, a middle-aged man wearing a Kangol-style cap and jeans. Mayfield is thin, thoughtful, and possibly a bit under the influence. Mayfield lives down the street from the store and is somewhat of a sidewalk philosopher in the area. He's known to hold court outside the store in summer months. That day, Mayfield is also an unexpected performer. The CAMERA CUTS to a MEDIUM SHOT including Chea, Mayfield, and me. Passersby look on, the camera rolls, a car driving by honks in acknowledgment of the marked moment. I'm focused and deliberate, along with Chea, performing in our billowing black dresses and sunglasses. As we complete unison choreography, Mayfield isn't deterred. Mayfield dances sharply behind us with his emaciated body. I didn't know it then, but as the CAMERA PULLS BACK you can see Mayfield mirroring Chea and me—you can see Mayfield actually incorporating Dunham and Graham technique into his moves on the spot. Mayfield isn't moving randomly; intoxicated or not, he's aware of his actions, and he's sculpting his moves in a refined conversation with ours. Mayfield is also shouting praise, encouragement, and instructions to us as we move. As we move together, he states wryly, "This is modern dance, y'all," as he keeps in rhythm with us. In the heat of the summer afternoon, I am intrigued, surprised, and a bit miffed. This is the first time a participant has so boldly entered the frame. I like it, but it is a bit dizzying. Is Mayfield mocking us, or just reflecting with his wry sense of humor, exploring the ethnographic prompt and taking me to task (something I do with theory and prompt as well)?

"Hit that step, girl," Mayfield dryly comments as Chea and I continue. He pauses from his participation and simply calls directions. He reminds me of a professional company director, machining our bodies with his words. "Coordinate now, that's it." The CAMERA PULLS BACK and you see the constant-orange Detroit-hot summer sun behind us. I'm feeling delirious and losing my place in space and time. Am I listening to a ballet master or to an *LST* participant? Who is Mayfield? It seems like he's the director, for these little ticks of moments. I submit to Mayfield, I keep dancing, and I even try to follow his instructions. It's uncomfortable to do so; I have to reach down into myself and demand that I cooperate with what's happening in the moment. But then, had I not made the claim that I would try to reverse the ethnographic gaze? Hadn't I hoped that *LST* as a frame would challenge the rehearsed roles of researcher and informant? I hadn't anticipated what it would feel like on the street when it happened.

I feel vulnerable. I stretch my legs and arms into a turn, whipping my head around to my spot, and I feel Chea's presence next to me. Maybe this is

a hint of what the reversal of the ethnographic gaze feels like. This reversal of choreography continues as it bleeds into ethnographic conversations. As he speaks on camera, Mayfield says, "Without art, we have nothing." He also speaks to the LST event crew. Mayfield grabs a stoic Todd Stovall and Eric Johnston, who are operating camera one and camera two. "Breathing is the essence of life, just breathe and smile with me," he tells them both as they video record. At one moment, late in the afternoon, Mayfield shakes Johnston's hand so vigorously that Johnston is pulled on camera.

CUT to a CLOSE-UP in which Mayfield grips Johnston's hand, and Johnston's hand is involuntarily shaken while he shoots the very CLOSE-UP we're viewing. The subject shakes the gazer—literally. Under the stifling sun, as I feel myself becoming light-headed with performing and documenting, and lighthearted with the effort of working so hard, I know that this shaking is important. Mayfield is shaking the ethnographic gaze—he has taken my choreographic prompt to task—he has managed to collapse theory, method, and practice into this tiny little moment, into this little slice of space, time, motion, words, and actions—this 4:29 minutes of theatre—of digital video, color, and sound, which abruptly ends as we FADE TO WHITE.

Liquor Store Theatre, Vol. 1, No. 3 (2014)

FADE IN FROM WHITE:

EXT. PALMS LIQUOR—(DAY)—ESTABLISHING SHOT—An urban liquor store, with neon lights testifying that the store is *OPEN* ablaze everywhere. People mill around; it's summertime in the city. Many of the people are dressed all in white. (Is there an urban revival of some kind nearby?) The name of the liquor store is reflected in the exterior decor, with weathered, tacky, neon-studded, plastic palm trees framing the edges of the parking lot and the entrance.

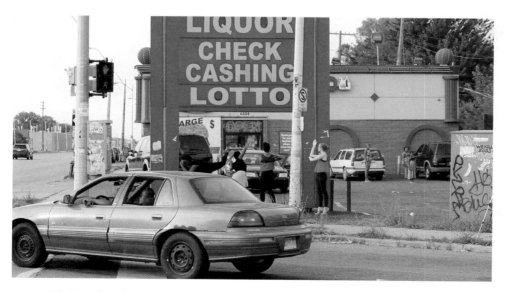

3.1 *Liquor Store Theatre, Vol. 1, No. 3* (2014). Left to right, Seycon-Nadia Chea, Ericka Stowall, Maya Stovall, Tessa Passarelli, and passersby.

The CAMERA ZOOMS IN to reveal the intersecting street signs above PALMS—GRATIOT and MOUNT ELLIOTT. We then CUT to a MEDIUM SHOT in front of the store. People mostly in their twenties to forties, dressed all in white, stream in and out of the liquor store. It looks like the people might form a church processional, the after-party to a holy revival, a group testimonial, or a collective baptism. It turns out that people were headed to a nearby White Party. The White Party is an urban United States phenomenon popular in summertime Detroit—attendees dress in fashionable iterations of white and proceed to board a large boat, or pack a grand hall, eat soul food from a buffet, drink from an open bar, party, and dance for hours together. It is a quintessential celebration of summer. Today, the surreal appearance of a sea of people in white up against the neon lights of the store grabbed me.

This moment of symbolic dress at the site of the liquor store provides an opportunity to discuss questions of site and substance in urban anthropological research. It might seem surprising that formal, organized religion, and the church as a site in particular, had an opaque (or perhaps nonspeaking) role in this fieldwork. Formal religion figures centrally in anthropological and sociological research around the world, and often in particular, concerning groups that are classed, gendered, sexualized, and/or racialized.[1] If formal religion was central in such cultural groups around the world, why not in McDougall-Hunt? In McDougall-Hunt, the analytic of paradox of place described the complex and often contradictory role that churches played. The most numerous type of business in the neighborhood was, in fact, liquor stores. With eight liquor stores operating seven days a week within the borders of the zone, they far outdistanced the churches in both quantity and duration that their doors were open. Further, the clientele had vastly different geographies.

The liquor stores in the neighborhood were patronized mostly by neighborhood residents, people who lived nearby and also (but more rarely) passersby heading to or from downtown events. The clientele of churches in the neighborhood was quite different. At the church next door to my studio-loft, for instance, just one of the ten members of the board of directors lived in the neighborhood. The deacon, a kind and generous man with a successful family, lived in a distant suburb. Every Sunday, the church parking lot would fill with late-model Detroit steel—the parishioners had money, and most of them did not live in the neighborhood. Save Sundays and perhaps once-weekly prayer, the church doors would shutter, the gates would close, and people would not be present in or around the sites. In spite of the mostly commuter congregations I observed at the church I could see from my roof-

top, and the other churches nearby in the zone, the churches did not have a simplistic relationship with the neighborhood.

The church next door held a monthly lunch, open to anyone in the neighborhood, and the church across the street gave food away weekly. Over the years, I saw church board members and parishioners sometimes show up at neighborhood meetings, regardless of where they lived. The churches in the area would also employ local people, housed and unhoused, to do odd jobs from time to time. In spite of some middle-class African Americans moving to the suburbs, many of the churches in the zone remained intact, with membership including suburbanites and people who still lived in the neighborhood. However, their use as a site in the sort of ethnography of the everyday I sought was untenable. The churches simply didn't have the persistence in the neighborhood that the liquor stores had. Moreover, the public spaces around the liquor stores represented a deconstructed (necessarily distinct from the structure of business ownership) space, a less hierarchical space that I sought: "smooth space."[2]

The liquor store was to social life what performance-on-street as prompt was to anthropological research, or to contemporary art, or to Western concert dance. Or, read the other way, the church was to social life what classical, formal proscenium performance was to Western concert dance, or what traditional participant-observation ethnography was to anthropological research, or what a classical, artist-locked-in-studio approach was to contemporary art. It wasn't that any of these figurings were a priori more or less urgent or critical than the others. Rather, it was that my approach was interested in destabilizing structure as much as possible, across these various fields, and that meant liquor stores, performances, and films unfolding on the streets and an attention to surreal transgressions alongside political-historical documentation and analysis.

The CAMERA PULLS BACK, and Winston Rankin catches my attention. Rankin is a tall, angular, mahogany-skinned man wearing thick-framed reading glasses and a black and white Africanist-aesthetics-tinged shirt over white shorts. Rankin's black-and-white printed T-shirt evokes the iconic West African adinkra visual symbols.[3] His blending of African diasporic aesthetics and, more to the point, the particular cultural aesthetic that the sea-of-white-wearing people evokes, brings to mind anthropologist Zain Abdullah's twenty-first-century ethnography of Muslim people in New York City's Harlem neighborhood. Abdullah theorizes, "African Muslims wear traditional clothing as a way to assert their African presence and to infuse urban space

with a new Islamic ethos."[4] Notably, Abdullah reflects, public spaces on the sidewalks surrounding retail establishments were central to this cultural infusion: "It's customary to see Africans sitting in folding chairs on sidewalks outside their favorite restaurants or variety stores. They form a semicircle, taking care not to block pedestrians, and talk about the day's events or catch up on the latest gossip from back home."[5]

The *Liquor Store Theatre* name, in fact, swirled from the Detroit African American context of the phenomenon Abdullah observed. People were creating their own public parks or squares in the streets and sidewalks, sharing news, moving through the day, and asserting particular cultural aesthetics. On this afternoon, back at Palms Liquor, the droves of people milling about in white reminded me of the importance of spirituality and cultural aesthetics in McDougall-Hunt's contemporary social life. While the assumed importance of the church as a social institution was overdetermined in McDougall-Hunt, the fact was, there was a quiet presence of faith and spirituality.

While I sought to meditate on contemporary social life in as nonhierarchical a space as possible, meaning the church congregation as a formal, private institution would not be my site of inquiry, the fact remained that people are spiritual beings and that subjective cosmology is part of human existence. The striking all-white attire of people around Palms Liquor that day brought to mind the question of attire of other people on the scene—the performers and myself.

At *Vol. 1, No. 3*, I was with a group of performers including Seycon-Nadia Chea, Ericka Stowall, and Tessa Pasarelli. Each of us was wearing dark sunglasses, black yoga pants, and brightly colored tops, and some of us had chiffon capes that floated in the humid breeze as we moved. On our feet, we wore sky-high stilettos during the adagio sequences, and during the uptempo sequences we switched to flats.[6] I was figuring out what worked, trying things out. How did it feel to move in something on the streets, how did it come off on camera, and how did people seem to respond to us in the spaces? In the previous episode, Chea and I had worn dresses; *Vol. 1, No. 2* was the lone episode in which dresses would ever appear. Ultimately, I moved to wearing all-black outfits—streamlined black sweats, tanks, yoga pants, tunics—if it was black and one could move in it, it would work. And always with the dark sunglasses.

Todd Stovall, whose original electronic music frames *LST*, had shared feedback that wearing baggy clothing would ensure we didn't attract what

he referred to as the wrong kind of attention. Stovall didn't think the high heels and the yoga pants were particularly ideal—he suggested workman-style jumpsuits at one point. But he relented that the choice of all-black would make it work. What exactly was the wrong kind of attention? I asked Stovall. "Men hoping for a date," he had replied easily. In addition to Todd Stovall's thoughts regarding attire, he offered feedback around personal safety.

Stovall's thoughts centered around an issue of much contemporary debate—the issue of guns. Given that I planned to traverse McDougall-Hunt performing and talking with people for the next several years, he considered, it might be advisable to obtain a Michigan concealed pistol license (CPL). Talk about surreal. (In spite of the surrealism, it turns out that Stovall's idea had artistic and anthropological precedent. Zora Neale Hurston carried a pearl-handled pistol as she conducted fieldwork, driving her Chevy along the winding, dusty roads of the southern United States in the 1930s.)[7]

Stovall assured me that his suggestion wasn't based on an assumed, gendered notion of frailty, but on a concern for socioeconomic reality. The fact was, he said, that I was conducting fieldwork with an expensive camera in an economically distressed neighborhood. He wasn't concerned about the camera, but he was concerned to know what I'd do if I needed to defend myself. While his analysis was sincere, it was likewise problematic. My aversion to guns made it unlikely, statistically, I'd be equipped to defend myself with one. With my stature, lack of gun skill, and overall aversion to guns, in fact, it was more likely that I'd be better positioned to run from a situation or, even better still, to avoid a situation through intuition, rather than introduce a gun.

I find the finality of guns, their quickness, and their accessibility, overall, a tragic combination of variables destined to fail us, time and again. I knew that carrying a gun wasn't a solution. What was interesting was the anxiety that Stovall seemed to experience about convincing me to get the CPL. It seemed that he was more concerned about the CPL than me. I wanted to ease Stovall's anxiety, and I did get the CPL. Still, I hated the idea of carrying a gun. I couldn't imagine carrying a gun doing fieldwork, and carrying a gun while making art? It seemed ridiculous.

It turned out that it would be ridiculous for me to carry a gun. In 2017, I accidentally carried this very gun smack into airport security while en route to the Whitney Biennial, in which I was a participating artist. I forgot the gun was secured in a locked zipper pocket in the bottom of a tote bag. I used the tote bag to transport the gun to the shooting range for practice, typically, every three months, I would go to the shooting range and practice. Since I hadn't carried the tote in months at the time of the Biennial, I had forgotten

all about the gun. Naive and forgetful, I packed the tote bag with writing papers, books, writing implements, and makeup, completely forgetting the gun zipped into the bottom.

Think of a rhythm of airport security: strange looks and whispered musings; police handheld radio talk; emergence of specially dressed guards. I was arrested at the airport. I was handcuffed. I was transported and detained in a jail. I was fingerprinted, booked, photographed, sized up—"A tiny little thing to be carrying that big gun, aren't you?" Over coffee the booking officers considered my fate. "Felony or misdemeanor?" the older, balding officer asked his colleague. His colleague shrugged and swilled coffee. Glanced me over. I kept quiet, tried to smile and look like myself. "Let's go misdemeanor today," he said. I sat silently.

I was briefly questioned. I explained myself as an artist and academic who is naive about guns, and for a year I dealt with the anxiety as to whether my case would be dismissed. Ultimately, after paying significant fees and working with a kind attorney who took pity on my situation, I was able to clear everything up. The situation was a stark reminder of the power of guns. Guns criminalize people in an instant. Guns kill in an instant. A gun, in fact, killed my dear father. Guns are, perhaps, irrational for the times in which we live. Guns destroy. In any case, these questions were centered around notions of power, violence, and control—all of which had gendered implications. In fact, at *LST* events, I felt that dancing was a way of challenging and resisting threats (or perceived threats) to personal safety—and simultaneously, a disavowal of danger and a disavowal of guns. Performance, video recording, and conversation were all measures of power and control that I deployed instead of guns. I realize I may have been grabbing for as much power as I was hoping to unleash in the neighborhood. As I reflect on the contradictions on the street, the scene FADES TO WHITE.

Liquor Store Theatre, Vol. 2, No. 1 (2015)

FADE IN FROM WHITE:

EXT. MACK & BEWICK LIQUOR—(DAY)—MEDIUM SHOT—We're on Detroit's deep east side.[1] There are people holding court in front of the liquor store, people holding court across the street in the parking lot of a tire and rim shop, perhaps ironically named Hood Tires after both the owner's surname and the distressed urban surroundings. It's a luxuriously rare, warm day in early spring, the first filming of the project's second year.

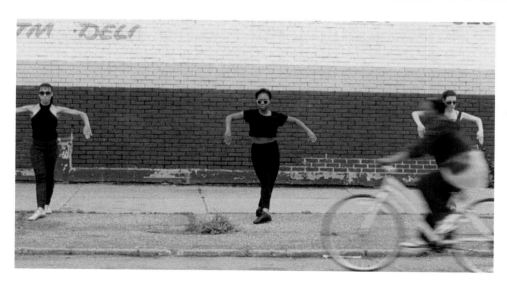

4.1 *Liquor Store Theatre, Vol. 2, No. 1* (2015). Pictured with Amanda Nummy and Ericka Stowall (center).

We JUMP CUT to the street intersections: MACK & BEWICK. Fluffy clouds loom in the background, bracketing the possibility of danger with the softness of the sky. This intersection is part of Detroit lore. Known as "one of Detroit's most notorious intersections," when I was growing up in Detroit, the intersection was sometimes invoked as a way of indexing oneself as harder-than-thou, along the lines of Chin's informant Tionna's ironic "homey-er-than-thou" performance.[2] Once, a friend of mine and I, both from relatively affluent middle-class homes, rode with her boyfriend to the intersection just to see what the hype was about. The better part of a decade later, there I was, staging performances and conversations at the liquor store right below the notorious intersecting street signs.

Technically, Mack & Bewick Liquor is not in the McDougall-Hunt neighborhood. It is deeper east, which puts it into the Islandview neighborhood. After I decided to continuously orbit the McDougall-Hunt stores only, I didn't return to Mack & Bewick Liquor. The same is true about Midtown Liquor, which I filmed right after Mack & Bewick. Midtown Liquor was located in the near-downtown neighborhood called Midtown and also referred to as the Cass Corridor previously. Some people still use the name. At any rate, there was a methodological reason for these shifts. Early in the second year of fieldwork, I considered attempting to orbit the entire city's liquor stores.

The Mack & Bewick and Midtown stores represented my testing of the waters. What I found at both filmings was that there was nuanced ethnographic material to be gained by speaking with people and performing in both the Islandview and Midtown neighborhoods. But because I wanted to ultimately connect to a neighborhood ethnographic frame, I decided to wrap the frame tightly—which meant only doing my filmings in McDougall-Hunt. Still, Mack & Bewick and Midtown were important to the project because they helped demonstrate the complexity and variety across Detroit neighborhoods. They demonstrated that there was no one neighborhood that could speak for the whole city. Now, with methodological backdrop daylighted a bit, back to *Vol. 2, No. 1*.

If McDougall-Hunt was economically distressed on the heels of the 1980s crack cocaine crisis, the compression of the automotive industry, and the structural violence rendered by discriminatory real estate legislation and practices, employment discrimination, and overt, oppressive racism, then Islandview could be said to be even more impacted by the same. Anthropologist Michael Taussig's description of flying into and then having lunch in downtown Cali, just a quick flight from Bogotá and way up in the moun-

tains, reflected the paradox of place I found at Mack & Bewick Liquor. Taussig wrote, "Hot and sultry, Cali is famous for the beauty of its women and as the birthplace of salsa. Women transform as they step from the plane. Semitransparent blouses and shorts so short you blush. Great flair by these goddesses on their motor scooters threading through traffic stuck at lights as helmeted soldiers guard bridges and overpasses looking down upon them."[3] Taussig's description evokes both political-economic-sociocultural-historical context and this certain feeling of mystique, pressing the reader to question what it is about Cali that we really need to understand. Next, Taussig spins into a description of Cali, a discussion that hits me with its familiarity. Not just familiarity in the context of text that follows, but for the way it is situated. It hits in the Stein sort of "there is no there there" feeling in which I'm awash at present as I adjust to living between Detroit and LA County.[4] It haunts. Flying in, Taussig writes,

> We go to lunch at The Turks in downtown Cali. In my memory it was always crowded, with tables and people sprawling onto the wide footpath opposite the old bullring, with idlers and beggars steering their familiar way through the diners. But today there are no customers. Not one. The raucous days of the cocaine boom are over. The big cartels have gone under, and smaller, discreet ones have mushroomed in their place. Factories are closed. Apartment buildings stand empty. Unemployment figures are off the charts, as are homicides. In this restaurant I feel I'm on a stage set with a fake waiter and I must do my very best to act my part and not let the team down. (What team would that be?)[5]

Cali was complicated—it was packed with people, actually (Taussig mentioned the sublime and irreverent women), but it was also described as vacuous at the end of the cocaine boom. I was writing against the idea that Detroit was empty. I was writing against this mythical narrative—the city had, after all, close to 700,000 residents at the time. Still, the economic devastation had caused this sense of violence Taussig described.

The CAMERA PULLS BACK to an ESTABLISHING SHOT of the side of the store. *Regular Ni**as do Regular Sh***. These words are scrawled on the side of the building in full-text spray paint—someone has blurred the slur and the profanity, serving to underline both. It seems that the spray-painted statement says something about the options provided by the political economics of the neighborhood. Alongside the *Regular* tag, Ericka Stowall, a performer with sultry, expressive movement quality, and Amanda Nummy, a performer with a quiet sense of intrigue about her, are performing with me. We slide and

spin under the midday sun, as a few passersby look on. Sturdy but well-worn homes loom beyond the store, where people are hanging on in spite of the economic devastation that's apparent—boarded-up commercial buildings, an abundance of litter, and a few emaciated, eyes-glazed-over people milling around who look as though they might be at a casting call for a zombie apocalypse series like *Walking Dead*. Only this is not a casting call; this is real life, interspersed with filming of unannounced performances and conversations to follow. The conversations at *Vol. 2, No. 1*, it turned out, were particularly smart and haunting.

A man named Ben Krause approached me in between takes. He was curious about the performances and asked what we were doing. I explained briefly and asked if he might share his thoughts on the neighborhood and the city. After providing the recruitment script, obtaining consent, setting up the mic, and adjusting the shot, we started talking on camera. Krause was in his fifties, wore glasses, a golf shirt, and had a thoughtful, introspective demeanor about him. I asked Krause to tell me about Detroit. He nodded and squinted a bit, thinking and staring up at the clouds.

"I've lived in Texas, Kansas, Illinois. I was in the military," Krause started. "What people don't understand is that what you hear about Detroit is not Detroit. That's an aspect of Detroit like anything else. Any big city. Detroit has a fraction of what it had before [population] but it's still a big city. The people here, we will be good. Give Detroit a chance. Don't look at what you see in the news. I know that Detroit has the best people I've met in my life."

I was struck by Krause's descriptions. He was toggling between the political economic-macro situation and the individual-personal-social—the "experiential geographies" that make a city what it is for the people closest to it.[6] For the people who make it. Another man, Ryan Wilhite, described some of the economics of the neighborhood.

Wilhite, in his mid-forties, wore a black T-shirt over black slacks. He had a muscular frame and piercing, keen eyes. Of the current status of the city, Wilhite said, "Well, I think it's trying to pick back up and come back around. They're doing a lot of building downtown, with the casinos and stuff. . . . The casinos, they played a part in the neighborhood going down too. A lot of people lost their houses and their money due to the casinos." Wilhite's statement undermined the narrative that casinos brought jobs and opportunity. Rather, it sounded from Wilhite's description like the casinos were actually a parasitic force in the neighborhood. Soon after this discussion with Wilhite, a key informant, Faygo Wolfson, would tell me of going to the casino

from time to time. Once, he told me he lost his rent money there. A twenty-something man with whom I spoke, Trayvon Clark, underlined Wolfson and Wilhite's reflections.

Clark was tall and lean, and wore heavy-rimmed black glasses and a baseball cap. His fair skin was smooth, and he didn't look more than twenty-five. I asked his thoughts on the city. Clark, who hadn't been in earshot while I was speaking with Wilhite, seemed to pick up where Wilhite left off. "Instead of building all these casinos, and all these hotels and, stuff downtown . . . downtown is not the only part of the city of Detroit," Clark said. "We need to be trying to build up our neighborhoods. We need to be trying to show our kids the right way." His understanding of uneven development was sharp and clear.

Clark continued, "While we worry about tourism, and people from other states or out-of-towners coming to Detroit, so we can bring them downtown. And when they come downtown, that's all they see, and it looks . . . ay—it's a different world downtown." He paused and took a breath, letting his observations sink in for a moment.

"But you need to come up to the neighborhood where there's blight, and every other block you see an abandoned house," he pressed. "You know what I'm saying? Something like that. It's bad though. We need to be focusing on the neighborhood instead of focusing on downtown Detroit all the time." In his twenties, Clark was not interested in more development downtown, or fancy casinos, or people from out of town moving to the city. Clark's concerns were right at home, on his block. He was interested in the children and young people in the neighborhood—he was concerned that they had something to do. Again, Clark's analysis pushed past mythical respectability politics that would have the "social ills of poverty and underdevelopment be blamed on the family, or seeming lack of it."[7] Clark explained that the structurally violent figurings of the neighborhood (i.e., lack of formal education, leisure, and employment opportunities) led to young people's involvement in a variety of substitute activities.

Clark cleared his throat and began, "Ah, we got a lot of young kids out here not doing anything with themselves. . . . Got a lot of robbery, drug dealing, and stuff like that," he reflected. And then, he got to the heart of it, continuing, "It used to be better than this back in the day. But it's just . . . the economy has gone down. . . . You got a lot of kids out here, like I said, on the street, not doing anything. . . . It's because they don't have anything to do." A beat. Then, Clark finished, "There are no activities to do in their neighborhood, so kids are basically getting into trouble."

I think Clark, standing before the camera, thoughtful, understated, young, and full of promise, is a "renegade dreamer."[8] Like the people Ralph learned from in his Chicago fieldwork, Clark wanted "a good job, a fulfilling life, safety, respect, and equality."[9] Clark was a renegade dreamer, as well, because, as Ralph wrote, Clark was doing the work of imagining "a different future for self and community even when living a life that's at odds with the dignity of one's aspirations."[10] I shall offer that Clark is not exceptional. I shall argue against the assumption that Clark was an excellent outlier, or a do-gooder who was unusual.

I think Clark is actually the underdetermined standard. He's the young African American man who is thinking, working, writing, and contributing to cities, towns, places, and spaces across the U.S. Clark is not the exception, I argue. He's the rule. We need to find ways to support Clark and the millions of youths like him around the country who need resources, opportunities, and access to the amenities that we all crave—education, jobs, housing, interesting leisure activities. Interested in Clark's perception of his own life, I asked if he felt he was performing in everyday life. I'll never forget his response.

"Oh yeah. Yeah. I do feel like I'm performing," he says. "I get up every day, I have children of my own, I take care of my business, and you know, I'm just a generous person." He pauses a moment. "And if I see somebody on the street that's not doing good, or if they don't have as much as I do . . . and if I have something, I'd like to give to them. I like to bring something to people. I like to lift up people. That's the type of person I am. But as far as performing, yes. I get up every day, I go to work, I take care of my business, I work my nine-to-five, and that's about it." He smiles and looks straight into the camera with a steady gaze. Clark, a brilliant renegade young person, is not only a dreamer but a doer. Clark reminds me of people I went to high school with, people in my extended family, people who grew up down the street from me. He's not an exceptionalist example. Clark is the possibility, the brilliant young person, that we might see if we simply open our eyes.

Vol. 2, No. 1 also forced a discussion of addiction, and in the context of the scene of the liquor store, alcoholism was central. While it's true that I wasn't interested in the site of the liquor store wholly for its contributions to substance abuse, the fact remained that the numerous liquor stores in this economically distressed neighborhood (and dearth of other businesses) had political-economic, sociocultural consequences. Downtown Detroit, just two to three miles from Detroit's near east side, had liquor stores. But in addition to liquor stores, there were yoga studios, tattoo parlors, bars, restaurants, vin-

tage clothing boutiques, dog day care centers, art galleries, sandwich shops, hair salons, and flower shops.

The importance of liquor stores in McDougall-Hunt and adjoining areas like the Mack & Bewick area was due to their sheer saturation, their utility of use, and their relevance in the neighborhood, if only due to the absence of other sorts of spaces. Still, because of this choice of space, the work could be misunderstood as a moralizing critique, or perhaps, on the other hand, as a naive exaltation of liquor stores and what they represented. I was more interested in meditating on the space and posing questions rather than asserting answers. However, the work required a critical analysis of alcohol and alcoholism's impact in this fieldwork, and more broadly in anthropological research.

Anthropologist Philippe Bourgois wrote that advertisements confronted his informants with images—and suggestions—of an escape alcohol offered. Bourgois's key informant, Primo, "was only drinking Private Stock . . . which was being marketed on Harlem billboards featuring beautiful, brown-skinned women draped in scanty leopard skins and flashing bright, white teeth, to attract a fresh generation of young, inner-city street alcoholics."[11]

Bourgois underlines the importance of the surroundings of the everyday (like billboards) in shaping lifeworlds and meaning making. Bourgois holds the work of the billboards responsible for what they represent, which is, as Bourdieu wrote, "Instruments which help ensure that one class dominates another (symbolic violence), in Weber's terms, the domestication of the dominated."[12] Symbolic violence, while useful, didn't go far enough to rupture the surface of things and understand what was going on in the day-to-day. It wasn't enough to present symbols as inherently powerful and people as automatically seduced by such violence.

However, I, like Bourgois, ultimately concluded that the liquor stores are symbols and sites of political-economic domination and hegemonic perpetuation of the same. Yet the day-to-day questions were more mundane than the level of ideological domination. Jumping back to my conversation with Trayvon Clark, as Clark said, some young people in the neighborhood turned to drugs because there weren't other activities to do; there wasn't "anything to do with themselves." It would be inadequate to say that the Private Stock billboard alone was enough to seduce fresh new alcoholics. Rather, it was a sociocultural, political-historical-economic framework that allowed the Private Stock billboard to stand alone.

In neighborhoods with abundant resources, like jobs, activities, and leisure opportunities, drugs still exist. Advertisements may be less heavy-

handed, but they are there. The difference is, what alternatives are there for people? If the answer is that there are none, Clark's theorizing once again asserts itself and also demands to be considered among Bourgois's theorizing of billboard hegemony and Bourdieu's theorizing of symbolic violence. Bourgois often wrote of alcoholism among his East Harlem informants.

Abraham, Primo's grandfather, was a "hopelessly alcoholic seventy-two-year-old man."[13] Bourgois's informant "Eddie's mother was abandoned by her alcoholic husband."[14] Primo's on-and-off-again partner Candy's child care provider would at times "pass out from some combination of Thunderbird, vodka, Bacardi, and beer," and Primo said his father was "an alcoholic, and he beat down [Primo's] mom every time he got drunk."[15] Considering Bourgois's documentation of alcoholism's devastating impact upon families, the classed dimensions of alcohol, space, place, and social life offer vast possibilities for analysis.

Sociologist Loïc Wacquant, for instance, conducted fieldwork in inner-city Chicago and found an entirely different calculus of substance use and abuse among his otherwise similarly classed, racialized, and gendered informants. The reason? Wacquant's meditation was on a group of men who had, as Trayvon Clark told me, "something to do." The men were part of an elite boxing gym led by the legendary boxing coach DeeDee Armour. In comparison with the African American and Puerto Rican American men Bourgois described, Wacquant's informants cut a different figure. Wacquant writes of informants and prizefighters working out at the Woodlawn Boys Club in late twentieth-century Chicago, "Every boxer must abide by a strict diet (avoid all sugar, starchy and fried foods, eat fish, white meats and steamed vegetables, drink water or tea). He must keep regular hours and inflict on himself an early curfew to give his body time to recover from the day's exertion."[16]

A U-turn from the "alcoholics" described in Bourgois's work, Wacquant's informant "Butch is pugilistic frugality incarnate: he trains and boxes with sobriety and economy; he knows how to deny himself for very long periods of time any deviation from the dietary, sexual, emotional or professional rules of the craft."[17] The head coach of the Woodlawn Boys Club Boxing Gym, DeeDee Armour, described the work: "Training in the gym, that's only half the work. The other half is the discipline: you got to eat right, hit the sack early, get up in the morning to do your roadwork, leave the women alone and everything—you know, taking care of your body."[18]

Wacquant's ethnographic framework—a boxing gym—may seem extreme. But then, isn't Bourgois's equally such? Understanding addiction, alcoholism, and subjectivity are complicated ethnographic projects. What did

it mean to understand addiction ethnographically, anyway? After observing the rudimentary identification of a dead man by the CTI (Corps of Police Intelligence) in Cali, Colombia, Taussig wrote in his diary, "I guess it's the first time—one of 'one such'—that I've really felt the meaning of violence, and felt both terrified and deeply sad for Colombia—this twisted, dirty, almost naked body in its sticky, dirty pool of blood clutching at its fish scales."[19] Soon after, Taussig critiqued his diary entry, and leaned into the question I ask above of addiction, as it pertains to violence.

Taussig asked, "What does it mean when I write to 'really feel' and just what is 'the meaning of violence'? What does it mean to reflect on these things as opposed to feel them?"[20] Taussig concludes that in order to discern the meaning of violence—or to feel it even if it hasn't landed on you, the viewer—one must understand violence as "transfigured by the law absorbing the violence and magnifying it."[21] I shall argue that addiction and alcoholism should be understood similarly. In the case of Bourgois's ethnographic landscape, alcohol was an activity—a form of entertainment or leisure in a political-economic model in which access to acceptable leisure and educational activities was nearly zero.

In Wacquant's ethnographic landscape, the violence of addiction and alcoholism was mitigated by the focal point of the men's lives—the boxing gym, which offered an exciting, acceptable activity that people's brains and bodies could chew on, rather than alcohol or drugs. To understand addiction anthropologically, I shall argue, is to understand what it is that the addiction is standing in for. The addict is not weak, deviant, lazy, or decadent. The addict is simply using alcohol or drugs in place of something else. In some cases, this might be a need for mental health treatment and other professionally administered, appropriate medications. In some cases, this might be a need for an activity like sport or art. To truly understand this is also to say that humans are flexible and connected to our environments in dynamic fashions.

In McDougall-Hunt, the overdetermined presence of liquor stores and the lack of educational, vocational, and leisure opportunities encouraged alcoholism and addiction from the perspective of spatial politics. In McDougall-Hunt, Taussig's discussion of violence in Cali translates to a discussion of both structural and physical violence, and to our subject here—the violence of alcoholism and addiction.

The spatial politics of McDougall-Hunt were violent—they absorbed, as Taussig theorized, the political-economic violence of the zone and magni-

fied this violence into eight liquor stores that were both sites of convenience for neighborhood shopping and social life and sites of possible devastation of the body and mind. Greg Winters would often say that he might drink too much, but that he didn't mean any harm, and indeed, Winters is one of the most honest and dependable people I've ever met. If Winters, or anyone else in the zone, is an alcoholic, this is a difficult neighborhood in which to live. Again, the violence of the spatial politics deems it nearly necessary for people to frequent liquor stores for basic shopping.

The eight liquor stores in the neighborhood, where the majority of residents rely on public transit, represent the main businesses available for shopping. With the closure of a national convenience store chain, there remained one grocery store in addition to the liquor stores, gas stations, beauty supply stores, and hair salons in the neighborhood. The inability to avoid liquor stores, even for someone who was attempting to abstain from alcohol, was a geographic reality and an everyday problem for people who were trying to avoid addiction to alcohol or other substances. Other substances were trafficked at the liquor stores. While I won't speculate here on the specifics of what was sold, where, or by whom, I know from fieldwork that other substances were trafficked. Over years of participant observation in the neighborhood, I've been informed by hundreds of people that some (not all) of the stores also serve as nodes of illicit drug trafficking.

One of the drivers of this work was to shine a light on the fraught politics—on the violence—of the overdetermined presence of liquor stores in low-income neighborhoods. Again, this driver was refined—I shall not argue that the stores were completely negative or devastating forces in the neighborhood. I shall also not argue that the stores are innocent. The liquor stores in McDougall-Hunt collect a certain amount of blood money. It was, and remains today, a fact. While many customers are celebrating or drinking relatively reasonably, or running errands unrelated to alcohol, some customers are nursing a devastating addiction. Some customers are enabled by the stores and are allowed to purchase alcohol while obviously inebriated. Blood money is part of the thing. I shall not shy from the facts.

And yet the store owners are not bad people with evil intentions to destroy lives. Most of the store owners are simply trying to earn a living, hardened by years of rapid-fire transactions of mostly drinks and smokes. It seems that Trayvon Clark, who told me about the problems in the neighborhood, had a keen understanding of violence. Clark's words kept echoing and reminding me of the sources of violence and addiction. Linked to Taussig's

theory of violence, Clark consolidated structural violence, risk, and the specter of addiction in his analysis of the neighborhood. "Instead of building all these casinos, and all these hotels and, stuff downtown . . . downtown is not the only part of the city of Detroit. . . . We need to be trying to build up our neighborhoods. We need to be trying to show our kids the right way." Clark's brilliant analysis hangs in the air as we FADE TO WHITE.

Liquor Store Theatre, Vol. 2, No. 2 (2015)

EXT. MIDTOWN LIQUOR—(DAY)—ESTABLISHING SHOT of Midtown Liquor's brick façade up against the bustling Woodward Avenue. It's summer and people are all aflutter. The clouds are high and opulent, as people of all ages stream through the streets and sidewalks around the store. The store is weathered and a bit out of place in its surroundings, which include, across the street, a bowling alley, a contemporary American restaurant, and a variety of other businesses. We're not in McDougall-Hunt anymore.

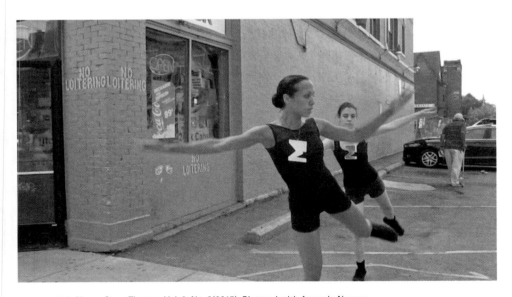

5.1 *Liquor Store Theatre, Vol. 2, No. 2* (2015). Pictured with Amanda Nummy.

During the second year of the project, I explored the idea of taking the performances and conversations across the city. At *Vol. 2, No. 2*, beyond the confines of McDougall-Hunt, I worked in a neighborhood known as Midtown. Midtown is part of a constellation of neighborhoods referred to as Greater Downtown Detroit. Kinney discussed the demographics and the politics of Greater Downtown, also known as "the 7.2" for the square miles of land area it encompassed.[1] Kinney's discussion is informed, in part, by the report known as *7.2 SQ MI*, produced by certain NGOs, private companies, and quasi-private governmental groups in 2013.[2] Kinney wrote that the *7.2 SQ MI* report "plays on the prior narrative of Detroit's fall to suggest that its rise will be possible when the population shift reverses and the balance is tipped back toward a decrease of black people."[3] At *Vol. 2, No. 2* that summer day in 2015, however, it did not seem that black people had left the city or the 7.2 square miles of Greater Downtown. Indeed, this particular episode would ultimately serve as an ethnographic metaphor for the contradictory picture of urban political economic development, in Detroit and around the world.

JUMP CUT to a MEDIUM SHOT of a thirty-something African American man, who tells me his name is Lil' Foot, wearing a sleeveless jean vest covered in metal spikes. His hair is done up in a blend of a Mohawk and locks, and he's intently focused. Lil' Foot stands in front of Amanda Nummy, a collaborating performer, and myself as we prepare to film a choreography sequence. It is incredibly humid that day, and the wardrobe selection reflects the heat. Nummy and I are wearing form-fitting bodysuits with short shorts, and we are surrounded by men—passersby, store patrons, and Lil' Foot himself.

Lil' Foot seems to hold the moment in the palm of his hand. He's tapping his foot to the beats from my nearby portable sound system, Todd Stovall's electronica compositions pulsing through the street. Lil' Foot's movements are inspired by a Michael Jackson choreographic aesthetic. The movement references, including lightning-quick shifts from motion to stillness, flashes of the hand in front of the face (or crotch), and, naturally, moonwalking, are unmistakable.

To this Jackson-esque movement quality, Lil' Foot adds his own choreographic spin. He has a move in which he spins to the ground on one leg, then drops and opens his body to the ground in reverse—riffing on a hip-hop dance move known as the death drop—but done in a different style all his own. Lil' Foot's choreography is in dialogue with Nummy and me as we all move together in the frame. Lil' Foot's performance also includes rap. He holds up his hand in front of himself, willing time and space to stand still as he spits,

Power, power, power, power
Power, power, power, power
Power to the people
People to the power
Made a million dollars, boy, did it in an hour
That don't mean nothin
Black or white, boy, that's power
Meet me in the White House
Chillin with Obama[4]

Lil' Foot's meditation on power and political economy consolidates the paradox of place I observed at the scene of Midtown Liquor that day. Forces of development and underdevelopment seem to be swirling at once, with new businesses coming and rents rising, on one hand, and on the other hand, the persistent lack of opportunities and resources in the area that has the streets and sidewalks around the store full of people who appear unhoused, strung out, or some combination. And yet, there are also a number of people who appear to have money and access to resources milling around. It is a surreal scene. Political theorist and activist Walter Rodney writes, "Underdevelopment makes sense only as a means of comparing levels of development. It is very much tied to the fact that human social development has been uneven and from a strictly economic viewpoint some human groups have advanced further by producing more and becoming more wealthy."[5]

Marable stresses that impoverishment and poverty are contextual and situation-specific. In other words, to understand poverty, we must think of it "as a comparative relationship between these segments of classes who are deprived of basic human needs (e.g., food, shelter, clothing, medical care) vs. the most secure and affluent classes within a social and economic order."[6]

Just outside of Kingston, Jamaica, in a rural town, Thomas found that postindependence persistence of white colonial economic domination dictated particular local responses to impoverishment. "Poorer Mango Mount villagers believed that their opportunities for individual growth and advancement (and, by extension, those of black Jamaicans generally) had not changed significantly since independence due to the institutional perpetuation of colonial hierarchies of value. This is why their common blackness trumped other status-based differences between them. It is also why they had already begun to pursue alternative paths for their own development."[7]

The "colonial hierarchies of value" documented in Thomas's Jamaica fieldwork, like political economy around the world, were linked to the U.S.

and to black America as well.[8] Political philosopher Cedric Robinson theorizes the interconnectedness of global black impoverishment, writing, "The poverty and deteriorating well-being of Caribbean blacks were the direct legacies of colonialism. Tens of thousands of West Indians came to the United States during the first decades of the twentieth century. It was work, too, that attracted them, and so they located in precisely the same black communities that received the internal migration."[9]

The "internal migration" of black people refers to what is known as the Great Migration in the United States, and it forever transformed Detroit's early twentieth-century landscape.[10] During the Great Migration of 1915–1930, between 1.5 million and 2 million African Americans moved from Southern states to urban cities in the Northern states.[11] Unfolding in cities around the nation, like New York, of which Robinson wrote, the expansion of African Americans in Detroit was particularly striking. Between 1910 and 1920, the population of black people in Detroit grew by 611 percent.[12]

During the 1920s, the growth continued at a rapid pace, with Detroit's black population expanding from 6,000 to 200,000.[13] What is historically striking about the Detroit case is that conditions of inequality set forth in the early twentieth century as the city was developing had yet to be addressed with cogent, proactive, political-economic policy. In contrast, political-economic policy enacted on the heels of the Great Migration set in motion a chain of inequity that would require empirical strategies to unwind. The U.S. government's Housing Act of 1934 offers a stark example.

The Housing Act of 1934 was legislated by the U.S. government on the heels of Detroit's (as well as that of cities around the U.S., including Cleveland, Chicago, Los Angeles, and New York City) striking demographic transformation. Historians and political scientists agree that the Housing Act of 1934's racist real estate practices were crafted in an attempt to mitigate (to the benefit of white people and the loss of black people in particular) increased competition for desirable housing, education, and employment.[14]

Ultimately, the Housing Act of 1934's four central elements promoted "the development of various legal devices, including zoning, deed restrictions, and racially restricted covenants to impose and increase racial segregation."[15] Toward these goals, the act featured four main elements, including, first, the creation of a nationwide credit plan that provided insurance to banks on up to 20 percent of home improvement loans. Second, the act essentially created an insurance system (called the Mutual Mortgage Insurance Fund), in which the government would fully insure losses on mortgage loans and home improvement loans. Third, the act created a synthetic, secondary market for

Federal Housing Administration (FHA) mortgages by establishing what were called national mortgage associations to buy and sell FHA-issued mortgages (the formal beginning of the real estate derivatives market that crashed the stock market in 2008).[16]

Fourth, and finally, the act established the Federal Savings and Loan Insurance Corporation (FSLIC), which insured the bank accounts and bank holdings of federal savings and loan association members.[17] On the surface, the Housing Act of 1934 appeared to stimulate the economy by offering relatively easy credit to new homeowners and insurance and a reliable secondary market to the banks. However, the trouble with all of this was the part largely unwritten and unspoken, that we now know to be glaringly factual. The fact was, the beneficiaries of the easy credit were white people, and black people were deliberately excluded from participation in the new wave of home ownership by the use of racially restrictive covenants, which developed from the Housing Act of 1934.

To understand the contemporary Detroit situation, it is essential to understand how racially restrictive covenants shaped and continue to shape the segregated landscape. Racially restrictive covenants are legalized, contractual agreements between neighborhood associations and individual property owners that outlaw the sale, occupancy, and even the leasing of property or land to certain people of color, and especially to black people. Before the Great Migration, racially restrictive covenants did not exist because they did not need to (think pre-1900, when segregation was largely de facto due to U.S. slavery systems).

Before the creation of racially restrictive covenants, restrictions on the transfer and sale of property were written into deeds. These deed restrictions covered single parcels of land, rather than entire neighborhoods. Where deed restrictions were at a micro level, racially restrictive covenants were at a macro level. These covenants were expressly designed and deployed to stop the movement of black people into predominantly white and more affluent areas.

To ensure enforcement, the consequences of violating racially restrictive covenants were harsh—in hopes of preventing nonracist sympathizers from taking corrective action. Property owners could be sued, for instance, if they attempted to assist in the selling or buying of property against a racially restrictive covenant. As the Great Migration expanded after 1910 and beyond, these covenants spread like wildfire across the United States.

Racially restrictive covenants created massive wealth disparities between people of color—black people in particular—and white people, who enjoyed the benefits of the FHA lending programs without restriction. As

home equity wealth was generated and transmitted among white people between 1910 and 1948, when the U.S. Supreme Court finally ruled racially restrictive covenants to be unenforceable, the existing foundation of the wide wealth gap between white people and black people in the U.S. was hardened.[18]

Returning to the Detroit case, the effects of the Housing Act of 1934 and the racially restrictive covenants that spawned a growing wealth gap in its wake are glaring. The city is segregated, not based on emotions or feelings, but more to the point—by home ownership and political economics. Political officials combined efforts with real estate brokers and agents in order to discourage and block people of color from entering the suburbs. Detroit suburbs such as Dearborn, Livonia, and Warren were all but 100 percent segregated using the combined tactics of redlining and brute force.[19] In fact, at the 1970 Census, of the 400,000 residents in Dearborn, Livonia, and Warren combined, just 186 self-identified as black on the census.[20] This was a stunning figure—less than five-tenths of a percent, or 0.046 percent.

Speeding back to the present, in the postbankruptcy Detroit context, suburbs like Livonia and Warren are, ironically, becoming increasingly of color, with movement of African Americans and hosts of people of color to less-affluent suburbs like these, while whites with means returned to Detroit's 7.2-square-mile Greater Downtown area. Indeed, it is empirically documented that as whites move to desirable areas of Detroit in the postbankruptcy era, there is a trend of people of color and poor people shifting to the outer reaches of the city limits, and even to what are becoming known as the lesser suburbs just beyond the city limits.[21] One has to wonder, is this classical accumulation by dispossession? Is this technical gentrification, where people with less money are moved out to make way for people with means? Is this urban process—the life cycles of cities, not necessarily tied to displacement? It is a combination of all these factors, and more.

From Lil' Foot's organic intellectual standpoint, his verses crystallize a number of political-economic nuances of modern and contemporary black life. Lil' Foot, demanding power to the people, also muses on the wealth disparities in the U.S., commenting that his alter ego "made a million dollars... in an hour." Finally, Lil' Foot commented on his own sense of paradoxical political economy as an unhoused (he informed me) black man in urban America, with a black president, in former president Barack Obama, commanding perhaps the most militarily and economically formidable country in the world. In addition to Lil' Foot's rap lyrics, his discussions of city life proved incisive as well.

JUMP CUT to a MEDIUM SHOT as Lil' Foot is interviewed in the parking lot of the liquor store. A group of men gathers around him while I attach his mic; he's holding a sort of street court as the men stand by listening. Lil' Foot's thoughtful eyes are intense as I ask him to tell me about the neighborhood. He quickly begins to talk about rents, which he says people are concerned about. "If you get SSI—I tell the truth—if you get SSI and the rent is $1,200 but you get $700 per month, that means they put you out. They put you way father down [away from the city center] and you can't even afford to live."[22] He pauses as he thinks a moment. The men behind Lil' Foot seem a bit unnerved by his discussion but continue to listen intently. "That isn't right," Lil' Foot continues. "Sometimes, we have to do something different, or we can't do anything different. SSI is not enough. It's not enough to live on, not in this neighborhood."

One of the men standing behind Lil' Foot nods in agreement as Lil' Foot describes escalating rents. His name is Bryce Morris. Morris is in his sixties, average height, and wears a baseball cap, a T-shirt, and jeans. He has a thoughtful air about him. Morris tells me that he lives near the university and that he too is concerned about rents.

In dialogue with Lil' Foot, Morris says, "Yeah, that's how I feel. Leave me alone. Let my rent stay the same. Let me keep my Section 8. I put it like that. Let me keep my Section 8—everybody else who is on Section 8, let them keep their Section 8 too."[23] The elegant simplicity of Morris's insightful point cuts through mythical neoliberal narratives of disciplined, individualized citizenship. Morris continues, "Because it's a hard struggle to be on Section 8. And we got battles to fight, and we got to pay water bills. People got houses . . . but I love my apartment. I can turn my own key. But they're out here shutting water off, and taking the keys from people, and everything." Morris's concerns with rising rents and water shutoffs harming the city's most vulnerable were rooted in economic reality.

After starting during my first year of fieldwork in 2014, the Detroit mass water shutoff crisis reached an apex in public-sphere newspaper and television media. By summer 2015, like the discussion in *Vol. 2, No. 2*, people across the city like Morris, and around the world, were concerned with Detroit's unwillingness to provide water to its most vulnerable people. *The Daily Show* and the United Nations pointed out the physical, public health, and economic violence to human rights in denying water to poor people, infants, pregnant women, and seniors. The political-economic paradoxes were deep.

There were approximately 65,000 delinquent residential water accounts owing $48.9 million to the Detroit Water and Sewerage Department (DWSD), a not-for-profit by Michigan mandate. Of these accounts, at least 3,000 were at risk for immediate shutoff.[24] Meanwhile, the DWSD estimated approximately 18,100 commercial accounts made up close to $26 million of the total deficit, over half of the amount owed by residential water accounts.[25] There was zero DWSD discussion of shutting off the water of the delinquent commercial accounts, with names like Ford Field delinquent $55,803; Eastern Market Corporation delinquent $60,911, and the Illiches at Joe Louis Arena owing $80,225.[26]

The largest debtor of all, it turned out, was neither a commercial account nor residential—it was the state of Michigan, owing the DWSD a reported $5 million.[27] The state reportedly disputed that charge, claiming it was due to a long-running broken water main. And yet residential customers owing $150 or more were at risk of water shutoff regardless of income level and circumstances, such as long-running broken water mains. Statistically, the lowest-income people in the city were at the highest risk of shutoff. The hurtful irony that the state of Michigan contained 21 percent of the surface of the earth's fresh water by volume and yet city governance in that state wouldn't extend water rights to all couldn't be clearer.[28] The politics of rents, SSI, and Section 8 recipients were not only on Morris and Lil' Foot's minds, but on urban political-economic scholars' minds as well. Perry et al. wrote,

> Despite the image of Detroit as being underpopulated with [a] large amount of vacant land, abandoned homes and buildings and, therefore, a place where displacement of existing residents would not be an occurring [*sic*], in the Downtown and Midtown areas where business, cultural institutions, higher education and medicine, are concentrated, there is rapid growth and revitalization with an influx of people with higher incomes that has resulted in a shortage of housing and rapidly increasing rents. As is the case with most urban areas, it also has a high concentration of subsidized low-income senior housing. Rather than being unique to Detroit, the issue of opting out of HUD contracts, resulting in seniors being displaced has great relevance to many cities across the country.[29]

Urban political economy scholars, as well as Morris and Lil' Foot's perspectives, were in dialogue with Lia Chris. Chris was in her thirties, tall and thin, and said she was new to the neighborhood. A white woman who appeared to be from a middle-income or higher socioeconomic class, Chris's

views connected with Morris's and Lil' Foot's. When I asked Chris to tell me about the neighborhood, she said, "There's a lot more development. . . . You know, it's a lot more places to go eat, go have drinks at . . . a lot more shops . . . where that wasn't the case maybe five or ten years ago."

Chris paused and thought, and added, "There are a lot more people moving in, coming from outside the city." I asked Chris if she was referring to Detroit broadly or to Midtown. Chris replied, "Midtown, I think. If people are . . . wanting to relocate to Detroit, they feel more comfortable maybe moving to Midtown than to . . . another part of Detroit." I asked Chris if she had heard about rental pricing changing in the neighborhood recently. She paused, nodding emphatically.

"Rents are going up. Yeah, they are," Chris said. "And luckily, I live like just less than a block away, and my rent hasn't changed in the past couple of years. But I know the building next to me, somebody that lived there . . . but he and a lot of the people that lived in that building moved to the New Center because they were raising the rent and they couldn't afford to live there anymore. Definitely, prices are going up. Well, I've only lived here for two years so, but I know prices are going up."

The reflections of Chris, Morris, and Lil' Foot provided ethnographic examples of the theories of accumulation by dispossession developed by urban political-economic scholars including Robinson, Rodney, and Marable, and theories of structural-economic violence of urban anthropologists including Thomas and Taussig. Their ethnographic reflections also challenged assumptions of agency and awareness within political-economic superstructure. Their reflections around surveillance on city streets, likewise, linked and contested associations between theory and lived experience.

The question of surveillance surges into our discussions. JUMP CUT from Chris to Lil' Foot. Lil' Foot, still surrounded and watched by a group of onlookers, describes his perception of unjust surveillance and policing on the streets and sidewalks of the city: "I go down to the Tigers game at Comerica Park, and the cops are harassing us for a beer. A beer! If I'm here on the street, right here, on the sidewalk, if you got a can of beer, they will throw you in jail. What about the criminals? What about the rapists? What about the killers?"[30] Onlookers murmur in agreement as Lil' Foot continues. "Nothing but people drinking beer in Comerica Park and all around it. What's the difference?" Lil' Foot's comment alluded to classed, racialized, gendered, and sexualized disparities in surveillance and policing practices.

Anthropologist Mary Patillo described such disparities in the policing of black and white youth in Chicago. "White youth," Patillo wrote, "are

given the benefit of the doubt by white authority structures," while black youth are treated with the heavy hand of policing and law enforcement.[31] This benefit of the doubt could mark the difference between a stern warning and no consequences versus an arrest, a charge, incarceration, a criminal record, or even death. The CAMERA PULLS BACK to a MEDIUM SHOT of Chris, who, as her partner looks on, describes the phenomenon and uses Patillo's exact turn of phrase.

When I ask Chris about her perceptions of surveillance and policing in the city, her response is honest and direct. Chris says, "It's true that I would get preferential treatment if I was doing the same thing as, like, a black person, that I would be given the benefit of the doubt way more than they would." She pauses for a moment, and her partner shifts a bit, looking slightly uncomfortable perhaps, as she continues. "Like even driving for example, like, not everybody here obeys all the traffic laws, like they'll run red lights and things like that and . . . I'll do that sometimes too, if nobody is around, and I just figure I'm probably, even if there is a cop there, they're not going to do anything, because of how I look." In Jackson's multiclass ethnographic fieldwork across New York City's Harlem neighborhood, his informants prepared for a political activism march, the Million Youth March, in part by discussing how to behave in public spaces during the march to best deter police brutality.[32] "Volunteers shuttled around handing out safety tips for youth, insisting that they follow certain general guidelines for their own physical safety: . . . 'Avoid confrontations. If stopped by police officers, don't panic, stay calm and be polite; do not run, no matter the reason.' 'Keep your hands where police can see them. Don't touch any police officer and do not resist even if you're innocent.' 'Remember all police badges, names, and patrol car numbers.' 'Don't get in the way or obstruct the police, because you can be arrested for obstructing justice.'"[33]

For Jackson's informants, the concern with safety in public spaces during the march centered on the risks of being misunderstood, misread, or mistakenly accused by law enforcement. In *Black Corona: Race and the Politics of Place in an Urban Community*, Steven Gregory analyzed the politics of space and place through anthropological research in the predominantly African American Corona neighborhood of Queens County, New York City. One evening, a Youth Forum was held to discuss Lefrak City housing development's resources for young people.

Public-space surveillance and policing disparities on the part of hired security guards, experienced by black youth in particular, quickly emerged as a central concern. Gregory writes that "a young man in his late twenties linked the harassment by Lefrak security to media representations of black

teenagers as drug dealers."[34] Thus, Gregory theorizes, "the testimony raised the possibility that black teenagers who were often the targets of police action could play a constructive role in neighborhood stabilization."[35] People, indeed, know the challenges that they face. The experts on the streets and sidewalks are the ones who can inform us as we work to understand contemporary social life and urban political economy through anthropological research and as we work to advocate for policy changes.

Following the murder of teenager Michael Brown in 2014 by police officer Darren Williams, the U.S. Department of Justice launched an investigation of the Ferguson Police Department.[36] The Department of Justice report found that

> Ferguson's approach to law enforcement both reflects and reinforces racial bias, including stereotyping. The harms of Ferguson's police and court practices are borne disproportionately by African Americans, and there is evidence that this is due in part to intentional discrimination on the basis of race. Ferguson's law enforcement practices overwhelmingly impact African Americans. Data collected by the Ferguson Police Department from 2012 to 2014 shows that African Americans account for 85% of vehicle stops, 90% of citations, and 93% of arrests made by FPD officers, despite comprising only 67% of Ferguson's population. African Americans are more than twice as likely as white drivers to be searched during vehicle stops even after controlling for non-race based variables such as the reason the vehicle stop was initiated, but are found in possession of contraband 26% less often than white drivers, suggesting officers are impermissibly considering race as a factor when determining whether to search.[37]

The Ferguson case is tragic on its own because Michael Brown, an innocent teenager, a son, a family member, a student, unarmed when he was gunned down, was unjustly murdered. Darren Williams, the officer who killed Brown, was not indicted. The Ferguson case also symbolizes the national crisis in policing disparities in the United States. The Department of Justice data gathered during the Ferguson investigation show that these problems are not mere emotions or anecdotes but empirical disparities based upon hard data. The phenomena documented by anthropologists and discussed on the streets of *Vol. 2, No. 2* are central to the disparities coursing through urban black political economy, surveillance, and policing.

JUMP CUT to a WIDE-ANGLE SHOT on the sidewalk fronting Midtown Liquor. Lil' Foot holds the street in the palm of his hand as he stands com-

pletely still, the beat somehow writhing through him in a way that can be visually read. Nummy and I are behind him, transfixed. This is a rare moment; ethnographic participants almost never opt to perform during choreographic segments as Lil' Foot is now.

We improvise along with him, look at one another, and launch into our choreographic sequence. We orbit around him: he's conducting us at moments; we are conducting him at moments. As we move into a moment of stillness, Lil' Foot looks at us and takes over. He moonwalks the surface of the street, he moonwalks the sidewalk, he moonwalks the city, staring down the camera, forcing me to attempt to contend with his complicated words, his moves, and his philosophies all at once.[38]

FADE TO WHITE

Liquor Store Theatre, Vol. 2, No. 3 (2015)

FADE IN FROM WHITE:

EXT. UNIVERSITY LIQUOR—(EVENING)—MEDIUM SHOT—A liquor store on the corner of Forest and Third Avenues in the shadows of Wayne State University, as the beginnings of autumn swirl in the Friday night air.

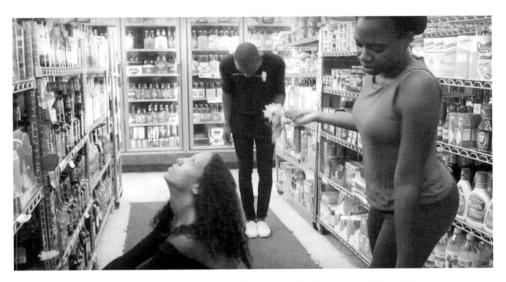

6.1 *Liquor Store Theatre, Vol. 2, No. 3* (2015). Pictured with Tim Schumack and Ericka Stowall.

It's fall, and a new semester is beginning at Wayne State University. University Liquor is just at the edge of campus, and the clientele reflects this precisely. A housing project complex for low-income people is just across the street, and less than half a mile away, there's another group of low-income-designated condominiums, clustered around a square block. Down the road another quarter mile is the Woodbridge neighborhood, where I grew up in a home my parents owned. Growing up, I remember the class differences between families in Woodbridge that owned or rented their homes, and the class differences between all of the Woodbridge youth and the youth from the nearby housing projects. The Woodbridge youth, in particular from the families who owned their homes, had outsized advantages across education, recreation, and employment opportunities. JUMP CUT to an ESTABLISHING SHOT of the intersecting street signs, Forest and Third Avenues.

It's bizarre to have these fluttering memories of the politics of the neighborhood as I stand on the scene now, preparing to film, perform, and talk to people about city life. The cool fall air scatters early leaves from mature trees, and we set up a shot. Ericka Stowall and Tim Schumack are performing with me today. We launch into a performance sequence. Schumack and Stowall each have their own sense of electricity, and a crowd quickly gathers. A handsome man in his late twenties, olive-skinned and clean-shaven, looks on while smoking a cigarette, his blithe fingers effortlessly flicking ash to the ground at turns.

A couple walks by, in their thirties, arm in arm. The woman, tall and attractive, wears a kente cloth head wrap and a wooden medallion around her delicate neck. The man, with dark, smooth skin, wears a Detroit Red Wings jersey over slim-fitted dress slacks. The young couple glides and winds through the small group that's watching our choreographic sequence; they are pure love in motion. CUT to a TIGHT SHOT of Schumack, Stowall, and myself. We stand next to one another, completely still, breathing heavily, as our sequence ends.

I quickly shift gears, moving toward curious people and opening up my energy to talk to people who might want to talk. I notice a slim, pretty woman in her forties or fifties who has been watching the entire segment. Her name is Kerry Baldwin, and she's wearing a city bus driver's uniform, complete with conductor's cap, embellished with Transportation Union Local Chapter patches and insignia. Baldwin walks over and talks with me a bit about what we're doing here, at the liquor store, performing and filming. Soon after, she's agreed to talk with me off camera. This, I would soon con-

tinue to observe, was a trend. Many women were delighted to speak with me but did not want to do so on camera. The politics of the camera were matched by the politics of the gendered, racialized, and otherwise classed differences and nuances of neighborhood politics. As we speak, these nuances spin to the surface. Baldwin tells me that, as her clothing hinted, she's a full-time city bus driver for the Detroit Department of Transportation. I am fascinated to speak with someone who must have seen so much.

"Can you tell me about Detroit? What's going on right now?" I ask.

"Well, from what I've observed in Detroit, there's still a lot of work that needs to be done in the neighborhoods. The focus is on downtown Detroit, Midtown, Corktown, and that's it. And it's pretty sad," Baldwin replies.

"What do you think is sad about that?" I ask.

Baldwin pauses for a moment and considers her words. "What I think is sad is that there's one man being allowed to buy up property in the downtown area, and he's concentrating just on the downtown area." A beat.

And then, continuing, Baldwin says, "And in my opinion, I think he should branch out and do some purchasing in neighborhoods and start helping clean up neighborhoods. Because he has the money to do it. But somebody has to put a stop to it. You can't just let him keep doing what he's doing. Trust me, I love Dan Gilbert. But I think that someone needs to put a cap on it, and say, 'Look, if you're not going to outreach to neighborhoods, then you have to stop acquiring property.' But the greed is there. So people are just allowing him to keep doing it. And it's just not right."[1]

Baldwin shook her head and paused. "But I don't live in the city," she concluded, shrugging, indicating her ability to influence the situation she described was unfortunately limited. "I work in the city," she says, gesturing toward her city bus conductor's cap. "Then, I go home," she continues, laughing softly. Baldwin's verbal cues marked this otherwise mundane, common dichotomy of living and working in different places as significant to her. I had to learn more.

"If I can ask, why is that? Is that a deliberate decision you made?"

"Yep, you guessed it. Deliberate," Baldwin answered. "I lived right across the freeway from like, '87 to '92, and then I lived in an apartment like three blocks over from '92 to '95. It was rough over here then." Baldwin gestures toward the housing projects and the Woodbridge neighborhood that loomed down the street and across the interstate. "And I think it's still rough over here," she concluded.

"I see," I replied.

Baldwin clasped her delicate hands, continuing, "I've been looking at lofts in the city. But I don't think I'll ever come back. I can't do it."

"Why do you say you can't do it?" I asked.

"It's just unsafe to me. From what I read, see, hear . . . it's just not what I want for me."

I was taken with Baldwin's choice of words. It seemed that she didn't think Detroit was unsafe in the absolute, but that it wasn't safe *for her*.

Then, continuing, Baldwin said, "I have a really negative look at the city of Detroit. I don't know how to say it. It's like the people have become animals almost. I was just on the phone talking to a friend of mine. She lives on Puritan and Greenfield. Or so I thought. She told me she moved three months ago to Rosedale Park, which is the Fenkell/Southfield area, right?"

"That's right," I said. "Why did she move?"

A beat, and Baldwin continued, "So, I asked her, 'Why did you move from the house you were getting ready to purchase?' She said, 'Oh, they got crazy over there.' She said, 'Did you hear about the two ladies that got raped yesterday?' It was one block over, literally, right behind her house. So, she's just happy she left."

I stood there, holding my audio recorder dumbly. I was stunned at the proximity to violence that Baldwin described. Her friend had just moved away from a neighborhood where she described gendered, sexualized violence as coursing through the blocks near her. I just nodded, listening.

In my silence, Baldwin mused, "And it's like, the neighborhoods, when I go home at night, and I'm driving from downtown to Lodge North, the 94 East, there are no street lights over the freeways. Like, I mean, this area, Midtown, will be lit up on the freeways. But then you go into a neighborhood north of here, and it's like complete darkness. And you can't see anything," she said.[2]

"What do you make of that?" I wondered out loud.

"I wonder, is that like a plan, or a ploy? It's like, it's a setup. But then they claim it's because the crackheads steal the mechanics out of it [the light poles]. I don't believe that. I don't believe that at all."

Baldwin paused, choosing her words, and continued, "Matter of fact, I have a good friend at work. Her son, unfortunately, two and a half or three weeks ago, was going to work, at 5:30 in the morning, on Jefferson and Pennsylvania—he was going to work, and all of a sudden, a man walks out of nowhere. The man was laying in the street, and he just got up and started walking. Unfortunately, Brandon hit him and killed him. That was the second

accident within three weeks, right in that same spot, by the Detroit water treatment plant. There are no lights out there. No street lights at all."

Baldwin shuddered a bit, reflecting on the tragedy she described. Baldwin's descriptions of acute violence, in this case accidental but no less jarring, again struck me. She continued, shifting her focus from violence to surveillance and disparities in city resources: "But guess what? The next day, after the accident—my girlfriend lives on Park. Park and Jefferson. Where the big homes are? Past Indian Village. So, close to the Jeffersonian. The apartments. About three blocks down there's the new $400,000 homes? The last street of the new homes there's a boat place. A marina. That's where she lives. She came to work the next day on St. Jean and Mack—the street lights were on in that spot. The next morning."

I wasn't sure what exactly to make of this. "Interesting," I replied. "Why do you think that was?"

Baldwin slowly raised her eyebrows with a look that many of my interlocutors gave me over the years—*isn't it obvious?*, her eyes said. "So, you mean to tell me, the lights got turned on after the man's death. Really?" She tilted her head ever so slightly to the right, looking like a classic high school graduation photograph as she waited for me to connect the carrot with the stick.

"So, you're saying that someone is aware of what's going on? That there's some kind of surveillance?" I asked.

"Yes, exactly!" She exhaled her bated breath, a proud lecturer. She continued, "And I just think it's a ploy, a ploy to rid the city of certain derelicts or certain types of people. But it's sad. It's really sad."

It sounded as though Baldwin had just read Taussig's diary, in which he documents the deliberate assassination of *viciosos* (people said to be drug addicts) or *delincuentes* (people said to be "murderous thugs") during the *limpieza*, or genocidal efforts of paramilitary operatives across Colombia's Cuaca Valley, particularly in the village of Cali from which Taussig worked.[3] In Baldwin's talk of "death lists," as in Taussig's diary, the murdered man is unnamed.[4] Although it sounded far-fetched, the idea that forces might be engaged in a "systematic assassination" of people deemed undesirable did not come out of thin air.[5] Baldwin was pulling this from somewhere, and her eerie discursive connection to Taussig's Cali haunted me. "What do you think this will do to the future of the city, in say, five years?" I pressed.

Baldwin paused for a moment, pondering. "In Detroit in five years, I see the same," she started. "I'll tell you why. Because five years ago, I was thinking the same thing. Like, what's Detroit going to be like in five years—will

I be ready to move back? When my daughter graduates next year from high school maybe? I don't think I'd move back. I don't think so," she concluded. She nodded slowly, as she continued. "Well, there are some changes I've seen around real estate.... Yes, there are, from what I've been told, five to ten fires a week in the area around Mt. Elliott and Grand Boulevard." I was familiar with the area; it was near McDougall-Hunt, perhaps a mile away or less. Baldwin continued, "From what I've been told, the developers, real estate speculators, are setting these fires. Have you heard about that?"

Again, I wrestled with ideas of deliberate, political-economically motivated violence. Was this Detroit or was it Cali, Colombia? "I haven't heard that hypothesis, but there are certainly a lot of fires in the area," I replied.

"So, people think the fires are being started by developers who want the land, who are sending people out to burn these places down, flatten the land, and then the city will in turn sell the property or land to these investors at a discounted rate, and then they will start to develop," Baldwin explained. "This was on *The Mildred Gaddis Show* Sunday morning. I was listening to it. There's a new reporter from the *Free Press* who was on the show. And he and Mildred Gaddis and another guy were talking about it. It's like, it's all planned. It's just—I don't know. Do you live in the city?" Baldwin turned the tables and asked me a question. I love it when people do that to ethnographers.

"I do," I replied. "I live on the east side, in a commercial district in the McDougall-Hunt neighborhood. I live in a studio that used to be a bank, and I have converted it into a studio and a loft. So, we're in the industrial corridor."

Baldwin nodded, quickly asking, "Across from the police precinct?"[6]

I was stunned by her immediate recall.

"Exactly," I said. "You know the city really well. They have finally taken the police precinct down. It was sitting there for ten years, empty. It came down last year, finally. That's a big upgrade from what it was. When we got over there, it was still sitting there vacant. We did a community garden there for two years," I said.

"Oh really? Is the garden still there?" Baldwin asked.

"No, I didn't do the garden this past year, because of the demolition over the summer. But I was so glad the station was taken down, because it was ten thousand square feet of open abandonment. My goal with the garden, in part, was to bring attention to the building and get it taken down, and it worked." My voice trails off on the recording, dazed as I realized Baldwin had taken over the role of the ethnographer, interviewing me.

"Well, that's good," Baldwin said. "What else do you want to know? I have to get back on the road," she said, glancing at her watch. I realized she had been standing there with me for over half an hour. I was grateful for every second of it. "You have given me so much to think about," I replied. "I just can't thank you enough."

My conversation with Baldwin at *Vol. 2, No. 3* was a critical point in the project. A thoughtful, middle-class, blue-collar, African American woman, she shared an entirely different view of the city than I had heard before. She was attuned to violence coursing through the city's urban process—economic turned physical—and her attention to violence was magnified by her desire to speak with me off camera. Hanging out with Baldwin, I started to note a pattern. Women-identified people were particularly knowledgeable about the city but were less likely to agree to appear on camera. Also, Baldwin's attention to forms of violence, and her refusal to discuss this on film, once again spun me back to Taussig's Cali. After paras killed two people that Taussig had known of, he went to speak with a friend who, he writes, "says she can't really say anything, it's too difficult. There is a barrier we cannot, dare not, must not cross."[7] Taussig's friend was a woman as well. I wondered if there was something ethnographic in the idea that "it's too difficult" to speak. Baldwin trusted me to speak off camera, but the way that her classed, gendered, racialized, and bus driver–informed political-economic understandings of the city landed, it was in fact too difficult to be on camera. Still, we were able to speak. Taussig writes that in spite of the difficulty in speaking of and listening to stories of economic and physical violence, "I will. I must. I have to."[8] Performance as prompt, or the dancerly prompt, was this *will*, this *must*, and this *have to*.

I spun a surreal frame in order to break through the social barriers that might prevent interactions with strangers on the streets. I sought a space that was abstract and open, so I needed sidewalks and streets. But standing around soliciting people for interviews wouldn't do. I added to Taussig's will, must, and have to another dimension of the same words. I had to bring something rather than simply extract. I would shift the scene while documenting it. And I must contribute something to a dialogue on cities—a critique that stands on its own and resists pedantic, bossy argumentation. A critique that lands on you by virtue of its flawed existence.

There was no doubt that my method had flaws—women did not want to be on camera to the extent men did, and I was documenting that by their absence. But my conversation with Baldwin demonstrated the dialogue that was yet possible, the barriers that could be challenged. I also realized, after

that deep discussion with Baldwin, that it was time to get ethnographically closer to a site. This meant that I would move back to McDougall-Hunt and work exclusively at the liquor stores there, and in the neighborhood, for the duration of the project. Ironically, it was the glimpses of intimacy that Baldwin shared at University Liquor on the edges of Wayne State's campus in Midtown that made me realize this.

The CAMERA PULLS BACK to a MEDIUM SHOT inside University Liquor. Stowall, Schumack, and I are dressed in dark clothing, holding space in the middle of the potato chip and snacks aisle. We move through a sequence. Sneakers lift, jeans adjust to an arabesque. Energy coils, we spin, and turn in unison. A quick jump, land, and then we start writhing. We're pulling the energy of the store into us and shaking it out, amplifying what's there and somehow, like photosynthesis, transforming it. We don't have to walk, we don't have to talk, we don't even need to dance. We can terraform the liquor store. We shake together, terraforming the liquor store. The walls evaporate around us and the city FADES TO WHITE.

Liquor Store Theatre, Vol. 3, No. 3 (2016)

FADE IN FROM WHITE:

EXT. SUNSET LIQUOR—(DAY)—WIDE-ANGLE SHOT—A luxurious blue sky and a busy Gratiot Avenue loom behind and alongside Sunset Liquor. The hand-painted storefront has seen better days, and the city-seasoned people walking around don't seem to be well heeled. It's early summer, breezy, and quiet. Birds chirp as traffic whirs by, spinning surreal urban nature sounds into the air.

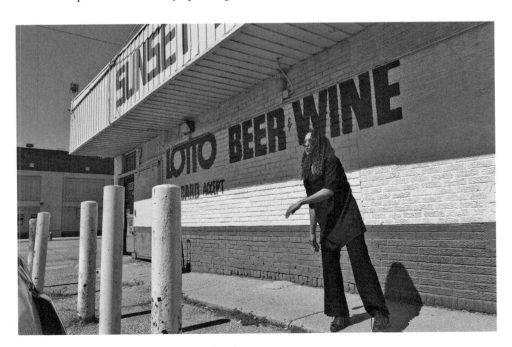

7.1 *Liquor Store Theatre, Vol. 3, No. 3* (2016).

Greg Winters didn't care for Sunset Liquor. In the five years that I followed him around the neighborhood, he never went there, and every time I'd film there, he'd avoid me like a virus. Sunset Liquor has a strange, lonely feeling. Winters once said to me, "I don't go to that store. Don't like it," and I can't blame Winters for staying away. Ironically, Sunset Liquor would have been the closest in terms of walking distance of all the stores in the neighborhood. The CAMERA PULLS BACK, and I'm alone. I'm wearing all black, dark sunglasses, a tunic over loose-fitting pants. I slide along the storefront, rubbing right up to the letters SUNSET LIQUOR behind me.

The music Todd Stovall has composed is haunting and tormented, and that's how I feel. Music has been a continuous source of cultural resistance, creation, and power in this city. Todd Stovall's music is part of that genealogy. In a discussion of music alone, Detroit's contributions to contemporary culture through African American cultural traditions and aesthetics are nothing less than monumental. From Barry Gordy's Motown, to John Lee Hooker's blues, to the MC5 and a Band Called Death's punk rock, to Queen of Soul Aretha Franklin paving the way for an entire generation of singers, to Kevin Saunderson, Derrick May, Juan Atkins, and Norm Talley's Detroit Techno, to the electronica hip-hop beats of the producer J. Dilla, whose music compositions would consolidate all of the above, to the electronic music compositions of the producer Todd Stovall, who composes the LST music— Detroit never let up; never stopped producing cultural genius.[1] Here, I discuss Detroit's music briefly, but multidisciplinary lists could be equally extensive across arts and culture broadly. And yet, in spite of the significant contributions African American Detroiters continue to offer the world, the political-economic foundation of the city was eroding on the weakness of its own racist foundation and rationale.

To my right I can see open drug trafficking. To my left traffic blows by. There's violence in the air, and I can't deny it. I spin a little world around me, insisting on a surreal scene, extending my arms and legs in an ethnographic call to action. I can't deny the hurt of the scene, and I can't pretend that this store doesn't consolidate layers of political-economic-historical failures. Failures to provide basic human services, failures to smooth development across a city, and failures to demand that businesses follow some sort of standards for the activities that may be going on around them.

The store manager was not a bad man; he was trying to earn a living like everyone else in the neighborhood. Like the drug dealers on the block,

the store manager was working to feed his family. As I performed slow dével-oppes across the façade, I felt the neighborhood pushing into me. In this, the third year of the project, the ethnographic work shifted. My focus shifted from what Jackson would call deliberately thin ethnographic encounters to what I shall call simmering ethnographic choreography.[2] It was in the third year of the project, in *Vol. 3*, that I had built enough rapport with some of my sidewalk encounter informants to follow them back into the neighborhood and into their lives after the camera lenses clicked shut. This is what I think of as the *Vol. 3* shift. The *Vol. 3* shift, notably, came after several videos I decided not to publicly present: the videos included in the series are not the totality of the videos I made. As a result, *Vol. 3* begins with *No. 3*. As I performed in front of Sunset Liquor in *Vol. 3, No. 3*, I thought of Greg Winters, who had become increasingly helpful in teaching me about the neighborhood and the logic of the everyday.[3]

While on paper Winters would have been listed as unemployed, he worked more than forty hours each week, easily. While Winters was usu-ally dressed in worn work boots, jeans, and work-weathered jackets or sweat-ers, his family owned a significant amount of property, and I lived down the street. At the same time, Winters could stand, at his own telling, fewer drinks and a few more plates of food, on some days. And who among us doesn't have a demon we keep at bay? I know I have a few. Regardless of his claim that he drank too much at times, Winters was ever devoted and pro-fessional. He was kind, reliable, and always moving, regardless of what he had or hadn't consumed that day. He showed up.

He worked and kept it moving in the zone, day in and day out. When-ever I looked up, Winters was maintaining his family's property, walking the neighborhood and checking in with neighbors, from factory workers to artists to people in underground economies; mowing, repairing, and weed whack-ing; chatting everyone up, and, increasingly toward the end of my fieldwork, stopping by the studio-loft to make things and talk about the neighborhood. I could almost see some of Winters's properties from Sunset Liquor, and I thought about him as I performed alone that day, as an incredibly slow trickle of people passed by, most unbothered and unimpressed by the choreographic sequences I repeated. Sunset Liquor was one of the locations where it was ex-cruciatingly difficult to get people to talk with me. CAMERA TWO JUMP CUTS to a MEDIUM SHOT of a young man quickly walking by—but he's not on CAMERA ONE, and you won't see him in the *Vol. 3, No. 3* video at all. The man's name is Blue, and he agreed to speak with me off camera, audio recorded only, like Baldwin in the video before him. This is gang territory, and it's controlled by the Crips.

The Crips wear blue. Everyone who spoke with me at this store told me their name is Blue. Generally, the fake names (pseudonyms, anthropologists like to say) I use in order to disguise people's identities are made up by me or by the informant I worked with (I also from time to time blur or shift details of people's lives, in a way that won't disrupt ethnographic jist, in order to protect confidentiality of identities). In this case, I used the fake names that people gave me, because I spoke with two people who each said their name was Blue. My mind was reeling—are they bullshitting me, playing with my naïveté? I don't think I'm that important—my best guess is that it's a practice used by people having affiliations in an effort to anonymize themselves in a way that blurs everyone so thoroughly, it actually riffs on the notion of individualized fake names. A collective fake name.

CUT to a shot of Gratiot Avenue as traffic whirs by. You feel woozy watching it when you're standing still on the sidewalk. Imagine eight lanes with no median, blurring by at fifty to sixty miles per hour, where the land is flat, the postindustrial buildings seem to be flattened like books on a bookshelf; all you see is sky above you and cars opening up alongside. Blue is in his thirties, tall, and has what I shall call the McDougall-Hunt body—or one of them at least—somewhere in between runway model and mixed martial arts fighter. He looks a bit amused when I ask him to sign the consent form. He does; he writes *Blue* in all places and selects audio recordings only, and initials it. "Can you tell me about this neighborhood?" I ask.

"I don't like it. It's boring," he tosses.

Blue's cold open was one I hadn't heard before, and over the years that gets difficult. "What don't you like about it?" I was intrigued.

"Everything. There's nothing around here to do. What are you going to do but walk around? And to the corner store, and back to the house, and to the corner store, and back to the house. . . . This neighborhood is boring. That's why I'm on the west side a lot. See, on the west side you can do whatever . . ." Blue paused a moment. "You do what you want to do on the west side. You can walk around, go sit at a park. And, there are no parks around here. It's just boring here," Blue finished.

"Now, what name do you consider this neighborhood?" I was attuned to Blue's broad geographic descriptors—rather than a neighborhood-level distinction, he opted to discuss sides of the city in terms of his likes and dislikes.

Blue tossed quickly back, "This is the east side."

"What do folks call this neighborhood?" I pressed.

"We call it Death Valley, if you actually want to know," Blue volleyed.

Blue was knocking it down. I had never heard this term either. "Are you serious?" I asked, openly shocked. Living in the neighborhood for years before that, I had heard a lot of terms, but never Death Valley.

"There's nothing around here to do. Come around this motherfucker, there's nothing to do. Nothing. It's boring," Blue finished. He looked at me like what he was saying was brutally obvious. It was obvious that Blue's opinion of the neighborhood would not be budging. I shifted slightly, asking, "What do you think of Detroit as a whole?"

Blue scoffs at my question, twisting his beard a bit with his right hand. "The city can do better. They're working on it. That they are. So . . ."

Blue had me at hello—he was intriguing and his dire statements drew me in. Yet I wanted more than his sweeping cynicism. I tried to feel for specifics. "If you could revamp this area, what would you put in? What do you think is missing from this neighborhood?" I rummaged. There's a long pause in the audio recording here, and in the transcript, where I source the snippets of dialogue that get my heart pounding and my blood rushing, I have written, "Very Long Pause."

JUMP CUT to CAMERA TWO, which records the traffic whirring past it with a WIDE-ANGLE SHOT as Blue responds. You won't see Blue in *Vol. 3, No. 3*, but you'll hear his haunting voice. His voice will drive into you and run through your bloodstream, demanding you deal with the pain and the contradictions of his response. "Life," Blue said. "That's about it. Life. This whole neighborhood is just boring. It needs more life," he reflected.

"Ten years from now, do you think this area will be the same as what it is, or do you see any changes?" I was curious about how Blue's stark statements would frame the future. Blue shifted gears quickly.

"It won't be the same. Everybody's buying up property, so it won't be the same. They already got downtown together—they're coming down here next. It won't be the same." Blue peered down Gratiot Avenue, which offered a straight-up-no-chaser view of downtown Detroit's skyline on clear days. "The next stop is right here," he finished. A lightbulb flashed—Blue's notions of the neighborhood as distressed were far from static or fixed.

"On Detroit generally, what do you think people should know about Detroit that they don't know?"

Blue thought for a few ticks. "It's a nice little area. A nice little place. A nice little glove or corner mitten . . . so. There's a lot more to see than coming down here. People like going places, like Belle Isle Park, for instance."

Just as soon as Blue showed hope for the city, he pulled back to icy critique.

"This whole area is just dangerous, and boring," he repeated. "A car accident happened right there, right there, right there, right there." Blue gestured toward a fender bender clearing in the center lane. "People getting shot up there at Palms . . . the liquor store right there. Yeah. At night, that store is dangerous. Real dangerous. You might have somebody you run into with problems. . . . A nigga might see you . . . like, 'Oh, nigga, what's up?' Like, 'Bow, bitch, bow. . . . *See you*,'" Blue said, forming onomatopoeia percussion with his voice for the words "bow, bitch, bow." The "bow" sounded like a resonating gun pop. I got chills up my arms and while I thought Blue was exaggerating, his descriptions were no less disturbing. His descriptions were based on something.

"Starting around what time does it get like that?" I asked. I wanted to know more, but specific disputes were not my research focus. I was worried about learning too much. And yet I had to know more.

"Shit, anytime," Blue laughed. "Anytime they get ready to *go*. Anytime when you did something to somebody—and they see you—it's anytime. They might get you then, they might get you later, they might get you now. . . . There's no telling. That's why I want to leave here." Increasingly, it sounded like Blue was involved in the sort of dispute he was describing. And there we were, standing in front of Sunset Liquor together. It was inevitable and, more to the point, although none of my key informants was involved in this social structure, the presence of drugs, gangs, violence, and the anxiety, fear, and paranoia that lurk on their heels was inevitable.

"So, are you concerned about that?" I asked.

"Yeah," Blue said gingerly. His otherwise bold voice wavered. "That's why me and my son and my wife are getting the hell away from this neighborhood. I don't have time for it. I don't have time for it. I'm not trying to wind up in jail for four years," he continued. "Might end up doing life. No, I'm good. I can't even sit in there for an hour, so I can't do four years. It's not worth it. We have to find somewhere else to go."

I felt a numb whirling in the pit of my stomach. Blue glanced nervously around, and I realized the risk he might have been taking by agreeing to stop and talk with me there. Or, I thought, was he exaggerating, trying to impress (or shock) with the notion of risk, danger, and violence? The look of the scene made deliberate exaggeration seem untenable. The hardness of the scene demands I take Blue's words seriously.

"Thank you for taking the time. I appreciate you," I say. After Blue walks away, taking a dirt path alongside the storefront to a row of wooden

frame homes just beyond the store, the CAMERA PANS from Gratiot Avenue back to the silent storefront. I'm in front of the store, moving ultraslowly through a choreographic sequence as the haunting electronica unfurls, crackling through the portable sound system's weary speaker. As I move, I stare at the trees just beyond the store, in front of which the Winters family lives.

In fact, four generations of Greg Winters's family lived on the same block, in four side-by-side Cape Cod–style neatly maintained wooden frame homes spread out across a long city block. Three of the homes were tightly maintained; one was in a liminal yet stable stage of remodeling, with new windows and fresh, bright paint. The family matriarch and patriarch—Winters's parents—originally owned all four of the homes on the block as well as one of the commercial buildings across the street.

As I move, I imagine the spaces across from the Winters family's block of homes. In this space were several long, open, grassy fields. Each open field was the size of at least half a football field and covered with sturdy, city-dense grass in the summers. The Winters family reflected both upward and downward mobility, an example of the complicated linkages of kinship, money, urban process, opportunity, and place written about by anthropologist John Hartigan in Detroit and anthropologist Mary Patillo in Chicago.[4] In one of the houses, a daughter of the family matriarch lived with her husband, several grown children, and a grandchild, the great-grandchild of the family matriarch.

The husband would go to work extremely early every morning, still in the dark of night, around the same time Todd Stovall left for work back then. One of the grown grandchildren had recently completed an associate's degree. A great-grandchild was always freshly coiffed. In nice weather, the little girl would sprawl across the lawns or porches of the family home, playing with educational toys supervised carefully by her parents, her grandmother, or her great-grandmother in turn. I spent a lot of time hanging out with Greg Winters over the years, and it was in this moment of the *Vol. 3* shift that our relationship began to deepen in terms of the time we spent together and the discussions that we had. Between my own family's longtime presence in Detroit, going back generations on my mother's side, and the longtime presence of Winters and his family, the question emerges of nativist anthropology's relevance or value.

Anthropologist Delmos J. Jones wrote, "The native anthropologist should be one who looks at social phenomena from a point of view different from that of the traditional anthropologist. I feel that this point of view should be admittedly biased, in favor of the insider's own social group. Thus,

when I seek to 'set the record straight' about some of the things which have been written about black people, this is not only justified but necessary."[5]

Jones anticipates that cultural complexities and contradictions are potentially more apparent to an anthropologist who has additional years of context, experience, and ties to a group than someone who arrives on the scene brand new. While I agree with this as a potentiality, I write against determinism, and I'm convinced that careful, rigorous anthropological research is a project that every anthropologist must continuously pursue. This writing against determinism includes a critique of the notion of the native. Group membership (whether geographical, cultural, linguistic, religious, ethno-racial, gendered) doesn't necessarily include shared values, experiences, or interpretations.

To assume nativist essentialism on the part of the anthropologist is deleterious. Assumed-to-be-shared essentialities erode our attempts to complicate, analyze, and describe what it means to be human around the world. What is a native, anyway? Although I am from Detroit, and lived in the neighborhood where I did fieldwork, I didn't grow up in McDougall-Hunt. Would I still be a native? Perhaps I'm an insider of some kind, but maybe not. From a methods point of view, anthropology done by insiders must be contextualized and evaluated for the organization, execution, and findings of its research. Insider anthropology, which I find to be a more useful term than nativist anthropology, has the potential to produce new forms of knowledge. However, it shouldn't be assumed that any method or approach is inherently superior. Jones anticipated the possibilities for methodological and theoretical innovation that an insider anthropology might produce, writing, "This change in mood may disturb many people. But if anthropology is to survive it must respond to the changing social and technological realities of the present. It is well known that part of the process of colonization involves the distortion of social, cultural, and historical facts about a colonized people. The emergence of a native anthropology is part of an essential decolonization of anthropological knowledge and requires drastic changes in the recruitment and training of anthropologists."[6]

While the conversation around insider anthropology has been extensive and sufficiently fleshed out before, the heart of Jones's musings remains pumping—and urgent. That insider anthropology may offer new ways of harnessing and responding to social and technological change, and the notion that such work might be productive toward finding ways of working more equitably—new ways of producing knowledge—is more compelling and inclusive than a hard-boiled notion of native anthropology.

Jones's writing seems to anticipate this project, where technology, sociality, and ways of creating knowledge are pressed forward in theory and method. Greg Winters challenged assumptions of hegemonic, cohesive neighborhoods (often glossed as communities) and also challenged an assumption that I could be read as an insider anthropologist in this context. Ultimately, I think this set of tensions is broadly applicable to anthropologist and participant relationships. One consideration that marks an anthropologist as an outsider, regardless of national origin, culture, or other identification tensions, is the status of the anthropologist as an academic with a PhD.

The fact that I had a PhD was interesting to Winters, and he became more curious about the esoteric requirements and rituals of the academic world over time. He realized that his status as my key informant was critical to all of this. Regardless of my Detroit lineage and the street-level capital associated with all of that, the PhD is of course an entirely different set of capital. To argue that completing a PhD in anthropology, in this particular way, does not produce a fundamental shift in relationships with places that we deem to be home seems naive. Winters began to do his own ethnographic research on me and on the academic world, it seemed.

As we worked together more, Winters became more and more involved in my work as an artist and scholar, while I became more and more involved in his work maintaining and securing the neighborhood. "I want to go back to school for a heating and cooling certification," Winters would often mention as we stood in front of my studio-loft, walked around the neighborhood, or, recently, hung out collecting glass shards from the curbs and sidewalks as we prepared to develop an art installation, *Untitled A*, that appeared in the *Fictions* exhibition at the Studio Museum in Harlem. "But I'll keep it moving, either way. I was a long-haul truck driver for a while, but I like maintaining the neighborhood now, so I like to be around here. With a heating and cooling certificate, I could do my business around here, and still keep it moving on the block," Winters told me on a steamy September afternoon as we were riding the QLine downtown to attend a meeting.[7] I was intrigued that Winters was interested in following my life in his own systematic way—as I had been following his over the years.

We started going to my art openings together with Todd Stovall. Winters viewed a first cut of a commissioned piece along with Cranbrook Art Museum curator Laura Mott at my studio-loft. But make no mistake: all of this wasn't about me. It was about Winters and his assertion of a mutual curiosity. After years of scaffolding our relationship from acquaintances in the

neighborhood, to neighbors, to ethnographer at arm's length, to, finally, central ethnographic star and ethnographer, it was as though Winters himself had become an ethnographer in the process.

Winters was using the ethnographic methods I deployed to learn about the neighborhood to learn about me. I shall offer that Winters asserted his subjectivity and complexity in a particular way through his own morphing into an ethnographer of the ethnographer. Rather than a fixation with me, Winters was taking what he was observing and gleaning about anthropology as a discipline and ethnography as method and practice, to turn the tables and try it out on me. Equally fascinating, Winters became more vocal about the presence of art in the neighborhood, and he began to express his interest in contributing, in a dramaturge or studio assistant sort of way, to the works I was making. He was not simply providing information to me—he was learning, transforming, and redeploying the information I was providing him. Winters viewed my work as an artist and ethnographer in relation to his own life in the zone, and used his positionality to me to shift his own positionality.

As he peppered me with questions about the book, art exhibitions, academic happenings, and the like, Winters would increasingly stud the conversation with his own ideas for his own next steps. Anytime he did this, I would get excited and try to get Winters to speak more about his plans and to encourage him to pursue concrete steps toward the certification. Ever a private person in spite of his willingness to help me with my fieldwork as key informant, and his dialogic relationship with me via ethnography, Winters wouldn't reveal too much. When I started speaking with Winters about his efforts to keep the zone clean and safe, I quickly started to feel like a curator talking to an artist about their practice.

"You do a little bit each day," Winters told me. "You work to put your whole self into it, your very best, and it turns out to be—decent." Winters had a dry sense of humor and tended to avoid platitudes. His description of the work he did to keep the neighborhood sounded like writing, making, and doing research—it was an ongoing practice, project, and process. "You keep it moving," he seemed to say every time we spoke. Keeping the long blocks against Mack and Gratiot Avenue clear of trash, debris, weeds, snow, and ice in the winter, and the Detroit grit that seemed to collect on the curbs and alongside them, was Winters's everyday mission. He was relentless. It was the essence of a practice—he did it religiously, with devotion, and without regard for anyone who might have thought his work a waste of time. People's relentlessness in the neighborhood was expressed in a number of ways.

The CAMERA PULLS BACK and we're in front of Sunset Liquor again. Crystalline sun rays bounce off my shades. I spin and turn as a man walks by, cool as ice. He's unaffected by my movements as he enters the store. When he comes out, he pauses and views the final ticks of a sequence. I stop, and he asks, "What are you doing?" I tell him. Then, "Can I talk to you about the city?" The information sheet and informed consent fly out of my notebook. He agrees but tells me he no longer lives in the neighborhood. I assure him that's fine—I'm interested in talking to anyone in the space and the place at this moment in time. While people tend to be residents of the neighborhood, I do talk to people who are not. The man's name, he tells me, and scrawls like a physician on the consent form, is Blue. Yes, you read that correctly—this is a different man at the same store on the same day, with the same name as the other man I spoke with earlier.

I clip the sound condenser to Blue's collar and set the shot. "Tell me a little bit about this neighborhood, just from what your impressions are," I start.

"Well, I just come over here to visit," Blue volleyed. "Mostly, the houses over here are run-down and need to be torn down. And the city needs to come over here and cut the grass every now and then. Drugs are everywhere," he mused.

"Drugs?"

"Yeah. Everywhere." A beat. Perfectly matter-of-fact. Then, "So, I just come over here to visit." Blue glanced around as though to see if anyone was in earshot of his comment about drugs. I was starting to feel like I was reading a page of Taussig's diary.[8] Drug and violence references aside, a more technical point—the way that Taussig uses first initial only as a way of further anonymizing informants—reminds me of the way that people use the name Blue today. Although the talk of drugs and violence leans toward Cali, Colombia, the drugs and the violence operate quite differently. In McDougall-Hunt, people who are not involved in the drug trade are generally left alone. There is a stable (although fraught) government and local police force. There are no paramilitary or guerilla forces in McDougall-Hunt. At present, the drug trade is incredibly fragmented and micro-concentrated in specific sites—which is why the following information Blue shared with me was a surprise.

"Now when you say drugs are everywhere here, what do you mean? What is going on?" I pressed.

"You got a lot of drug houses around here. People coming in from the suburbs, and they buy drugs over here. That's all I can say. I live in Shelby

Township, so I just come over here every now and then. So that's all I can tell you about this neighborhood."[9] Blue sounded like he felt he'd shared enough. His linguistic cues and his body language demanded that I leave the topic alone at that point. I didn't want to derail the interview.

I pivoted. "Can you tell me about Detroit as whole? What's going on right now?"

"Well, they're moving forward. And there's a lot of business coming back in the city. And you got Illich, and Gilbert, dealing with downtown, and some people are migrating back out here to the inner city. . . . That's about it," Blue reflected.

"Do you think in ten years the city will be fundamentally different than what it is now, or no?"

"Yeah. It's different now. It's already different than it was a couple years ago."

"What about this neighborhood? Will it change eventually, or no?"

"Yeah. Because they're working their way this way. So, I would say, in about ten years, everything will be back to normal like it was. You know," he said. "The owner of this liquor store, Ted, has been here longer than I have."

"I've heard that. How many years?" I asked.

"Thirty-five years or more," Blue gauged, nodding.

"That's a long time," I replied.

"Yeah, he's a good man," Blue answered.

"Thank you for your time," I said. "And thank you for your service," I said, noting his army veteran jacket. CAMERA ONE films the traffic flowing at the edge of our conversation. You won't see the second man named Blue in the *Vol. 3, No. 3* video, because he agreed to audio recordings only, like the first man named Blue. But in this case, you won't hear the second man named Blue in the video at all. You won't hear Blue talking about drugs in the video, because daylighting his contentious text in a video that would be seen around the world was untenable for me at the time I did the video edit.

The reason why was that I had a strong intuition that the second man named Blue was, in fact, there to buy drugs. I couldn't be sure. But my gut feeling demanded I not edit the second Blue into the cut. He was from the suburbs, visiting, and he was walking toward one of the houses that he said was a drug house, where people from the suburbs came to buy drugs. Maybe Blue was a visitor helping a friend or checking on a relative. Maybe he was simply having a beer. Maybe he was sober. Maybe he was buying drugs. I couldn't know.

As the second man named Blue walks toward the smattering of houses he told me were trap houses, the veteran emblems on his jacket and cap, embellished with black sequins and black rhinestones, catch the sunlight, and the city, sidewalks, funky urban cottages, and edge of the storefront disappear as we FADE TO WHITE.

Liquor Store Theatre, Vol. 3, No. 4 (2016)

FADE IN FROM WHITE:

EXT. PALMS LIQUOR—(DAY)—MEDIUM SHOT—A weathered, well-seasoned liquor store. Plastic palm trees still abound, but they're more distressed than we saw in the last video. Likewise, the sign proclaiming Palms Liquor at the edge of the parking lot is crumbling. Loose electrical wires and fading, peeling paint are dripping from the edges and the bottom of the sign. A cool fall feeling whirls through the scene, a reprieve from the recent hot, stifling days.

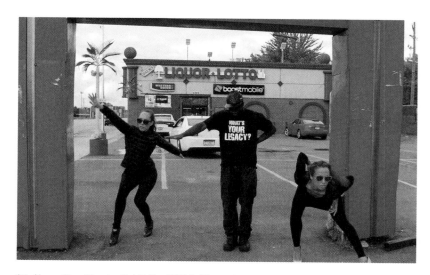

8.1 *Liquor Store Theatre, Vol. 3, No. 4* (2016). Pictured with Biba Bell and Mohamed Soumah.

Today is one of the magical days. There might be unicorns spinning through the skies or mauve-colored rose-scented magic dust whirling in the clouds. Today, on a shiny day whirling with the energy of early autumn, I gather a small cast and take to the streets. As we pull into the dust-covered paved parking lot, I glance at the two performers joining me that day, Biba Bell and Mohamed Soumah. Bell and Soumah know of one another through the art scene but have never performed together. They have something in common—a certain presence that shifts the energy of the scene. They are both incredibly athletic, creative performers. They are each so firmly wrapped in what we call an "it factor" that neither of them even need to move to be performing.

JUMP CUT to an ESTABLISHING SHOT. The storefront is framed with city life. People are ambling around. There is a steady stream of customers and cars, and the vivid sky shouts possibilities. Todd Stovall sets up the sound system and the video equipment, and Soumah, Bell, and I begin to move about the sidewalks and streets surrounding the stores. We occupy the space with our presence. On tough days and on magical ones, once we start moving, dancing, and shifting around the passersby and traffic, the sidewalk starts to slide away. The temperature changes.

There's a sense that people's minds shift in a strange way. Including my own. After two years of coming to terms with the gendered space of the liquor store, the inscribed cultural norms of patriarchy and power on the scene, and the writhing presence of racist/capitalist superstructure, I shifted toward a sense of meditation.[1] This was after the *Vol. 3* shift that happened in the previous episode. I had a feeling of understanding the stakes and working to analyze and describe them.

With Bell and Soumah, we cover the space with our movement sequences, the parking lot, sidewalks, streets, and even inside the store. JUMP CUT to a MEDIUM SHOT of the three of us, performing a choreographic sequence under the Palms Liquor sign at the intersection of Mt. Elliott and Gratiot. We move through the crisp air, our all-black attire braced against the red background. A woman in a car passing by films us on her cell phone as she rides by in the passenger's seat of an old Buick. A couple pauses, pulls over, and watches: What is happening here? The scene is set. The afternoon is transformed. The city is moving with us. The scene of *Vol. 3, No. 4* illustrates the potent role performance plays in ethnographic context and in urban anthropological research. Further, the scene of *Vol. 3, No. 4* shows how dance anthropology has infused this work, and how the work has transformed the limits and possibilities of dance anthropology.

Conquergood developed the coperformative witnessing concept I mentioned in the introduction through his analysis of the writings of philosopher and abolitionist Frederick Douglass.[2] Conquergood posits that researchers conduct "an ethnography of the ears and heart that reimagines participant-observation as coperformative witnessing," rooted in Douglass's call for plantation ethnography in the nineteenth century.[3] In making his claim for coperformative witnessing, Conquergood cites Douglass's challenge as rationale. Douglass writes, "If anyone wishes to be impressed with a sense of the soul-killing power of slavery, let him go to Colonel Lloyd's plantation, and, on allowance day, place himself in the deep pine woods, and there let him, in silence, thoughtfully analyze the sounds that shall pass through the chambers of his soul, and if he is not thus impressed, it will only be because 'there is no flesh in his obdurate heart.'"[4]

The potent qualities of Douglass's suggested approach provide theoretical and methodological supports to Conquergood's proposal that "the power dynamic of the research situation changes when the ethnographer moves from the gaze of the distanced and detached observer to the intimate involvement and engagement of co-activity or co-performance with historically situated, named, unique individuals."[5]

After the *Vol. 3* shift that spun me from the liquor store scene back into the neighborhood, the scene of *Vol. 3, No. 4* bracketed the possibilities suggested by Douglass and by Conquergood. The CAMERA PULLS BACK to a WIDE-ANGLE SHOT of the performers on the scene. Working with a structured improvisational score around the idea of a straight line, our bodies form tessellations, grids, and stick-straight pathways. Next, we shift to a unison choreography sequence, which we set together on the spot. After about half an hour, a small crowd begins to collect.

A group of people pull up in a late-model Chevy and record us on one of their smartphones. Vic Mahon, a tall, knife-thin man in his late teens, pulls up in a gray GMC SUV. He pauses and watches our choreographic sequences for a few moments before ducking into the store. Fifteen minutes or so later, Mahon appears on the sidewalk again and pauses to smoke a cigarette while he views a choreographic sequence that is winding down. Mahon leans on the edge of the storefront, taking a long pull on the smoke. As we finish and walk out of the view of CAMERA ONE, Mahon walks up to me.

"What's going on with this?" he asks.

After I explain that I'm talking with people about the city and making films about city life, Mahon offers, "I'll talk to you." This interaction with Mahon illustrates how dance as prompt represented a new turn for

a tried-and-true method. Ethnographers have used dance as both method and subject in getting to the core of cultural logic, traditions, and aesthetics. Dunham established what became the classical approach to dance anthropology participant observation in the 1930s.[6] Dunham's study of Haitian Vaudun prioritized, in addition to African diasporic religion, performance and movement, Dunham's status as a choreographer and performer integral in her emergence in the performance culture of Vaudun. During her initiation into Haitian Vaudun, Dunham theorizes dance as the essence of being human, writing, "We danced, not as people dance in the houngfor, with the stress of possession or the escapism of hypnosis or for catharsis, but as I imagine dance must have been executed when body and being were more united, when form and flow and personal ecstasy became an exaltation of [a] superior state of things, not necessarily a ritual to any one superior being."[7]

Dunham established a performance-centered approach to fieldwork, yet, importantly, her work reflects a critique of hierarchy and an interest in the deconstruction of classed, gendered, religion-based, racialized stratification. Dunham's model of practice theory through dance ethnography of a related cultural group informed the canon of anthropological research. Dunham's work did not reflect a heavily functionalist approach, where performance is read as metaphor for society writ large, but in oversimplified readings of Dunham's work, a functionalist approach is sometimes amplified. Not that a functionalist approach is inherently problematic. Anthropologist Sally Ann Ness's Cebu City, Philippines, fieldwork, for instance, analyzes in a relatively functionalist way the connections between dance and society across religion, social life, and cultural aesthetics.[8] Ness's effort to analyze Cebuano social life via Cebuano dance styles is a distinctive approach to dance anthropology, more classically functionalist than Dunham's abstracted approach. Ness writes of characteristics of Cebuano dance as proxy for cultural logic: "Highly duplicatable, quickened patterning was thus a mode of organizing social energy, both mental and physical, in time and in space. It was an especially salient feature of local life and a recognized element of Cebuano ethnic identity. In the *sinulog* performances, this phrasing style was perhaps the most powerful polysemic or multi-vocal sign evident in the performance process. It represented a calm but liquid energy state, animated only slightly by minor sources of disturbance."[9]

Anthropologist Deirdre Sklar's dance ethnographic research across Tortugas, New Mexico, develops the literature further and marks a dance anthropological turn from functionalist to interpretive.[10] Sklar follows a religious and cultural community group through its yearly three-day Virgin de

Guadalupe fiesta. Sklar's work locates dance and movement practices, from the everyday to the ceremonial, as central in contemplating Tortugas social life. Sklar writes of the fiesta's elaborate preparations, "Its choreography was like a postmodern dance score in which a set of tasks is repeated from one performance to the next. In Tortugas, these tasks could be enacted by any permutation and combination of the participants. The kitchen score included distinctions between men's and women's work, but these were neither permanent nor rigid. Washing dishes was men's work and chopping onions women's, but dishwashing was once women's work, and men sometimes helped chop the onions. Everyone knew the score well enough to improvise on it spontaneously."[11]

Like Ness, and like Dunham, Sklar analyzes a series of actions, or choreography, with an attention to the implications for social life and cultural logic. Sklar writes room for the unknown into her analysis, with the interest in improvisation and change over time. Beyond direct metaphor, Sklar begins to look for spaces of the inside, spaces of the unknown, and spaces of dialogue and dynamism. Performance theorist Barbara Browning develops this fraught space of the unknown. In Browning's dance anthropological study of Afro-Brazilian performance cultures, she follows artists of samba, capoeira, samba-reggae, and more subgenres in their performance lives and beyond. While Browning locates, names, and credits the African diasporic aesthetics, histories, and ethnographies that inform Brazilian dance cultures, Browning ultimately complicates Africanist aesthetics in the process:

> Locating what is "really" African in Brazilian culture is, as I have argued in the preceding chapters, not a simple project of mapping surface continuities. Much more interesting is the continuity of strategies for cultural survival. Of course, this argument is itself a tricky maneuver. It's what allows Bimba—and his student—to give two accounts of the sources of capoeira regional. Bimba "laughed at" the charges of foreign influences. He also "admitted" drawing on U.S. and Asian techniques. His student tells us not to take the statements (which ones?) literally, because they were strategic—and the strategy is recognizable to anyone who is familiar with the strategy of the game.[12]

Browning daylights her informants' different views and also her informants' awareness of the complexities of their own conceptions and descriptions of their own cultural positionings. Instead of dance as path to stratify, what about dance as path to complicate? Browning seems to ask. This fieldwork deploys dance in a fundamentally different way, in front of liquor stores,

but shares Browning's interest in complicating understandings rather than reducing them. Cultural theorist and ethnographer Marlon M. Bailey presses the method further. In Bailey's ethnography of ballroom culture in Detroit, Bailey conducts a participant-observation investigation of LGBTQ people who organize themselves into what are known as houses.[13]

In the houses, performers engage in alternative kinship arrangements. Both artistic and familial links are created as house members take part in what are known as balls. At the balls, house members compete in dance competitions, style or fashion competitions, and the ubiquitous voguing competitions. Bailey's ethnography both incorporates and critiques a functionalist analysis of performance cultures. On the kinship structure of a particular house in Detroit, Bailey writes of his informant Noir's perspective, "Noir identifies a common problem when some house parents use their prominence and power in the scene to lure new and less-established members to their house for sex. Yet, Ariel and Pokka placed a partial injunction against 'incest' among siblings, a prohibition that undergirds a heteronormative family. But there is no biological basis of the kin relations in the house; therefore, there is no real incest involved. Thus, while Ballroom members engage in a radical revision of the heteronormative bio-family in some ways, its members simultaneously reinscribe and uphold that very heteronormativity in other ways."[14]

Bailey's performance ethnography of an LGBTQ cultural group represents a critical transgression in dance anthropological research. Religion and performance were often linked in canonical dance anthropological research. This connection with religion, whether Vaudun in Dunham's fieldwork or Catholicism in Sklar's work, provides an intuitive structural, hierarchical, normative stratification that acts as a current in the fieldwork. Bailey's performance ethnography, conversely, pressed the limits of structure, hierarchy, and belonging by centering a group that exists outside of a single religious text or governing body.

Bailey writes that LGBTQ performance cultures allow for a particular "visual epistemology" that "consists of a combination of the performance of race, gender, and sexuality and the interpretations and revisions that members of the Ballroom community deploy."[15] In other words, house members perform with attention to their own interiority and with a sense of subjective strategy. With this subtle shift, we build on an analysis in which the anthropologist conducts movement analysis to attempt to distill a cultural group. Rather, the "visual epistemology" that house members perform and deploy is read and centered by the ethnographer. Some of the reading that is done

highlights the fact that we cannot know exactly what people are thinking and doing at a moment of performance.

Like Bailey, anthropologist Judith Lynne Hanna deploys performance ethnography in a set of gendered, sexed, and sexualized spaces. Hanna's dance anthropological research of exotic dance clubs across the United States offers an intimate view of clubs, exotic dance performers, and various legal, religious, and urban ecological questions that flow from the controversies around the clubs. Like Bailey, Hanna's approach inherently critiques the connection of religion to dance anthropology. However, in contrast to Bailey's fieldwork in which religion is largely abstracted, religion is a constant force in Hanna's ethnographic landscape:

> Strongly erotophobic outside the marital bed, Christian Right (CR) Activists orchestrate attacks on the "poisonous" exotic dance, especially what they call "petting zoos," "sexual assault parlors," and "rape cubicles." They try to suppress nearly all information and entertainment about "sex" apart from marital sex education through the church. Ironically, at the same time the CR as a whole argues for less government, CR-Activists push for expanding state control over sex and sexuality. Yet, a number of exotic dancers have told me they saw the very same man fighting exotic dance in the name of religion in one community ogling their dancing in another.[16]

Where dance anthropological research historically inhabits a landscape where dance cultures reinforce religious hegemony, Hanna's and Bailey's research interventions complicate the genealogy. Bailey's fieldwork documents a site in which belonging, community, and expressions of subjectivity exist beyond heteronormative, hegemonic sites like the church. Hanna's fieldwork documents ideological confrontation between Christian Right activists and the exotic dance scene. Hanna's work, in some ways, posits the structural planes of religion as threatened by the presence of the post-structural planes of exotic dance. Where the connections and sutures and fissures between these forces are blurrier in Bailey's fieldwork, in Hanna's we see a structural opposition that's untenable.

However, as the passage above indicates, there is ethnographic evidence to support that the chasm may not be as far in reality as it is in ideological fictions. While Hanna's and Bailey's approaches critique dance anthropological research as a necessarily tame, docile, functionalist method, both approaches land in the traditional application of performance ethnography, or the narrower canon of dance anthropological research, in the analysis of a particular,

formal performance culture. The fieldwork in this book, on the streets and sidewalks of Detroit, takes a departure here.

I have taken a U-turn from performance ethnography of formal performance culture. I have placed performance as prompt on view for my would-be informants, at the same time documenting it, for the purposes of both complicating what performance is and how it can land, and what it can mean as ethnographic prompt. I have taken conceptual art as a simultaneous practice—transgressing the limits of making in the doing of the fieldwork itself. I was making a body of work while conducting fieldwork. This, I shall argue, is not unlike writing a book about one's fieldwork.

Bailey's notion of visual epistemology is critical to understanding how this approach is conceived. The visual epistemology that is produced in the video series happens over the course of years across the video project, as a complicated tapestry of people, landscape, city, form, music, words, sky, thoughts unfolds. Performance as medium—as conceptual art medium, as ethnographic prompt, as mode of thinking and discussion—figures centrally. At *Vol. 3, No. 4*, performance as prompt's potency bubbles to the surface of the street as Vic Mahon speaks.

JUMP CUT to the corner of Palms Liquor, where the sidewalk meets the edge of the storefront. Vic Mahon's neck is covered in tattoos, and he's wearing a hoodie over low-slung khakis. The hoodie sleeves are pushed up, revealing full tattoo sleeves on each arm from wrists to triceps. You won't see this particular scene in the video series, as the topics Mahon discussed were too personal to be published along with his image. As the traffic streams by, Mahon responds to my question of what's going on in the neighborhood. "What I really want to talk about—I applied for a Bridge Card. I'm nineteen years old. And I recently was working, but I stopped working. I was working through a temp agency." He paused a moment, then continued.

And recently a lady came to my house—well, my mailing address—I don't stay there. It's my brother's house, and she asked me, "Where do you stay?" And, you know, I do my thing. I house-hop. I'll spend the night over at this female's house, or my homeboy's house, you know. . . . I just be doing my thing. . . . So, I don't really have a stable home, you know, that I can call my own. . . . So, she came up and told me I'm lying about the whole situation about my application. She's talking about, she's going to press charges and put a warrant out for my arrest, and I'm like, it's this serious about a Bridge Card. . . . I'm like, I'm nineteen years old, and I need your help! I need the government's help.

I listened, processing the cruelty that a government agency would investigate a housing-insecure nineteen-year-old receiving a meager amount of food benefits.

Mahon continued, "Like, y'all are feeding me every month. It's not like I'm lying on the application. And she came, and she pulled up on me, and she was so mean and aggressive, like, baby—it's not that serious!" He shook his head. "She made me withdraw the application and they took the Bridge Card back and everything! Yeah. I'm like, y'all are out here. . . . They were investigating me. They were watching my brother's house for like four days. Because I pulled up, in the morning one day, you know, after I dropped my homegirl off at work. And I pulled up over my brother's house. I go over there a lot. That's how come I was there. I use my mailing address as his place," Mahon explained.

Then, Mahon continued, "When I pulled up over there, I saw some people across the street, and they started taking pictures of me and everything! There were two people in the car and they were taking pictures of me." He laughed incredulously. "And later that day, that's when the lady came knocking on the door, and she was like, we got videos and pictures of you coming in and out of this house. She was trying to say that I had a house and couldn't get benefits. And I tried to explain to her, like, this is my brother's house. And if you look it up, my great-grandmother owns this house. So, this is the family's house. So, even though I don't have my own stable home, like, I can always come here. . . . And for you to sit here and tell me I lied on my application just because you see me coming in and out of this house, I just didn't appreciate that." Mahon shrugged and took a drag on his cigarette.

"That's incredible," I said. "No wonder you wanted to talk about it."

"It's crazy!" Mahon replied. He extinguished his cigarette on the concrete. "They only approved me for like $150 in food a month. And it hadn't even been a month. And I'm like, man, what, you want me to pay the money back? All that for $150?"

"So, they spent all that time?" I couldn't seem to formulate a coherent question. The absurdity was mounting.

"Investigating me!" Mahon finished the question with the answer. "I'm like, don't y'all have better things to do? I'm nineteen years old, and I'm not selling drugs or doing anything wrong. . . . She asked me a thousand questions and tried to catch me up like I was lying. I feel like they need to take their time and go worry about something else. I'm like, y'all investigating me over a Bridge Card!" he concluded.

"So, what ended up happening?" I asked.

"They left it alone," Mahon replied. "They sent me a letter in the mail to my brother's house the other day, like, 'Your benefits have been canceled.' I'm like, I only been on for two weeks! And they canceled it. And that's about it. But I don't care though. But I do want it! Like, I want my Bridge Card! I needed that."

I struggled to be impartial given the ridiculous injustice of the facts. "That's just wrong!" I agreed. "That's supposed to be a safety net if people lose their job like you did! I completely agree with you. No safety net for someone who is nineteen years old, doesn't have a stable place to live, and needs some help to eat?"

Mahon nodded. "Then, she said they just changed the rules. You have to be twenty-two or something, not to mention your mama. I'm like, 'Sweetie, I been taking care of myself since I was sixteen years old.' Me and my mama, we're not on bad terms or anything, but as far as taking care of me? Everything I got, I buy myself, you feel me?"

I nodded. Mahon continued, "So, I feel like it's no point in mentioning my mama's name on there. And the money she makes, that has nothing to do with me. She got her own bills. I got a little brother who's younger than me. Like, I been taking care of myself and been working since I was sixteen. And now that I'm nineteen and I need a little help, y'all sit here and say I'm lying. I feel like Detroit was doing too much, that's all."

"Yes . . . I agree," I said. "Now what do you think about this neighborhood—do you know anything about it?" I was concerned about discussing Mahon's personal details for the entire interview. I knew the discussion of his Bridge Card would not be in the edited video; I was hoping to get to some discussion that wouldn't compromise his privacy.

"Yeah," he said. "So, this is my hood right here, Mack and Mt. Elliott. I grew up here. But, the neighborhood, it's up and coming I guess. It's so-so. There isn't really much over here. Nothing positive. Recently they just opened up a little facility for the younger kids, right here on Vernor and Mt. Elliott, and I think that's a positive thing. . . . But other than that, there isn't really too much going on around here," Mahon answered. I was struck by the gentrification-speak phrase Mahon used, "up and coming."

"What do you mean by up and coming?"

"I mean, I see them trying to improve stuff, like, recently they've been knocking down all the abandoned houses in the neighborhood, and I think that's a good thing, like they've been coming and cutting the grass in the neighborhood, and I feel like that's a positive thing," Mahon replied.

"What do you think about what's going on in the city? Downtown and stuff?" I asked.

"One thing I know . . . I don't know too much about the streetcar on Woodward. I want to know more about it, because when I drive down there, it's in the way to me. And I had a couple other people say they feel it's in the way, because it's right in the middle, and then there are car lanes on both sides, and I want to know the big plan of how it's going to work out in the end," Mahon continued.[17] "There's a lot of art around here. Some of the art—I love art—I love seeing pretty things and everything. But some of the art they do in some of these neighborhoods doesn't look like nothing." I drew in my breath, knowing where he might be going with this. "And I really don't know why it draws all these people from out of town to even come look at it. Because, see, they are not from here. So, when they come, they're looking at it in a fascinated way." Mahon was elaborating a classical insider-versus-outsider analysis. I stayed quiet as he continued.

"But I look at it, like, if that junk was in *your* neighborhood, you wouldn't want it in your neighborhood. You're walking down the block, and it's an abandoned house with lots of teddy bears on it. Like, how is that art? I guess it's art as long as it's not in your neighborhood, where you have to live!" He paused.

"The area that was down there," Mahon said, pointing toward the Heidelberg Project. "And then, the bears are all dirty, and dusty, and dingy, you know. It's not art to me. And I can't believe people want to come and take pictures of it. Like, knock all that junk down. It's not art. You go to LA or something, go to their downtown, and it's really pretty and really nice. And it has real art statues. Like, the art over there," Mahon said, gesturing toward the Heidelberg Project, "it looks like it all came out the dumpster." His face softened a bit.

"I have to be honest," he continued. "Because some of it, like, for instance, the boots. Y'all got a whole bunch of old boots. And y'all putting a whole bunch of raggedy boots together and trying to make it art. Like, it doesn't look good. It looks raggedy and cheap. I have to look at it every day." Over the years, the neighborhood insider critique Mahon expressed was repeated by different people.

Mahon's critique, and the irrational reverence he felt outsiders had for the project, were reflective of the paradox of place analytic. It was indeed a paradox that the people who appreciated the Heidelberg Project the most seemed to live the furthest from it. However, this wasn't true across the board. I was a supporter of the project, and I appreciate its DIY aesthetic more than

Mahon seemed to. But I didn't grow up in McDougall-Hunt. Still, I knew of people who had lived in the neighborhood for decades and were Heidelberg Project enthusiasts. It wasn't a binary association, but there was something paradoxical in the way the project landed.

"You mentioned something really interesting," I said. "The people from out of town coming to see the art. Why are those people fascinated with this . . . with what you call junk?"

"Because it doesn't look like that over there, where they're from," he tossed easily. "So, this is something new to them." He gestured around the storefront and to Gratiot Avenue behind him. "Like, I know people back in the day, when Detroit had a really bad . . . you know, people heard bad things about Detroit. To me it's not that bad. You come here. There's crime everywhere. Everywhere. If you've been around here, you're kind of used to it. But I really don't know why they like coming to see that junk. I really don't. I guess it's something new to them, because they don't have to see it every day," he finished.

He gestured again toward the space of the liquor store parking lot. It was as though performance as prompt had seeped into Mahon's interest in describing the staging, as it were, of the parking lot. The discussion demonstrates dance's transgression of the boundaries of dance anthropological research.

I was deploying performance to study a city and a neighborhood, and the role that dance played here was central. It situated our conversation as outside of the structure and the hierarchical society that Mahon described. "Just because we're all lingering outside the store doesn't mean there's anything terrible. Like, we're all really just chilling!" He smiled. "This is our neighborhood. We're just chilling. We're saying what's up, before we pull off. And to somebody that isn't from here, or they're from the suburbs, and they ride past, and they see all these people outside, sagging their pants and stuff, and they're like, oh that's a rowdy store! Like, naw, baby it's not even that serious, like, you know," he chuckled.

"That's a good point," I said. "So, like, when one person pulls up, then another person pulls up to say hi, then . . ."

Mahon nodded. "There are lot of us around here. . . . Like, everybody knows everybody. And especially if you're in the same neighborhood as the people who grew up here. I'll pull up, and I might have three cars behind me. Then my homeboys from down the street might be pulling up. Then, it's six or seven cars out here and twenty people! It just looks bad!" Mahon shook his head. "People might be like, 'Oh, I don't want to stop there, like, oh I

might get robbed!' Or, 'Oh they might shoot me!' Like, 'Naw, baby, we all out here getting money our own ways.' No crime. But people just have to stop looking at certain situations and just thinking the worst," he mused. Mahon stood there in his low-slung jeans, looking vulnerable and thoughtful with his nineteen-year-old smile. I nodded and smiled back, just being there in that moment with Mahon as the storefront slid away. My camera lens clicks shut and the city FADES TO WHITE.

Liquor Store Theatre, Vol. 3, No. 5 (2016)

FADE IN FROM WHITE:

EXT. MANNONE'S LIQUOR—(DAY)—ESTABLISHING SHOT on an unseasonably warm autumn afternoon in front of Mannone's. The store has seen better days. The green-and-white-painted storefront is snow-whipped, and the hand-painted signs are so heavily rain-faded and chipped that they're nearly illegible. Barbed wire festoons the top of the store. The flow of customers is so slow that it scarcely appears the store is open.

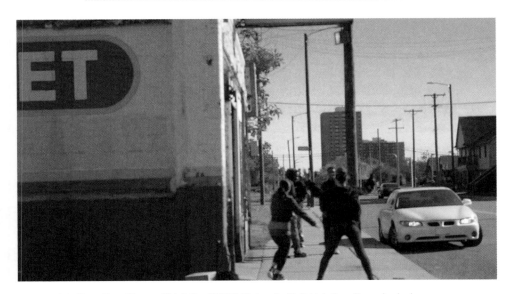

9.1 *Liquor Store Theatre, Vol. 3, No. 5* (2016). Pictured with Fabiola Torralba and onlookers.

In contemporary Detroit, the struggle for the city was on people's minds. As I struggled for medium in contemporary art practice and struggled for method in approach to urban anthropological research, the question of what it was that people worked through in urban social life surged and writhed in the neighborhood around me. JUMP CUT to Fabiola Torralba, a collaborating performer for the day, and myself, in front of Mannone's. The sun bathes the frame. In spite of the hardscrabble surroundings, the sky resonates with plush clouds, and afternoon sunbeams dance across the sidewalk. We move through choreographic sequences we set together on the spot. The sequence combines balletic, hip-hop, and voguing movement references. We're wearing jeans, hoodies, and dark sunglasses. After performing for twenty minutes or so, moving through various shots, and getting enough B-roll footage to support edit, I notice two men hanging out.

They had been watching a performance before and after doing their shopping. As we pause between shots, they amble over and ask what's going on. Their names are Hector McGhee and Zander McGhee, and Hector is Zander's uncle. Soon, I'll end up at their kitchen table, doing math and talking about city life, but for now, we're standing on the streets and sidewalks, as the McGhees feel me out. Hector McGhee is in his fifties, handsome and bookish, and he's tall and lanky. His voice is crushed red velvet tinged with icy Kool Menthols—smooth; sharp. He reminds me of a professor, and I think he'd be a good one. After some small talk, Hector McGhee is curious enough about what it is that I'm doing that he agrees to an interview. CUT to CAMERA ONE, where Hector McGhee stands alongside Mannone's, wearing dark sunglasses and a black zip-up sweater.

"Can you tell me about this neighborhood?" I start.

"Well, it's a rebuilding neighborhood," Hector McGhee replies. "I've seen it at its worst, and I've seen it on the comeback, and I believe it's a good neighborhood. It's a mixture. I see Koreans, I see blacks, I see whites—it's a good combo. Yeah," he concludes.

"Now when you say you've seen it at its worst, what have you seen?" I press.

"Well, I've seen it neglected," Hector McGhee replied. "I've seen dirty mayors come here and forget about the city. And I've seen people take it into their own hands to come back. That's the point where we are now."

"What changes have you seen in this neighborhood recently?" I ask.

"Well, the rebuilding, like I said, I've seen new buildings and new things. And services are coming back to the neighborhood. I wouldn't be anywhere else right now. I think I'm in the center of the happenings of Detroit right now," Hector McGhee replies.

He pauses a moment, and begins, "I think we're coming back to the Luster Days." A beat. "I'm old enough to have seen Detroit at better times. Before the riots, and everything. I love downtown, and I think everybody does, because I see more people coming back downtown now. It's hard to find parking downtown. It's on the comeback," he tosses.

We had been talking about art off camera; attempting to continue the discussion, I ask, "What is the role of art in this neighborhood?"

A beat. "Well, I don't know. Our children need to be exposed to that. If we want them to have culture when they get older, they need art. So, based on that, any kind of art, I feel that it only adds to what we need for the city for the future." He pauses a moment. "The children are our future, right? So, we need to point that in the right direction. Art has always been universal, so why not introduce them to that?"

Hector McGhee mentioned he lived nearby, and I wondered if he had thoughts on the Heidelberg Project, which was also nearby. "Are you familiar with the Heidelberg Project?"

"Yes, I am," Hector McGhee replies.

"What role do you think it plays in this neighborhood?"

A beat. "Attention," Hector McGhee replies. "This was the forgotten neighborhood. Now everybody sees us. Feels our plight. So it was a good idea. I have no problems with it," he finishes.

A beat, then, he adds, "You got people touring the project. You got people spending money now. I see this neighborhood on the news at night. Besides the homicides. You have crime scenes. Sure, Heidelberg . . . anything to uplift the neighborhood. It's positive, sure," he says. Although his words are straightforward, I can't help but think he sounds like he's reading a script in his descriptions of the Heidelberg Project.

I pivot, thinking about the presidential election, which had elected President Trump just days before. "Do you think there will be any major changes in Detroit based on the outcome of the presidential election?"

"No. I say no. I say no because ultimately, Detroiters have to make Detroit what it's going to be. No candidate can impact the city like the residents. So, it won't make a difference who is in there," he predicts.

I'm interested in Hector McGhee's focus on people shaping the city. "Can you tell me about the people in this neighborhood?" I ask.

"Well, most people over here are cordial. They will speak to you, because we're in the same situation together," he replies. A beat.

"It's all about families," he continues. "We're full of schools around here. In the mornings, you can't get through traffic—the streets are full of

people taking their kids to school. That's positive, you know. This neighborhood, we're on the comeback. We're on the comeback and the residents are going to make the difference." A tick. "I think," he adds.

"What are some of your favorite things about the neighborhood?" I ask. I wonder if Hector McGhee is sanitizing his responses. His use of words like *positive, comeback, uplift,* and *making a difference* make me wonder if he's simply telling me what he thinks I want to hear. However, McGhee's continual recentering of the people—the neighborhood residents—as being central to change makes me wonder if his views are more complex than he's perhaps letting on.

"What I love about this neighborhood, on a given night, you can look to the sky and it's blue. It's all lit up, and it's from the activity downtown and everything." A second.

Then he continues, speaking in the present tense as though he's telling a story that's unfolding before our eyes: "The lights are on at Tiger Stadium and the Lions are in town at Ford Field. The sky is all lit up and we can see it over here. Those are the memories I have of Detroit right now, you know? It's good."

The through-the-looking-glassness of Hector McGhee's memory strikes me.

"And Detroit itself," he continues, "we take it on the chin every day across the nation about how bad we are. But we have to live here. I just hope we don't get to the point to start believing what we hear or what we read or what people think about us, and let that make a difference. On our comeback, we don't have to take anybody with us—that's how I feel," he concludes. A glimmer of contrarian thinking presses forward. I think his use of the word "comeback" is strategic, and finally, he ruptures the expectation of respectability and uplift politics associated with the word. He makes it clear that he wants the current residents—not simply the newly arrived residents—to benefit from the comeback he mentions.

Thinking of a brief exchange at the beginning of Hector McGhee's discussion, I ask, "I have one more question about the moment when we first met earlier. You approached and asked if I was from Detroit. Why was that, if I might ask? Why did you ask that?" I wonder if his feelings toward Detroit newcomers are linked at all to this earlier question.

He pauses for a moment. "I asked that because I'm used to seeing outsiders approach me for stuff like this, you know, films, interviews. Not the people that live here. I know they're concerned, but they won't take the first step

to put themselves out there. So I didn't think you were from here. I thought you could've been from South Carolina or something. Yeah, I didn't know. But I see you're a Detroiter now," he says.

Hector McGhee continues, "I've been an east sider most of my life. This neighborhood used to be called Black Bottom. That freeway over there, which is Chrysler, was a street called Hastings Street at one time."

"What happened to Hastings Street?" I ask.

"What happened? Chrysler. The freeway. People going to the suburbs. Instead of taking Woodward to the suburbs. That used to be the quickest way to the suburbs, north and south. Woodward Avenue. They made Chrysler over where Hastings Street used to be. Paved over it. Juke joints and everything were on Hastings Street. You see, it takes an older person to tell you about it. I'm telling you what people told me, because I'm only fifty-one, you know," Hector McGhee says.

"That's a lot of history," I reply. It seems our interview is more like a conversation—there is no finite beginning or end to it. "Have you heard any talk about the excitement that people have for what's happening in Detroit now, in this neighborhood?" I ask.

Hector McGhee pauses briefly, considering the question. "Yeah, people have an excitement about it, but they're afraid the changes are going to make the city for the wealthy."

A beat. "They think that we should be pushed to Southfield because there's no lake point view. And they're not part of the revitalization. So we're skeptical about the comeback. Because, are you going to raise the rent? We already have a lot of problems here. Is it going to get worse? Is it going to cost us more? That's what they're worried about. Skeptical, that's all," he says. The kernel of criticality in McGhee's soft commentary blooms into a sidewalk philosopher's critical geographic reflections. JUMP CUT to Fabiola Torralba and me performing in front of the store during another take. A group of teenagers wearing hoodies and jeans saunter by, all boyish and dreamy. They pause briefly and watch us, and even dance back to us, very briefly before and after they get their snacks at the store. They smile and wave as they walk away, and we do too. It's a sweet exchange that sticks with me long after. As Torralba and I perform, I think about McGhee's mention of the Black Bottom neighborhood. According to urban legend, certain parts of the near east side, including present-day McDougall-Hunt, were dubbed Black Bottom for their rich, velvety soil. I gained personal experience with the rich soil—in fact, during the gardening I did in the neighborhood over the years, I found

that anything I'd put in the ground would grow like crazy. One of the eldest residents of the zone, Farmer John, grew cotton in his backyard—a testament to both the rich soil and his expert gardening skills, brought to the neighborhood from Alabama in the late 1940s. This history was also contested, however. Some people felt the area was referred to as Black Bottom because it was at the bottom of the downtown area, with its position just two miles east of downtown and less than a mile north of the Detroit River—and had a high percentage (nearly 100) of African Americans.

The Black Bottom area included Hastings Street and, as Hector McGhee mentioned, was paved over to build Interstate I-375 in 1945. By mentioning the historic Black Bottom neighborhood, which included parts of McDougall-Hunt, McGhee brought years of African American art and cultural traditions into our discussion. In evoking Black Bottom, he also referred to a complex cocktail of memory and cultural claims to space and place that was well summarized in toponyms, or names of places. The neighborhood name Black Bottom, referred to by my informants of all ages from twenty-somethings to people in their nineties, was a strange place name when it came to historical maps and census figures. The name did not appear with frequency on historical maps, it turned out.

As a result, there was no formal footprint of what Black Bottom could be said to include. Still, present-day residents of McDougall-Hunt referred to the neighborhood as part of what they said was the "real" or "original" Black Bottom, as Hector McGhee and other informants did over the years. And while the place name Black Bottom was used frequently when I conducted interviews with residents, including McGhee and passersby, historic maps tell a different story.

In 1884, the east side neighborhoods near the river were referred to as Potomac due to the aquatic geography. The consolidations of black people as the neighborhoods moved north were referred to as Paradise Valley or Kentucky around the same late nineteenth-century time frame, due to the high percentage of black residents. And still others referred to the same areas as Dutchtown or Germantown, due to the many immigrants from those European regions. And yet, the names of the neighborhoods were fluid, as the relatively high concentration of black people on the east side of the city remained consistent.

The complexity of neighborhood place names continued through the next century. In the 1960s and 1970s, after the 1940s razing of parts of Paradise Valley (also referred to as Black Bottom) to make way for I-375, busi-

nesses owned by black people were forced to close, and black people were forced to move further east. As a result, some activists began referring to areas now called McDougall-Hunt as the New Black Bottom.

While McDougall-Hunt was formally mapped historically as part of the Paradise Valley neighborhood, people consistently referred to the zone as Black Bottom, far more than they used the Paradise Valley neighborhood name. Reflecting the paradox of place, there was a fluid relationship between mapped history, urban legend, toponyms, and memory across people of all ages in the neighborhood. While the Black Bottom and Paradise Valley areas were often described as being destroyed by the so-called urban renewal projects of the 1940s and 1950s, residents in McDougall-Hunt resisted these claims by continuing to use the Black Bottom name in particular, and by re-inscribing the Black Bottom neighborhood name on McDougall-Hunt, as McGhee did today. The CAMERA PULLS BACK and Hector McGhee is standing alongside his nephew, Zander McGhee. I've already exchanged contact information with both McGhees, due to my fascination with Hector Mc-Ghee's slowly unfurling sidewalk philosophy and his curiosity to learn more about what I was doing. Next, Zander McGhee offers to participate in an interview.

CUT to a MEDIUM SHOT of Zander McGhee, in his twenties, with savvy brown eyes that seem to peer to the center of things. He's average height, with a slim build and a quiet presence. He's wearing a black hooded sweatshirt over jeans and Nike sneakers.

"Can you tell me about this neighborhood?"

A beat. "Yeah. It's a pretty good neighborhood, out of a lot of them around here in this area. You got a lot of good people around here; not too much happening. That's about it," Zander McGhee says. I think of Vic Mahon, and of the young man named Blue I spoke with recently. Mahon, Blue, and the younger McGhee were in their twenties or younger, and spoke of the lack of things happening—the lack of things to do and the lack of opportunity—in the neighborhood. It seems that this phenomenon is of the most concern to the young people who live there. I note this, but I don't want to push Mc-Ghee into a discussion and lead him to discuss something I've perhaps assumed to be important. I want to let him lead the interview, as I try to do with each conversation.

"When you say good people, what do you mean by that?"

"You know, you got certain people you deal with—they hang with people you know, and they all keep the neighborhood together. You got kids in

the neighborhood. You got a lot of adults that know each other so the kids play together. That kind of thing," he concludes.

"Can you tell me about what's happening in Detroit right now?" I ask.

"Construction! A lot of construction. I think they're trying to make the city more expensive, you know, more worthwhile to see. So, let's see how it turns out," Zander McGhee replies.

"What do you mean by making the city more expensive?"

"Attracting more money, and attracting more people to spend money," he replies easily.

"What do you think this will do, like the city becoming more expensive? What's the relationship with this neighborhood? Will things get better here? Or no, do you think?"

"There needs to be some attention brought to this neighborhood, so that people can get what they need. Right now, that's not happening," he replies.

"What are some of your favorite things in this neighborhood?" I ask.

"My favorite things . . . I guess the river. I have to say the river. Because that's one thing that you will not find on the west side. Straight-up desert over there!" Zander McGhee replies.

"What is it about the river? Tell me about the river."

"You know, you got the RiverWalk. You got downtown Detroit near the river. You know, you got Grosse Pointe. Places where you can go to the park, right off the river."[1] Zander McGhee's eyes light up as he describes it.

"How do you feel at the river?" I ask.

"I feel like I'm in Miami. I can imagine I'm in downtown Miami somewhere, you know? You can see another country from across the water. It's a little sight to see," he concludes, smiling.[2]

"What else do you think is important about the city?" I ask, hoping to connect to his newly relaxed demeanor as he described the river.

"Well, with the involvement of art, you have to think, like, music is an art too." A tick as he thinks.

"So, I mean, this city is big with art, period, like we sell out stadiums with our musicians. I say that's pretty big. Yeah. So, I mean, it's history. We have history," he says. "It's not just music, or the people who made it—it's about all the legends in the same place at one time!"

He pauses a second. "I mean, it's not just about an individual person. It's Motown! I like that about Detroit." Then, he pauses again and looks squarely into CAMERA ONE.

"We do have history, no matter what anybody says." A beat. "We have history, and we got industry," Zander McGhee concludes. As in my conversation with Hector McGhee, I'm struck by Zander McGhee's complex views of the city. It seems that they each have much to say. The *Vol. 3* shift is in full effect. After we wrap the shoot for the afternoon, I set a time to meet up with the McGhees back in the neighborhood. Zander McGhee is studying for a math placement exam at a local community college and has asked me to work with him. JUMP CUT to days later. The cameras are not rolling. I have only my notebook and an audio recorder app on my iPhone. I walk up the pathway to Hector and Zander McGhee's east-side condominium, and we continue our conversation.

In the 1960s on Detroit's deep east side, Hector McGhee was born into a family with seven siblings, a son of Trisha and Randolph McGhee. One of Hector's siblings was Lena McGhee, Zander's mother. Hector McGhee was the second oldest son. The McGhee family experienced several unexpected deaths of kin in the 1970s. His father died of cancer when Hector was a young boy, and his older brother died after the second time he was hit by a car while crossing an east-side street. These events, Hector McGhee said, brought him quickly to the role of family patriarch. With the air in his east-side condo thick with cigarette smoke, holiday casserole, and the acidic twist of a recently cleaned kitchen, Hector sat at the kitchen table where we usually hung out.

"I'm a sibling of seven kids. As of this year, there are only three of us left—me, my younger brother, and my younger sister. I lost a sister to cancer. I lost a mother to a heart attack. I lost a father to cancer." A beat. "My older brother, he got hit by a car twice. The second time took his life. So that put me in the older brother slot early on. And then two years later, my father died, so that put me as the man of the house. So, it was a quick rise. I kind of missed my childhood," he said. Hector McGhee's descriptions of life on Detroit's east side shook with elements of performance—whether his own on the job as a former factory worker, or the performances of others moving through his neighborhood—from artists to gang members to factory workers, and everyone in between.

Hector McGhee took a hard pull on his square and said, "Back when I joined the service, you could join at seventeen. So, I joined at seventeen. Why I joined the service so young was because my girlfriend down the street come to me—'I'm pregnant,' she said. We tried to keep it from our parents until we couldn't keep it any more. And then the father said, 'You give me a plan now, or I'm going to shoot you.' So, I ran, and I joined the service," he concluded.

The bookended events of losing his father as a young boy, and just a few years later becoming a father, thrust McGhee into adult life. He served in the U.S. military, receiving an honorable discharge years later. During the time he was in the service, he was surprised to find out that his baby daughter, Katie Mc-Ghee, and her mother, Laura Padgett, had moved across the country.

"Meanwhile, the girl I went to the service for—I came back, a local pimp and dope dealer had moved my girl to Texas with my daughter. And that's where they've been ever since." His eyes clouded and he wrung his hands. He explained that his relationship with Laura Padgett and Katie Mc-Ghee disintegrated. Hector McGhee matter-of-factly explained, "The guy she went to Texas with, he died three months later of a brain aneurism. So, Laura and Katie were stuck down south in Texas, with the remaining of his money he had put up to convince her to come out there, so Laura couldn't show her face back in Detroit . . ." His voice trailed off. It was clear the familial separation he described was still being negotiated decades later.

Hector McGhee explained, "Now we're looking at over thirty years later, and me and my daughter, we're trying to work out a relationship because she was taught I abandoned her. Even though she was moved out to Texas without any input from me, while I was in the service. You know. So, we're working on a relationship now where, you know, where we can get things better for us. I'm a grandfather. Katie has three children—she married her high school sweetheart." He earnestly described his hopes to rebuild a relationship with his daughter. It was a labor of love and a work in progress that he held dear. Turning back to the earlier days, following the split between him and Laura Padgett over three decades ago, McGhee remarried.

"I was married, after Laura, to a woman named Giselle, and that didn't work out. Wife decided to leave and that's fine. We all have that option. But, after that, I was down in the dumps, and I was actually thinking—not of hurting myself—but I was in a self-destructive mode. And something reached and touched me on the shoulder and told me I had to change directions. And I changed directions," Hector McGhee said. Also during this time, Zander McGhee's maternal grandmother and Hector's mother, Cora McGhee, passed away suddenly due to a heart attack. Hector went through an intense period of depression and introspection following his divorce and Cora McGhee's death in the 1990s. After his mother's passing and his divorce, he found a good, steady job at a box manufacturing factory in a metro Detroit suburb.

The factory manufactured boxes and packaging for automotive parts suppliers, which would then pack parts in these boxes and ship them to au-

tomotive original equipment manufacturers. Although the pay was decent and the hours were steady, the working conditions were rough, Hector Mc-Ghee said. He stuck it out, persevered, day in and day out, making boxes on the line. In 1999, a workplace accident shifted the trajectory of his career as a factory worker.

"In 1999, my hand got caught in a machine, in a box-cutting machine that malfunctioned. And the guy at the job who saved me was my worst enemy I thought. We never got along. But when I was in an emergency situation he did the right thing. He cut the machine off. And saved my hand. Because the machine was pulling me into it. And this is the result. It's like a bionic hand. You know." As he finished his sentence, McGhee held his right hand out for me to see, opening and closing his fist. He knocked on the thumb joint of his right hand with the left, and it made a hollow, echoing sound like a gavel dropping down; wood on wood. Hector McGhee continued to recount the events of that day. "EMS came to the accident. They said, 'Where's his hand?' Because my hand looked like a bloody rag. They asked, 'Is his hand in the machine?' And that really scared me, because I didn't know if my hand was in the machine. So, they took me to the hospital."

Once at the hospital, McGhee had emergency surgery to preserve and reconstruct his hand. "They told me it would take about ten years before I could use it again," he said. "And now it's good—it's my strongest hand. And the surgeon told me that, but at the time I didn't believe him." While he had since recovered, the many years of struggle following Hector McGhee's 1999 workplace accident had taken a costly physical, emotional, and financial toll. He explained further details concerning the accident and the contentious relationship between his workplace and his interests afterward.

McGhee took a pull on his cigarette before he exhaled, took off his glasses, and rested his arms atop the kitchen table. "This was at a factory called Acme Containers. They made boxes for parts for the Big 3 Motor Companies," he said.[3] "They abandoned me as a worker really, after the accident. I wanted to sue the manufacturer of the box-cutting machine, which was built in Italy. They couldn't get in touch with the manufacturer, so I hired a lawyer, and he flipped on me, and went to my company's side, and I got a nickel off that. I got a good lawyer much later, and that lawyer went back and got what he could salvage, five, ten thousand dollars, a little better than a nickel. And now I'm rebuilding my life," he said.

McGhee's reflections, though casually described in his matter-of-fact way, reflected the intense stress and tumult of his workplace. After the accident, Hector McGhee was moved from the job of line worker to security of-

ficer at Acme Containers. He described the security officer position as unnecessary for the small, already tightly secured factory. McGhee wrung his hands a bit as he said, "So the boss gave me a job as security officer, for a place that's locked up that you can't get into anyway. But he had to give me a job because of the insurance arrangements. I still had to have a job. I left that job and I went to another job, but every job I went to, they wanted to hear about the hand. You know. Because it was in worse condition then. At the time, that stood out, that stopped me from getting jobs and things." His voice trailed off. "So, at the time, I was kind of depressed. I wanted somebody to hire me for my skill and not what I came to my skill with," he said. Two years after McGhee's accident, September 11, 2001, happened. Although Acme Containers was based in a Detroit suburb, 9/11's impact was felt in McGhee's day-to-day, he said.

"When they blew up the Trade Center I was still at Acme, in 2001. When they took all the planes out of the air, my boss told us, he said, you guys aren't going to have a job because we're being attacked. And we couldn't understand how could he say that, because this happened in NYC, and it wasn't established that attacks would continue or even what had really happened. But, I was off work for two weeks and then he finally opened it back up and everything, two weeks less pay. I had an ignorant boss. I hate to say it. But he wasn't looking at things right."

For Hector McGhee, who was his family's sole earner at the time, losing several weeks' pay without warning was a deadly financial blow. When he returned to work, his bills were behind and the relationship with Acme continued to sour, due to what he viewed as the nonessential security officer work, the lack of pay for two weeks, and the boss's hostility toward McGhee's lawsuit against the Italian box machine manufacturer. Inevitably, he left Acme soon after those events. "Finally, I found a job that hired me in spite of the hand. Then my marriage went on the rocks, because it wasn't the highest-paying job. I had a wife that thought, you should've got the big lawsuit, we should be set now. A wife that I'd been with thirty years. So, you would expect a lot out of a person that you've been with thirty years. You don't count [on] the circumstances that can get in the way of that, generally. And she didn't. We've been separated for three years now, and I hear she wants to have contact with me, now that I'm rebuilding."

A beat. "But, I choose not to have contact with her—'I wanted you to be with me when I was down, not when I am on the way up.' You know. 'You should've been there,'" he said longingly. When it came to being there and sticking it out, McGhee had at least done that geographically concerning De-

troit's east side. Except his several-year stint in the armed forces, he had lived on the east side all his life, since he and Zander's mother Lena McGhee grew up off Van Dyke.

Born in the 1960s, Hector McGhee was coming of age during Detroit's stunning demographic transformations from the 1950s through the 1980s. Between 1950 and 1980, the city's white population fell from 1.5 million to 414,000, and the black population climbed from 300,000 to 750,000. However, some neighborhoods, like McGhee's, were steadily African American during and after the demographic transformation. As such, there was no shift from white to black that he saw in terms of his family's housing situation and neighborhood. McGhee explained the relatively constant demographics of the east-side zone that he recalled.

"I've basically always been an east sider," he said. It was a line I remembered him saying at our liquor store discussion. "I was down here when it was still Black Bottom, if you remember that," he continued. I nodded. "We had no natural enemies, because the white people went to the west side and they left the east side to us. So, I thought the east side was ours. There were no problems. There were black officers, black merchants. . . . There weren't Arabs. I didn't see a Middle Easterner until I was a teenager. We were taking care of ourselves. And those were the days of food stamps. You get a food stamp and go to the store. . . . This was the 1970s. Everybody had food stamps back then, even if you had a job. And so, I stayed on the east side all my life. I remember when the factories were booming. There was no crime. Because there was food everywhere, no one was hungry," McGhee explained.

At the center of the shift from a majority white to a majority black city was the issue of housing and associated economics like jobs and education. The fissures and chasms of racism and bitter hatred toward ethnic and cultural groups was a consequence of political-economic inequality and struggle. Scholar of cities Thomas Sugrue wrote that housing was the most charged racial concern in the city since World War II.[4] As historians Reynolds Farley, Sheldon Danger, and Harry J. Holzer wrote, the struggle for neighborhoods and for housing was not a peaceful one.[5] Legal and political intimidation as well as racist neighborhood association–militia brute force were used to stake claims and mark borders. The house—the family dwelling—consolidated so much. It was personal, yet it was political. It was cultural, yet it was economic. The space of the home was a metaphor for the right to exist in the city itself.

White neighborhood associations used violent tactics to keep people of color from moving in, Sugrue wrote. During the daytime hours, some such

associations recruited white stay-at-home mothers to protest with picket lines around the residences of whites rumored to be planning on selling to blacks. At night, the same associations recruited teenage boys to break windows, destroy the lawns, or burn the sheds and garages of homes of blacks moving into majority white areas.[6] While McGhee perceived his east-side surroundings as consistently African American, the fact was, interests across the city were literally fighting and undertaking violent vigilante action to keep it so.

Perhaps the most empirical consequence of violent political-economic neighborhood segregation was the vast economic, employment, and educational advantages and disadvantages conferred on residents of different areas. The crack explosion of the 1980s was demonstrative. Hector McGhee described the view of the backstage pass to the crack epidemic in his own neighborhood. McGhee looked thoughtful and wrung his hands quietly, as he said, "In the 1980s, crack devastated the neighborhood. I lost a lot of friends to it, and a lot of people went to jail. But I think the crack is coming back." I was surprised to hear such gritty realism.

"I don't think crack is over yet completely," he said. "One thing about the black spirit . . . we're fighting, and if we have no action or results, we go to what we know. We get high. We get high to forget and we get high to accept what we're going through. Until blacks have a better advantage on this earth or in Detroit, drugs are just going to be a stone's throw away. Going back to that time, I see that," he said. He took a light pull on his cigarette. Darkness had descended outside and the breakfast nook was quiet and warm. The crack epidemic seemed far away, and yet, to Hector McGhee, it loomed as a threat to the neighborhood.

McGhee described the goings-on at the liquor store where we first met. "Up here on Gratiot when I go to the Gratiot store. Gratiot and McDougall. At the liquor store people are out there begging and you know what they want money for," he said matter-of-factly.

> At the gas station, up here, you give this guy a dollar. The crack house is forty feet away. The dollar you give him, you see him go to the crack house right after. I asked him one day, "What can you do with that dollar I give you? Why do you go to that crack house?" And he said, "The dope man gives us the crumbs off the crack. For that dollar, you get the crumbs from the rocks." . . . So when he asks me to give him money now, I know he's a crackhead, and I don't want to support that, so I don't give him money anymore. He doesn't know that him telling me what

he does with the dollar changed the situation. So, you can't say the drug problem doesn't exist. It's here. It's here. It's still here.

Indeed, right in front of the liquor store where we met, on the day we met.

Through the course of this conversation and many others, Hector Mc-Ghee described his ideas concerning topics as varied as the Heidelberg Project, the drug trade in the 1970s and '80s, access to public spaces and parks, and the shifting migration between city and suburbs. His rich stories had the quality of a performance scholar or a critical geographer—or maybe I was starting to hear them that way after hanging out so much. McGhee's discussion of Detroit's political economy smacked of a vein critical to performance—choreography. He seemed to deploy the theory of choreography as strategy in analyzing the shifts of power, domination, and subordination in the neighborhood and beyond.

On McDougall-Hunt's 1980s backstory, McGhee reflected, "In the '80s too, they also had those gangs out here. The Errol Flynns (aka the Flynn Nastys or the Nasty Flynns) and the BKs (aka Black Killers). You could be standing at bus stops and they pull up. . . . They say, 'What side you on—BKs or Flynns?' You had to think quick. You know. If you gave the wrong answer you got blasted. I remember those days. I was glad when those days were over." The imposition of private affiliations into public spaces like the situation Hector McGhee described was commonplace, he said.

It was clear that the midcentury northward movement of businesses, in part caused by the installation of I-375 and the 1945 obliteration of the mostly black-owned businesses of Hastings Street, contributed to the circumstances at hand.[7] As Ralph wrote, the emergence of gangs in McDougall-Hunt was an economic, organizational response to a neighborhood reeling from lack of access to the city's resources.[8] Marable's political-economic analysis of the 1960s–1980s interlocked with McGhee's and Ralph's. The connections between their theorizing, from the university to the street, were jarring. Marable wrote,

> Two other strategies emerged during the 1960s which increased the state's role in the suppression of Black leaders and the Black working class. The first, which involved the significant expansion of the Black prison population, was effectively used to maintain a high proportion of Blacks within capitalism's necessary reserve army of labor—a strategy not unlike that of convict-leasing in the 1800s. The second, established a sophisticated surveillance network and a police-state apparatus to blunt Blacks' criticisms of white supremacy and the political econ-

omy of capitalism. Both efforts combined to curtail the advancements achieved by the Civil Rights and Black Power Movements.[9]

McGhee's analysis of the street-level violence, criminalization, and chaos over these three decades was not anecdotal. The compression and suburbanization of the automotive sector, along with the expansion of police networks and carceral populations, had exactly the effect McGhee described, and Ralph and Marable quantified. Black political activist movements, like those led by James and Grace Lee Boggs in the 1950s and 1960s in Detroit, seemed to become increasingly stifled by right-leaning rhetoric of law and order. Tensions were high in the 1970s and '80s, McGhee reflected. Tensions were still high, he said, because there was a failure to extend what he called "the right to citizenship" to most residents.

The fact was, even as I conducted fieldwork, the right to citizenship, as McGhee called his ideas, including access to decent housing, quality education and employment, clean water, and quality shopping, was not extended to most low-income people in the McDougall-Hunt zone. How could it be, with a median income of $13,000, and an unemployment rate upward of 40 percent? Although resources seemed increasingly scarce over the decades McGhee described, and inclusive participation in a productive city was elusive, a different sort of population was, at the same time, exponentially growing.

"The [street] gang's shift toward illicit entrepreneurialism was on par with the systematic transformations in the American social order,"[10] Ralph wrote. As corporate-style gangs with complicated organizational charts formed in place of formal labor opportunities in many cities, drug trafficking was increasingly rampant in some low-income zones, and increasingly criminalized.[11] Marable wrote, "By the early 1980s the annual national incarceration rate of 250 per hundred thousand was the third highest in the world. Not surprisingly, the leader was South Africa, with 400; but some projections for U.S. prison growth could exceed that figure within a single decade."[12] Marable, writing in 1983, accurately predicted the future. In 2016, the United States led the world with 693 incarcerated people per hundred thousand. In fact, no founding North Atlantic Treaty Organization (NATO) country was even remotely close—the UK's rate of 145 jailed people per hundred thousand was a distant second place. Legislated poverty, segregation, racialized policing and racist police brutality, and de facto and de jure education and employment discrimination led to the "increased tension" McGhee described.

In the Detroit case, destroying Hastings Street, which was a hub of black business, just at the time the automotive industry was beginning to shrink in the city and to consolidate in the suburbs (and other parts of the world), as Ralph noted, was a crippling economic blow to McDougall-Hunt. Increased police surveillance, coupled with racialized mandatory minimums for nonviolent drug offenses, contributed to a stratified system of neighborhood decline and prison industry engorgement. Meanwhile, the tension McGhee described as associated with lack of decent work, deteriorating housing, and the movement of money across Eight Mile Road led to volatile situations in the most unexpected places. Even dancing at a nightclub.

McGhee smiled with ambivalence as he stretched his arms and leaned back a bit in his chair, taking me back to the scene he was describing. "Back in the '70s, they had a song called 'Le Freak!' by the music group Chic. That was a bad song. Because when the song came on, you freaked the girl you were dancing with.[13] Even if the boyfriend or husband was sitting over there. It caused fights, killings, and all that stuff. 'Freak Out.' If you research it you'll see that song caused a lot of fights and killings. By Chic. So, I've been through all of that." He continued.

"That's why I'm scared of this gangsta rap now, because it's entertaining, but some kids take it past entertaining. And they think that's the way it should be. That's the problem I have with rap. It's entertaining. But those fools who take it too seriously, you know. That's what I worry about," Hector McGhee said. McGhee's ambivalence about disco music and rap or hip-hop music said much about the creation and consumption of black aesthetics as it relates to the struggle for a city. While McGhee came from a tradition of cultural forms enriched with black aesthetics—his beloved aunt, Lottie Claiborne, an international performer during the 1960s, studied with Katherine Dunham—his up-close experiences of violence and violence's very loose ties to some art forms left him with ambivalence.

For McGhee, his location in a neighborhood struggling for access to resources led to these cultural forms being degraded by the conditions surrounding them. In contrast, one on the outside looking in might enjoy the art forms without rubbing up against the grit and the struggle that Hector McGhee encountered. He often discussed the Heidelberg Project as well, complicating his earlier discussions at the liquor store. McGhee thought as he lit a fresh cigarette. "I remember when Heidelberg Project started out. The first thing I thought was, he was crazy. Until I realized the money behind it. People are backing this man. And he's an artist. Any way you look at it, he's an artist. If he weren't an artist, he wouldn't draw the attention. But I ques-

tion, could this same place be set up in Birmingham, Michigan [an affluent suburb of Detroit]? That's what I question."

Like Vic Mahon, Hector McGhee questioned the relevance of the work to those closest to it. Although McGhee acknowledged the project as art, his critique of the work centered on the struggle for the city. McGhee argued that the interests of the residents were not being considered in the work; rather, the opposite was the case in layering the aesthetics of abandonment through readymades and found materials. McGhee stressed that he didn't want to seem as though he was speaking negatively of the Heidelberg Project, but that he had to speak his mind. He gently extinguished a cigarette in the porcelain ashtray on the kitchen table.

He explained, "Okay, you call it art, and you have all these people come out to the exhibits, all the white folks, they come out, and they praise this thing. Would you praise that in Birmingham? That would be junk. And I just feel like if a city is on the comeback, you don't feed them junk. There should be a place for that. You don't throw despair down in the middle of this despair." He paused for a moment. "And that's what you're doing. Most people I talk to say, 'Oh, that's junk, man! Why can't they do that out there if they like it so much?' It's not helping us. It's true it's bringing recognition to the artist. It's bringing recognition to the neighborhood. But that's the limit of it," he concluded. Again, McGhee repeated that he held no ill will toward the artist or the Heidelberg Project. Rather, McGhee's critique focused on the theoretical concept of the struggle for the resources of a city.

"It's not really helping the people who have to watch it and look at it every day. It's just discouraging. To the people on the ground, who live here—imagine if you woke up to that junk every day. We'd like to see rose gardens. Something to look forward to. It's a hustle for him. He's an artist, because he took the time to do it. But it's the wrong time and the wrong place for it. If you ask me. My opinion. Yup. We deserve rose gardens. Sure, we do." McGhee looked slightly uncomfortable as he explained his perspective on the Heidelberg Project. It was as though he wanted to share his views, but that he was worried about offending me. I had shared with the McGhees the fact that I was friends with the artist Tyree Guyton and his partner Jenenne Whitfield, who ran the project. Hector McGhee's ambivalence in sharing his feelings about the project was not so much related to this as reflective of the complicated opinions of people in the neighborhood concerning the impact and status of the Heidelberg Project. The Heidelberg Project was both mirror and reflection, consolidating the right to the city and the paradox of place.

McGhee took a drag on his square. "We worry about being second-class citizens in our own city," he mused. A beat. "These people were born here. They live here. They work here. They've been here. So, we should have decision making. We shouldn't just be told what it's going to be." He paused, musing. "We want to be part of the resurgence. We want to benefit from the resurgence. But now, we don't see any benefits coming to us. So how am I going to be part of something that I know won't affect me?" A beat.

"The Pistons are coming back downtown, so now tickets are going to be higher. That's really nothing to look forward to. We already can't get out to Auburn Hills now to see a Pistons game. We don't have the money or the means. But now you're going to have it in our city and we can't afford it? That's how a lot of people feel, and I'm on the bandwagon with them." McGhee leaned through the uplift politics, the misdirected quality-of-life politics, and the moralizing of failed political economy. The lightweight rhetoric he had plied me with at the liquor store scene was long gone.

"Will the 83 percent black people of this city benefit in this recovery, and will the low-income and working-class people benefit?" I asked.[14]

McGhee took off his glasses and methodically cleaned each lens with a silk cloth from his suede glasses case. "I think in the long run, we will all benefit, but the only way we can do that is [to] get on the same page," he continued. "We must realize that Detroit has taken sacrifices to get to this point now. And the people who stayed, like us, took those sacrifices. So, we need to protest. We need to be out there protesting. What's in it for us? We're sitting back and waiting. So, do something for us. That's how I feel about it. Because, the thing about it, Detroit will have its day," McGhee reflected.

A beat, and he continued, "I just want to be there when they have it. I will go through all the struggles and everything. We need alliances where we can build things together. That's how I look at it. We're one race. I feel sorry for people going through tragedies. White or black, it doesn't matter. I wish we could get away from the race thing. When it goes down, we're going together. There are no different spots in hell. There's no black hell. Send the blacks to black hell. It doesn't work like that. I like what Tupac said. White and black do crack. White and black do crack." McGhee chucked wryly. "Black people have been through so much oppression in life—we've been through mostly everything you throw at us. We have been through so much of a struggle."

"What do you envision for Detroit?"

McGhee thought for a moment. "I envision jobs galore," he started. "I envision a need for somebody, everybody. . . . I envision that I get some of the

benefits of the resurgence. That I go down to the performing arts venues and enjoy myself. That they let you walk free with your family. They're going to be charging people to do the RiverWalk. They said they want the boardwalk to come all the way to Belle Isle. They're going to charge you to walk that sucker onto Belle Isle. It's unbelievable. They want to charge you. And I think that's a travesty. That's a slap in the face."

McGhee paused and took a sip of water. "They took Belle Isle and they gave it to the state. Now, everywhere you look it's empty. Everywhere you look there's a state police officer. It used to be cool to smoke a little joint on the island and be peaceful and nonviolent. But now you can't bring it on there. There's no liquor. Sure, you shouldn't drive and drink. You used to be able to spend the night out there, camp with the children. Now they have the boat races, and you have to pay all this money to get out there. What if I'm not a boat race fan? Belle Isle used to be a public park. Now you want to make some money, and charge me." McGhee mused on the politics of space and place as we sat there at his kitchen table, the cozy domestic scene, including a vase of pink roses in the center of the table, the plush dining chairs, and the china and crystal sets in the nearby china cabinet, contrasting with his criticality. "The kids growing up now, they don't know the culture of Belle Isle," he explained.

"This is the right to the city! The right for participation in a city. For all of us! What do you think about that?" I was struggling to contain my excitement at hearing McGhee's thoughtful analyses.

"Sure! The right to the city!" McGhee exclaimed. He pounded his fist on the table, like a professor making a point during a seminar, viscerally moved by a concept. "When I was coming up, on Belle Isle, you could do horseback riding, archery—they had all those things! You could just go participate. As kids, we thought it was Disneyland. That was the closest we could get to Disneyland, was going to Belle Isle. There used to be a tunnel to get out to Belle Isle. There used to be a regular bus going out to Belle Isle. Now, it just restarted," he said. "But who is it for? That's the kind of thing they should do. So that everyone can access it. All kids. Our children, if you don't give them things to help culture them, how can you expect them to be cultured? That's my point. You expect these kids to be good, but you're not giving them good things. Summertime, every kid used to have a job. They didn't want to stand on the corner and rob somebody. They have the energy, so they need something to do with it," he concluded. I thought of Mahon, Clark, Blue, and now McGhee's critique of political economy and its consequences for young people in the neighborhood. McGhee shook his head

slowly. "They need something to do," he repeated. I nodded, feeling like I was back in a seminar and McGhee was my professor.

McGhee could theorize the city like this with one eye closed and one hand behind his back. He was a sidewalk philosopher and an organic intellectual who discussed practical and philosophical art, public spaces, urban ecology, urban process and gentrification, and overall city life. In *Selections from the Prison Notebooks of Antonio Gramsci*, Gramsci describes two types of intellectuals—traditional intellectuals who were part of a stratified, formal system of knowledge creation (and thought to be beyond economic systems), and organic intellectuals who were part of the labor force, that is, workers and laborers in an economy.[15] Every class produced intellectuals, whether traditional or organic, and organic intellectuals were particularly important in spreading dominant ideas, or hegemony.

The reason for organic intellectuals' particularly critical role was that organic intellectuals "must reason with the masses and engage in a decisive 'war of position' to consolidate the hegemonic status of the class interests of which they share."[16] In other words, for organic intellectuals, ideas and theories were the result of praxis, rather than the other way around. McGhee's position as a Gramscian organic intellectual destabilized the polarized Detroit narrative that had Detroit in a theoretical vacuum. His observations made clear the fact that Detroit was at the center of a global conversation around cities, space, place, and access. As McGhee's comment demonstrated, despite mythical narratives that painted longtime residents of the city as oblivious, people were aware of and interested in the politics of urban process. The neighborhoods portrayed as decadent, derelict, and decaying were pulsating with thinking people. Residents like McGhee knew that in claims on the city, the real-deal people of the city like him were ignored, while wealthy investors advocated for the interests of the very few.

Ideological claims on Detroit's cultural assets often ignored most of the city's residents. Data gathered and presented by anthropologist Alex B. Hill, who produced the *Liquor Store Theatre* atlas for this book, between 2011 and 2013 demonstrated the disparity between Detroit's emergence as a creative economy and those who could access the opportunities.[17] The Detroit Creative Corridor Center (DC3), the group behind the popular arts and culture event the Detroit Design Festival, had less than 10 percent people of color in its network of creative mentors between 2011 and 2013.[18] Hill determined that between 2011 and 2013, just 30 percent of business incubator participants selected by DC3 were people of color, amid Detroit's population of more than 80 percent African American people.

For Hill, "There is a real problem in the Detroit creative community in that there is a racial disparity in regard to who gets funding."[19] In the same article, Hill presented map data demonstrating the concentration of DC3's Detroit Design Festival events between 2011 and 2013. The Design Festival events were concentrated in the greater downtown area in which *7.2 SQ MI* was focused as well. The problem was not geography; it was geography without context.

Hill wrote, "The missing ingredient in the case of both artists and non-profits is the lack of understanding for historical context and root causes. If you hope to do anything in Detroit, it must start with a critical perspective on the city's history of racism, regional separation, and the need for equity."[20] It goes without saying that creative projects like the Detroit Design Festival or DC3 are free to establish connections and efforts in any area they wish. However, Hill urged an acknowledgment of history, inequality, and demography given Detroit's context. Likewise, Kinney urged analysis of implicit racism that seemed to encourage departure and stagnation of people of color in the city's center.[21] The Detroit Future City (DFC) plan, the city's unofficial master plan published by hired consultants in 2013, reflected Detroit's glaring blind spot regarding empirical racial disparity, as analyzed by Kinney.

The DFC was criticized for sourcing a small number of relatively elite residents in its surveys and for failing to consider the historical and political context of Detroit and its neighborhoods in the DFC plan. In the 347-page document, the words "race" and "racism" and any discussion of impacts on neighborhoods were mentioned only briefly—fewer than three times in the entire document. Critics considered this indicative of a status quo DFC plan that failed to incorporate the economic injustices experienced for decades by the city's black people, people of color, poor people, and working-class people. Moreover, the DFC plan was indifferent to the reality of the present city, with over 80 percent black people.

Like Hill and Kinney, I argue that investment in and of itself can be a neutral force of urban process. However, I join McGhee, Kinney, and Hill in urging a critical, historical, contextual analysis of investment and business interests. Are we furthering inequality with projects that fail to consider the historical context? Are we contributing to disparities by adding disparities onto an already economically distressed city? Are we furthering a mythical exoticism of low-income and black people by sourcing cultural aesthetics from people who are excluded from funding opportunities? These were questions I asked at the scene of the store and beyond, as I orbited into the lives of informants like McGhee.

My informants and I did not need theories specific to Detroit to think through my ideas. It was clear that the Detroit questions were questions central to all of human existence. Who matters? Who gets to participate? Who gets to tell a story? I lean back in McGhee's kitchen table chair and breathe in the luxurious secondhand smoke unwinding from the ashtray in the center of the oak table. The smoke fills the space between McGhee and me as we look at one another across the table, thickening and blurring our perspectives until we only see a cloud between us, and we FADE TO WHITE.

Liquor Store Theatre, Vol. 3, No. 6 (2016)

EXT. CHARLEVOIX LIQUOR—(DAY)—ESTABLISHING SHOT—This store is down-trodden—there are no two ways about it. The tan storefront is covered with greasy, hand-painted proclamations of BEER & WINE, CHECK CASHING, MONEY ORDERS, and LIQUOR LOTTO in red, black, and yellow. People come and go slowly; it's a lazy, autumn Saturday afternoon. I'm alone today in front of the store.

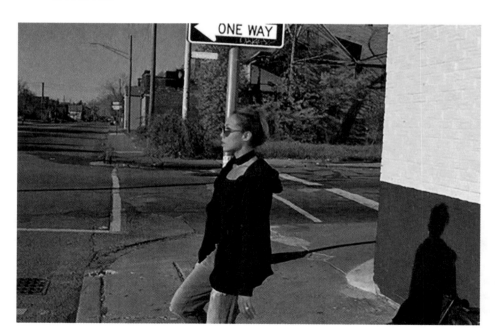

10.1 *Liquor Store Theatre, Vol. 3, No. 6* (2016).

Nick Ocean, whom I had met two years earlier at the first event, walks up as I'm performing a choreographic sequence and Todd Stovall is filming. "Maya! You still doing this?" Nick Ocean flips the words as he approaches. Ocean has long, curly hair and sharp, chiseled features. He is shorter than average, with a sinewy build and thoughtful eyes. Ocean's question was one I got more and more after the *Vol. 3* shift. People began to recognize that the project was now orbiting the eight liquor stores in the neighborhood. "Didn't I see you the other day at a different store?" people would ask. Some people asked if I was finding new information in discussions with people at the different stores.

"Nick!" I reply, happy to run into him. "Yeah, I'm still doing this. You were one of the first people I ever interviewed," I say in response to his question. "Do you remember?"

"Of course," Ocean tosses back. "Over at the Blue Store." He pauses for a moment. "So how are you doing? Besides hanging out at the liquor stores, what have you been up to?"

"This time, I'll talk to you behind the camera," he says, sensing my attention as I lean toward my consent forms. It is clear that Ocean wants to talk, and that the prompt of the performance has grabbed him, but that he has no interest in a recorded conversation. This was also a phenomenon I encountered at least once at every event. Ocean had an inquisitive streak, and anytime I spoke with him it felt like he was actually interviewing me. Today, we talk about the weather and the presidential election. After chatting for a few more minutes, Ocean stops talking, and his calm, pleasant facial expression evaporates and becomes somber.

"I heard you got into it with Sally over at Heidelberg Project," Ocean says. A beat. I was stunned. Another beat. A few weeks ago, a woman named Sally Wilks had been offended by my naive attempt to amicably intervene in an exchange between Wilks and a pair of Heidelberg Project visitors. Wilks, who described herself as a recovering heroin user, was asking the pair of visitors for money. They did not give Wilks money and didn't respond to her in any way. They ignored Wilks, who retaliated by yelling at the visitors that they were rude and insensitive, and on and on. As I walked by, I said hello to Wilks and tried to engage her in a pleasant conversation, as a way of diffusing the exchange with the visitors. Long story short, it didn't work. Wilks's tirade was instead shifted toward me. I tried to walk away as a mode of peacemaking, much like the visitors did, and it seemed that Wilks became more an-

noyed by this. Looking back, I think my attempt to help was presumptuous and silly. Neighbors helped de-escalate and all ended amicably. Still, rumors were apparently swirling that we had "gotten into it." I didn't agree with that characterization, but it was true that something had happened.

I had speculated that liquor stores in the neighborhood would be sites of sociality and news sharing. While the stores were problematic, contributed to substance abuse, and represented the broken political economics of the neighborhood, the fact was that they served a variety of purposes that the people who used them made possible. Simple mathematics meant that I would be able to talk to more people in the spaces surrounding liquor stores than any other public common area in the zone. It wasn't that the stores were created by the owners and managers to serve a purpose of sociality—it was that the neighborhood residents developed this secondary function for them. News sharing at the stores was expected; I had failed to envision that the news sharing could include me being told about myself.

Another beat. "I wouldn't say exactly that we got into it," I reply, too quickly. "It was more of a misunderstanding, at least on my end . . ." My voice trails off. I don't want to say anything more about it.

"Yeah, yeah, I get that. Well anyway, God don't like ugly," Ocean says, nodding and looking very serious.

"What do you mean by that?" I ask.

"Well, the same way she got into it with you, but much, much worse, Sally got into it with somebody else at the liquor store down the street." He gestures to the next nearest liquor store, which was about a quarter mile away.

"What do you mean?" I ask.

"They got into it, you know . . . and she ended up busting out somebody's car window. Right there in the liquor store parking lot down there . . . and, so . . . then, she went into the liquor store to get her stuff. You know, whatever she was buying. But she didn't know the person whose car window she broke was outside waiting."

Ocean pauses. I'm not sure where this is headed. "So, when Sally came back out the store, they ran her over with their car. Right there in the store's parking lot," he adds. I want Ocean to stop the story and tell me he is exaggerating. Unfortunately, he is not exaggerating.

"So, they ran her over . . . yeah, man. She was stuck under the car. She's in the hospital now. Critical condition." I stand there in silence, stunned. Todd Stovall's minimal electronica in the background vaporizes into the noise of traffic going by. The thought of performing and filming seems absurd.

"That's absolutely awful," I reply. "I'm going to pray . . ." I hear my voice trailing off again.

Nick Ocean stares back at me as I stand there, silenced with the awful revelation. It seems like he's trying to read my understanding of the situation. "Well, you can't keep messing with people and not get it back eventually," Ocean says, and looks at me, calculating.

I respond, too loudly and too emphatically, "But running someone over on purpose? No one deserves that."

Ocean nods, looking not so convinced. "I'm sorry it happened, too. But that's the way it goes . . ." We change the subject, and the afternoon continues. I get back to work. Another event at another liquor store in the neighborhood. But something is wrong. I can't get Sally Wilks out of my mind.

As I looked for people to interview, I felt no satisfaction in the news sharing that had just occurred. I felt no satisfaction in experiencing the sociality of the liquor store in action. I suppose I had failed to imagine that news sharing would or even could be like this. News sharing was supposed to be polite and pleasant. Sociality sounded proper and collegial. News sharing and sociality didn't have the sound of violence. News sharing and sociality didn't have the sound of death. I chided myself for being bright green. My approach suddenly was in question. Why on earth was I performing, filming, and talking to people at liquor stores where such crude acts of violence could happen?

The next day, I kept asking myself the question and thinking about my position and implication in all of it. I cleaned my studio-loft, worked on some chapter revisions, rendered some footage, and stretched my sore and stiff body through a reluctant ballet barre. I was processing Ocean's conversation and news sharing all day. The conversation, and the event itself in which Wilks was run over, forced the discussion of performance in contemporary social life. More specifically, the event and the conversation forced the question of performances of violence in contemporary social life, what this meant for my urban anthropological research approach, and what it meant, most importantly, for the politics of space and place in the neighborhood.

Gregory's politics of space and place analysis highlighted critical themes of policing, surveillance, performance, and violence.[1] Developed in his northern Queens fieldwork, Gregory sought answers to central questions of how and why particular groups garnered and maintained political power. Performance in contemporary time was at the core of Gregory's analysis and offers a connection to the streets of McDougall-Hunt, and the core of partially abstracted connections between social life, performance in the everyday, and

the political. Gregory writes of a report, *Police Strategy No. 5: Reclaiming the Public Spaces of New York*, published in 1994 by the office of Mayor Rudolph Giuliani, which

> outlined a broad strategy for "reversing the decline in public order" by enforcing "decency" in public spaces. . . . Citing the writings of James Q. Wilson and George Kelling, *Strategy No. 5* advances the thesis that signs of unaddressed disorder in public spaces, such as street prostitution, "boom box cars," aggressive panhandling, and graffiti, invite further disorder and more serious crimes by signaling to society that "no one cares" (Giuliani and Bratton 1994:4). This breakdown of decency exacerbates fear among urban residents, causing them both to abandon public spaces and to leave the city. Unaddressed disorder, the report argues, is therefore the first step in the "downward spiral of urban decline" (Giuliani and Bratton 1994:4).[2]

Gregory's anthropological and political-economic research, and his informants, say otherwise. Gregory writes, "*Police Strategy No. 5* provided a revisionist genealogy of urban decline, situating its origins in the crypto-semiotics of fear and 'decency,' rather than in the structures and processes of urban political economy. At the ideological level, *Strategy No. 5* appropriated the concept and language of 'quality of life' politics, narrowing its purview to *signs* of disorder that could be read by residents in their local communities."[3]

In contrast, Gregory writes, "neighborhood activists used the 'quality of life' concept to refer to a fluid and heterogeneous set of problems and issues, ranging from environmental pollution and school overcrowding to crime, graffiti, and poor municipal services."[4] The critical problem with *Strategy No. 5* was how it "reinscribed quality of life as a *moral* category which, eliding the power relations that structure urban life, drew its content from a politically shaped notion of deviance."[5] The violent act that Ocean recounted, and the harsh analysis he conducted concerning the origins of the violent act, are central to understanding how and why performance in contemporary social life is political. The "revisionist genealogy of urban decline" Gregory theorizes is at the center of the big lie, the mythical narrative, of "quality of life as a moral category."[6] Central to the McDougall-Hunt fieldwork was a layering of such discussions— through performance, through visual imagery, through conversations.

The question of why one would have discussions about city life, on the scene of what could be read as a decadent site of city life itself, was made even more vivid in thinking about the horrific performance of violence that Wilks survived. It wasn't Wilks's fault, so much as it was that of the brutality

of the political-economic-sociocultural situation of the neighborhood, that this violent act occurred. An extensive set of conditions were necessary for such a thing to happen as a result of an argument. In terms of approach, the choice to film the location of the liquor store and discuss city life with people rendered visible the "revisionist genealogy of urban decline" Gregory wrote of.[7] Filming at the stores daylighted the empirical political-economic situation of the neighborhood.

The films showed, as people in the neighborhood spoke of their complicated lives and variety of perspectives, the empirical economic injustice that preceded any sort of behavior. The decision to blast a boom box or to paint graffiti, or to organize a knitting club, or to go to Bible study, or whatever, came after sweeping political-economic-historical choreographies. Such political-economic-historical choreographies include racialized housing legislation and discrimination, employment and education discrimination and disparities, police brutality and disproportionate surveillance, criminalization of substance addiction and alternative economies, industrial and postindustrial economic cyclicality and drift, and decline of urban governance. The fact was, these choreographies were the mechanisms of urban decline (whatever the term "urban decline" connoted).

The conversations in *Vol. 3, No. 6* demonstrated both the ill-formed reasoning behind *Police Strategy No. 5* and the ways in which residents embedded in the conditions of urban decline came to interpret their own situations. I think Ocean's perspective was interesting in that in spite of Wilks's status as a heroin-addicted, housing-insecure woman in the neighborhood, Ocean felt that she could be and should be responsible for the violent situation at the store. Ocean insisted on Wilks's personhood and on her status as an agent. But the fact was, Wilks's vulnerability as a low-income, unemployed, self-identified recovering heroin addict who was an attractive, upper-middle-aged, black woman in an economically distressed neighborhood mattered. The fact was that Wilks was vulnerable as a result of these particular intersections.

The fact that Wilks was run over deliberately by a vehicle at the liquor store reflected her frailty in a superstructure in which power and domination was consolidated at a meeting of various planes. Would a wealthy man have been run over at a liquor store parking lot after a dispute? Would I? I had been performing at liquor stores for over three years and had never been threatened. This wasn't because I was a saint. This was in part because of the social capital I wielded, and to deny this would be naive.

Involvement with drugs factored into questions of safety in the zone, which was true for women in particular. Somehow, the calculus of one's right

to personal safety seemed to change if there was the perception that one was using or dealing drugs. I thought again of Taussig's diary.[8] During the *limpieza* in Cali, Colombia, this calculus of violence was in stark effect. Not only were drug users, or *viciosos*, viewed as logical targets of violence by civilians, but they were targeted for the mere fact of their drug use. A similar philosophy, although it gutted me to admit it, wound through McDougall-Hunt. There was a whisper that drug addicts brought it on themselves, even among locals who understood the political-economic challenges on the ground.

The more I thought about it, the more complicated violence in the neighborhood was, and the more intricate the relationships between drugs, money, violence, power, domination, political-economics, jobs, gender, sex, sexuality, and urban politics were rendered. At least the films captured this in real time. With the films, I was able to bracket some of these complexities into a single frame. Not that the frame would explain them or that the liquor store film events could reduce these complexities. Rather, the opposite was the goal. I hoped to show how complicated these relationships were.

Wilks was reasonable when sober. Drugs changed everything, and when they did, no grace was extended. There was no "She's drunk/high, let her be, take her home." There was the ultimate in violence; assault with a two-ton deadly weapon. There was Wilks, stuck underneath the car when EMS arrived. Thankfully, she survived and recovered. But the extreme example of violent retaliation against Wilks was connected to why it was that I was performing and filming at liquor stores.

Performing and recording on the streets lets me be there, on the scene, in a way that upends the myths of *Police Strategy No. 5* and the surfaces of the behind-the-scenes comments of *Vol. 3, No. 6*. Performing, recording, and listening to people on the streets produces a meditation that jumps from register to register, allowing space for the paradox of place to surface. CAMERA TWO PULLS BACK and my informant, Faygo Wolfson, is walking by. You won't see him on camera, because it won't be until late in *Vol. 4* that Wolfson consents to appear in one of the films.

But Wolfson is behind the scenes, making art in the neighborhood, doing the labor of living and being in a place that is, in many ways, a difficult place to be. *Vol. 3, No. 6* is one of those quiet days when I spend more time talking with people off camera than on. Instead of performing extensive choreography with a cast, I'm moving through a hustle sequence and thinking about Ocean's revelation.[9] When Wolfson walks by, I am relieved at a new person's presence on the scene.

Faygo Wolfson was a middle-aged man who lived with his family in a bright pink-and-white stucco house about a quarter-mile walk from my studio-loft. Wolfson was artistic and philosophical, wore his hair in long braids, was tall and lean, and perpetually smoking a square. His attire was relentlessly striking, and he defied gender binaries in his attire and approach to daily living. He was a master of DIY couture—his elaborate outfits were fashioned from the everyday, made fantastic with modification. He wore sequins, beads, shards of glass and mirror, in all colors of the rainbow, with flowing fabrics festooning his DIY jeans and tops. His approach to making hats was similarly conceived. Wolfson's hats were stunning. In fact, one of his hats stopped me in my tracks the first time I saw him wearing it.

Constructed from found objects of the neighborhood, the hats that Wolfson made were a meditation on making, on materiality and form, and, I thought, on the McDougall-Hunt zone itself. The first handmade hat I saw Wolfson wearing was chic black velvet, covered in diamond studs, with a long ponytail attached to the back of the hat (Wolfson's own hair, saved after a series of haircuts, and eventually sewn onto the hat). The hat also contained candy wrappers from the local gas station, liquor bottle labels from the local party store, and various additional elements from the neighborhood. Wolfson was not formally employed but he kept quite busy running errands on foot and by bus for his mother and his aunt, making hats, and writing. Art, labor, and movement were central to Faygo Wolfson's struggle for the city, as they were in similar and differing ways in the lives of Greg Winters, Hector McGhee, and Zander McGhee. Wolfson's work in the neighborhood also consolidated the paradox of place.

Wolfson's hats reflected the violence of the area—but unlike the Wilks situation, the hats represented a moving of violence in another direction— toward creation. Wolfson's hats, festooned with chicken bones from discarded food bank giveaways, he told me, used syringes (needles removed for safety), and shards of glass from the sidewalks, were violence transformed. The complexities of the neighborhood were reflected in his hats—but complexity did not mean utopia. JUMP CUT to Wolfson and me, in front of CHARLE-VOIX LIQUOR. I take off my sunglasses and feel relieved to speak with him. Wolfson gives me hope. Is it irresponsible to feel hope from an informant? JUMP CUT to a WIDE-ANGLE SHOT that captures a nearby open field, tall, 'hood grasses swaying in a late afternoon breeze, a group of older men dotted with a few women holding court behind the liquor store, uninterested in my actions, and the storefront itself, where Wolfson and I stand. Today he's wear-

ing a mesh hoodie over a purple rhinestone-studded T-shirt, black slacks with patent leather patches sewn on the front, and his hair is in a long braid.

"See," Wolfson said, pulling in the smoke off his square, "I let them do that." He gestured toward the traffic streaming by us. A beat. "They're all doing that. Why do I need to add to it? No need for that," he said. "I can do other things with myself, working in different ways. For my family, you know, and for expression . . ." Wolfson's voice trails off.

"What do you mean, exactly, when you say they're already doing that?" I ask.

"I mean, look at all these cars lining up to go somewhere. Somebody has to stay over this way; make things happen over here," he replies. Wolfson's wry reflections concerning the lack of economic opportunity in the neighborhood, and what this means to him and his family's lives, are central to understanding the connections between political economy, power, domination, and violence in the neighborhood. On a continuum with the draconian policing strategies reflected in *Strategy No. 5* and the harsh philosophy of dialogic violence Ocean presented, Wolfson and his art practice resonate at a nuanced frequency.

Wolfson is neither indifferent nor nostalgic, cynical nor naive. Wolfson is present, and he reflects the complexities I am attempting to understand. In the end, Wolfson gives me hope for the neighborhood and for humanity, and I decide that is okay. I nod slowly, understanding Wolfson's point. Wolfson's performances in the neighborhood are as urgent as performances of violence. In fact, Wolfson's performances are likewise informed by violence. I stand there, trying to make sense of this. Maybe you can. For now, the storefront, Wolfson, and I FADE TO WHITE.

Liquor Store Theatre, Vol. 3, No. 7 (2016)

FADE IN FROM WHITE:

EXT. GRATIOT LIQUOR—(DAY)—WIDE-ANGLE SHOT of Gratiot Avenue, with traffic flowing along, the open sky looming above and around us, and the awnings of Gratiot Liquor framed against the cold white of the sky. The CAMERA PANS across the street and my studio-loft looms at the corner, concrete, marble, gray, and black against the clouds. It's a chilly December afternoon. Gratiot Liquor, we see as the CAMERA PANS back around, is now shuttered—closed permanently.

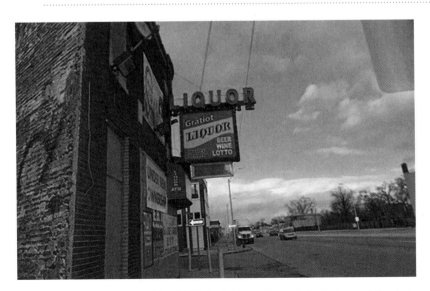

11.1 *Liquor Store Theatre, Vol. 3, No. 7* (2016). Gratiot Avenue looms in the background; the store is now shuttered and closed. The signs adorning the store in 2016, the author removed in 2018 and 2019, and they formed the *Untitled* sculptural assemblage series.

The air is frigid and the sidewalks are nearly empty, although a steady stream of cars lines Gratiot and Mack Avenues. Today, I'm alone, performing in front of a shuttered store. I wonder if the store will be torn down. We've shifted from eight operating liquor stores in the neighborhood to seven. I'm not entirely alone, it turns out. I've invited Zander McGhee, Hector McGhee's nephew, to help me film since Todd Stovall is unavailable, and it's best to have someone behind the camera (if possible) when I'm in front of it. Zander McGhee nonchalantly hops off the Number 34 Gratiot Avenue bus, wearing a camouflaged winter hoodie, baggy jeans, and a pair of sneakers.

The CAMERA PULLS BACK and Zander McGhee saunters toward me and my unmanned Nikon, as the cars on Gratiot are stacked up, waiting, at a red light. I'm performing in front of the shuttered store, and I can see in my peripheral vision some of the people waiting in their cars watching me and McGhee. Are they wondering why this young man is rushing toward me? Or are they wondering what each of us is doing? Or are they just bored drivers, waiting for the light to change? I'm not sure, so I remove all doubt and greet McGhee. I break performance mode and wave at McGhee as he approaches. I want to avoid any doubt or misunderstandings on the part of passersby. We give each other a brief, platonic half-hug and I begin to show him how to work the Nikon. McGhee listens intently as I briefly show him how to shoot in automatic and manual modes, how to zoom in and out, and how to pan his shots. He's a quick study, even in the frigid air.

However trivial these seconds seem now as I write these words, I felt an urgency at the time to make clear McGhee's innocence to the passing cars. The politics of this thought, of these brief moments, and my concern for McGhee being in danger through a possible misreading of his actions revealed a great deal about the reality of the neighborhood, the city, and the world for young black men. Inequality of education and employment opportunity; disparities in policing, surveillance, and police brutality; and disparities in arrests, convictions, and incarcerations caused little moments like this one to be infused with such fine-grained awareness of one's surroundings, the interpretations of others, and the perceptions we may unwittingly generate.

JUMP CUT to a MEDIUM SHOT of Gratiot Liquor behind me. I'm performing a slow, methodical sequence of hand movements while Zander McGhee films. It's well below freezing. McGhee is not wearing gloves (my hands are burning in pain even with gloves). Still, he sets up shot after shot, take after take, and shows no signs of being bothered by the cold. In fact, it's so cold today that there are no passersby, save for the men loading food donations from a produce truck into the nearby church-run pantry. I wonder aloud if

McGhee thinks anyone would walk by at all. "Too cold," he replies. "I doubt it . . . but I'll talk to you again," he jokes. I agree, delighted by his suggestion.

"Can you tell me about this neighborhood?" I jump right in after we change up the shot and he's miked.

"People are looking for work," McGhee replies. "People want work that's close to their homes, and there isn't much around here. You know, if you have to travel by bus to a job, that's money. And if your job isn't making too much to start, it's an issue to deal with. So, the biggest thing now in this neighborhood is the need for work," he concludes. Both wage labor and affective labor were continuous themes in McGhee's stories of his struggle for the city. Part of the labor, in fact, was the pursuit of decent-paying work. Because of the limited opportunities in the neighborhood for formal wage labor, finding work seemed itself to hold an overdetermined status in the zone. It was an intense labor of effort to find legitimate work. To support a family, one needed work. To find decent work, often one would need the support of a family to take the time to search and locate the opportunity through application and networking processes.

It's so cold that we wrap the shoot soon after, and at my suggestion, when my hands can't bear it any longer. Once in the car, I ask if twenty dollars is decent compensation for his hour of work. He looks surprised. "I didn't know for sure if you'd pay me," he says. "It's too cold not to," I toss back. "Although it's cold, we got a lot done," I muse. McGhee nods. "Yeah, you got plenty of dance shots, and the interview was cool. Short and sweet," he says. We climb into the Cadillac and drive to the nearby ATM.

As we sit there, I'm thinking about how months ago we met at a filming, and today Zander McGhee filmed for me. Talk about reversal of the ethnographic gaze. It was a strange feeling, but it wasn't wholly satisfying. In some ways, it felt like the space between us was growing more and more. I want to do so much more to help McGhee. Here I am handing him a twenty-dollar bill, which is in fact a relatively decent hourly wage in cash, but given the fact that I'm now showing videos around the world at fancy exhibitions, twenty seems inadequate. Yet I can't afford anything more.

I've been cobbling together the financial resources to do this work—no grants, no fellowships, no benefactors. While I wanted to do more for McGhee, the fact was that financially I couldn't. I had executed a reversal of the ethnographic gaze, and I had effectuated a destabilization of the assumed roles of ethnographer/artist and informant/subject. It seemed the question I had landed on was—okay, so . . . now what? Because of Zander McGhee's youth, his need for opportunities, and his awareness that working with me

might produce some opportunities, this "now what" question seemed to inflect our ethnographic relationship. McGhee, who is studying for a mathematics exam at the college where he has been newly accepted, asks if I'll come by again to work on math. I agree, and we also agree to talk more about life on the east side.

It's a rainy Sunday evening, and I'm sitting with Zander McGhee at the kitchen table, in the east-side condo he shares with his family. Previously, when I interviewed Zander's uncle, Hector McGhee, I noticed photographs of the famous burlesque performer Lottie Claiborne all over the room and found out that Claiborne was Hector McGhee's aunt and Zander McGhee's great-aunt. It took a while for Claiborne's presence at a kitchen table, via photographs all over the nearby family room and breakfast nook, to sink in. Today, it's really sinking in as I sit with Zander McGhee, preparing to discuss city life with him off camera.

Lottie "The Body" Graves Claiborne, as I mentioned earlier, was an international American performer who had a successful career as a burlesque entertainer alongside numerous top jazz musicians and performers.[1] Claiborne's presence in the home (in both photographs and in person) when I orbited into the lives of Zander and Hector McGhee was a powerful example of the presence of art, labor, and movement in the neighborhood. Claiborne graciously greeted me and, while I didn't interview her, was supportive of my efforts to learn about the neighborhood through performances on the streets and sidewalks. Claiborne was said to have performed and associated with artists including Louis Armstrong, Aretha Franklin, Billie Holiday, and Dinah Washington.[2] Claiborne's presence, bracketing my conversations with both of the McGhees, is an uncanny reminder that art is already in neighborhoods. Regardless of what an artist does—wherever she goes and whatever she makes—art is already there. The same is true concerning a person studying people, also known as an ethnographer. The expertise—the knowledge of the city—is already in neighborhoods. Thinking, understanding, meaning making, and creating order out of the onslaught of information in which they are immersed is what people do.

As Jackson writes, "people play with and manipulate these class-inflected actions in order to get as much social mileage out of them as possible— and to make sense of a hierarchical socioeconomic order by binding it to controllable social behaviors."[3] Rather than languishing as unwitting characters in a social hierarchy, Jackson's informants are alive with thought and agency in performances of—or against—their supposed economic positionings in Harlem in the late 1990s and early 2000s. While self-aware performances

do not lessen the impact of police brutality, employment discrimination, or redlining, such performances demonstrate the keen awareness people had concerning their own circumstances—a concept underdetermined in much ethnography and historiography of low-income people. As Marx pointed out, the division of labor was more the cause of social conditions than the effect—and people understand this.[4]

When we met, Zander McGhee was an aspiring college student, recently accepted at a local college, and working with an admissions adviser to finalize his registration, financial aid, and placement exams. McGhee's quick mind contrasts with his carefully probing eyes. His eyes seem to move in slow motion, calculating everything around him. He's about six feet tall, with an easy smile and a smooth voice. He has a love for adventure that's palpable as we speak. He leans back in his chair, takes a drag on a cigarette, and tells me about growing up in the city.

In the middle of a tropical Detroit summer in the mid-1990s, a teenage girl named Lena McGhee gave birth to a baby boy who was to be named Zander McGhee. "My mom was young when she had me," McGhee says. "I was the only child at first. Basically, I remember the east side because my childhood was spent there. That's where my family was. My mom had a lot of stuff going for herself. She was taking nursing classes and stuff like that. So, I was on the east side with my grandmother until she died. Then, we moved to the west side, and I was in middle school then," he concludes.

In the late 1990s just before the century's turn, the sudden passing of Zander McGhee's grandmother (Hector McGhee's mother) had a major impact on his life. Zander described the stability he had known as careening off balance without warning. As he stated, the family moved abruptly from the east side of Detroit to the deep west side off Joy Road. McGhee stares at the ornate gold placemat underneath his outstretched fingers as he speaks. "We had to really adjust to not having any grandparents," he says. Still, McGhee found ways to have fun in spite of the challenging time. "Around that time, we had the ice cream lady around the corner—she used to have the cookies and cream cups. Ice cream, summertime . . . bike riding . . . we'd go riding our bikes around, about twenty of us from the block . . . for about four or five miles, then come back. We used to do flips off porches—we would do flips on mattresses—we used to see who could cap-wheel the longest in the middle of the street." McGhee pauses, smiles as he reflects, and continues. "Clubhouses . . . snowball fights . . . we used to shovel snow for money." Although Zander McGhee's fond memories of his west-side life glitter with the excitement of childhood and being freshly alive in a city, his reflections also quietly

betray the stress and trauma he experienced following his maternal grand-mother's unexpected death.

He took a drag on his square and thought a moment. "Around that time, I went to a couple group homes. There were problems in the family. My pops was caught up in another marriage. So, he was trying to marry some-body else but trying to mind me as much as he can without getting into it with my mama or whatever. Man, we used to do a lot of stuff in the neigh-borhood though," McGhee says, turning his attention back to more shiny, ef-fervescent memories. It was clear that back then, as a preadolescent, McGhee was in over his head with the familial responsibilities that emerged with his father's departure for another family and his grandmother's sudden passing. "In middle school by this time I was taking my little brother to school and I was going to school, and my mom was working many shifts," McGhee tosses.

The challenges woven through these simple sentences for a young boy adjusting to a new life were reflected in the subsequent tumult, which saw Zander attending some four middle schools and moving through multiple group homes for children before he ultimately graduated middle school. Zan-der McGhee shifted middle schools repeatedly because he was moving from group home to group home, and he would have to shift accordingly to go to the nearest neighborhood school. Describing a dizzying choreography from school to school in a calmly matter-of-fact tone, McGhee reflects, "So . . . I went to Brooks Middle School, I went to Coolidge Elementary . . . and when I left Brooks I went to Drew for a little bit, a few months, and by me being in placement, I had to finish the rest of school that winter so I went to four different middle schools my whole time to get to high school." He pauses.

Understanding the pressure of human adolescence for any young per-son, combined with bouncing from school to school, it seems to be a miracle that McGhee could graduate from middle school, on time, and with hon-ors, from Murphy. "By the time I got to Brightmoor where I finished middle school, I went to Murphy Middle School—that was my last year—but I was making the honor roll. I was making like 3.5 or higher and stuff like that," he reflects. Zander McGhee's central stories of childhood, it seems, are focused on movement—biking, flipping, popping wheelies, moving through the city. He focuses on positive experiences in spite of the challenging hand of cards he's working with. However, the stark realities of what he had to overcome as a young boy remain clear. As McGhee sits in his east-side family home and tells me the stories of his life, he offers a vivid glimpse of complex relation-ships between past and present.

Living deep west in a zone referred to at turns as Brightmoor and Old Redford, McGhee was an active and engaged young student at Redford High, smack on Detroit's famous Eight Mile Road off Woodward Avenue. The corner has since been covered over with concrete, with a big-box retailer where the school used to be. Zander explains, "They built a Meijer on top of it now, but we got our memoriam for the Huskies, in loving memory, because they're dead now—there will never be another Husky." He smiled and took a tiny sip from a forty ounce. The question of where one went to high school was often discussed in Detroit sociocultural positioning. In Detroit, it seemed, where one went to high school said a great deal about one's socioeconomic positionings at the time in the city. It was geographical, social, cultural, and particularly economic. There was a kind of calculus of social capital, geographical allegiance, of belonging, that rested in this question of high school. It concerned Detroiters who were truly from Detroit proper, as in the city of Detroit only (excluding suburbs). If someone claimed to have grown up in Detroit, and the question of where you went to high school came up, and the person said, "Suburb xyz High," then the person was considered a Detroit poser by hard-core local standards. If you went to Cass Tech (like I did) or Renaissance, you were considered a Detroit elite. Renaissance was even more elite than Cass, perhaps. If you went to King, you were almost elite, but not quite, perhaps. Deep east and deep west schools, also known as neighborhood schools, tended to reflect hard-core street smarts, tight geographical allegiances, and, in many cases, lower socioeconomic positionings.

In the McDougall-Hunt zone, teenagers went to a variety of schools. Many young people attended King High School, which was just a few miles from the zone on Lafayette Street at the time. However, many caught the Gratiot or Mack Avenue buses out of the zone to attend magnet schools, charter schools, or, in some cases, relatively nearby neighborhood schools. Toward the end of my fieldwork, I got to know a teen in the zone, Blake Smith, through an introduction by Greg Winters. I was looking for a skateboarder to participate in a performance event I'd been commissioned to produce by Cranbrook Art Museum's curator of contemporary art and design, Laura Mott, and Greg Winters went to work as soon as we spoke about it. A few days later, he introduced me to the grandson of one of his friends in the neighborhood. Blake Smith, eighteen at the time, was a knife-thin, stylish, all-black-wearing skateboarder and punk rocker/hip-hop emcee from McDougall-Hunt. His flawless brown skin, shock of curly hair, and calculating wit were distinctive. When I met him, he didn't bat an eye at hearing

about the upcoming performance and my request to collaborate with him as a skateboarder.

It turned out, he was also a virtuosic breaker, and he proceeded to execute a series of perfect flares on the spot, right on the sidewalk, when Winters introduced us. Smith also shared his lyrics and beats with Todd Stovall. His lyrics were fast, sharp, and ironic—somewhere between a very young Danny Brown, Big Sean, and Eminem. Smith went to King High School, and it was clear that he was extremely intelligent and cultured for his age. When I introduced him to some of my students, it turned out that he already knew one of them from the local art scene. Todd Stovall and I invited Smith to our studio to sit in on rehearsal, and he didn't bat an eye, again, coming into our bank-turned-studio-loft and viewing us working.

In meeting and hanging out with Smith briefly through the performance event in which he participated, it was clear that McDougall-Hunt not only contained adult artists like Tyree Guyton and Faygo Wolfson—brilliant teenage artists like Blake Smith were in the zone, developing, thinking, living, and hungry for opportunity. In the case of Blake Smith, the artistic, alternative (by any measure) persona he embodied could be considered an unexpected representation of young black masculinity. Like the four different black men who were my key informants, Smith's performance of black masculinity was in contrast to mainstream depictions of conservative black respectability and/or black pathology. Like Zander McGhee, Mahon, Clark, and other young people I spoke with in the neighborhood, Smith was looking for things to do that were interesting.

Embodying neither respectability politics nor pathological narratives, these young men represented what cultural theorist Mark Anthony Neal called a "new black man."[5] The new black man, Neal theorized, was not really new. In daylighting discussion of the new black man, rather, Neal hoped "to create new tropes of black masculinity that challenge the most negative stereotypes associated with black masculinity, but more importantly, counter stringently sanitized images of black masculinity, largely created by blacks themselves in response to racist depictions of black men."[6] The embodiment of a new black man (whether or not the man was heterosexual was not the point) might be "queered" by an "intellectual" demarcation, Neal theorized.[7]

Likewise, a positioning as a black man in the so-called 'hood, beyond the confines of a traditional capitalist (gainfully employed at a company), heterosexual (married and/or having children), and/or ghetto (drug user or dealer) frame, would be likewise queered. McGhee and the other men I followed in the zone, it turned out, regardless of gender identity or sexuality,

were new black men. Do I mean that these men were an aberration? Not at all. On the contrary, new black men are the norm. In other words, they are new to mainstream knowledge, perhaps, but they are not new to themselves or to their neighborhoods.

Unique, subjective, idiosyncratic, black men have existed since racial categories were created. What was new about the men is our ability to recognize, to theorize, to critique, and to embrace as complicated subjects the men in front of our faces. Young men like McGhee and Smith were present in the zone, and the complicated cultural, political-economic environment coursed through their lives as well. In particular, Smith's and McGhee's young black masculinity, as they looked for opportunities in the neighborhood and beyond, demonstrated the complex nature of masculinity, opportunity, meaning making, and purpose among men of all ages. In the warm east-side breakfast nook where Zander McGhee and I are sitting, surrounded by industry photographs of his famous dancer great-aunt, it's so cozy that condensation beads up along the curves of the forty ounce Zander McGhee so slowly swilled. A homemade blackberry pie sits on a credenza, contained in Tupperware. Cigarette smoke clouds the room; as usual, the air is thickly perfumed with domesticity—cooking, cleaning, dinner, cigarettes. McGhee continues his story.

McGhee tells me he was a dedicated student during his freshman and sophomore years and during that time participated in numerous activities and kept his grades up despite raising himself and his younger brother following his grandmother's passing. He stayed away from the block, as he put it, by keeping busy in school. "I was in Brightmoor then, so I got to know the neighborhood over there. Met a couple people, joined the robotics team, was on JROTC for three years. I was the captain of the robotics team. We built a robot to compete in the national competition, and we traveled to Vegas and to Atlanta, and out of a thousand teams we came in the top one hundred. When I was competing against them, Hawaii and Japan had the best teams." He lights a square and takes a slow drag, nodding at the fond memory. His precarious living situation during high school crept into the background in his descriptions. Unfortunately, his living situation when I was hanging out with him over the course of months was still unstable, some ten years later.

"We did better in Atlanta, because we had competed in Vegas first. We were in the Georgia Dome in Atlanta. We were in the Omni Hotel across from the CNN building. I was young," he reflects. Zander McGhee's work of moving through school activities and moving through the country with his activities as a way of staying away from what he described as happening in

the streets was a constant theme. A beat. "In high school, I wasn't really on the streets because I was doing all this kind of stuff. I knew people who were in the streets, somewhat. You know. You gonna mix with the neighborhood. We all grew up with each other, so of course, but it was my choice not to get involved with it. Trying to travel or get on the next trip, so I caught a couple, I did catch a couple good opportunities."

Keeping busy, and keeping moving, are presented by McGhee as oppositional, or resistant, to being in the streets. A beat. "I was on the golf team," he continues. "You'd be surprised. You'd never think I'd be doing that type of stuff." But he did stray from his focus on golf, robotics, and Junior ROTC, although the details he chose to share with me were limited. McGhee continues, "So, I was doing the same thing my first two and a half years. Then, I started slipping off." After graduating high school, McGhee tells me, he did not go to college. Instead, he began traveling around the U.S. with only his loose ties with friends and extended family in various parts of the country.

Again, affective labor and movement were central themes. He didn't have money for college, so a bus ticket or a one-way flight across the country served as his entrée to secondary education. "So, I started in DC and I ended up in Florida right outside of Orlando. I had a little spot, and got a little job, had a place to stay at. So, I moved out there. I actually moved out of town when I was nineteen. I didn't come back to Detroit until I was twenty-one or twenty-two. It was good to move. I had to learn," he muses. After returning to Detroit following movement up and down the East Coast to the south, McGhee struggled to find work. His struggle continued up to the moment of our discussion that day at his great-aunt's kitchen table, as he explained his pressing desire for independence.

In considering Zander McGhee's travels after high school, I argue that he created for himself a DIY gap year, or even a DIY college experience. The gap year, something people with means have been doing for quite a long time, refers to a period of travel or intense exploration after graduating high school or college, before moving to college full time or to work full time. To do a gap year (or years) in style and with opportunities in place takes resources—money and access. Zander McGhee constructed his own gap year/s despite not having access to such resources.

McGhee traveled across the U.S. and tried living in various states including New York and Florida, working and earning a living as he went. McGhee's gap year was art, labor, and movement; his DIY gap year demonstrated what I term a powerful human universal of yearning for self-discovery and represents the subjectivity of the new black man. And yet the chasm between

the DIY gap year and a gap year studded with resources and opportunities is vast. During a DIY gap year, if a young person gets in trouble of some kind, it will be much more difficult to navigate. If money runs out or spots to sleep on a couch run out, the backup plans are undefined and unclear. The young angst that is a human universal, the desire to move and to explore, has stark divisions in its choreography. Referring to Lepecki, the economics of a gap year are choreographed, or choreopoliced, by economic class. A critical Marxist discussion of labor is a structural support in thinking about McGhee's DIY gap year.

For Hardt and Negri, writing in the late twentieth and into the twenty-first century, Marxist theory of material labor and use-value required intellectual expansion.[8] As post-structuralist neo-Marxists, Hardt and Negri conceived of immaterial labor, which offered an understanding, particularly applicable in contemporary postindustrial economies like Detroit, that not all labor could and would produce tangible goods. Affective labor—or labor that produced feelings and experiences rather than objects—was a form of immaterial labor.[9] A gap year was affective labor, machined into time and space.

A gap year would allow a young person to gain experience living life in the so-called real world, and would allow a person to consider the possibilities of study and of thinking and living. A gap year, in short, while possibly not beneficial monetarily, would provide a host of cultural experiences that would help a young person forge ahead more successfully toward college, work, or whatever. However, the gap year is economically cruel. If a young person doesn't have the familial support to finance a gap year, it might become a financial burden, or it might be impossible. And yet the desire to travel, to expand, to learn, and to grow is not limited by socioeconomic class. In spite of his economic class, McGhee was brimming with curiosity, motivation, and a desire to travel and see the world.

Supporting a post-Marxist labor and economic analysis, McGhee explains how his DIY-style gap year, however desired at the time, caused complications when he returned to Detroit. "Right now, I'm in a situation where I have to get back on my feet. I mean, where I can pay my own bills without depending on somebody. Where I have my own house and it's my house. No roommate. I could rent it out, or let somebody stay temporarily, but no roommate," he asserts. It's clear that McGhee is in a tense financial situation, but he never goes into much detail beyond the day-to-day. McGhee is a study of complexities. He's open and invited me to his great-aunt's home. And yet he places substantial partitions around parts of his life and draws lines through

certain of my questions that he won't answer fully. For instance, he does not discuss his romantic relationships as part of our extensive discussions, ever. On several occasions when I try to broach the subject, McGhee doesn't respond with any level of detail. Instead, he vaguely mentions having to break up due to moving—geographically or ideologically—with a former partner. No further details are ever given.

I choose to respect his boundaries. Respecting boundaries, as an ethnographer and as a person, means everything to me. And even with the partitions McGhee placed around certain topics, it is clear that he has vast experience condensed into his everyday life. McGhee has dealt with tremendous challenges before reaching his twentieth or thirtieth birthdays. He is not a dope dealer, not a stick-up man, not a hustler. Regardless of the income bracket of his family, of the experience of bouncing through group homes for children at the speed of light, McGhee has crafted meaning in family, in work, and in movement. McGhee has goals he hopes to pursue. His life on the east side is not exotic—and yet, he has overcome a great deal.

Zander McGhee often thinks and talks about his future. In his mid-twenties, he shares his thoughts about approaching thirty. He says, "Even to this point, I learned a lesson that's going to hold me up when I fall into my thirties. By your thirties, you either come up or come back down." He crushes a square in the smooth porcelain ashtray and takes a break for a moment from our discussion, gesturing to me to pause the tape. Great-aunt Lottie Claiborne has called to him from her room. A vivacious octogenarian, Lottie Claiborne is at the moment recovering from a strained ankle.

McGhee returns to the kitchen after coming to her call, cuts a slender slice of blackberry pie and pours a tumbler of water. He brings these things to his great-aunt and invites me back briefly to meet Claiborne. "He's a sweetheart, this guy," Claiborne says as her velvet brown eyes sparkle.

When we return to the breakfast nook and our discussion, McGhee stares intently into the distance. "As a man, you feel like you have to take care of your household," he says. "Your wife, your kids. It's different than going and visiting somebody and babysitting—then you go home, peace and quiet. It's different, day in and day out, you have to deal with your own mess..." His voice trails off and he swirls his forty ounce around, not sipping, but thinking as he whirls the liquid around in the glass bottle. "Or," McGhee continues, sipping slowly, "you can run away from your own mess and let somebody else clean it up, but what's the fun in that?"

McGhee's eyes burn into mine, and I nod in response. I'm not exactly certain if McGhee is talking about himself, his father, or his uncle, or if he's

speaking generally. "Other than that," he says, "you might see me on the TV screen one day. No telling what I'll be doing or what I'll be selling. I'll be in your book, as long as you don't make me the kingpin dope dealer. That'll be all right. I'm looking for work. I'm trying to do the school thing. I'm living life." A beat. "For the most part, that's pretty much it," he concludes. I look at Zander McGhee's fresh face, full of hope and clever wit, and also full of an awareness that the opportunities around him are limited versus his dreams. I lean back and listen, nodding slowly and dumbly, wishing I could do more than run this damn audio recorder. There's nothing more I can say, nothing I can do right now, other than document, I realize. So, together, we FADE TO WHITE.

Liquor Store Theatre, Vol. 4, No. 1 (2017)

FADE IN FROM WHITE:

EXT. BEER WINE LIQUOR—(DAY)—MEDIUM SHOT of a strip mall storefront. People are milling around. It's January, cold but mild enough to be rainy instead of snowy, and President Trump was inaugurated today. The name of this store, BEER WINE LIQUOR, pulls no punches. Beer Wine Liquor is embedded in

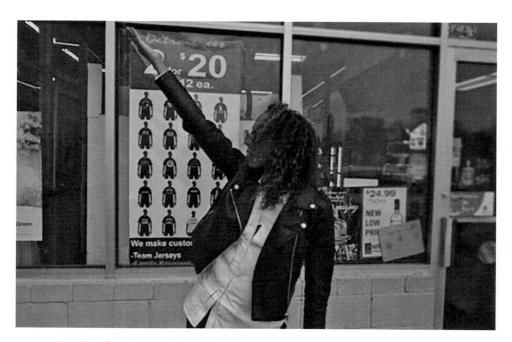

12.1 *Liquor Store Theatre, Vol. 4, No. 1* (2017).

a constellation of stores including a low-rent grocery store called Save A Lot that charges ten cents for plastic bags, a beauty supply store, and a religious candle store. A group of older men hold court nearby and Gratiot Avenue traffic rolls along.

Although there's a steady stream of customers and passersby, today no one wants to talk to me on camera. As usual, I am spending a considerable amount of time talking to people off camera, having discussions with people who did not wish to sign a consent form of any sort. Today is the first filming of the fourth year of the project, and to date there has never been a filming in which no one talked to me. However, like today, there have been a number of filmings where no one wants to talk on camera. These days tend to result in lonely, searching, mournful-looking videos that bother me. I worry that they look narcissistic to someone viewing without context. These lonely videos are also, simply put, sad looking to me. Am I simply dancing around at stores, silently, not speaking to people, oblivious to my surroundings? Is it an exercise in melancholia? No and no. The accidentally silent videos happen only when people don't want to talk on camera—but people always talk behind the scenes, thank God.

And then there are the streets. The streets, like Gratiot Avenue today, talk to me. The streets are actually pressing figures in the neighborhood for their mark making on the ethnographic landscape. Although *Vol. 4, No. 1* isn't vibrating with the rich conversations of other videos, today's quiet scene lets me pull back and think about landscape, access, power, domination, and the politics of place and space. At any rate, with President Trump's inauguration today, there's a feeling of spectacle in the air. I felt the need to get out on the streets and sidewalks, and think. The Inauguration Day *Liquor Store Theatre* event was not a sort of dancing in the streets as festival. Rather, this was performance as medium, as analytical tool. As Randy Martin wrote, "movement is possible and unavoidable—it is intuitive for those who dance or attend to it fully. But the social significance of this goes beyond what is formally recognized as dance to apply to life itself and therefore to politics—the uncertainties and motions of life in the contemporary world."[1]

The documented performances and conversations on the street are a way of negotiating and exploring "uncertainties and motions of life in the contemporary" in McDougall-Hunt and in the world—like the inauguration of a possibly deadly president, for instance.[2] Along these lines, fusing the interests in medium in art making and in the substance of the world, the

video work becomes a postminimalist statement, in which the empirical and the philosophical are reconciled with the making of art and the doing of ethnography.[3] Here, the postminimalist frame was poured with a foundation of neo-Kantian interests including philosopher Jean-Luc Nancy's critique of mythical community and philosopher Angela Y. Davis's critique of mythical freedom-in-stasis.[4]

For Nancy, the idea of a fixed community was doomed from the start; by definition, an attempt to distill a variation of complex bodies into a single, fixed body would fail. For Davis, the notion of freedom as fixed was likewise doomed. Reflecting on a freedom song of southern U.S. black people during the twentieth century, Davis wrote, "They say freedom is a constant dying / we've died so long we must be free."[5] For Davis, the turn of phrase evoked irony, self-reflexivity, and hope. The postminimalist perspective I take machines the theories of both Davis and Nancy, bringing a philosophical approach to political questions into reality—at the scene of the liquor store by performing, discussing, and documenting. In other words, I machine ideas. I place them into a praxis. The critique of simplistic ideas of human existence—freedom and community—is revealed on the streets. Likewise, the complex irony of the crushed political-economics of the neighborhood alongside the vibrant cultural and intellectual lives of the people who live here reveals itself.

As I perform today, the smell of savory fried chicken zooms from the front door of Beer Wine Liquor each time a patron enters or exits. Chilly winter rain beads up on my faux-leather jacket, my fingertips grow numb, and my Nikes grow sidewalk-worn from too many piqué turns and too many chassés across the concrete. My eyelashes collect mist, and my hair grows damp. As I move, I watch Gratiot Avenue. Gratiot is, I think, somewhat like the racist/capitalist economic apparatus of the city's superstructure itself. If one has a car and a destination, one is good to go. If one has even a bus ticket and a destination, there is a good chance. If one has nowhere to go, and no way to get there, Gratiot quickly becomes dangerous. Traffic flies by with urgency. Either you move or you get out of the way.

Those in cars had little concept, mostly, of what it was like to be a pedestrian crossing Gratiot at its busiest points. It was difficult and accidents were frequent. Pedestrians getting hit on Gratiot often seemed to be low-income people or children, like Hector McGhee's brother who was hit during their childhood, who were walking long distances between bus stops or destinations. Gratiot also personified a collective forgetting that merits cri-

tique. Unbeknownst to most contemporary Detroiters, Gratiot Avenue was a pre-French and pre-British spatial form. Developed as a hunting and traveling path by Native Americans, it predated the transfer of Detroit from Native American, to French, to British, and also predated modern capitalism's structural emergence in the city.

CUT to my studio-loft. We're orbiting away from the scene of *Vol. 4, No. 1* for a bit, but we'll be back. One evening, I sat in my studio-loft, listening to Gratiot Avenue slide by to my left and the vintage white radiators gurgle moist heat to my right. I was pondering the politics of Gratiot Avenue. Then, a shocking news headline appeared in the *Detroit News*: "Gilbert—I'll Build Jail for Gratiot Site."[6] The politics of the news were untenable. The article explained that billionaire real estate investor Dan Gilbert's company, Rock Ventures LLC, was proposing a land-for-jail deal.

Gilbert's companies were controversial in Detroit, in large part due to the alleged role of one of his groups, Quicken Loans, in Detroit's residential mortgage foreclosure crisis. Quicken Loans, previously ranked as the country's second-biggest originator for direct-to-consumer mortgage loans, was accused of hundreds of improperly underwritten FHA-insured loans by a U.S. Justice Department lawsuit. An investigation conducted by the *Detroit News* determined that 52 percent of the Detroit homes for which Quicken Loans originated FHA-insured mortgages over the years 2005–2014 that ended in foreclosure were blighted and in need of removal. Moreover, the Justice Department found evidence of mortgage origination fraud and predatory lending across various Quicken Loans companies.[7] While Gilbert was lauded by many as a positive economic force in the city for his role in developing the downtown area, the U.S. Justice Department lawsuit against Quicken Loans and its $32.5 million settlement proved a devastating connection between low-income and black people's unjust loss of their homes and the enrichment of Gilbert's increasing real estate and business empire.[8]

In the proposed jail deal, Rock Ventures (Rock) would take over a new jail building that Wayne County had been struggling to complete. In exchange, Rock would relocate the jail to an area further from the city center and would take ownership of the former jail site, located at the foot of Gratiot Avenue, closer to downtown Detroit. At this Gratiot Avenue site, Rock would build a major-league soccer arena. Rock's proposal, hand-delivered to Wayne County offices, was striking in its connection of the U.S. carceral system and capitalism—both urgent discussions of the right to exist in a just world.

The Rock Ventures proposal, submitted by Dan Gilbert and a business partner, Tom Gores, appeared unabashedly beneficial to Rock. The proposal requested immediate control, with no cash outlay by Rock, of the current Gratiot jail site and a $300 million payment to Rock from Wayne County. With the $300 million, Rock Ventures would build a new eight-acre, 1,600-bed jail and juvenile detention facility at the new site, between East Warren and East Forest on the city's near east side, just east of Interstate 75.[9] With the Gratiot site Rock Ventures would receive in the proposal, the company planned a $1 billion mixed-use development anchored by a 23,000-seat major-league soccer franchise team to be owned by Gilbert and his companies.[10]

Located at the edge of downtown Detroit, the Gratiot site would have a significant impact on Gilbert's current real estate holdings. Gilbert purchased property worth over $2.2 billion in downtown Detroit beginning in 2011, buying and renovating over ninety-five properties and leasing them to large national tenants.[11] It was daunting that in the proposed jail deal, $300 million in taxpayer funds would be transferred to Rock Ventures to build the jail, along with the Gratiot land. The construction of the jail, under Rock Ventures, would become an entirely private project—removing public accountability and oversight. Rock Ventures and Gilbert's companies had no previous experience constructing criminal justice facilities. The Rock Ventures proposal presented a direct consolidation of criminal justice and capitalism, financed by taxpayers and outside public accountability, as described by one of the company's bosses.

"We will deliver to the county a modern, consolidated criminal justice center with no risk and at the same dollar amount they believe it would cost them to complete the project on Gratiot," Rock official Matthew Cullen said in a company statement.[12] Aside from the questions of ethics in integration of taxpayer dollars, jail construction, and transfer of county-owned land to private companies, the mathematics of the Gratiot site had to be considered. In 2013, after the county began construction at the Gratiot site, the project was stopped after officials found the construction effort was $90 million over budget. This $90 million was on top of $150 million in taxpayer-funded bonds drawn by the county.[13] Wayne County calculated that an additional $200 million would be needed to complete the Gratiot site construction project; Rock's request for a $300 million payment plus the Gratiot site land set forth a shrewd business deal for Rock, at taxpayer expense. The blunt math of the proposal revealed the unified force of racism/capitalism; I could not obscure the empirical reality as I wrote.

The Gratiot site was once again, thinking back to the Blackburn Rebellion of 1833, mired in a controversy where captive black people were at the center. What was at stake was similar—ownership and wealth at taxpayer expense in the Rock case and at the expense of black people's life and liberty in the Blackburn case. The racial disparities in incarceration in the United States also figured into the equation, and the audacity of Rock to propose such a deal in a predominantly African American city. African Americans made up nearly half of the 2.3 million people incarcerated in the U.S., although they were 12 percent of the population and committed crimes at rates like whites.[14]

In spite of this fact, disparities in incarceration are monstrous. In spite of the equal offenses across racialized groups, in some states in the U.S., African American men are sentenced to prison for drug-related offenses at rates twenty to fifty times greater than white men.[15] In sentencing, black people suffer much harsher sentences. Black nonviolent drug offenders are sentenced on average 58.7 months—roughly the same sentence the average violent white offender receives (61.7 months).[16] Whether the Rock deal was good for taxpayers and the overall well-being of the city, time would tell. However, the entrenched racism and resulting disparities in the U.S. criminal justice system were empirically confirmed, and the insertion of Rock Ventures into this web of power in Detroit was stunning for its replication of cycles of racism/capitalism.

With a multibillion-dollar deal mired in racism and capitalism happening down the street from my studio-loft on Gratiot, at the site of the Blackburn Rebellion, how could I change my argument that racist/capitalist enterprises in Detroit operate as a single force? I could not. I would not. The starkness of the Rock Proposal was undeniable. I had to dance it out in the street, document it, and write it here. This deal exemplified in literal, empirical terms, spoken by Rock itself, the feeling of so many deals before it. I had to name it. I had to tell it. I had to write it. Gratiot had again proven to be a complicated, powerful informant, mired in the single force of racism/capitalism.

As cars zipped through the frigid air, Gratiot whispered to me with its silky-traffic soundtrack—name, document, describe, and analyze. The audacity of the Rock jail deal came with anxiety for people in the neighborhood. While bankers and businesspeople were set to make money, people in the neighborhood were anxious. People were anxious about the future of the neighborhood, and the future of their access to amenities like the RiverWalk and Belle Isle. As development pushed east, Gilbert's interest in the jail site

at the foot of Gratiot Avenue proved people's concerns about development's impact on the most vulnerable residents to be merited.

JUMP CUT to a MEDIUM SHOT in front of Beer Wine Liquor. The rain continues to mist as people stroll by, checking out the performance or simply going about their errand running. Car doors slam and shopping packages are placed in trunks. The group of retirees holding court nearby continues. They watch, and even talk to me from a distance, but don't seem interested in being on camera. Sandy Larson, a woman I know from the neighborhood but haven't seen in a few years, pulls up with her husband in a battered midnight blue van. She is filming the lonely solo performance with her smartphone, sitting in the passenger's side of the van. After a number of minutes, I end my shot, and Larson beckons me after she ends hers. I don't know her well, and I don't know her husband, Reggie Larson, at all. I met Sandy Larson, actually, back at the garden a handful of years ago. She helped me plant kale and trellis tomatoes for a few hours one year, and another year, we planted strawberries with a group of my friends. I hadn't seen her since.

Sandy Larson is medium height, with deeply toned brown skin and a shrewd gaze. I don't really want to approach Larson's car. For some reason, it gets on my nerves when people beckon me to cars. It happens sometimes. But I know it's safe and that Larson means no harm. I walk over to her. The van where Larson and her husband are sitting is festooned with personal items, household goods, groceries, and other items I can't discern. It looks like they're living out of the van. I try to focus on Larson and not peer into the van anymore. "You still doing this, huh, Maya?" Larson asks, jolting me to reality.

"Yes, Sandy . . . another day, another video," I reply, smiling slightly. I am surprised Larson remembers my name after the years that elapsed since we last spoke. I'm also surprised Larson knows about the liquor store filmings as we've never spoken at one. Then my mind's eye flicks back to *Vol. 1, No. 1*. I remember now—Larson was there! Although we didn't talk on camera at the filming, she was there.

"Good memory," I add.

"So, what are you trying to find out? What's the goal?" Larson presses. It's a damn good question. Perhaps it's *the* question for perceptual art and anthropology alike.

"I'm interested in what people think about their city and their neighborhood," I reply. "And it's a series of art films, too."

Larson nods. "Keep on. It's good. We need this." A beat. Then, "Hey, you got something I can hold?" I don't have any cash on me, and I feel aw-

ful for it. I wish I could give Larson some money to help out. From the looks of the battered, cluttered van, she's in the midst of a financially challenging time.

"Can you come by the studio later today and I can have something for you," I say. "I don't have anything on me now." Larson agrees and also asks me for my phone number and my website. I give her both. Reggie Larson is sitting quietly in the driver's seat while we speak. I wonder what they're doing next as we bid goodbye and I get back to performing in the January mist. I hope Larson comes by later and I can help her out somehow. Her question haunts me still.

The CAMERA PULLS BACK to a WIDE-ANGLE SHOT of Beer Wine Liquor. This day consolidates some of the feelings I get thinking about year after year of this demanding project. The project is demanding, and it demands I continue, as gentrification explodes. Sometimes I feel lonely. Sad. Isolated. Haunted. Some days it hurts to film. But it is also a liberation of some kind. It's not that the people are sad. On the contrary. The people are interesting, fascinating, people like anywhere else in the world. It's the overarching political-economic situation of the neighborhood that makes me sad sometimes, where people are living in vans and young men tell me there's nothing to do. And yet so many possibilities seem to emerge when I document this little moment in time, in this little neighborhood, in this little city, on this little earth, in this little universe. Maybe it's all a mirage. The CAMERA PANS across the front of the store, where people come in and out of the double glass doors, and I'm performing a series of slow balances. The glass storefront and Beer Wine Liquor's position inside the shopping strip mall make for a sharp contrast to most of the concrete-block, hand-painted stores in the neighborhood. As I slide along the strip of sidewalk in front, I consider that Beer Wine Liquor almost looks like an art gallery storefront. I glimpse my eerie reflection in the glass and think of conceptual artist William Pope.L's 1978–1980 piece *Thunderbird Immolation*.

In *Thunderbird Immolation*, Pope.L sat in meditation in front of Castelli and Sonnabend Galleries in New York. Pope.L's meditation was a potentially lethal one, however, in which he was encircled with bottles of ghetto fortified wine including Wild Irish Rose and Thunderbird, Coca-Cola, and matches. As Pope.L sits in meditation, he douses himself periodically with a blend of the wine and Coke.

Given the presence of matches, Pope.L's alcohol-saturated body, and the perception of the possibility of fire, the threat of immolation was a disturbing conceptual (although not necessarily material) reality. Cervenak writes

that Pope.L used "Thunderbird, the cheap wine Ernest Gallo funneled into inner-city neighborhoods during the 1970s" to render visible the "absence and invisibility of black people" who were "the means for Gallo's economic end."[17] "In *Thunderbird Immolation*," Cervenak writes, "Pope.L makes this life script visible, but with a difference. He neither drinks nor dies. Instead he threatens self-immolation."[18]

As I think of Pope.L sitting in meditation on the New York street, surrounded by artifacts of alcoholism and projecting the possibility of self-immolation, I think of a ghostly ethnographic presence. I think of a ghostly ethnographic presence, too, as the CAMERA PULLS BACK again and we see people in the reflection of the glass of the storefront alongside my all-black-clad performing silhouette. Pope.L's *Thunderbird Immolation* creates a philosophical framework through which to critique contemporary life and to view the possibilities of "an unconstrained life beyond the secular," as Cervenak writes.[19] I shall argue that Pope.L also mingles ethnographic inquiry and conceptual art making. In *Thunderbird Immolation*, "For Pope.L, a proximity to lack, death, and desecration suggests not the end of movement but rather its new beginning. A seeking. A way of moving through the world unbound by attachment," Cervenak writes.[20] This kind of seeking reverberates in the filming today at *Vol. 4, No. 1*. As the misty rain settles on my sunglasses, my vision is blurred. President Trump is inaugurated, Sandy and Reggie Larson drive away in their midnight blue van, the crowd of retirees holding sidewalk court swill from their slim brown paper bags, the storefront door opens and closes as kids and their parents come and go, and we all FADE TO WHITE.

Liquor Store Theatre, Vol. 4, No. 2 (2017)

FADE IN FROM WHITE:

EXT. MANNONE'S—(DAY)—On an unusually warm winter afternoon, a WIDE-ANGLE SHOT captures the battered storefront, the frosty, grassy fields alongside it, and a slow trickle of people coming and going.

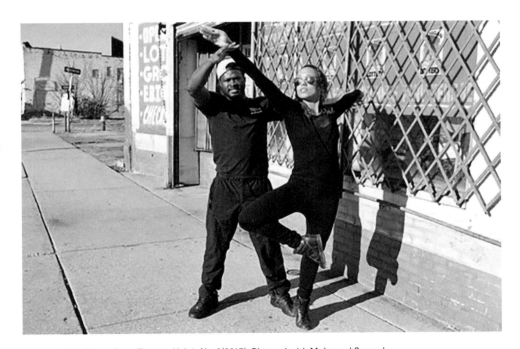

13.1 *Liquor Store Theatre, Vol. 4, No. 2* (2017). Pictured with Mohamed Soumah.

The paradox of place streamed through McDougall-Hunt, and it streamed through the filmings and resulting videos. And yet the paradox of place is an analytic that I offer as flexible, fluid, and usable for theorizing places around the world. The scene and the discussions of people of *Vol. 4, No. 2* reflected such contradictions in high definition. Moving into the fourth year of the project, some of the people in the neighborhood have seemed to accept me and the project as a roving, well-known alien, something that is weird but no longer unanticipated when I pop up filming, performing, and talking with people at the eight stores in McDougall-Hunt. In a way, the filmings have created their own register of affective labor. And then the resulting videos transgressed it. This disturbs me on some levels. I feel some degree of guilt about it. And yet this is the breakthrough work that has earned my position as an artist who can make a living from doing and ultimately selling art. Somehow, the affective labor of the work slides into paradox of place. In this case the paradox of place is conceptual, and I consider the place of video works in the art world, in the canon of urban anthropological research, and in the neighborhood itself.

The category of affective labor, Hardt and Negri's category of immaterial labor that produced immanence rather than hard goods, included all sorts of labor going on in the neighborhood. And yet, as the videos were set to appear in the Whitney Biennial very soon, it was unclear if they could possibly remain in this category. No doubt there would be a museum and private collector art market for the work following the Biennial. Once I was selling work with price tags in five figures, was this affective labor anymore? I wasn't sure, but I was sure that much of the labor happening in the neighborhood, from Winters's meticulous maintenance of the block to Wolfson's meticulous hat-making process, to McGhee's DIY gap year, was affective labor that mattered and demanded documentation.

With the notion of immaterial yet immanent labor, Hardt and Negri acknowledged that labor gendered feminine such as cooking, caring, and loving leaned toward the affective. For Hardt and Negri, feminist theoretical analysis had us understand immaterial labor as equally productive and value producing as material (durable goods–producing) forms of labor. However, the broad category of affective labor Hardt and Negri offered, for the philosopher Johanna Oksala, was exactly that—too broad to satisfactorily complicate the variation of works the category glossed.[1] Oksala was skeptical of purportedly feminist appropriations of affective labor that failed to critique such a glossy category. Pace Oksala, I was wary of deploying affective labor defined by extremely heavily cited philosophers as a theoretical framework in

my own search for new ways of thinking. And yet this was part of the paradox, I decided. This was part of the paradox of place that was on the streets and sidewalks.

JUMP CUT to Mohamed Soumah, the collaborating performer that day, and myself alongside Mannone's. Soumah holds my left wrist as I stretch into an arabesque, my right leg extending at a ninety-degree angle behind me, my left arm extended above me, and my right arm extended to my right at a ninety-degree angle. Soumah walks slowly as he twists my wrist, pulling me into a promenade alongside him, making a full circle in the arabesque. We complete the circle and he takes a glissade just slightly in front of me. I stretch the right leg, continuing toward an arabesque penchée, and Soumah steadies me, pulling me toward 180 degrees.

Just shy of it, he releases the pressure, recalibrates the wrist, and I flick the leg over my shoulder, pressing just beyond 180, then quick releasing the leg, letting it rebound down to the left and encircle the other, as we turn together in a soutenu. We hold the moment for a beat. Another. Our hands tremble a bit before we let go. I notice a middle-aged man and woman standing nearby, mildly curious. I cut the shot. I hope they want to talk. The man tells me his niece just graduated from college, and he wants to "help me out" by interviewing. The woman agrees but says she can't be on camera. She wants to help, and agrees to an interview, as long as she's not in the resulting video. I promise, pull out the appropriate consent forms, mics are produced, and we get into our conversation.

JUMP CUT to CAMERA TWO, where I'm talking with Isaac Dion. Dion is a tall, middle-aged man with steady brown eyes. "Can you tell me about this neighborhood?"

It feels like coming home, asking that question, at this point. Out here on the street talking to people and filming, I feel more at home and more comfortable than in any other moments in my life these days. "This neighborhood is rundown. That's what I can tell you about it," Dion tosses quickly back. I'm dizzied by his abrupt response. "What do you think about what's going on in the city right now? With new money coming in?" I ask. A beat.

"I think that's a great thing. I think that's a great thing," Dion replies. *Not the platitudes*, I'm thinking. *Don't tell me what you think I want to hear*, I'm thinking.

"What is your vision for this neighborhood as more money comes toward the city?" I press, hoping to get more.

"I hope they put up more houses, build more houses, instead of just planting trees. There are a bunch of trees being planted, you know, being

planted all up and down Chene. I'd rather have more houses being built, to make the neighborhood look better," Dion replies. I'm relieved that he is opening up. Dion continues, "Some of the art in the neighborhood, I think it's all right. But I think sometimes it's overdone. Like on Mt. Elliott, it is a bit superfluous," he adds.

"You're talking about graffiti?" I ask.

"Yeah. And all the tires and shoes and bears . . . it's a bit much, over there at the Heidelberg Project. But art in itself, it is nice," Dion says. Again, the paradox of place, slithering up from the cracks in the sidewalk. Talk to most people from another country or even another city who have taken a tour, and they love the Heidelberg Project. When you talk to people from the neighborhood, often the responses are equivocal, ambivalent, reluctant.

The paradox of place consolidates and describes longtime McDougall-Hunt residents' relationship with the Heidelberg Project. Because the residents have little or no economic mobility, the presence of economically mobile people coming to their neighborhood to view readymades (perhaps heaps of trash to residents) is a punch in the gut. I am starting to feel a bit like this. Am I punching the neighborhood in the gut by becoming a famous artist by filming at liquor stores in the neighborhood? Ultimately, these videos become a part of my ticket out of the neighborhood. These are awful, ugly questions. But they are ultimately questions all artists and anthropologists face when we work with people or neighborhoods, or we benefit from people and places that for whatever reason have less mobility than we do. As I stand on the sidewalk, I think about Greg Winters, Faygo Wolfson, and the Mc-Ghees. Videos and art world aside, my anthropological informants will remain here long after I'm gone, I thought. The problem of subject and object in anthropological research isn't going anywhere. I seem to find myself with double the problems and, possibly, double the antidotes, with this way of working. Or perhaps double the tormented soul—equally artist and equally anthropologist. Double the cannibal, or double the shawoman? How does Pope.L's *Thunderbird Immolation* or the anthropologist Eduardo Viveiros de Castro's *Cannibal Metaphysics* land on these questions? In my angst, discomfort, and whirling soul, I find solace in works and words of artists and anthropologists also pursuing ugly questions.

"The question of *Anti-Narcissus*," Viveiros de Castro writes, "is thus epistemological, meaning political. If we are all more or less agreed that anthropology, even if colonialism was one of its historical *a prioris*, is today nearing the end of its karmic cycle, then we should also accept that the time

has come to radicalize the reconstitution of the discipline by forcing the process to its completion. Anthropology is ready to fully assume its new mission of being the theory/practice of the permanent decolonization of thought."[2]

Like Pope.L's radical refusal of collective death with his reconstituted wine play, Viveiros de Castro proposes a disciplinary repurposing that demands a shaking-off of structures of knowledge and knowledge making. Dion continues his analysis. In order to improve the city, he says, the solution is simple. He pauses a moment, preparing his words. "Pretty straightforward," Dion says. "Straighten the neighborhood out. Bring more money to the city. Those are the main issues. More money, more jobs, means less crime," he concludes. "Did I help you out?" Dion asks me off camera.

"Yes," I tell him. "More than you know."

Dion seems a bit embarrassed by my over-the-top response but quickly shrugs it off. He nods and glides to his nearby car.

The CAMERA PULLS BACK, and an attractive, forty-something woman with long, curly hair and sparking eyes is watching us. Her name is Judith Miller. You won't see Miller in *Vol. 4, No. 2*, however, because she declined to be on camera. "Can't do that, oh no. Definitely no cameras," she says, once again making me think of the women of Taussig's diary; smart, strong, guarded, vulnerable, and cautious.[3] "But I want to help you out," she says. The camera loves her and her black pea coat, but you'll never get to see on video how pretty, how clever, Miller is. You can see it here though, in your mind's eye.

JUMP CUT to Miller, standing in front of Mannone's, bracing against the wind as it whips her long hair. It's March warm, which means it's still Detroit cold. "Can you tell me about the city?" Miller has told me she knows nothing about this neighborhood, so I start with the city.

A beat. "Well, Detroit has been revitalized. Everything is coming back. You see a lot of new homes being built, and a lot of people riding bikes and walking. There's no fear where there used to be. Everything is well lit where it used to be dark. The streetlights are on now. Downtown is booming. New businesses." I'm surprised at such positivity from Miller, who didn't wish to be on camera, making me think she had controversial things to say.

"What about the east side of Detroit?" I press, knowing that the east side is not so easy to talk about.

A beat. "The east side is coming along, because they're still building new high rises and apartment buildings. More people are moving into the downtown area," Miller concludes. A brilliant dodge.

"What are people concerned about as the city is picking up steam? What are people's concerns and struggles? What are the top three concerns?" I press.

"Well, I really don't know about their concerns . . . but I have heard that with the city being revitalized now, the whites are moving back in, and the blacks are moving back out," Miller says. A beat. "So, basically, they're getting the city ready for the whites. More prominent white people are moving into the lower east side area now. There's a mixture of concerns, but that's the main concern. The people that were here on low income, they are going to be moved out. So, working people are concerned," Miller concludes. Now I understand why she didn't want to be on camera. She had something to say. "I think we can make a transformation," she continues. "It's about people working together. It could happen. But black people have to stick together and make it happen. We're the majority of this city and we deserve to enjoy it as it revitalizes," she concludes. I can't agree more, and I can't hold my poker face. Miller begins to look a bit uncomfortable, and we end our recorded conversation. "I'm glad you're doing this," she says as she walks to her nearby car. "This is a start."

Miller's concerns about participating in the city's revitalization was a shared concern among working-class, low-income, and black people I spoke with. My informants in the neighborhood also shared these concerns. As I followed my informants into the neighborhood, beyond the scene of the filmings, Miller's concerns reverberated as well.

Orbiting for a moment from *Vol. 4, No. 2*, some of Miller's concerns were discussed at a neighborhood meeting I attended around the same time. At this neighborhood meeting, hosted by Jennene Whitfield of the Heidelberg Project, attendees included a motley crew of artists, new residents, professionals, and nonprofit workers who had been invited. It was striking that residents like my informants, hardscrabble folks who had been in the neighborhood for years, were not invited. For several reasons, this neighborhood meeting stood out relative to numerous neighborhood gatherings I attended over the course of living in the zone for many years. At the meeting, people discussed their sense of belonging—or, more to the point, why they felt they belonged.

Two main ways of belonging were articulated by residents—through labor or capital and through notions of race. New white residents often (not always) indexed themselves relative to the neighborhood by using their self-proclaimed whiteness as a mark of difference from the majority. For these residents, the decision to move to a 95 percent black neighborhood was a de-

cision to reject the real political and economic advantages of mythical whiteness, or perhaps it was to exaggerate them by casting themselves against a backdrop of mostly low-income and black people.

By rejecting a mainstream, white neighborhood, these new residents embraced counterculture and plunged into an alternative lifestyle. But at the same time, in performing whiteness in a neighborhood of mostly black people, the new residents seemed to exaggerate being white and the benefits that came with it—possibly more than if they were just among thousands of white people in, say, a wealthier white area. Labor was the second way people related to the neighborhood. In this dimension, while race was explicitly deprioritized, financial interests were heightened.

Newly arrived residents, particularly relatively affluent people, tended to associate and mark their relatedness to the neighborhood through capital. This was often discussed regarding the purchase and ownership of residential property. This was not always true, but it was a trend that emerged in this meeting and at ten similar meetings of this group and others in the zone. Discussion of resident labor streamed through the meeting. Longtime residents and residents with deeper ties than pockets tended to mark their relatedness through their affective labor—what they were doing in the neighborhood— rather than their financial connections to the neighborhood. As the evening unfolded, residents' references to race, capital, and labor were drawn into vivid relief.

Inside the local community organization in which we met, a group of people were already seated at a conference table, ready to begin. I walked in and took a seat. There was a tray of Jets Detroit-style square-crust pizza and a large bowl of salad atop the table. Whiteboards were on either side of the conference table, and a pot of sludgy coffee beckoned from the corner. I pulled out my notebook and quietly introduced myself to a young woman named Jenna Wilson. Wilson was the director of a neighborhood nonprofit that offered after-school activities to children in the area. Wilson, who had recently moved into the neighborhood, had been working to organize the community around safety and youth activity efforts since she arrived two years before.

Next, another woman, middle-aged and wearing glasses, introduced herself to me. Her name was Bella Franks, and she wore an elaborate head wrap, a long skirt, and a pair of reading glasses studded at the corners with tiny pink crystals. Franks said she was interested in creating a neighborhood art center for senior citizens in McDougall-Hunt. Franks described her idea in detail, saying that she wanted to offer everything from cooking classes,

to sewing classes, to painting classes, in a large house she inherited from her great-uncle. Twenty minutes after the meeting started, with the pizza getting cold, latecomers began to trickle in.

An older white couple named Chris and Stella Keil walked in. Chris Keil, a tall and heavyset man with black hair and glasses, was in his sixties. He worked at a local university as an administrator, and his partner, Stella Keil, who was shorter and blonde, with an imposing voice, owned a travel agency. After a few more moments, another white couple walked in. In their forties, both were tall and sturdy, with kind smiles. The woman, Ellen Jay, was an investment banker with a local venture capital firm, and her partner, Jared Jay, an Episcopal priest.

As Ellen Jay introduced herself, the most striking part of her introduction was the number of times she used what I shall call financialized words to describe her place in the neighborhood. Words like "bought, purchased, invested, acquired" were used so much that it was impossible to ignore. After a few sentences, I started counting; Jay used the word "bought," at least six times during her brief two-minute introduction. It became clear that for Jay, relatedness to the neighborhood was marked by her financial ties to property and the financialized language with which she described her ties.

As Chris Keil introduced himself, he too mentioned three times the "home that [he] bought at a great price." As he introduced himself, Keil stated there should be a program for "artists who are low income" to purchase property at low cost in the neighborhood. He thought it should mirror the tiny house program starting in northwest Detroit. Keil's idea was interesting, but I wondered why such a program wouldn't apply to all low-income residents regardless of profession—why should artists be the only low-income people eligible? Stella Keil's introduction was brief and to the point.

Moving around the table, another resident waxed financial. Like that of his wife Ellen, Jared Jay's introduction highlighted his interest in executing his "vision for the property he bought" with her. These residents were most definitely doing things with words—they were asserting their positions as property owners.[4] Classed difference in goals and perceptions were linguistically performed and marked as the meeting continued. An indexical, financialized speech register asserted itself—there was a particular way of talking about the neighborhood that indexed one as a newcomer who had "bought in." However, the idea of ownership was itself dicey. The majority of the newcomers to McDougall-Hunt, present at this meeting and otherwise, purchased property through bank loans—mortgages.

This meant that property was held by the bank until it was paid off. The new residents asserted their property rights and associated claims to the neighborhood with immediacy, however. In listening to tonight's discussions, it sounded as if everyone who had recently purchased property in the neighborhood had paid cash. From discussions of banks and mortgages, I knew this was not true. Curiously, many people who lived in the zone and did own their property outright (the Winters and Wolfson families, for instance) were not invited to, or for a variety of reasons were not able to attend or interested in attending, community meetings styled for more bourgeois newcomers.

With financialized words, new residents indexed themselves as owners and as investors. Perhaps they were trying on what they felt was a new role in the neighborhood. And still these claims were minimal and modest. The Keils and the Jays were not large-scale developers or speculators; they each purchased single-family homes for their own use. And yet the words they used to describe their place in the neighborhood were overtly financialized. In contrast, longtime residents spoke of their social and cultural ties to the neighborhood, regardless of whether they were property owners. I argue that this dichotomy represents an attempt for new residents to assert their claims to ownership in an area to which they had weak or no social ties. Indexing oneself through words, known as nonreferential indexicality in linguistics, is a language strategy people use to make a point about their position in the world.[5]

By indexing themselves with financialized words, the Keils and the Jays used what linguistic anthropologists Johnstone, Andrus, and Danielson describe as "linguistic forms that evoke and/or construct what is sometimes called 'social meaning,' a concept that encompasses matters such as register, stance, and social identity."[6] The financialized linguistic strategies helped the Keils and the Jays carve out a sense of belonging, on their own terms, in the zone. Alongside their financialized speech registers, the Keils and the Jays often invoked race to index themselves in the neighborhood, as I mentioned previously.

Indexicality, however, is complicated and shouldn't be assumed to automatically correlate with classed, gendered, or raced group memberships. Linguistic anthropologist Mary Bucholtz wrote of indexicality, "in an indexical theory of style, the social meaning of linguistic forms is most fundamentally a matter not of social categories such as gender, ethnicity, age, or region, but rather of subtler and more fleeting interactional moves through which

speakers take stances, make alignments, and construct personas."[7] In other words, while the calculus of financialized words had implications in context, it shouldn't be assumed that classed group membership was deterministic. Rather, people of the zone indexed themselves and created meaning around themselves in a variety of ways. Still, refining assumptions around indexicality, as Bucholtz encouraged, did not reduce the concept's importance.

Linguistic anthropologist Michael Silverstein wrote, "by this time we can surely say that the work of contemporary linguistic anthropology has firmly established that any, a.k.a sociolinguistic, fact is necessarily an indexical fact, that is, a way in which linguistic and penumbral signs-in-use point to contexts of occurrence structured for sign-users in one or another sort of way."[8] Like Bucholtz, Silverstein worked toward a refined indexicality. The result was Silverstein's n-th order theory of indexicality.[9] With n-th order indexicality, Silverstein suggested we understand positionings "being manifested micro-sociologically ('in co[n]text') as indexical categories … dialectically constituted somewhere between indexical n-th- and $n+1$st-order value-giving schemata of categorization, wherever we encounter them."[10] In other words, while the financialized and racialized words new white residents used at a community meeting were fascinating indexical markers, an analysis of the words alone was "a dialectical partial, a beginning, at best."[11] To penetrate the superficial, it was essential to analyze indexicality in context.

In the context of that night's neighborhood meeting, as Johnstone, Andrus, and Danielson wrote, the Keils and the Jays used notions of whiteness and financialized words as a "kind of correlation between a form and a sociodemographic identity or pragmatic function that an outsider could observe."[12] Stark historical-political-economic implications were associated with financialized and racialized indexicality. Recall, for instance, the Housing Act of 1934's racially restrictive covenants and the blockade of capital against black people in particular. The Housing Act of 1934 had dire implications in Detroit, and the economic consequences continue to reverberate. The structural supports of wealth disparity were constructions at the tessellating planes of whiteness, blackness, and how finance capital was (or was not) accessible. While the Keils and the Jays didn't intend to do harm, their indexicality strategies reflected the starkly racialized historical-political-economic calculus of race, money, and where people were able to purchase property. This calculus was graphed in Detroit from the eighteenth century up to a neighborhood meeting in the present. The neighborhood meeting included discussions not just of private property, but of public and quasi-private property, like grassy fields and vacant lots.

Jenna Wilson, a middle-class African American woman in her forties, was more focused on safety and crime in her discussions than on indexing herself in a particular way. Jenna Wilson said she directly associated what she called "high" (uncut and long) grass with "prostitution and cars being stripped down" (disassembled for the sale of automotive parts). Wilson also said that she felt a personal responsibility to "maintain the high grass in the neighborhood"—hiring companies and recruiting volunteers to keep city-owned, vacant grassy fields, well cut. Wilson repeatedly stated that she didn't feel safe in the neighborhood.

She mentioned her nieces and nephews who visited her from time to time. When they visited, she said, they might ask to walk to the liquor store or the gas station to get a snack or some fresh air. She didn't and wouldn't let them, she said, because the neighborhood was so dangerous. When Wilson said this, I thought about *Liquor Store Theatre* events and the dancing, talking, and film documenting at these dangerous stores in the zone. I also thought more about the "high grass" statements.

The "high grass" discussion demonstrated a disoriented way of theorizing urban poverty and crime. The idea that the grass was the cause of crime was reminiscent of the now-well-criticized broken windows policing theory popular with some urban planning departments across the United States in the early 1980s—the same theory that Giuliani used to rationalize the misdirected *Police Strategy No. 5.*[13] This was, again, a conflating of cause and effect, a moral hijacking of political-economic concerns.

A moralizing of quality of life, when quality of life was controlled in reality by things like jobs, education, recreation, transportation, water, food, and neighborhood amenities. The idea behind broken windows policing, as argued by Giuliani's *Police Strategy No. 5*, was that small offenses of disorder in neighborhoods—like broken windows or tall grass—would ultimately lead to serious crime. By keeping the grass low and the windows intact, city planners and police departments could reduce crime. This thinking was misplaced for its failure to acknowledge the underlying forces of segregation, discrimination, and legislated racism across housing, education, and employment practices that left swaths of people's economic realities underdeveloped.

Wilson also said that she liked to bike, but that she didn't bike in the neighborhood—she biked instead deliberately out of the zone, through a biking/pedestrian greenway called the Dequindre Cut that bisected Mack Avenue just west of McDougall-Hunt. Despite her concern with the safety of the neighborhood, Wilson was ardently working for a better future in her day-to-day. She was working, she said, to bring T-ball and soccer teams for

youth to the local baseball diamond she set up. She was also bringing tennis courts, ballet classes, and a host of resources to the neighborhood. She was not just talking, she was acting, I noted. Wilson's perspective of the neighborhood as categorically dangerous leaned to clichés, and her theories of broken-window policies left me wanting more context, but her actions said more. She was writing a new future for the neighborhood with her work.

Wilson was not a city planner or a police officer watching from afar; she was a resident doing her own affective labor to change that which she viewed as problematic. The tall grass, the lack of activities—she was not merely talking about it but was doing in order to help change the situation. In contrast, Ellen Jay and Chris Keil, middle-class European Americans in their forties, described the success of the neighborhood as hinging on the arrival and financial investment of what they each referred to as "new people." Ellen Jay repeatedly mentioned the need to bring "new people" to the neighborhood while, in contrast, Jenna Wilson mentioned the need to bring activities and services to the neighborhood.

Ellen Jay mentioned the need for "restorative justice" and "healing" among the existing residents, in addition to what she called the "new people." Ellen referred to an incident that took place in the Corktown neighborhood, one of Detroit's oldest and whitest enclaves, with an Irish past and a quickly gentrifying present. Ellen said that during this Corktown incident, a group of newly arrived white men got into a dispute with an unhoused black man who had been occupying property in the area for years. The outcome was that the group of white men badly beat the single black man. The man survived, but a rift in the neighborhood began to increase because of this awful incident, Ellen Jay said. As a result, she said, a restorative justice group was founded in Corktown to have meetings and to work through conflicts with facilitated workshops and discussions. As Jay described the situation, I thought about her contradictory relatedness to the neighborhood. She wanted to acknowledge injustice but in the process had failed to comprehend complexities. There was a cliché binary in which the drastic explanation of an extreme situation was bookended with her desire to recruit more new residents. It was a bizarre discussion that reflected the oddities in thinking and actions of well-meaning newcomers to complicated neighborhoods. It was helpful, in tracing threads of reason through these complicated tapestries, to return to McKittrick's radical geography theory.

As McKittrick writes, racism distorts and contorts the recorded histories of places and spaces.[14] At the Heidelberg Project neighborhood meeting

tonight, McKittrick's theories resonated and served as an anchor to grasp, as the frustrating meeting unfolded. There was a sense in the meeting discussions that conflict between class and ethno-racial identities was individualized and based on personal points of view—as though the unhoused man and the group of men who beat him were simply personally at odds. The truth was, the class conflicts between the men who did the beating and the lone man were equally, if not more, critical than the petty, individualized disagreement that led to a horrible act of violence.

The structural forces, such as racist Federal Housing Administration lending practices and decades of de jure racism, for instance, implemented by the Housing Act of 1934, went unmentioned at the meeting. The connection between the whites who were eager to "buy," "acquire," "purchase," "take over," and "get" property and land, and the blacks who have subsidized these transactions through the urban crisis in Detroit,[15] seemed to be all but nonexistent in the language of the meeting. There was no discussion of accumulation by dispossession. Rather, the discussion kept returning to financial transactions and acquisition of property. As Coates wrote, "the ancient American dilemma's white-hot core—the problem of 'past unequal treatment,' the difficulty of 'damages,' and the question of reparations," was yet burning.[16]

Chris Keil asked about a possible meeting with the Detroit Land Bank, stating that he wanted access to houses and properties with an eye toward possible acquisition. He repeatedly mentioned artists and how artists are "not interested in race or class. They just want to create." When he said this in the presence of Tyree Guyton, Guyton laughed, deliberately and heartily. Guyton's art, as abstract and whimsical as it is, is most certainly class-conscious. It is intensely political by its very existence in a neighborhood writhing with the paradox of place. The same could be said of my own efforts.

The paradox of place was also an analytic for understanding new residents' use of racialized indexicality. Chris Keil recounted a story for the group, leaning back in his chair and tossing a shock of hair as he spoke. Although he was in his sixties, he was fit and known to ride a Harley. "I was in Corktown riding my motorcycle, and I was surrounded by all these white hipsters riding their motorcycles! I was like, wow, I'm not unique here, except for my age. I need to get back to McDougall-Hunt!"

Jared Jay similarly indexed himself as white and as being whitened by being in a black neighborhood. Jay said, "We don't need more white people in our lives! We are white enough! We don't need to be around more white

people. That's why I moved here, to McDougall-Hunt, instead of to Cork-town or something." (Demonstrating the arbitrary nature of so-called racial categories, Jared Jay's wife, Ellen, who identified as white and spoke several times of her whiteness, had smooth skin of a darker golden-tan tone than mine.) What exactly made the Jays "white"? In effect, their proclamation—and also, their decision to relocate to an all-black neighborhood. Ellen Jay and Chris Keil both mentioned Corktown as being overly white already; for them, this was a reason why moving to a black neighborhood was interest-ing. A disturbing implicit statement twirled through their words. It was as though the black people in the neighborhood existed only to enhance their whiteness.

Related, in the zone's calculus of subject and object, and the para-dox of place, a newly relocated white resident of McDougall-Hunt named Mike Mills wrote on his website (and sent me the link) that "being loved on by black people saved his life" and that therefore he decided to move to McDougall-Hunt where presumably he would encounter black people. The idea of white people moving to a black neighborhood to feel "whiter" or to feel "unique" or "loved on" in their whiteness seemed odd. Imagine the re-verse. Odd, indeed.

Whiteness as an asset that disappeared when you were surrounded by whites who might be more prosperous, and so on, was problematic. These ideas required critique. Did black people exist to bolster the structural sup-ports of whiteness that Mills and others yearned for? Emphatically, no. An-other example of these ideas stood out in Jared Jay's continued claims that new people moving in would be the city's ticket to economic well-being.

As the meeting wound down, Jay said, "This city was built for two million people. So, until we have two million people again, we're going to be bleeding cash. It's just basic math. So, we need new people, we need art-ists, moving to places like McDougall-Hunt to fill up all this empty space." As Zander McGhee, Hector McGhee, Greg Winters, Faygo Wolfson, Sally Wilks, Jenna Wilson, Bella Franks, Jerome and Lindsay Drake, Tyree Guy-ton, Jenenne Whitfield, Lance Durant, Todd Stovall, and Chris Keil himself demonstrated in their presence, McDougall-Hunt was far from empty. It was brimming with people, and it was brimming with the paradox of place.

As the discussion continued, contradictions and classed perspectives continued to lurch forward. Whitfield was set to meet with one of the direc-tors of the city's planning and development department the week after the neighborhood meeting, and she said that she would tell the planning director at the time, Maurice Cox, of our intentions to create a neighborhood associa-

tion. Ellen Jay suggested that the group also create a community land trust as part of the neighborhood association to begin acquiring land as an association. Chris Keil suggested forming a neighborhood watch for the association.

Jenenne Whitfield and I were immediately skeptical about the neighborhood watch idea. I mentioned that we should be aware of the politics of representation—a group of residents new to the zone forming a neighborhood watch upon arrival? I thought about the murder of the teenage Trayvon Martin in 2012 by a supposed neighborhood watch man, George Zimmerman.[17] I asked if we could bring longtime residents and residents occupying vacant homes into the neighborhood watch discussion. People looked at me like I was crazy. I thought I had better be quiet and write field notes. It was hard to keep quiet during that meeting and many others like it during my fieldwork. I found myself in a precarious position at the meeting because I wanted to be a quiet artist and ethnographer. At the same time, it was hard to be silent. I wanted to suggest the need to begin with history, context, political-economic analysis, and nuance rather than apolitical clichés. JUMP CUT to Beer Wine Liquor. The misty rain is still falling, and I'm wrapping the shoot. How can I document what's going on around me and pursue a way of working that searches out the paradox of place? I stare up at the cloudy January sky as we FADE TO WHITE.

Liquor Store Theatre, Vol. 4, No. 3 (2017)

FADE IN FROM WHITE:

EXT. MT. ELLIOT LIQUOR—(DAY)—We open with a MEDIUM SHOT of Mt. El-liot Liquor's storefront. There's a man in a bright red sweatshirt standing in front of the door. He's not moving. It's sunny, and the carefree clouds that swing above seem to defy the tense atmosphere. Today is one of the lonely days—there's no cast—just myself, all alone. People slowly come and go, sub-ject to the gaze of the red-sweatshirt-wearing man in front of the store. He glares at me when I set up a shot near him. Unimpressed, or worse.

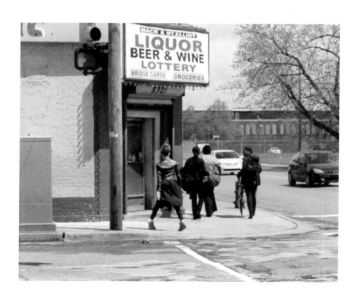

14.1 *Liquor Store Theatre, Vol. 4, No. 3* (2017).

This storefront sits on a fault line of Bloods and Crips territory. We're standing on the balcony, overlooking the consequences of decades of bad—or zero—political-economic policy or city interest in improving living conditions. Calling Mt. Elliot Liquor a storefront isn't even a simple visual gesture that I'm using to give your imagination a push. Literally, this store seems to be a front for the drug trade. There is an open drug and sex market happening in front of, and alongside, the store. For a six-month stretch, the front of the store was spray painted with the words "X gave me herpes," along with a phone number at which X could be reached.

The graffiti was then blurred out with a makeshift cover-up for months before it was finally painted over properly. Every time I drive past the store, there looks to be a woman bearing the pain of all of human existence on her shoulders, standing alongside the store, skin wrapped over bones, pretty face covered in bad makeup, staring down traffic, proclaiming, *you know you want me.* Apparently, she's right, because every day, she or another woman is here—along with the man in the red sweatshirt, or his proxy, undoubtedly, wearing red. This store, at the moment, is controlled by Bloods. The Crips are around, but seem to have less clout than they want.

JUMP CUT to me, fumbling with my camera and tripod in a parking lot across the street from the storefront. I'm setting up a shot, and I realize that in order to get any sort of depth of field, I have to set my shot across the street from where I'll be performing. The sidewalk in front of the store is so shallow, and the presence of the man in the red sweatshirt and the others swirling around him is so pressing, that there isn't enough real estate for me and the camera to be on the same city block. The camera will have to be unmanned—remember that I'm alone today—while I perform and talk to people across the street. I set the shot, pray that my judgment of composition and depth of field are reasonable, flick the camera into automatic shooting mode, and cross the street, portable speaker in tow. The CAMERA PULLS BACK and you see the storefront, me, and passersby as traffic spins by us on Mt. Elliott Street and Mack Avenue.

I'm wearing all black as usual. A long black tunic under a leather jacket, black Nikes, and shades. Passersby look at me with disdain, amusement, or irreverence in turn. Unfazed, I perform my choreographic sequences to the crackling electronic music blaring from the portable sound system across the street. I try not to think about the CAMERA, which indeed is PULLED BACK, unmanned, across the street. *Stretch. Press. Pull. Slide.* Stretch, press, pull, slide. Stretch-press-pull-slide. Stretchpresspullslide. I feel less like I'm performing and more like I'm trying to stay alive, or simply get my shots in and go, as I

move. The notion of an interview seems forlorn. Schoolgirls and women who are sex workers walk by. The man standing his ground in front of the liquor store leaves the frame for a moment. I finish a sequence and decide I should cross the street and reset the shot.

JUMP CUT to a MEDIUM SHOT where I'm walking across the street, back to the camera, and a man is walking in the opposite direction. He's wearing a blue sweatshirt and a blue-and-yellow leather jacket. After I cross the street, he doubles back and walks up to me. Another man, also wearing blue, joins him. The men abruptly begin to speak to me. "Hey, the block is hot over here, and it's about to get hotter. *You* need to get off this corner," the first man says. This was a first. In four seasons of doing this project, I'd never been told by passersby to leave or that my presence was a problem.

"Really?" I ask. "I live down the street, and I've been making these videos for three, going on four years now." I felt indignant, and I'm pretty sure it was apparent in my voice.

"We don't want to see you go out like that," the first man said. The second man nodded. "We'd hate to see something happen . . ." His voice trails off.

"But I know people in this neighborhood," I protest. "People know I'm just making videos and not trying to mess with people's business." I must sound like a total idiot.

The first man nodded. "I know about this video you're making," he says.

Suddenly, I realize the first man is Blue, whom I met and interviewed via audio recording at *Vol. 3, No. 3.* "Blue," I say, "I remember you from last year. We talked at Sunset Liquor."

"Yeah," he says, allowing a slight smile. A beat. "But, you need to go— *now*," he says. I see the urgency in his eyes. I hear it in his voice. "I'm just trying to look out for you," Blue says. "They'll take your camera. Or something. If you don't go."

Blue and his companion fade into the cityscape, leaving me to deal with their words, hanging in the air. Double time, I pack up my camera. I realize he's serious, and he's trying to help me out. My heart starts pounding double time, too. I look over my shoulder and I see a man wearing a red puffy coat walking a little bit too quickly, directly toward me. He is looking me right in the eyes. I say hi, and he doesn't respond. He keeps striding, and he keeps staring. I jump in the Cadillac, and we FADE TO WHITE.

This was the last video I made at Mack & Mt. Elliot Liquor. This store is also where Sally Wilks was assaulted. I came to the conclusion that this

was the most violent of the eight stores in the neighborhood. But why? What made it violent, and what made the gang activity so obvious here, at this site? Ironically, the store was situated right next to a behavioral health and drug rehabilitation agency. I went into the store, long before the filming of *Vol. 4, No. 3*, and it could hardly be called a store. Grimy, miserable walls and floors were covered in salty, sugary, artificially flavored merchandise. The store manager, behind thick walls of glass, had an accent so thick it cut the air like a blade. There was a security guard, I guess, sitting on a crate, openly carrying a gun, eyeing everyone who walked by. (I don't mean to disparage people who are working to feed themselves and their families. The gang members, drug dealers, store owners, and everyone else are just trying to earn a living.)

Still, I didn't understand how this store could function this way, openly conducting criminal activity less than a mile from the local police precinct station, two miles from downtown Detroit, so close to city hall, in the richest country in the world. The paradox of place crystallizes scenes like this—and this scene crystallizes the paradox of place. In a country of tremendous wealth, pockets of political-economic-historical failure sit, unseen or unimportant. Just miles away, million-dollar real estate development goes up, and people marvel at how cool Detroit is. Meanwhile, gang territory was so tightly managed—and worked at such a micro-level—that filming an art video was untenable at one particular store. Apparently the other stores didn't have this precise dynamic. Anthropologists and artists, still, have to understand that our understanding is limited. Even though I had years of experience making videos and talking to people at the liquor stores, the people who lived in the neighborhood knew much more.

JUMP CUT to a TIGHT SHOT inside my Cadillac, where I'm still sitting in the driver's seat, where you left me at the end of *Vol. 4, No. 3*. I decided to go for a drive after that strange video, and to meet up with a woman in the neighborhood named Tee Lewis who had agreed to talk with me. I came to know Lewis through the rare images of *LST* I'd posted on Instagram, where Lewis and I followed one another. One of the images from a store she knew well had grabbed her attention, and we stayed connected from there. Lewis had glacier-blue eyes, hair the color of summer ale, and a soft, gritty voice. She seemed to be perpetually in a positive state of mind, which contrasted against her hyper-street-smart statements and proclamations.

In following Lewis on Instagram, I noticed she took care of many neighborhood dogs and cats. (I am a major fan of both.) I often liked Tee's

Instagram posts and asked her about the neighborhood animals. In other words, we had more in common than an interest in the liquor stores in the neighborhood. As the rain comes down, I see Lewis walking toward me in her long, burgundy coat, her faded blue jeans matching her eyes and the wind whipping her hood across her face. I pull the Cadillac up next to her and invite her into the car. We start talking about the neighborhood, and Lewis shares that she doesn't just rescue dogs and cats in the neighborhood. She tells me how she helps out neighborhood teens, and sometimes teens who are just passing through the neighborhood, for whatever reason. Her own three teenage sons were enough to keep any parent busy, but she extended her concern into the neighborhood.

"It's easier rescuing dogs and cats than it is teenagers," Lewis tosses.

"Do you really help teenagers? From the streets?" I press.

"Yes, sometimes," she replies. "Right now, I'm helping Legacy graduate. Every day I wake up and first thing, I tell Legacy, you have to graduate. Get up and go to school, girl—it's time for you to graduate . . ." Lewis's voice trails off. She says she also helps people to whom she referred as the homeless people in the neighborhood.

"You know Lindsay, the woman who's always asking for money?"

"Yes," I reply.

"Well, I had to tell Lindsay I'd slap the black off her if she didn't stop begging during funerals in the neighborhood," Lewis says. Her sharp words catch me off guard. In the next breath, Lewis indicts racism and sexism in the neighborhood. As we discuss the videos I'm working on, a discussion of one of the stores in the neighborhood bubbles up. Lewis tells me she worked at a particular store for six years.

"I worked there for six years, for $2 per hour," she says. "Cash under the table. The owner told me I was too old, and that I couldn't get a job anywhere else, and that I should just take what I could get. He would call me and ask me to babysit his Maserati, by just sitting in it while he was in the liquor store flirting with women. I would come down from my place at all hours, just to babysit his car. One time, he had me deposit $5,000 cash in a bank account for him—meanwhile he's paying me $2 per hour. I knew all his personal affairs. He and his wife had me come over to their place and rake their leaves around their mansion." A beat. "They paid me $20 for that," Lewis says. "They said I didn't do a great job—I was like, if you want a great job raking leaves around this huge castle you better hire a landscaping agency."

She laughs incredulously, then continues, "I fed my sons off that $2 per hour. I worked a lot of hours in that store. . . . I quit a few times too, and then kept going back. But the last time I quit—I'm not going back now. Because it's not right. I remember one day he noticed my shoes. Then he asked me if I got my shoes from *the black people*. I told him not to talk like that in front of his six-year-old daughter, who was standing right there. I told him he should be ashamed of teaching an innocent child racism, and to look where his store was at," she says.

I nod. "You were right to call him out," I say. "On all accounts."

Lewis stops short—she wants to clarify. "Now, I'll scrub a toilet with a Q-tip if I'm getting paid," she says. "I don't mind the work! But $2 an hour . . ." Her voice trails off.

"Oh, I agree," I reply. "You should be paid fairly for your work. Those rates of pay are not just unfair, they're illegal . . . way below minimum wage," I add.

Lewis nods and continues, "Anyway, I came to this neighborhood from out east after my husband passed away. I like it. I try to help people and the animals like the dogs and cats too. Someone told me I should write a book about it and get out of the ghetto when I get it published." She nods wistfully. "But I don't mind it here." Next Lewis shares some lines of her poetry. The few lines she recites to me are harsh and poignant, if a touch literal. But there is something there.

Lewis has stories for days about the neighborhood. She tells me about being robbed at gunpoint for her phone and some cash, and how the police asked her what she was doing at the ATM at such an hour (seven o'clock in the morning, she says) and that it was her fault she was robbed for being out so early. Lewis also shares that she dislikes alcoholics, and voices ardently that she doesn't drink, smoke, or do anything else. Her hard-edged talk, her obliteration of racism in one moment, and her dances with overt racist humor in the next are jarring. Lewis is negotiating the edges of a shell of privileged classification tension. It is evident that Lewis knows she has much more in common with her neighbors than what her whiteness might represent elsewhere.

As we chat, I ask Lewis if she knows Greg Winters. She replies that she does and that he has come over to her house for dinner a few times. "We're friends," she says. I wonder out loud if she knows that Winters's family owned property on the other side of Gratiot. Lewis replies that she didn't know that, that she only knows that he works over that way. "Yes, we're friends. He's a

good guy. But just friends! Nothing more than that," she repeats. Lewis asks me to drop her off at the Kentucky Fried Chicken fast-food restaurant down the street, and, after a few lingering last moments of winding down our discussion, I do. As she leaves the car, she turns and tells me she wants to have another discussion and to be included in the book.

After today, we will have many, many discussions and moments together, it turns out. I swirl around in the Caddy and pull back onto Gratiot, heading to my studio-loft in the soft rain, from a strange and lonely video shoot, to a conversation, and now back home, all within one mile, and within three different worlds. I pondered Lewis's hidden *Liquor Store Theatre*—the backstage view Lewis provided, far beyond the backstage view I intended to offer the public.

Lewis revealed a different dimension of the liquor store, pulsating beneath the surfaces of my awareness and of the videos. It was a disturbing, paradoxical dimension in which figurings of racialized, aged, gendered, and sexualized hierarchies danced, glanced, and bounced off one another. The stark contrast between Lewis and the Jays and the Keils of the recent community meeting also left me thinking. The notion of whiteness in Detroit was complicated, as was the notion of blackness. Moreover, the notions of both concepts were shifting and yet marked with certain enduring political-economic characteristics. About twenty years have passed since Hartigan's fieldwork across Detroit's Briggs and Warrendale neighborhoods.[1] I found that while much had changed, much had stayed the same.

Hartigan wrote, "As a subject of academic and political scrutiny, whiteness has two primary characteristics: first . . . whiteness manifests a certain logic in its political, aesthetic, and historical sensibilities—that blackness is its symbolic other. Second, in structural terms . . . whiteness effectively names practices pursued by whites in the course of maintaining a position of social privilege and political dominance in this country."[2] Hartigan's description of whiteness as general (not Detroit-specific) political-economic strategy maps well with the Jays' and the Keils' linguistic indexicality, and notions of race, at the recent neighborhood meeting. Both couples deployed their self-identified whiteness toward articulating their sense of belonging in the neighborhood. Hartigan's description of whiteness as strategy holds up today, broadly, across the world as we know it.

What is fascinating, in terms of the dynamic status of space, place, and race, is that Hartigan's analysis of whiteness and blackness in Detroit twenty years ago beckons an update today. I don't highlight these limits to

assert Hartigan was incorrect in his ethnographic analysis. Actually, the opposite is true. Hartigan was correct twenty years ago. And times have quickly changed. These contradictions and the shifts over the course of twenty short years underline the fluidity of notions of race and racialization. Hartigan wrote in 1999, "Whatever its status nationally, whiteness is not hegemonic within this city. Blackness is locally dominant: 'black power' shapes the politics; 'black dollars' and 'black fashion' define the landscapes of consumption. This is not to make the absurd assertion that whiteness is irrelevant in Detroit; rather, its operations do not possess a generically 'unmarked' or 'normative' character. White racialness, here, is the subject of frequent marking and is often chastised as being out of place."[3]

In sharp contrast to twenty years before when Hartigan was working, at the time of my fieldwork, whiteness was in fact hegemonic in Detroit public discourse narratives. Headlines proclaimed that white businessmen had saved the city, white entrepreneurs received the lion's share of national media attention, and white people were hailed as the newcomers who would resurrect the city from sure suffocation.[4] However, across the 139-square-mile, 700,000-person, 83 percent African American city, whiteness is not necessarily hegemonic in reality (there is a thing called math). It is amazing to consider that in this brief time frame, in Hartigan's passing of the ethnographic baton to me, the hegemonic imperatives of black power and black dollars had become niche, and the economic dominance of white people in the city had become a reality.

As a result, the positionality of whiteness had largely changed. And yet, for Lewis's experience, working for $2 per hour under the table at a liquor store in Detroit, Hartigan's analysis holds its accuracy. More broadly, Hartigan proposes a complicating of whiteness—like the long-standing effort to complicate blackness—as a strategy in understanding its function in social life. And yet, where whiteness is concerned, Hartigan reflected on the problem of undermining the cultural construction of whiteness as a category in doing so. Still, in the Detroit case, Hartigan contended, "By viewing whites as a racial minority, in different class positions, subjected to racial predicaments and racialized judgments, we can begin to recognize racial dynamics—those involving ambiguities and uncertainties—that will be increasingly common in this next century."[5]

The tables have turned in Detroit since Hartigan's fieldwork at century's shift. As jails are built for low-income and black people, fancy restaurants are built for whoever can pay—and the patrons are mostly white. The

days of black power in the city seem forlorn and long since passed. Yet white people like Lewis continue to struggle in the city alongside their black neighbors. And black people continue to make the city move with their work, their tax dollars, and their relentless pursuit of a life here. I pull into the parking lot of my studio-loft, watch as the rain hits the windshield, and we FADE TO WHITE.

Liquor Store Theatre, Vol. 4, No. 4 (2017)

FADE IN FROM WHITE:

EXT. MOTOR CITY LIQUOR—(DAY)—AN ESTABLISHING SHOT of Motor City Liquor's storefront as Gratiot Avenue traffic whirs by, and the city skyline hangs in the distance, shows a busy, bustling, early spring day. I'm performing alone today, wearing sunglasses and a black tunic over gray leggings and a long gray T-shirt. The spring air is charged with possibility as the electronic music from my speaker mingles with passing cars' found music.

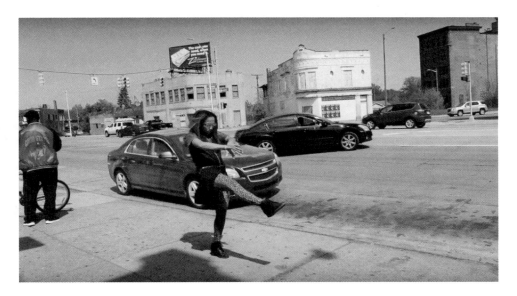

15.1 *Liquor Store Theatre, Vol. 4, No. 4* (2017).

Today there is a steady stream of foot traffic, in spite of my own solitude. Thinking back to the first time I filmed here three years ago, I marvel at all that has changed. The city seems to be full-steam ahead—rushing toward something. Exactly what, I'm not sure. More and more, people were talking about art and its importance in city life, and, also, people were talking about spaces and places in the city they held dear. Was it that I was getting better at asking questions, or that the people of the city were more acutely recognizing the city's trajectory? The CAMERA PULLS BACK and we see Charlene Athens, a tall woman with long braids and a sublime smile, walking by. Athens is wearing a hairstylist's jacket, like she's in the midst of the work day. Athens pauses for a moment, taking in the scene, watching a take of a choreographic sequence. Before she emerges from the store again, I end the take, in hopes that she will stop and ask me questions. She does.

"What do you have going here?" Athens asks as I reset the camera shot. After some explanation, she agrees to an interview.

"Can you tell me about this neighborhood?" I ask.

JUMP CUT to a MEDIUM SHOT of Athens, in front of the entrance to Motor City Liquor. "Oh, my God! Detroit!" Athens replies. "Detroit is a beautiful place." A beat. "I grew up in Detroit. Over on the east side," she continues. "Deeper east. Actually, Detroit is a place. . . . It's like a family. They talk about east and west—but it's really not that." A man walks by, wearing a T-shirt that says *Organize, Win Power, Build Justice*. He stares down the camera with engaged curiosity.

"It's a community," Athens says. "Where I grew up, over by East Warren Avenue, to this day, I can still go over there and get a meal." She laughs. "Matter of fact, that's where I'm going to go in a minute."

Athens continues, talking about art in the city. "My art is more hair," she says. "I'm a stylist." Athens pauses a moment and displays her elaborate braids for the camera. More like urban styles," she says. "I'm a braider." The found music, blaring from a nearby car, sounds pleasant in the background as it plays 1990s R&B. "I actually started doing hair at Kettering High School. They closed it down. Over off of Van Dyke." Athens pauses a moment, reminiscing.

"But my art is different," she continues. "It's black culture. A lot of people now are wearing more natural styles. So that's more what I do. Natural styles. In fact, let me show you." Athens pauses and pulls out her smartphone. "I know you got a camera and all that, but let me show you." Athens scrolls through her phone and selects an image of an elaborate braided hairstyle.

"That's my art," she says. "To me, that's art. It's a talent. It takes time, and that's how I make money day by day," Athens says.

"Yes!" I agree, chiming in off camera.

"The thing is, we all started from the bottom, and we're all trying to get up to the top," Athens continues. "But me, average kid, I grew up playing basketball. I never thought hair would be something I'd be doing today, but it is. It pays all the bills and I'm living comfortably. I will say that." JUMP CUT to a WIDE-ANGLE SHOT facing Gratiot Avenue. I move through a choreographic sequence, as the traffic slides by behind me. JUMP CUT back to Athens, who shifts gears. "In Detroit, we really need to stick together," she continues. "That's really what it is. Once we learn to support each other, I think the city will blossom way better. You've probably heard the word or the term 'hating,' but there is a lot of that. Like crabs in a bucket. Some people don't want to see you succeed. Some people don't want to see you do better," Athens says.

"But my thing is, at the end of the day, we're all trying to . . . be something. Do something. I never wanted to be famous. I just want to be known for what I do, to be something." JUMP CUT to a MEDIUM SHOT facing Motor City Liquor. I'm holding a lunge; static. The electronica crackles through the air. CUT to a MEDIUM SHOT of Athens, who continues, "What I will say about the city—I just don't want us to let the city be taken away from us. If you guys were able to go on Belle Isle, back in the day—wow. Belle Isle had a lot of stories. A lot of art. You would see graffiti art, you would see dance art, you would see all kinds of art. Basically, they took a lot away from us now. But we have to have our voice." A beat. "So, hey, this is Charlene, from the east side," she quips, giving herself voice tongue-in-cheek.

"But, we do," she continues, serious. "We have to have our voice. And that will make us pop. That's what I think," she concludes. CUT to a WIDE-ANGLE SHOT with Gratiot framing me as I continue through a choreographic sequence.

JUMP CUT to Stacey Klein, a slender twenty-something young woman who wears a white head wrap and jeans. Like Athens, Klein expressed ambivalence about changes to the city as new people move in, policy shifts, and the politics of space and places recalibrate. Klein underlines Athens's comments as she concludes, "Like I said, this is the real east side, this is the old east side, and we're not going *anywhere*."

Athens's and Klein's reflections on the struggle for the city, and their concerns around continued access to the city's amenities, resonated across the neighborhood and the city. From the McGhees, to Winters, to Wolfson, to

Lewis, longtime residents were concerned that a shifting politics of space and place and the loss of the black-power ethos of the 1990s and early 2000s could leave them behind. Often, on lonely days in which I'm performing alone, I think about interactions with informants and in the neighborhood generally over the years. As I perform at the liquor store today, I think about Faygo Wolfson's handcrafted hats and how they seem to consolidate the paradox of place, which itself is shaped by the struggle for the city.

I imagine Faygo Wolfson, standing in his usual spot in front of the old Blue Store, before it closed. When I open the door of the studio-loft and we catch each other's eye, he waves. I wave back and continue toward the parking lot as usual, if I'm not riding my bike. The weather is rainy and threatening thunderstorms. The air, raw. I doubt that Wolfson wants to talk in the rain, so I head to my car. As I pull out of the parking lot, I'm surprised to see Wolfson. He must've sprinted across Gratiot to reach the car so quickly, I thought.

Then, in the next instant, Wolfson takes off the elaborate, whimsical, handcrafted hat he's wearing and hands it to me. He asks if I want the hat. He tosses the question casually. Wolfson's casual demeanor seems ironic after three years of us discussing his making a hat for me. As I consider reciprocity and exchange, I think of *The Gift* by anthropologist Marcel Mauss.[1] In *The Gift*, as Mauss explored fundamental human principles of obligation and exchange, objects and entanglements in archaic societies were deliberate, strategic, and thoughtfully planned matters. This seems to be true for Wolfson as well. Wolfson granting me one of his custom hats—something he had never done before, he told me—was akin to Mauss's monumental form of exchange, called an "exhibition."[2] Mauss wrote that exhibition exchange would take on a public and performative frame—such as the giving of food and public feasting, or *sagali*.

Wolfson didn't host a feast or sagali, but his gift was public—I wore the hat in the neighborhood where Wolfson's hats were well known and singular; I also wore it out around the world, where I would end up telling people about Wolfson and his art. I'd be marked with his artwork whenever I wore it—marked with Wolfson and by the neighborhood itself. I'd be a walking exhibition of his work. Mauss's exhibition exchange applied in Wolfson's case as well because of the obvious linguistic connection I drew between a more common use of the word "exhibition"—an art exhibition—and the fact that I found Wolfson's hats to be works of fine art. While Wolfson was not publicly inscribed as artist with a capital A, and his affective labor of making art was not yet publicized, there was no doubt that Wolfson was an artist mak-

ing art. I emerge from my Maussian exhibition daydream and respond to Wolfson.

"I can't accept this work without compensating you," I reply. "Of course I want the hat!" After a beat, I realize we need to figure out a price. After we do so, I realize I don't have the cash on me. "Want to run to the bank with me?" I gesture for him to join me in the car. He walks around the Caddy.

"Front or back seat?" he asks. His question knocks me off balance and reminds me of the still-present power dynamics of our relationship. In spite of our links through my fieldwork and through Wolfson's and my art making, we are still not exactly friends. The spatial separation Wolfson suggests we might take on in the car reflects the conceptual separation of our lives. Although our relationship was built on art and the city, the realities of class stratification yet remained.

"In front, of course," I reply. He smiles and hops in, and we start toward the ATM, putting the slightly awkward moment behind us. As we drive up Mack Avenue toward the bank, he takes a deep breath.

"This car smells like a million dollars," Wolfson says.

"Thank you . . . but I don't know about that," I reply. "This car isn't new."

"This isn't new off the lot?"

"Oh, no," I reply. "Not even by a long shot. This is a 2005."

"Oh, okay, so it's not new off the lot."

We pull up to the bank and find a place in a long line of cars twisting behind the ATM. Six or seven cars deep, cars are stacked, waiting to get cash. We sit and wait. "So you told me your brother was a stick-up man back in the day?" Waiting in the line at the bank, I think of a conversation a few months ago.

"Yeah, he was," Faygo replies, a bit uneasily. "You remember that, huh?"

"Yeah," I reply. "That's hard to forget. Who did he stick up? Drug dealers? Or just anybody?" I press.

"He stuck up the riff-raff, mainly, like drug pushers and hoodlums, you know . . ." Wolfson's voice trails off. We finally get to the front of the line, and I retrieve Wolfson's fee for the hat. Somehow it feels final. An exchange we have been building toward for over three years. "Now, I'm going to the casino," he says as soon as the cash is in hand. "Want to give me a lift that way?"

"Really?" I ask, surprised.

"Somebody has to win," he tosses back. I run my hand over the hat, designed and hand-stitched by Wolfson, and turn his words over in my head.

Wolfson's words, "somebody has to win," haunt me for the rest of the day. JUMP CUT to Motor City Liquor, where I finish a sequence, clear my mind, and come back to the present. The idea that someone has to win haunts not just me, but people I talk to in the neighborhood about the shifting city and the McDougall-Hunt neighborhood. I'm not sure why urban process has to be a zero-sum game. I'm not sure it always is, but it seems to be, a lot of the time. People are concerned that some of the changes to the city, including stadium construction, increased security and regulation of the RiverWalk and Belle Isle Park, and the expansion of mass incarceration facilities, will cause somebody to win. It doesn't appear that the somebody is longtime, low-income, black residents who fall outside the slick NGO and community development, art money, or entrepreneurial circles. I think about Wolfson's art and his words as the city around me FADES TO WHITE.

Liquor Store Theatre, Vol. 4, No. 5 (2017)

FADE IN FROM WHITE:

EXT. MANNONE'S—(DAY)—MEDIUM SHOT of the familiar green-and-white storefront, with teenagers walking by, cars parked in front, and my collaborating performer that day, Mohamed Soumah, striking a pose in the doorway alongside a green sculptural object. Todd Stovall built several sculptural objects for an upcoming art exhibition and for a performance at the Whitney Museum. We decide to bring one of the sculptural objects to this filming to create a surreal frame with sculpture-movement-city all twirled into one. The sun is out.

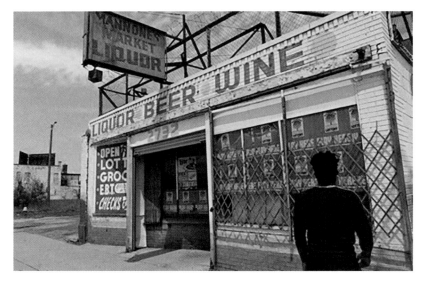

16.1 *Liquor Store Theatre, Vol. 4, No. 5* (2017). Mohamed Soumah is pictured.

It's springtime in Detroit. Today we will shoot two videos. I'm trying to get in as many as I can before I leave for Aarhus, Denmark, in late May.

The atmosphere at Mannone's is strange today. The usual manager, who has previously asked, "When will this project end?" in jest, acknowledging the project's duration, is not here. There's a different manager on site, and he doesn't seem particularly sympathetic to my efforts. After unloading, setting the shot, and getting enough street B-roll to be satisfied, Todd Stovall and I unearth the sculptural object from the back of Stovall's SUV. The sculptural object is about three feet tall, and it's on a mobile platform, remote controlled. The object is green canvas stretched over a wooden frame that Stovall has fashioned into the shape of a sort of lightning bolt. The sculptural object seems whimsical and ironic to me—it definitely doesn't seem ominous. Shows what I know. Not only does the manager seem annoyed today, but the presence of the sculptural object is problematic to some passersby.

I set the shot, and Soumah and I start a choreographic sequence alongside the edge of the storefront. I want to be sure not to block patrons' egress, as usual, while we're performing. As we perform, Stovall remote controls the sculptural object around us. It's orbiting Soumah and me as we move through our sequences. Stretch-pull-shake-turn, we go, as the sculptural object goes forward-backward-side-to-side. As we finish a sequence, I notice an older woman wearing a long, flowing skirt and an elaborate hat watching us, and especially the roving sculpture, closely. She watches with an intensity that betrays fear, which is something I haven't come across. The woman disappears into the store quickly. Soumah continues a sequence as Stovall and I look on. He moves from a slow, mechanical glissade into a bold, hyperkinetic kick. Then, stillness. Soumah catches the beat and launches into a contemporary choreographic phrase, blending classical ballet, the Senegalese dance style *sabar*, and B-boy moves. As he concludes the sequence, the woman and the store manager of the day once again appear at the doorway. Somehow, I can see that the discussion is not particularly positive, at least, from my perspective on things.

Before I know it, the store manager, Kahlid Akil, approaches us. "You can't be here. You have to leave!" Akil says, a bit too loudly. A beat. Thus far, a store manager has yet to tell me to leave or to stop filming. This is a first.

"Why?" I press. "I'm making an art film and a documentary about the city. We won't block any customers, and we'll stay on the public sidewalks," I add, stressing the word "public."

"What is this thing?" Akil gestures toward the sculptural object. "My customer is scared! Is that a bomb?" Akil presses. A beat. Again, I'm stunned. A bomb?

"I've been making films at liquor stores in the neighborhood for going on four years now," I reply. "This is a sculpture—it's artwork. I live in the neighborhood, and this is art. . . . It's a project focused on the people in the city and this neighborhood . . ."

My voice trails off as I see the store manager's eyes quickly frosting over. His English is relatively limited and my Arabic is nonexistent. He doesn't seem to understand the project, nor does he seem to remember my presence filming here over the years. Mannone's, in fact, has the most videos in the full body of work. I try again. "We're on the public sidewalks. We won't bother your customers, and, if anything, we will attract positive attention. More business?" I hope he can understand that, if nothing else—the color green. No dice.

"I'm calling the police if you don't leave!" he snaps, exasperated with what must seem to him to be my ridiculous responses. I resolve to finish my shot and then pack up. But we do finish our shot. I think that a good defense is to just keep dancing. I say so, and it's audible in the video at the very end.

Soumah and I continue our sequence. The Detroit police do a cruise-by in a few moments. They check us out—you can see their car in the video too. CUT to a MEDIUM SHOT of Soumah and me, in our jeans and shades, looking slightly disoriented, as we stand far away from the storefront, with the store in view maybe forty feet behind us. We perform a unison sequence as the Detroit police glide by, discreetly checking us out. They don't bat an eye, and they don't stop or even seem to consider stopping. And that's the end of that. I get my shot, and decide that I've been stubborn long enough. I haven't interviewed anyone, so I'm trying to figure out what to do.

Knowing I'll be leaving soon for Denmark, to write up my fieldwork, I ask Soumah and Stovall if they're willing to shoot another video. A man walking by hears. "Motor City Liquor is better than this place, anyways! Do your thing at Motor City! Come on!" He beckons. His energy is contagious and it's settled. As we pack up, I think of how different this experience at Mannone's has been, compared with the prior year when I met Zander and Hector McGhee. I suppose this might be the final Mannone's video. I ponder, feeling a bit nostalgic. As the connection to Mannone's seems precarious at this point, my connection to Zander McGhee, and Hector McGhee by way of Zander, is fraying as well. As I prepare the second shoot of the day, I think back to the last time I saw Zander McGhee.

JUMP CUT to a MEDIUM SHOT at my studio-loft, via my mind's eye. I was sitting at my desk, writing. Some time had passed since I'd spoken to Zander McGhee, so when his number along with his photo avatar surged onto my iPhone screen, it seemed alarming. Even a phone call was unusual; normally McGhee would text. I checked the time—8 a.m.

"Hello?" I answered.

"Hey," McGhee said easily. "What's up?"

"Just working," I replied. "What's going on?"

"You know we never met up before," he said, referring to our attempts to link up for him to borrow money. In the course of these attempts to link up, both of us had grown frustrated with the logistical limits of the other person, and we never met.

"Yeah, of course," I said, "I waited for you that day . . ." My voice trailed off as I thought back to a day I had waited for McGhee at what I thought was our designated meeting spot, and it had never happened. Wires crossed, on both ends, again. "So, what's up, you around?"

"I'm going to be over that way toward Mack and Gratiot later on today," he said. "Could we link?"

"Sure," I replied, "but I do have some other things going on today." I explained to him that I lectured for my Introduction to Anthropology students that day. I offered that McGhee could come to my office hours before, or we could meet up after I finished with the students. He said he would come to office hours and asked for a ride. I agreed, and he asked me to pick him up at Mannone's, the liquor store where we first met. I agreed, and four hours later, after finishing writing and prepping my lecture for the day, JUMP CUT to a WIDE-ANGLE shot of my Cadillac, waiting in front of Mannone's at noon on the nose, looking for McGhee. But it wasn't to be. Wires crossed—again.

I had to press on toward campus in order to make office hours on time. Once there, at the tail end of office hours, Zander McGhee called again. He said he was on his way, and he was taking me up on my invitation to sit in on the Introduction to Anthropology course. The previous semester, when McGhee and I were hanging out, I learned he was planning to enroll at a local community college. I invited him to sit in on my intro lecture, as he would need to take a similar course soon at community college. After office hours, I strolled to the lecture hall across campus as usual, sipping a syrupy-bitter espresso, happy that McGhee was coming to class but unsure of what to expect. I hadn't seen him in some weeks, and I knew he was couch surfing.

JUMP CUT to a university lecture hall, where a WIDE-ANGLE shot captures rows of students. I was twenty minutes into my lecture—the construction of

gender was the topic—when McGhee walked into class. When he walked in, all heads in the room snapped around and looked at him with faces ranging from confusion to mild concern to nonchalance. His appearance was striking, so this was not odd. McGhee had a purple and blue left eye—severely and freshly swollen, almost as if he had come directly from a fight to the classroom in its freshness. He was lean to the point of being gaunt; not thin in his usual way, but rather, days-without-eating skinny. He wore the same doubled-up hoodies he had worn when I last saw him—only then his hoodies were crisp and washed. This time, they had the street luster of being only spot cleaned for months. His shoes were sidewalk smoothed, and his low-slung jeans looked insufficient considering the frigid conditions outside. His eyes saved him. They were cool and calm, intelligent and friendly. In spite of the shiner and the clothing, his warm brown eyes made him seem like he might belong in the classroom. Once again, as when I reunited with him in front of the Blue Store months before, I felt like I was shielding him from the uninformed gazes of the students.

"Hi, Zander, come on in," I said to him in front of the classroom, interrupting my lecture. "Sit down. Glad you could make it." I smiled and nodded slowly as he chose a seat, to put him as well as the roomful of anthropology students at ease. Everyone seemed to understand and relaxed into their seats. McGhee listened intently during the lecture. He took out a tattered paper and pen from his jacket pocket and took some notes. He was as attentive as, or more than, the majority of the students who were paying to be there. Whether he hung on every word more because someone he had met at a liquor store in his neighborhood was giving a lecture, because he wanted to borrow money, because he was genuinely interested, or something else, I cannot know.

Regardless, McGhee was intent on hearing the lecture. On break, he shared some thoughts. "Your talk was good. Most of it was common sense, you know. Like . . . inequality, and how classes are created to keep some people down. Like, gender is close to race like that. It's common sense to me," he scoffed. A beat. "But, it was good," he allowed.

I nodded. Zander McGhee often had a somewhat jaded, icy point of view that could bring you back down to earth. "You're right," I agreed. "Sometimes the most obvious things are the hardest to understand."

The students broke into discussion groups next, preparing to present their thoughts on the readings. McGhee and I used a few minutes of the students' discussion time to take a brief step outside, where I gave him $25 he had asked for. I asked him what was going on. It was like looking at a dif-

ferent person, talking and being with him. He seemed desperate, edgy, exhausted. I could see the looks of students and passersby—with his attire and his bruised face, we caught many stares. My heels, fedora, designer bag, and professoresque United States American English shielded us from too much hostility. People would look a bit tense, then glance back and forth between us, and relax. But it was ironic and interesting—because McGhee's face was beaten up, and his clothes were tattered, people were looking at him like he was a threat. In reality, in that moment, McGhee was the vulnerable person. In comparison to myself and the relatively privileged students, on the scene of a university campus, McGhee was not the person in the power position at all, and he knew that.

"I think I scared some of your students," he said. "They're not used to seeing black, huh?" His eyes sparkled at his dry pun.

"You mean black eyes? From fighting? The intro students? No, they're not used to all that." I laughed at his dry humor and at some of the students' puritanical vibe. We walked quickly back into the classroom, where McGhee remained listening to the students' presentations and my concluding lecture until 5 p.m. when class finished for the week. Afterward, McGhee and I walked through the anthropology department, where I saw several colleagues. I noticed my colleagues doing double takes at McGhee. Not too alarmed, but the shiner was striking. I thought about the paradox of place running through this scene—how it felt strange as an anthropologist to have an informant who had obviously been in a fight standing next to me at the university, when we were only a few miles from his neighborhood, where I met him in fieldwork.

We ended the evening across the street at Tim Horton's, a local café. We were able to catch up a little bit over coffee and grilled cheese sandwiches printed with grill marks, as fat white snowflakes spun circles outside the wide steamy window fronting the café. I found out that after Zander McGhee's disagreement with his family, he had been living in shelters once the couch surfing ran out; the source of his facial bruising and purple eye was a fight at the shelter. I urged him to reconcile with his uncle and great-aunt and to move back to the east-side condo where we used to hang out. He expressed that that wouldn't be possible—"I have to get my own," he said. He asked me if I needed an assistant. I told him I'd like to offer him work to help with shoots now and then like before, but it wasn't anything stable. I'd keep an eye out for leads and would help him with a job search, I said. I asked if we could meet up at the Detroit Public Library next and job search for him together. He said he'd like to do that.

McGhee and I talked for an hour or so more before Todd Stovall came to meet with me. McGhee and I tried to set up a follow-up meeting time, but we weren't sure when would work, sitting in the busy café, trying to organize our very different lives to a common date in the coming days. "Let's go with the flow," McGhee said.

I nodded. "Yeah, let's link up again soon." I walked out to meet Stovall, not knowing if I'd ever see McGhee again. I wanted to do so much more to help. I realized that the extent of help I could likely offer in the near term was making videos and writing.

I pulled out my notebook and scribbled on its nearly-full pages as the snow deepened on the streets and sidewalks, and the temperature slid lower and lower. The CAMERA PULLS BACK and we're finishing packing up, back at Mannone's, where I met Zander McGhee what seems like forever ago. I look around. Furniture store, church, liquor store. Across the street, liquor store, tax place, beauty salon, menswear store. Concrete on concrete on concrete as traffic whirls by. McGhee was looking for opportunities, for ways to earn a good living legally, and for links that would allow him to pursue his interests while going to school.

It seemed that in this neighborhood, such goals were close to untenable. One would have to venture to a job, a school, or some other connection outside the neighborhood to make money legally in the formal economy. This was a paradox of place. This was an economic conundrum. The store manager watches with relief as we drive across the street to the next location, and we FADE TO WHITE.

Liquor Store Theatre, Vol. 4, No. 6 (2017)

FADE IN FROM WHITE:

EXT. MOTOR CITY LIQUOR—(DAY)—AN ESTABLISHING SHOT outside the bright yellow façade captures Mohamed Soumah and a man wearing an old English Detroit hat, sitting on a milk crate nearby, observing. After moving from across the street, where we left *Vol. 4, No. 5,* we've arrived here. The city moves around us, with people and cars moving along, and the front door is swinging open and closed as customers come and go.

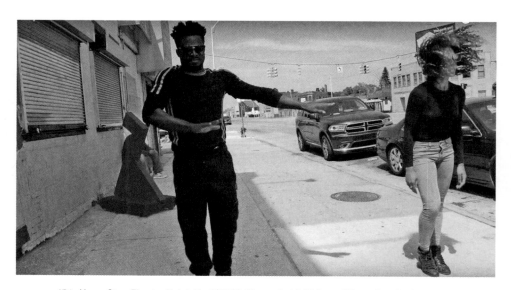

17.1 *Liquor Store Theatre, Vol. 4, No. 6* (2017). Pictured with Mohamed Soumah and onlookers.

A twenty-one-year-old, Juwan Lumpkin, was killed at Motor City Liquor—days after this filming.[1] The death and the events around the young man's death, so close to the conversations with people about the neighborhood, the store, and the city, loom around *Vol. 4, No. 6.* The video will always be marked with violence—the death of a painfully young person. Lumpkin and others were allegedly attempting to rob an off-duty cop. Regardless of the facts of the event, well-cited impunity of state violence, distressed political economy, and the lack of opportunities in the neighborhood make dismissing Juwan Lumpkin's death untenable.

It is calm, though, on the day that we film. The conversations with people, however, point to an awareness of violence simmering below the surface in the past and concern about its presence in the present or future. The paradox of place is in full relief as people talk about the economically surging downtown and the surging violence that continues to whirl around McDougall-Hunt. Although the young man's death and the associated shooting have, for me, overshadowed this video, for now, we go back on the scene. JUMP CUT to Soumah and me finishing a choreographic sequence. The sculptural object, still with us, glides by and comes to a halt near the curb.

Jared Kroman, the man sitting on the milk crate with us, is miked and ready to talk. CUT to a MEDIUM SHOT of Kroman. He's average height, wearing a Detroit hat, with thoughtful, expressive eyes and a strong build. I ask about the neighborhood, and Kroman hops right into conversation. "Even this corner we're standing on . . . this used to be the wild, wild, west," Kroman starts. A beat. "I mean, anything and everything was happening on this corner. But it seems to me that things change." He pauses a moment and continues. "Things are changing in our city. That is not the normal, anymore at the liquor store. I mean, it can get wild. . . . Look, we're in front of a pawn shop, and things were really happening . . . but it has calmed down, and it's really a blessing, and a good thing to come," he finishes.

"What's going on in Detroit right now?" I ask. "Even beyond the neighborhood."

Kroman thinks for a beat. "I can remember, downtown, you could hear a pin drop," he says. "There was nothing downtown. Now, there's art, galleries, people walking the streets, riding bikes, we got . . . it's coming back. It's really coming back. And I'm really excited about it. But I have to prepare my children for the city that's coming," he adds.

I ask Kroman what he means by that—a focus on children. A beat.

"We're trying to prepare for our children's children," he says stoically. "We probably won't see the full outcome of everything that's changing right

now. . . . But I think our kids' kids will really benefit from the things that are happening in the city. There are a lot of great things happening in the city," Kroman concludes.

The CAMERA PULLS BACK to a WIDE-ANGLE SHOT of Soumah and me, performing alongside the sculpture, following the discussion with Kroman. We're wearing jeans and shades as usual, and we're a bit drained from the crush of back-to-back shoots. We slide through geometric motions, executing a series of steps centered on Dunham technique, Japanese butoh, and the angles and architecture of the city. We finish a passage of unison choreography and take a break as a man and woman approach. The man, Glen Christian, is in his sixties, with a sliver-thin frame, sunglasses, and a cool, logical demeanor. He's miked and we're talking quite soon, as the woman he's with, his wife, looks on closely from off camera.

"Can you tell me about this neighborhood?"

"This is what we call the marketing district," Christian replies. "And the neighborhood itself is undergoing a lot of development. I've been part of this area practically all my life, so I've seen a lot come and go." A beat. "And I really see where the city is going forward. I would like to see more, but this is great. This is a good start," Christian concludes, pausing while sirens scream by.

"Less than a mile from here, Heidelberg Project . . . an artist, a local artist, was taking throwaway refuse and redoing it. And within a year or two people started coming from everywhere just to view his work. And art itself is in the eye of the beholder. Some people see beauty; other people see junk. You know. But it's a start," he concludes. After a moment, Christian broadens his discussion. "This area is a good area, and, looking downtown, what we call downtown, it's really developing. And I would like to see more, but I'm content with where we're at now, as a step forward," Christian adds.

"What do you think are some of the most important developments?" I press.

"Number one to me, one of the major improvements . . . like Belle Isle Park, that's a jewel for the citizens of Detroit. That's a jewel. A decade ago, it was like the strip. Guys and girls went down there just to shake and bake and do whatever," Christian laughs. "Now, there's a fee to get on the park, and you have to have your plate stamped with a park emblem on there, so, it's a takeaway . . ." Christian's voice trails off for a moment, as he considers the status of Belle Isle.

"But then, it's an improvement, because the park should be enjoyed by children. As a child, I can honestly say I remember being there. And they had little horse and carriages and things like that, and we used to ride them.

I would like to see that come back," he says. A beat. "More than anything, I would like to see the city blossom, and the children get a chance to see and enjoy the things that are readily available to them." A beat. "We're right here on the water," Christian adds. "What more can you ask for? We can fish, and do all of that."

"What are your thoughts on what's happening in the city?" I ask.

"The greatest change I can see is that people start to come together more," Christian says. "It's a long way from that Big Four, STRESS situation that I grew up in."[2] A beat. "Back then, it was a city that was controlled and governed by 90 percent Caucasian people, and we didn't have a voice. I believe it was 1972—Coleman Young became mayor, and it opened up a whole new avenue for city, government jobs. So, each little thing, in time, had its purpose. And I really can see some of the benefits. Just look at the area and see that we have three new stadiums—you know, there's a lot of money being poured into the city. And that's a whole new avenue for jobs, and people just being together," Christian concludes.[3]

A beat, as I think about Christian's historical commentary. "What do you want to see going forward?" I ask.

"That to me, is the greatest accomplishment that we can make, is just, people unite, and it would be a better place. Wouldn't be that carjacking, armed robbery type situation." A beat. "A young lady can come to the store without being in fear of her virtue being taken, you know," Christian continues. "A guy can come to the store without worrying about half his head getting tore off for a couple of dollars. You know. That, to me, is the worst." Christian pauses for a tick.

Then he concludes, "And . . . I would like for my children, and my grandchildren, and my neighbors' kids, just to be able to go to the store and go to the park." The sheer simplicity of Christian's wish is stark and hits me hard. I swallow, finding it difficult to respond. I nod and, realizing we've been talking for quite some time, thank Christian for the opportunity to speak with him. Days later, when I read about the fatal shooting in front of Motor City Liquor, Christian's stark words and his simple wish haunt me. His words are eerily prophetic, and my heart is broken, thinking that in the United States of America, we've become so desensitized to gun violence that shoot-outs at the corner store (and in schools) have become concerns of daily life. Like stepping on a piece of gum or screwing up your parallel parking. Only deadly. Only gutting families and possibilities.

In the case of McDougall-Hunt, the violence that bubbles up is connected to gun culture, but it's also connected to racialized economic violence

that can be hard to pin down for its centrality across philosophy, history, and the everyday. As anthropologist Arjun Appadurai writes, "Of all . . . contexts for violence, ranging from the most intimate . . . to the most abstract . . . the most difficult one is the worldwide assault against minorities of all kinds."[4] And, as Ralph theorizes, violence's subtle presence in distressed neighborhoods need not be kinetic to be deadly:

> I soon started realizing something . . . : Justin's disability was obvious because of his wheelchair. But in Eastwood, injury was everywhere. And injury took many different forms. There, people did not merely speak of injury in terms of gunshot wounds. Longtime residents saw injury in the dilapidated houses that signaled a neighborhood in disrepair; gang leaders saw injury in the "uncontrollable" young affiliates who, according to them, symbolized a gang in crisis; disillusioned drug dealers saw injury in the tired eyes of their peers who imagined a future beyond selling heroin; and health workers saw injury in diseases like HIV and the daily rigors of pain and pill management that the disease required.[5]

It was particularly cruel that antiblack economic injury led to physical violence, in McDougall-Hunt, in Ralph's Eastwood, and in Appadurai's global context. Days after filming, I read a newspaper article's account of the fatal events, trying to understand what happened. I was struck by the response to the shooting. In light of the connection to the Detroit police via the off-duty officer, Councilwoman Mary Sheffield called the robbery attempt "domestic terrorism."[6] Although the off-duty officer was not wearing any Detroit police attire or driving a squad car during the incident, Sheffield prioritized the police connection in further comments. The shooting was "the ninth incident in less than a year's time that a Detroit Police Department Officer has been the victim of gun violence in Detroit," Sheffield said.[7]

Sheffield continued, imploring people in the neighborhood to come forward. "Someone knows what happened last night. Someone knows those who may have been with the suspect. Someone saw the suspect who stole the guns from the scene and what car they were driving. Now is the time to speak up and speak out as you would want others to do if you or a loved one was the victim of a crime. Now is the time we show our officers that the community truly supports the men and women in blue."[8] Meanwhile, Detroit Police Department chief James Craig appeared at a press conference outside Detroit Receiving Hospital, where the wounded officer responsible for fatally shooting Lumpkin was recovering. *Detroit News* journalist Dickson wrote that during Craig's visit with the recovering officer, "The officer told Craig that he

wants a police motorcycle. The department's motor unit handles traffic and provides protection when dignitaries come to town. Craig told the officer: 'Recover, and we'll do everything we can to get you that motorcycle. But it's a rigorous amount of training.'"[9]

Sheffield's and Craig's comments reflect a lack of racialized political-economic awareness and criticality. While both are performing their job duties, and their comments reflect that, the comments of both reveal ways in which Detroit's leadership is encircled in willful blindness as it pertains to antiblack economic, structural, and physical violence. Would Lumpkin and his nineteen-year-old accomplice feel compelled to attempt a robbery if they had economic, vocational, and/or educational opportunities? Does anyone care that medical evidence supports the fact that people of their age do not yet have fully formed brain capacity as it pertains to decision making? Further, the commentary around perpetrators of mass school shootings rarely includes mention of "domestic terrorism."

If this term isn't applied to mass shootings, why would it be applied to an attempted robbery of one individual? While robbery at gunpoint is certainly horrific, Appadurai and Ralph's anthropological analyses of violence demand these questions be asked. The trouble was, no one in Detroit seemed to be asking such questions. The fact was, the silent, slow, economic violence of the neighborhood's lack of jobs and educational opportunities, and the political-historical violence of the Big Four and STRESS, led to acts of violence unfolding on the surface of the street in the now in Detroit. And yet Detroit is far from alone. Analyzing violence in Cali, Taussig reflects, "In a famous passage, Nietzsche suggests that criminals become hardened by observing that they and the police use the same methods, except with the police, the actions are worse because the police excuse their actions in the name of justice. What sort of methods? 'Spying, duping, bribing, setting traps,' says Nietzsche, 'the whole intricate and wily skills of the policeman and the prosecutor, as well as the most thorough robbery, violence, slander, imprisonment, torture, and murder, carried out without even having emotion as an excuse.'" Finally, Taussig concludes, "Nietzsche helps me understand why the violence of the law sickens me more than the violence of the criminal. . . . Nietzsche helps me understand how the violence of the law is not only a question of guns, handcuffs, and gaols, but worse, what gives that violence its edge and its lip-smacking satisfaction is deceit in the service of justice."[10]

What I find disturbing, reflecting on the shooting and the press conference discussion afterward, is the failure to consider or to even make vocal the underlying racialized political-historical-economic problems in the neighbor-

hood that lead to petty crime. To focus on the Detroit police officer's desire to join the motorcycle unit, just after killing a twenty-one-year-old, strikes me as egregious—tone-deaf and insensitive. As young men and women have told me over the years at filmings, the lack of activities and opportunities in the neighborhood continues to be a major problem. It continues to prop up a market for crime, gangs, and drugs. What would you do if there was nothing to do in your neighborhood?

You might dance at liquor stores. You might try to rob them. Apparently you could get killed there, too. In this, the fourth year of fieldwork, I feel increasingly ambivalent about my position in the neighborhood. The structural violence of the neighborhood is visible to me when I open the door to the studio-loft. I see a boarded-up liquor store, a now-closed food pantry, and a block full of abandoned buildings across the way. I feel it when I move through the neighborhood alone wearing high heels, when I'm fishing in my pocket for my keys at night, and when I walk into a liquor store without my gear and my cameras. And yet I'm insulated from the violence in the ways that artists and ethnographers are ever insulated from their subjects. Even if we work not to be, we are, and it's part of our existence. I can jump into my car and leave, and I can and will eventually leave this neighborhood. The violence of the neighborhood, like my relationship to it, is paradoxical. The philosopher Hannah Arendt writes of this paradox, "Violence, curiously enough, can destroy power more easily than it can destroy strength, and while a tyranny is always characterized by the impotence of its subjects, who have lost their human capacity to act and speak together, it is not necessarily characterized by weakness and sterility; on the contrary, the crafts and arts may flourish under these conditions if the ruler is 'benevolent' enough to leave his subjects alone in their isolation."[11]

On an early summer afternoon, I've just finished a few hours of studio work. I pause to check my phone, allowing a moment of indulgence in the dopamine hits of Instagram. I notice a direct message from Tee Lewis and open it up. It reads like this:

LEWIS Maya did you see? They smashed into Sams liquor store last nite. Right through the front doors. I feel bad for him.

MAYA Is that Sunset Liquor?
This neighborhood needs help.
That's too bad.

LEWIS No, the one your friend did backflips in. Palms Liquor.
 Yes, it does. This stuff is out of control. Soon we won't have any
 stores here to shop in.

MAYA Oh wow. That's too bad.
 Yea that's totally out of control.

Palms Liquor was not only the store where Soumah had executed per-
fect backflips at one of the filmings the year before—it was also the store
where Tee Lewis told me she had worked for $2 per hour, for years. Lewis held
no ill regard for Palms Liquor, and she was saddened by the robbery. In spite
of the economic injustice Lewis endured while working for illegal wages, she
was more concerned with the possible impact on the neighborhood.

For all its faults (which were numerous), Palms Liquor was a (relatively)
better maintained liquor store in the neighborhood. It had a wider range of
small consumer goods and food items. It was cleaner and more organized
than the other local stores. At the time, Lewis was concerned that the manag-
ers might pack up and leave, more than anything else. Lewis's reaction to the
Palms Liquor robbery, I argue, was one of strength. Arendt writes of strength
in the presence of violence, "Strength, on the other hand, nature's gift to the
individual which cannot be shared with others, can cope with violence more
successfully than with power—either heroically, by consenting to fight and
die, or stoically, by accepting suffering and challenging all affliction through
self-sufficiency and withdrawal from the world; in either case, the integrity
of the individual and his strength remain intact."[12]

In the face of the neighborhood's myriad forms of violence—from the
abstract to the intimate, as Appadurai says—Lewis and my central infor-
mants, including Winters, Wolfson, and the McGhees, worked to maintain
the strength and integrity Arendt writes of.[13] For Wolfson, this meant a turn-
ing inward and a focus on his art and his poetry. For Winters, this meant a
focus on the safety and cleanliness of his family's block. For Hector McGhee,
this meant a focus on rebuilding his life and relationships with his family
and a commitment to understanding the politics of the city around him. For
Zander McGhee, this meant pursuing a better life through school and also,
unfortunately, refusing to accept his family's charity. For Lewis, this meant
a loyalty to the neighborhood—to the teenagers and the neighborhood cats
and dogs who depended on her for food and shelter, and even to the store
manager who grossly underpaid her.

JUMP CUT to a WIDE-ANGLE SHOT of Gratiot Avenue. A large red tour bus floats by as Soumah and I perform a pass of unison choreography. A car pulls up, and a woman jumps out, scarcely glancing at us as she strides into the store. Kroman sits on the milk crate again, sagely watching our movements. As the city pushes through another day, the violence presses down into the concrete and for a moment, it might be any neighborhood, in any city, anywhere in the world. People moving. Traffic moving. The wind blows a little bit and the clouds loom overhead. I think about Kroman and Christian's reflections.

Both men were skeptical about the benefits the city would offer them. Rather, they were focused on the benefits Detroit's new development might bring their children and grandchildren. Kroman and Christian snaked through the violence and found a sort of strength. A strength that was pulled and culled from the future dreams and possibilities of their descendants. I am ambivalent about such strength for its depth of exasperating injustice. Wisdom is already on the streets, I realize. That's why I'm here, talking to Kroman and Christian, I realize, as we FADE TO WHITE.

Liquor Store Theatre, Vol. 4, No. 7 (2017)

EXT. SUNSET LIQUOR—(DAY)—AN ESTABLISHING SHOT captures an endless strip of bright, cloudless sky framing Gratiot Avenue, the white and blue storefront, and my collaborators, Seycon-Nadia Chea, Bana Kabalan, Mohamed Soumah, and Todd Stovall. The matte white paint and the romantic store name, written in bright red letters, make me think of a tropical island. Today, there is something odd about this store, as usual. The foot traffic is

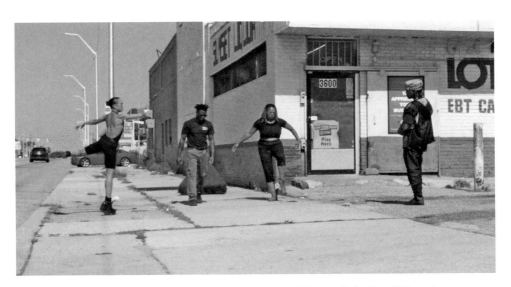

18.1. *Liquor Store Theatre, Vol. 4, No. 7* (2017). Pictured with Seycon-Nadia Chea, Mohamed Soumah, and Faygo Wolfson. *LST, Vol. 4, No. 7* was commissioned by the Cranbrook Art Museum.

so light that to use the word "trickle" would be generous. It's a warm fall day, and traffic glides by, the business of the neighborhood continues, and Todd Stovall's sculptural object meanders along as I capture B-roll, wondering what the day may hold.

A lot has changed over the years, and I can feel it in the air. Leading up to my solo exhibition at Cranbrook Art Museum, the museum commissioned *Vol. 4, No. 7*. I have to say, it feels surreal, as I stand in the sunshine, preparing to perform a sequence with Chea and Soumah while Kabalan controls the sculptural object and Stovall controls the sound. JUMP CUT to a MEDIUM SHOT as we stride into a choreographic passage. We're wearing all black with sunglasses, and cars slide by opposite us. Over the summer at an artist residency in Aarhus, Denmark, I've written up much of my Detroit field notes, and I've made a new body of work called *Harbor Square Ballet*. I've also made several new choreographic works, called *Untitled 1* through *Untitled 3*.

This choreography has landed in a style of its own—a style that I find satisfying in a way that makes me interested in pressing the limits as I work. I like to describe the movement quality I've been developing as a combination of voguing, finger-tutting, classical ballet, contemporary, and pedestrian movement. One of the signature elements of the works is the speed, precision, and bizarre pathways that the arms execute during phrases. Staging *Untitled 3* in front of Sunset Liquor, after performing it in the middle of a fountain in Aarhus all summer, feels odd.

But that's not all that's odd. Today there is a tense atmosphere at the store. I notice a man walking by, leering at all of us—he's annoyed, and he's making it clear. He goes into the store briefly, then returns to the parking lot, staring us down, and takes the back pathway near the large dumpster that leads to what I think is a sort of underground market down the way, judging by the slow trickle of people that come and go. CUT to a WIDE-ANGLE SHOT and we see the man appear once again and pace in front of the store. We're in the middle of a choreographic sequence, so his comments seem odd. "They need to stop recording people!" the man exclaims. "They don't have permission for this!" A beat. "I don't want to be on anyone's video," he adds. Todd Stovall is becoming tense, and he considers approaching the man. Rather than talking to the man, I want to ease his concerns visually.

I increase the intensity of my movements as I press through the choreography. When I get to a particular rapid-fire section of arm movements, I jump right up in front of the camera, blocking the lens with my body, so

that the man can see we are not filming passersby. We are not spying. We are filming ourselves performing. One of the reasons why the choreography is so important is that it makes me part of the spectacle. If there is some spectacle of the liquor store, rather than taking on the role of the voyeur, I make myself part of it and implicate my own excess as an artist and anthropologist willing to go to obsessive lengths to do a project, in the making of the work.

Somehow, I think the man understands, with our intense movements and my deliberate blocking of the camera, that we are not recording people without their consent. He disappears back into the store. We continue on. The man's revulsion toward my camera is ironic. This year, the project has gained so much visibility that it has become strange to me. My personal life has changed: I frequently get emails from strangers asking about my work; participating in exhibitions and talks around the world has become normal; and I have a solo museum exhibition opening up in my hometown.

Although I'm living in the neighborhood and working in the studio and on the sidewalks every day as usual, there's no denying that things have changed. These changes make me feel like something of a spectacle—a feeling I don't particularly like. I understand the man's revulsion. His revulsion also leans toward an awareness of the spectacle of urban black poverty. At moments like this, and over the years, I contemplated what the work was doing to critique—or to continue—such spectacles. While I intended the work to be a critique of objectification and insensitive spectacle, it was true also that in playing with the notion of spectacle through performance and film, I would be walking a tightrope. Adding to the precarious tightrope was the overrepresentation of black people (in realms of mass representation and in urban anthropological research) in settings and spaces like that of the liquor store.

Sociologist Elijah Anderson has written of such spaces, "Urban taverns and bars, like barbershops, carryouts, and other such establishments, with their adjacent street corners and alleys, serve as important gathering spaces for people of the 'urban villages' and ghetto areas of the city. Often they are special hangouts for the urban poor and working-class people, serving somewhat as more formal social clubs or domestic circles do for the middle and upper classes."[1]

While Anderson contends that the businesses he writes about are "their place" where "they set the rules," he writes harshly clinical descriptions of the cast of characters on the block.[2] Such clinical descriptions render people simplistically, at times, missing opportunities to complicate understandings of poverty, addiction, and class struggle. Anderson's description of regulars and

wineheads—regulars are working people who drink now and then for a release, and wineheads are chronic alcoholics—leans in the direction of Bourgois's rendering of alcoholism and crack addiction. Anderson writes:

> Regulars regard the typical winehead as a person who cares little for public proprieties. Whereas regulars, for example, pride themselves on, and even form as a group around, the activities of buying and drinking "expensive good stuff," like Old Forester or Jim Beam or Jack Daniels, and of drinking it behind the closed door of Jelly's liquor-store room, they know the winehead thrives on drinking cheap wine—for which he usually must beg—on the public streets and sidewalks. Similarly, the typical winehead is known to have no compunctions about "passing his water in public" against the nearest tree or the side of Jelly's building.[3]

The word "winehead" illustrates problems with black people and low-income people's representation in scenes like that of the liquor store. My interest, in part, in documenting the scene of the liquor store, was to understand what was behind the use of alcohol and drugs. It was to understand the people and their thoughts, words, hopes, and dreams. Rather than collapse people into a stratified hierarchy, I wanted to demand why the hierarchy existed and what it meant for contemporary life.

Still, I worried constantly about documenting the scene of the liquor store, about representing people I spoke with there, and what this all meant as it landed in museums around the world. At the Whitney Biennial in 2017, four *LST* videos were installed in the same gallery as Dana Schutz's *Open Casket*—a painting of Emmett Till—which artist Parker Bright protested by blocking the view of the painting, wearing a T-shirt emblazoned with the words *Black Death Spectacle*.[4] As I consider the politics of representation, from contemporary art, to urban anthropological research, to social movements, I understand why the man at Sunset Liquor is annoyed by the presence of my camera.

There is critical significance behind the man's irritation with my anthropology and art making at the liquor store. I find in the man's skepticism a rumbling of the need for "the ideal of anthropology as a permanent exercise in the decolonization of thought, and a proposal for another means besides philosophy for the creation of concepts."[5] The man does not know that I obsess over careful, thoughtful representation, and that the goal is to show people's complexity and subjectivity. How could he know? In *Vol. 4, No. 7*, the skeptical man tries to get us removed from the premises, it seems.

He brings the store manager out, gesturing toward us as if to say, Look, they need to go. CUT to a WIDE-ANGLE SHOT as we execute sequences of flickering wrists and twisted ballet. The manager, the skeptical man, and another curious passerby all stand together, observing us for some minutes. The manager decides we're not annoying enough to be asked to leave, apparently, and he retreats into the store. The curious man and the skeptical man both amble away, after some particularly misogynistic remarks are made within earshot: "I'll tear both of them up," the curious man says, as Chea and I pass by with a traveling choreographic sequence. "You know you're wrong for that," I say, and I'm glad to cut the sequence.

Not everyone on the scene, however, is annoyed by our presence. JUMP CUT to a MEDIUM SHOT as we launch into another choreographic sequence, the sculptural object floating behind us. John Silver, an upper-middle-class-looking man in his late thirties, is immediately interested and walks up as we complete a sequence. Silver is slim, wears sunglasses, a polo shirt, khakis, and a Tigers cap. As we finish a phrase, Silver, to my surprise, joins us in the shot. He slaps five with Soumah and proclaims, "This is Brother Love," posing with Soumah in a MEDIUM SHOT as Chea and I try not to smile in delight behind them.

After I cut the scene, Silver quickly offers to speak with me. "You good?" He asks as I mic him and check the sound.

"Yeah," I reply. "So, can you tell me about Detroit?" I start.

"Detroit is awesome," Silver replies. "My people grew up from here. Things change, but they made things happen for us, and they're trying to make things better. There are a lot of things going on in Detroit. I just want everything to work out. I mean, I can't do it by myself. It's a people project," he finishes.

"Can you tell me a little bit more about this neighborhood? What do you call this neighborhood?" I ask.

"Well, this neighborhood was known for . . . the art gallery on Elba and Ellery." A beat. "Also, the Heidelberg Project. I'm quite sure you've heard of the Heidelberg Project," Silver says.

"Of course," I reply.

"Well, it's all about that. It's called M & M. The reason why they got the name M & M is you have Mt. Elliott right up the street, and on the other side, you have Mack. And, that's where you get M & M from. Mack and Mt. Elliott." Silver pauses for a moment.

"It's not a gang slang, or anything like that. It's not anything provocative or anything like that. It's just where everybody came from." A tick goes by. "If you knew how to get to Mack, you knew how to get to Mt. Elliott," he adds.

It's clear that Silver has a lot of history here. He continues, talking about the past several decades and how the landscapes changed. "And Ziedman's is right down the street. You have the pawn shop, Ziedman's. Henry the Hatter's. Ah, man, everybody loved it. This was the greatest time of Detroit."

Silver thinks for a moment, reminiscing. "You had Sherman's on the left-hand side of Gratiot. It was beautiful. We don't have that anymore. They took Sherman's away from us. They took Henry the Hatter's away from us. . . . They took the White Castle. . . . There was a White Castle right around the corner, right around the corner from this store," he finishes.

I detect a sense of nostalgia in Silver's commentary. He zooms back to the present. "But I don't live here anymore, but it's a beautiful thing, to just come down to my community, and still see that some of my people are still here," he says, smiling quietly. It's apparent that regardless of changes, Silver loves the neighborhood.

I pivot, wanting to talk to Silver more. "So, we've been talking neighborhood, Detroit, like, can you tell me what's going on in the U.S. right now?"

"Politics?" Silver asks.

"Well, just whatever is important to you," I reply. "Yeah."

"Politics!" Silver responds quickly. Then he takes a final drag on his cigarette and deftly flicks the ash, extinguishing the flame with a twist of his wrist.

"I'm not really fond of what's going on right now," Silver starts. "I have family members that served in the military. . . . I have family members that are in the military right now. . . . Donald Trump, who is our president, I really feel as if he has been disrespectful to himself, his people, and everyone that voted for him, and the ones that didn't vote for him."

A beat, then Silver continues, "Yes, I know you are a businessman, but you are not a politician. You don't understand what really goes on. And you are causing more trouble that America is trying to face right now," he concludes.

After a tick, Silver continues. His voice is restrained, and his demeanor is careful. He wants to speak his mind but is meticulous in his effort to appear measured and respectful. "I think my president, Donald Trump, is hurting us right now," Silver says. "Truthfully, I'm not going to say anything bad about him, but if it was my choice, I want him impeached or out of office."

As we wrap up the discussion, I ask Silver a final question. "What do you think people need to know about this neighborhood?"

Silver pauses and thinks for a few seconds. "So, I was blessed to travel the world," he replies. "So, I know different cultures; I've dealt with different

cultures; I know different languages. . . . What I can say to that is, be aware of your surroundings, and just look at the positive things that people say. No matter where you go, no matter what you do, or where you're at, there's always someone who's going to say something negative about something." A beat. "I'm not a negative person," Silver continues. "I'm not the person that looks at the glass as half-empty. I look at it that it's half-full. So, just look at everything in a positive way, and I think we could be better people."

Vol. 4, No. 7 turns out to be a special day. As we're filming, from across the street I see Faygo Wolfson's unmistakable profile. Wolfson is wearing one of his hats as well as a medallion. We catch one another's eyes from across the blurred pathways of passing cars. We wave. My memories are imprinted with greeting Wolfson like this—across Gratiot Avenue's flying traffic. Wolfson sees that I'm filming and crosses the street. By now, I've known Wolfson for years. We've talked and he's shared so much with me—all off camera. I wonder if he'll be on camera in a video today, for the first time.

After greeting one another, we launch into another choreographic sequence. Another take. This time, we set up at the edge of the storefront, where the façade meets the sidewalk. Wolfson is interested, even wandering into the frame to watch more closely as we perform. While I move through a sequence, I hope to have the opportunity to talk to Wolfson about his own art today. It turns out, today is to be the storied day that this happens. After the sequence cuts, Wolfson offers to go on camera. "It's time," he says softly, smiling.

"Can you tell me about Detroit?" I launch.

"Well, Detroit is a marvelous place," Wolfson begins. "Since I've been here for thirty-five years, it's been extremely positive, and the criminal element has disappeared." A beat. "So, Detroit is a very distinguished place, to bring up children and to learn a trade," he concludes. I can't help but noticing the deliberate irony in Wolfson's comment—"the criminal element has disappeared." The mass incarceration explosion of the late twentieth and early twenty-first centuries has indeed caused "criminals" to disappear, mostly for nonviolent, petty crimes.

"Can you tell me more about the people?" I press.

"People in Detroit," Wolfson starts, "they're separating, and they're moving to other places." A beat. "To quiet places." And another. "Because of their movement, I'm becoming lackadaisical sometimes. So, it's hard for me to remember what type of art forms that they are in, or images." Wolfson pauses a moment, thinking. "A lot of artful people are here," he adds.

Wolfson, again, leans into contentious choreographic dynamics. People who have been in neighborhoods like McDougall-Hunt for a long time have,

sometimes, become fatigued with the stress and pressure of meager city services, lack of neighborhood shopping, jobs, and educational opportunities, and the rampant crime (or fear of crime) that results from resource-strapped geographies. In spite of Wolfson's incisive comments, his words are coded. He speaks in a fantastical, allegorical way that defies a simple understanding.

Wolfson continues his allegorical prose, adding, "By the majesty of disappearance, they're still here." A beat. "But they want quiet and peace. I look for their art forms, but I can't find them right now." He pauses again, longer this time, and then adds, "I'm pressed to find them." And then, turning the discussion back to his own experience, he concludes, "I'm just really the person that's looking for attraction from my hat. I'm trying to find my people when I wear this hat." The skin on my forearms jumps with excitement. Wolfson has mentioned his hats. I pivot and fly toward the opportunity.

"Your hats are hypnotizing. They're amazing," I say from behind the camera. "This is how we met—it's funny you say you're looking for your people with your hats—because we really met, like, I was so fascinated by your hat. I had to, like, try to start a discussion. So, your hats have that force. Are the hats connected to the street? Do you find materials in the neighborhood, or do you go seeking out things and buying materials?"

Wolfson pauses a moment, and then quickly picks apart my blathering question. "Oh," he says knowingly, "I pull it out of the rubble of my mind. Okay. It's like layers. Layers of thought." A beat. "You parlay the thought. You lay it out there. In your mind. You study that. In contrast, nothing in contrast can take your attention away from it, then you know you have a thought. And you're building on it. Every night you go to sleep. It's going to build up," he finishes. I feel like I'm on a studio visit with Wolfson there, learning about his practice, right in the middle of the sidewalk at *Vol. 4, No. 7*.

Just when I think I'm gathering concrete information about Wolfson's practice, he takes a fantastical turn. "It's like flesh that tears away from the body," he continues. "It rips open. And you get more . . . you get more . . . energy, as it pieces back together. New growth, and new skin coverage . . ." His voice trails off, as he seems to realize he's become quite abstract.

"Philosophy!" I proclaim from behind the camera.

"Yes," Wolfson replies easily.

As Wolfson stands there, in front of the Faygo Bottling Factory, I reflect on the significance of the moment. In addition to the fact that his nickname is Faygo, and he's in front of the well-known Detroit-based soft drink (pop if you're from Detroit) factory of the same name, it's a surreal day for

other reasons. Here I am, making a video commissioned by an art museum and talking with one of the central people of my fieldwork's artistic practice. Things are becoming pretty meta.

Art talking about art talking about art. Anthropology talking about anthropology talking about anthropology. Returning to the man who was annoyed by my camera at the start of the film, these contentious topics revolve around the politics of representation—in contemporary art and in urban ethnography. The lines between art, life, ethnography, image, representation—these are contentious lines. Moving through a choreographic sequence, with Wolfson looking on, I think about my conversation with Wolfson and the reaction of the skeptical man to our presence, I think about the choreographer Bill T. Jones's piece *Still/Here*.

Still/Here, which premiered in 1994, sourced personal narratives from a variety of people, young to elderly, living with HIV/AIDS and other terminal illnesses. For eighteen months, Jones led a series of gatherings that he called Survival Workshops. Moving through ten cities in the United States, talking with people, filming, and conducting movement workshops, Jones used the resulting raw material to develop the moving-image elements of *Still/Here*. The piece is a multimedia effort designed for proscenium stage, containing video projections, music compositions, narrative, and choreography ranging from gestural, to live ensemble, to mimetic, to abstract. The work premiered in New York City, receiving a positive review from the *New York Times* dance critic Anna Kisselgoff, who wrote that *Still/Here* was "a true work of art, both sensitive and original."⁶ However, *Still/Here* had its skeptics.

One of these skeptics, the *New York Times* dance critic Arlene Croce, was so skeptical that she refused to review Jones's work. The fissure between Croce and Jones extended beyond creative-world beefs that mark where taste, ego, and image fix into a complicated cocktail of like and dislike. The Croce and Jones fissure, rather, turned toxic. As I think of the skeptical man who wanted us gone from the scene, and I think about the politics of representation on the streets and sidewalks of *LST*, I think about Arlene Croce's visceral, extreme reaction to *Still/Here*. Croce's response is better understood through direct excerpts from her writing than through summary-from-afar. This is ironic because Croce, in preparation for her review-that-was-not-a-review of Jones's piece, did not actually see *Still/Here*. Croce chose not to see *Still/Here*, and this decision is at the center of the caustic write-up. Croce writes, "I have not seen Bill T. Jones's *Still/Here* and have no plans to review it. In this piece, which was given locally at the Brooklyn Academy, Jones presents people (as

he has in the past) who are terminally ill and talk about it. I understand that there is dancing going on during the talking, but of course no one goes to *Still/Here* for the dancing."[7]

What, then, do people go to *Still/Here* for? Croce has a hypothesis that people go for the spectacle of what she terms "victimhood," writing, "The cast members of *Still/Here*—the sick people whom Jones has signed up—have no choice other than to be sick. The fact that they aren't there in person does not mitigate the starkness of their condition. They are there on videotape, the better to be seen and heard, especially heard. They are the prime exhibits of a director/choreographer who has crossed the line between theatre and reality—who thinks that victimhood in and of itself is sufficient to the creation of an art spectacle."[8]

Context is critical. Jones has AIDS and his late partner, Arnie Zane, died of AIDS in 1988. Jones came of age in the 1960s, emerging from the "Dada experimentation" movements of the time, imbued with the aesthetics of LGBTQ communities, the antiwar sentiments of post–Vietnam era flower children, and the aesthetics of conceptual, postmodern dance communities.[9] This context isn't enough for Croce, who wrote a scathing description of Jones's positionality, indicting substance and strategy at once. "What Jones represents is something new in victim art—new and raw and deadly in its power of the human conscience. Jones's personal story does not concern me. (It was told in the November 28 issue of the *New Yorker*.) But his story intersects vitally with cultural changes since the sixties that have formed an officialdom, a fortress of victim art. Bill T. Jones didn't do this all by himself; in fact, he probably didn't mean to do it at all."[10]

Croce's critique, while claiming not to be, for better or for worse, is personal. To critique Jones's artistic-political actions and at the same time proclaim that Jones "probably didn't mean to do it at all" seems strange. To claim that Jones's personal story is insignificant seems naive—critics understand that the artist's identity is a question often at the center of a critique. Croce provides some context around her position, offering,

> As a dance critic, I've learned to avoid dancers with obvious problems— overweight dancers (not fat dancers; Jackie Gleason was fat and was a good dancer), old dancers, dancers with sickled feet or dancers with physical deformities who appear nightly in roles requiring beauty of line. In quite another category of undiscussability are those dancers I'm forced to feel sorry for because of the way they present themselves: as dissed blacks, abused women or dis[en]franchised homosexuals—as

performers, in short, who make out of victimhood victim art. I can live with the flabby, the feeble, the scoliotic. But with the righteous I cannot function at all.

Jones's *Still/Here*, a mixed-media, evening-length work produced for a proscenium stage, differs from LST in terms of form, structure, and substance. And yet there may be some common ground between *Liquor Store Theatre* and *Still/Here*. Croce uses the word and concept "theatre" to probe her problems with the formulation of the same within *Still/Here*. "In theatre, one chooses what one will be. The cast members of *Still/Here*—the sick people whom Jones has signed up—have no choice other than to be sick. The fact that they aren't there in person does not mitigate the starkness of their condition. They are there on videotape, the better to be seen and heard, especially heard. They are the prime exhibits of a director/choreographer who has crossed the line between theatre and reality—who thinks that victimhood in and of itself is sufficient to the creation of an art spectacle."[11]

Croce believes, as outlined in the above distillation of theatre in the work, that the starting point of "people living with HIV/AIDS" is unacceptable as art. That is, the existence of the people as infected with a terminal illness as subjects, to Croce, has moved *Still/Here*, and any work like it, beyond the specter of critique. Croce's lightning-rod analysis of people living with terminal illness as unacceptable subjects, in twenty-first-century anthropological theory, method, and research contexts, is untenable. Anthropological research, in contemporary contexts, is about searching out subjectivity, logic, custom, rhyme, and reason in any human group—often, especially in groups structurally marginalized in onto-historical-political-economic hierarchies. Still, Croce's analysis doesn't fall completely flat in anthropological contexts, if and when her concerns are transposed from matter of subject to matter of degree.

Contemporary critiques of urban anthropological research are particularly sensitive to spectacle and representation. Although no anthropologist schooled in the past twenty-five years would argue that an ethnography of people living with HIV/AIDS is inherently problematic, they would ask serious questions: What are the theory and method underlying the work? What are the ethics? Are you doing anything to ensure monitoring of people's health during this study? Even if your research is exclusively social—you're working with people who are physically ill—how are you prepared to deal with this? Why are you doing this work, with people living with terminal illness—what's your angle and what's your agenda? Whom are you repre-

senting? What's your connection to the people? How are the people compensated? Who is the audience for the work? Who will benefit from it?

Those are only a few of the more basic starting questions that anthropologists should have about any such work. Neither Croce nor Jones claim to be working or critiquing in the realm of anthropology, but I argue that Jones's work in *Still/Here*, and Croce's critique of it, has significance in both contemporary art and anthropological research contexts. Croce's critique is important in part because it misses the mark, but in the process of missing the mark, Croce unearths a number of critical issues in both contemporary anthropological and art contexts. My discussion of Croce's nonreview of Jones has been done already, in contemporary art contexts. What I'm adding here is a discussion that includes an attention to anthropological research. After all, Jones used ethnographic methods—interviews of real people—to develop *Still/Here*.

Croce opens her piece on Jones with a stark line. It's a confession. "I have not *seen* Bill T. Jones's *Still/Here* and have *no plans to review it*," she wrote.[12] Croce, I shall argue, is providing a glaring confession, or a critique of her own failure as an art critic. But this failure is more than a problem for a critic. This failure, I argue, centers around the word "seen" and all that goes with it. See, what critical feminist approaches to anthropology and to art attempt to do is to *see*. To see means we attempt to see everything in the world around us. Not just what we think is triumphant, superior, or most like ourselves. We attempt to see it all. To find logic in it. To document it, to abstract it, to find pleasure or pain, or some combination in it. Croce's confession that she has not seen the work she will be writing about—and equally important, that she has no plans to review it—gets at the heart of many huge questions and problems in art and anthropology.

To be seen is to be considered, to be heard—and, I argue, to be critiqued. The gaping hole in Croce's analysis is that Croce has allowed her own perception of people living with terminal illness to cloud her ability to analyze a work. I haven't worked with people living with HIV/AIDS or terminal illness, but I can make the obvious assumption here that people living with such circumstances are complicated people who create countless ways of understanding the world around them—just as all people do.

Croce's assumption that Jones's decision to work with a particular group of people renders his work "undiscussable" provides an argument, on the pages of the *New Yorker*, that, like it or not, Jones's work is utterly necessary.[13] Croce's conclusion that people living with terminal illness are defined, flattened, and reduced by their status, and obscure all else around

them, makes Jones's work urgent. People deserve to be seen. The fact that an artist is grappling with this question of subjectivity and forcing the critical hand (if not the critical eye) to come to terms with the question shows that Jones's work asks urgent questions.

Bill T. Jones's *Still/Here* remains a groundbreaking, ambitious work. In 1994, *Still/Here* was timely. It seems more important today. I find a video of the full-length work excerpted for Public Television. The video begins with people sharing their brief stories of terminal illness experiences. The people combine movement of their bodies with their own words to describe their experiences of being terminally ill. Their movements range from miming the rocking of a baby during breast-feeding to karate kicks. The discussions center on their illness and their experiences of diagnosis, acceptance, and the ways in which their families orbited their experiences. The slick production and the quick jump cuts contrast with an aching cello solo that hums in the background. From the video, projected above the stage, the focus cuts to the proscenium stage, where the Bill T. Jones company performs movements associated with survivors, with one performer saying the people's names and mentioning some of their inspirations, as they slowly perform the movements.

In spite of its numerous elements of genius, I want *Still/Here* to give me more tension. Video footage of movement workshops with his subjects leans to utopic. The joyful expressions on people's faces seem unbelievable. It feels staged. And yet, the closer I watch, forcing myself to do so, forcing myself to see . . . I can see that it's real. It takes discomfort to get there. It takes a shutting down of my own expectations and of my own sense of affect. It takes a patience and a sense of careful seeing. *Still/Here* has done for performance something that anthropologists talk about quite a lot. With the work, Jones made a marked innovation in method. The work was and is a game-changer. Jones introduced ethnography, and an attention to real people, into a full evening's work for the proscenium stage.

Anthropologists have been using participant observation and ethnographic interviews for centuries. Where I find *Still/Here* potent, so long after the Jones-Croce discussion, is that anthropologists are increasingly using multimodal methods in their work, and that artists are increasingly using ethnographic methods in their work. *Liquor Store Theatre* and the way that I work as an artist and ethnographer seem to rest squarely in these crosshairs. Part of what such efforts do is to force us to view people, spaces, and places that make us uncomfortable.

Such efforts, I argue, also require continual critique—by the author of the works and by critics alike. Ultimately, Jones's description of his effort is

satisfying. Sitting in a preconcert theatre for a documentary interview, Jones wears glasses and a yellow sweater over dress slacks. "The profoundest questions I can ask," Jones explains, "can be answered by other people."[14] Jones, I shall argue, was advancing the traction of the anthropological in art contexts, as well as advancing the traction of multimodal efforts in the anthropological. The trick is, ethics, politics, and aesthetics figure centrally in all these worlds. It's a lot to do, and a lot to analyze. I think this fact was behind Croce's critical lapses. A refusal to see. I'd argue that the need to see all sorts of subjects actually makes the critic more and more essential, in art and in anthropology contexts. Art is ever a blend of taste, time, sex, politics, breath, and death. I don't have to call work political because I don't need to. The politics, the economics, and the histories jump from the streets and sidewalks.

When we can move beyond ideas of the serious, the pure, and the best, we can move to spaces and places where context, connection, representation, and justice matter in contemporary art and contemporary anthropology. If critics or anthropologists can understand the seriousness of all people, spaces, and places, we might be able to move this thing forward. I realize I've been daydreaming, and we JUMP CUT to a MEDIUM SHOT of John Silver as he finishes up his conversation with me.

"Any last thoughts on the neighborhood?" I ask.

A beat. "M & M blessed!" Silver says. "Forty years and better. It gets no better than this." A beat.

"I remember when this was gravel," he continues, gesturing toward the ground. "Now, we got sidewalk. Now look at it. It's back to where it was in the beginning." Silver smiles, pauses for a tick.

"The.

"Shit.

"Don't.

"Stop."

Silver concludes his interview carefully, placing a breath between each word for emphasis. He unclips his mic and walks off camera, a slight, ironic smile playing across his lips. Traffic whirls by on Gratiot Avenue; the street noise is ambient, intoxicating found music as we FADE TO WHITE.

Liquor Store Theatre, Vol. 5, No. 1 (2018)

FADE IN FROM WHITE:

EXT. PALMS LIQUOR—(DAY)—WIDE-ANGLE SHOT—A down-at-the-heels store—we've been here many times. By now, anemic plastic palm trees and blown-out neon adorn the scene. Trash swirls in the parking lot. It's December in Detroit—and it feels like it. It's bitter, it's raw, and my body aches. My heart also aches surveying the fast-deteriorating store since the last time I filmed here. A slow flow of customers winds through the sidewalks and parking lot.

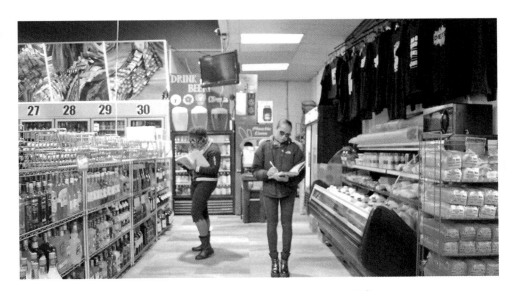

19.1 *Liquor Store Theatre, Vol. 5, No. 1* (2018). Pictured with Seycon-Nadia Chea.

I've just touched down in Detroit after my first semester as an assistant professor at Cal Poly, Pomona. I'm reeling from the sharp air, the west-to-east jet lag, and the buzz of pulling up to a brand new *LST*. We jump right in—with Chea and Todd Stovall hanging out on the streets and sidewalks as I pull B-roll.

The CAMERA PULLS IN to a MEDIUM SHOT of a flashy, late-model bit of European steel parked in front of the weathered store. Perhaps it belongs to the store manager on shift today. With the white December sky and the ruthless high-noon light penetrating the shot, the scene of the liquor store is violent. The hazy white light will make for a stark video. It's disappointing, but the weather conditions are not the only harsh situation that I'm analyzing. Rolling through the fifth year of the project and reflecting on Detroit's racialized political and economic historical formation, I have been, more and more, understanding liquor stores in the city as sites of dispossession. I'm understanding the stores as sites of violence—slow violence and fast violence. Not that the sites of the stores don't remain complex—they do remain beyond a singular analysis. Still, a number of transformations have further shifted my perspective and analysis. The CAMERA PULLS BACK—WAY BACK—and now we've entered my thoughts.

Since we clicked over from *Vol. 4* to *Vol. 5*, I've settled into a position as a tenure-track assistant professor and an artist in the Department of Liberal Studies at Cal Poly Pomona, and I've shifted to a bicoastal existence. My maternal and paternal families remain in Detroit, where my maternal family has lived for four generations. During this time, my brother Josef Cadwell was sent to prison for a stretch. While I was preparing to defend my dissertation, he was moving through the preincarceration judicial process. Cadwell and I decided then to embark upon a project together, and we've been reading and writing together incessantly (using pricey prison email and telecommunications to do so) ever since. We've been writing for our lives. Two years later, our book, *Writing through Walls*, is forthcoming.

The net effect of these changes is that my perspective has shifted. I find myself reflecting more upon state violence. Persistent liminality pushes against me. Reflections upon either place from the situation of the other permeates the everyday as I write with my brother. Three months later, I met DeShawn Dumas, a conceptual painter and academic, at the San Francisco Art Institute (SFAI) during the run of a solo exhibition, *Under New Ownership*, curated by Frank Smigiel. I was at SFAI giving an artist talk; Dumas, a postgraduate AICAD (Association of Independent Colleges of Art and De-

sign) fellow there, was invited to the talk and the dinner to follow by Smigiel. I met Dumas on a Friday at 6:15 p.m. Three hours later, there was no turning back. Working through this shifting analysis, we JUMP CUT to DeShawn Dumas's conceptual art practice.

The CAMERA SURGES—the CAMERA, in fact, TIME TRAVELS BACKWARD—hurtling through memory; through U.S. case law files; through northern Indiana newspaper clippings; through tears—to a MEDIUM SHOT of Derrick Conner. Derrick Conner is DeShawn Dumas and his sister Ashley Conner's older brother. It's May 1995—Dumas would be eleven years old, his little sister Ashley eight, and their older brother Derrick Conner twenty-two. Conner's tawny skin is springtime bronzed. A carefree smile plays at the corners of his mouth. Conner is in Elkhart, Indiana, a SMALL TOWN of around fifty thousand. The CAMERA PULLS UP to a city block, looking like Anytown, Main Street, USA. Typical suburbia looks.

Imagine looks such as, Look 1—diner, shoe store, church, flower shop. / Look 2—pharmacy, theatre, gas station, coffee shop. / Look 3—Derrick Conner, jeans, sneakers, bookstore, bike, stalking, harassment, death, lies. The CAMERA PULLS BACK, and two middle-aged white men, Steve Ambrose and Frank Owens, are behind the young Derrick Conner in the FRAME of a WIDE-ANGLE SHOT. Ambrose and Owens are police officers, but neither you nor Conner knows that because they're in plain clothes as the CAMERA PULLS UP to a MEDIUM SHOT and proceeds to 360-PAN both sides of the block.

A sort of quiet settles around us. A prefix quiet. A harbinger quiet. The quiet is only there for a second. Then all hell breaks loose. The CAMERA SURGES FORWARD as the SOUND BARRIER BREAKS and RAPID-FIRE, CLOSE-RANGE GUNSHOTS ring out. The CAMERA SURGES BACK, searching out the CLOUDLESS SKY, refusing to objectify the brutal violence in this moment.

The golden-sunny afternoon is shattered. The rhythm of the shops is split open. The rhythm of the day is sliced up. People run. People cry. A plain-clothes dirty cop, Steve Ambrose, has shot Derrick Conner in the back numerous times with the standard police-issued firearm, the GLOCK 22. Ambrose has murdered Conner, according to the U.S. court report files. The empirical reality of what happened on that day cannot be mystified: Derrick Conner's life was unjustly taken by a plainclothes cop. The structural violence and the brute-force gun violence of Conner's killing was followed by even more violence.[1]

Structural violence relies on erasure to go viral. Structural violence, then, has at least two phases. The first phase is the killing or the physical violence—Derrick Conner's murder. The second phase is the cover-up, the erasure, and

the deliberate distortion—Derrick Conner's autopsy, in which state officials deliberately obstructed the truth. Derrick Conner, a son, a brother, with not so much distance between an adult and a child version of himself at twenty-two, was a friend, a classmate, and a young man (barely) . . . Derrick Conner's body was not treated like this; rather, it was treated like an enemy of the state; like a *corporis non grata* . . . The U.S. court report indicates, "According to the forensic pathologist, the initial autopsy was not properly performed and some of the bullet wounds were damaged, making it impossible to determine the direction of the bullet's entry."[2] Moreover, "the responsible pathologist, Gerald Quinn, allegedly cut out sections of the bullet wounds, misinterpreted the nature of the wounds, and attempted to cover up the fact that all of the bullets that struck Conner . . . entered through Conner's back."[3]

It is difficult for me to render in words the precipitous pain, the reeling injustice, the unfurling sickness, the pit-of-gut drudgery, the screaming at a cellular level, that the autopsy fraud demands. Gerald Quinn, the hired pathologist, and Jeanette K. Albert, the coroner, deliberately mutilated bullet wounds on Derrick Conner's body in an effort to distort—to erase—the truth. A person, a son, a brother, a friend, Derrick Conner, rendered an object through execution. Through murder. Then, again, a person, a son, a brother, a friend, Derrick Conner, further harmed in death, further violated by the state.

As I write this my body and mind course with anger and with disgust at Ambrose, Owens, Quinn, and Albert, and, more to the point, at the systems and structures of the United States framework that enable them to murder with vicious audacity. All I have are these words to name the crime—the first crime committed by murdering an innocent, full-of-life person, son, stepson, brother, possible future father, Derrick Conner, and the second crime of the egregious, deliberate, invasive cover-up of his murder. And that wasn't all. Another cover-up attempt occurred during witness interrogation. John Mortakis, another police officer, "allegedly influenced the responses to the polygraph questions by making inappropriate comments to the witnesses and threatening them. . . . Mortakis also withheld evidence that may have assisted the Grand Jury in its investigation of the murder charge against Ambrose."[4]

While Derrick Conner's extrajudicial execution is difficult to comprehend, the injustice experienced by DeShawn Dumas and his family continues today. Countless grand jury failures to indict, not-guilty verdicts, suspensions with pay, administrative leaves, and promotions, all granted to murderers, all prove that the U.S. judicial system remains intrinsically white supremacist.

The family experienced both the murder of Derrick Conner and the subsequent cover-up. Time does not heal these wounds. This violence becomes more gutting, more biting, more insatiable over time. This is the type of complicated violence that different people process in different ways. This is the viral, state-imposed, and state-sanctioned terror that wipes out countries. And sometimes—rarely—this kind of ravenous violence is recalibrated. This is at the center of DeShawn Dumas's art practice.

The CAMERA ROLLS FORWARD, FLOODS FORWARD, TIME TRAVELING TWENTY-FOUR YEARS. We open up to a WIDE-ANGLE SHOT at SFAI. We're on the pier in San Francisco: fresh air whisks from the Bay; dark moon, salty brine, glistening yellow, plush black, whirling gray. A sign announcing my solo exhibition looms, but that's not why we're here. We're here to visit Dumas's studio, well after midnight after a post-talk dinner. JUMP CUT to the IN-TERIOR of one of Dumas's studio spaces, where he has been making work that links sweeping questions of surveillance, antiblackness, and terror at scale to Dumas's own firsthand experience of this terror.

Walk in the studio. Slick black lines floor and walls. Remove shoes. Stand still. Time clicks forward. Feel the wane of laminated glass under your feet. See yourself magnetizing bullets. Find yourself becoming stardust. Time travel spins you. In this installation series, *The Black Light*, the paintings, floor treatments, and illumination sources serve as portals. Talismans. Bullet wounds on acrylic glass devastate your locus of control. Is this beautiful, or is this a tick away from death? Both.

In this work, Dumas enshrines slavery's afterlives as street executions. The crime scene is concretized through glacial postminimalist aesthetics. Dumas shoots high-caliber bullets through his work with a standard police sidearm. He strategizes, stages, and executes what I call analytical gunplay. He shoots his work in an elaborate choreography vibrating with the mass executions he critiques: among them, the execution that his dear brother suffered. Dumas sanctifies Derrick Conner with precision, but it's not a precious precision. Rather, his approach is cold, calculated risk and makes gorgeous that which is demonic.

Dumas's works also read sumptuous, poetic, abstracted—there's activity at the margins and through the interiors. At moments, a viewer may lose track of the fact that the series, *Ballistic Testimonies*, emerges from police state terror. That is, the state terror of Derrick Conner's death and the physical and social deaths of tens of millions of African American people before him. From the year 1526 to the present, right here, in the United States. The CAM-

19.2 DeShawn Dumas: *The Dark Is the Light (The Truth and the Way)* (2019). Partial installation view, solo exhibition, DeShawn Dumas, *Ballistic Testimonies*, presented by Bass and Reiner, Minnesota Street Project, San Francisco.

ERA SURGES FORWARD—decades forward. In May 2017, twenty-two years after Derrick Conner was murdered, Juwan Lumpkin, twenty-one years old, was executed outside Motor City Liquor by an off-duty police officer, about forty-eight hours after I filmed an *LST* video.

The cases of Derrick Conner in Elkhart and Juwan Lumpkin in Detroit align because state-sanctioned and state-imposed terror upon African Americans has never been acknowledged and, since the year 1526, has never let up. Dumas's work with his brother has also forced me to come to terms with this at a level emergent alongside the conceptual art practice and writerly engagement with my own brother implicated in state terror, as we develop *Writing through Walls*.

My brother Josef Cadwell, a writer, is in the final days of a years-long prison stretch. He has been working through a process of slow state terror in contrast to the instant state terror responsible for Derrick Conner's death. In my brother's case, surviving a mass incarceration process that is likewise disproportionate, genocidal, terroristic, and emergent from the U.S. slavery system is our project. This *Writing through Walls* effort with Josef Cadwell is a project where we've used serialized, systematized prison email exchange to link ourselves, and have in the process linked art world, academy, prison, and tens of millions of people enmeshed within these structures.

Spinning back to the streets, I've been recently immersed in an ongoing project in Saskatoon, Saskatchewan, Canada, called *Public Library*, a series of video- and photo-documented interactions and discussions in downtown Saskatoon, amid a crystal methamphetamine explosion in that city.[5] *Public Library*, working in a majority Aboriginal Canadian neighborhood in the streets surrounding the downtown library branch, has pushed me to reflect between African American and Aboriginal Canadian genocidal contexts.

From the streets to the archives, my ongoing neon sculpture project, *1526 (NASDAQ: FAANG)*, draws on tens of thousands of pages of historical research to isolate critical dates. These dates begin with the work, *1526*, with a tiny buttercream neon sculpture and a postcard detailing the South Carolina rebellion in which formerly enslaved people successfully gained freedom. The year *2019* work honors women in the McDougall-Hunt neighborhood who were murdered by a serial killer.[6]

In between, Adrian Piper codified conceptual art (*1968*); Detroit artists invented techno music (*1981*); mandatory minimum prison sentences exploded mass racialized incarceration (*1991*); Toni Morrison won the Nobel Prize (*1993*), and so much more. The *1526* works are an attempt to scrawl out realities that are bigger than the years of these events unto themselves—*1526*

pushes into neon lights the stunning, the monstrous, and overall the political, economic, and artistic works that make the world tick, for better, for worse, or for end of days.

Months later, on October 30, 2019, my dear father, Martin Cadwell, an intellectual, took his own life. My earliest memories are swimming with my father in Lake Michigan and obsessively reading and writing with him, years before I was school-age. My father is among the most brilliant people I've ever known; my mind is still reeling from his sudden death, and my work as an artist and anthropologist is forever transformed. All these changes land in the *how* of what I'm working on. And so, the transformations land in my ongoing *Liquor Store Theatre* analysis, months and months after the cameras have switched off. Amid these shifts, my analysis of liquor stores in McDougall-Hunt has become increasingly scathing, political, and economic.

I am unable to theorize the site of the liquor store as gathering space or proxy for business amid macroeconomic geographic apartheid trends. Rather, the stores are sites of violence and dispossession. From the inferior-quality food, to the eruptions of gun violence, to the slow iv drip of crack, coke, heroin, liquor, beer, and wine into people's bodies—the liquor stores, overall, do extreme physical, economic, and cultural violence to the neighborhood. The eight liquor stores in the neighborhood, simultaneously, do an incredible cash business.

The average liquor store in McDougall-Hunt, according to publicly available business revenue records, earns around $400,000 per year. This in a neighborhood with an estimated $14,000 median annual income. All of the stores in the 0.39 square mile are owned by Arab Americans, in a neighborhood upward of 95 percent African American. None of the Arab American store managers lives in the neighborhood. There is no denying that the stores represent hubs of licit and illicit drug use, trade, commercialization, and industry. Recently, an illicit, multimillion-dollar drug business was found to be operating at the scene of a similar locale, a check-cashing business down the street from the *LST* sites, in which $17 million of laundered, stashed cash and illicit drugs were located on the scene during a police raid.[7]

Meanwhile, African American Detroiters in McDougall-Hunt are treated with patronizing, paternalistic overtones by the Middle Eastern American store owners, charged exorbitant prices, and subjected to poorly appointed, poorly maintained storefronts, public spaces, and interiors associated with the liquor stores. In my videos, I render the stores urban readymades; I machine a particular aesthetic, turning the decay inside out—for a few moments, in

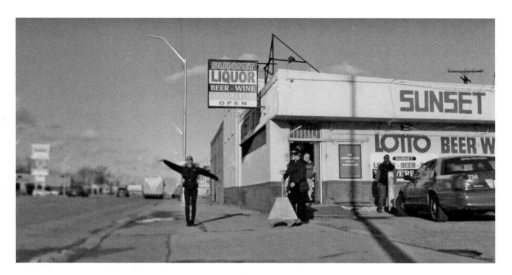

19.3 *Liquor Store Theatre, Vol. 5, No. 2* (2018). Pictured with Bana Kabalan, onlookers, and the sculptural work of Todd Stovall: *Sage Unit* (2018).

a video. I touch the edge in the landscape and make it my own; make it the people's. And then the videos end.

After the videos end, the fact remains—these stores are not luxurious, they are not plush, they are not even well appointed, and they are absolutely not acceptable productions of space in one of the largest cities in the world, in one of the wealthiest countries in the world. As gentrification—accumulation by dispossession—whirs through postbankruptcy Detroit, McDougall-Hunt quietly looms two miles east of the city center. And yet the neighborhood's dollars are soaked up in large degree by the low-quality, overpriced goods sold in offensive liquor stores. Over the past six-plus years, the condition of all of the stores in the zone has markedly worsened, with little to no maintenance. I cannot gloss this over.

I have interviewed several store managers as well during the project. I can't reduce or crystallize anyone—store managers included—in this work. The store managers I've interviewed are decent enough people, just as all of the store customers I've interviewed over the years are decent people as well. And yet the calculus of the situation—the political-economic injustice of it—must be crystallized. I have been forced to face the reality that the liquor stores in McDougall Hunt weaponize the antiblack economic and physical

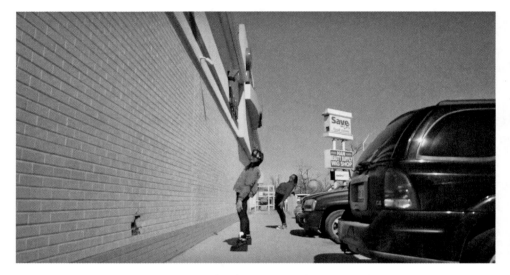

19.4 *Liquor Store Theatre, Vol. 6, No. 1* (2019). Pictured with Seycon-Nadia Chea.

violence festering in the city for hundreds of years. Meanwhile, people's opinions, thoughts, and musings continue to complicate and shift. As *LST* continues and pushes forward, I am locating a different set of ideas to investigate, trace, and press. As I work to find the velvety and the dusty at once—while I meditate on the political, economic, and historical tragedies that the stores consolidate, I am still there, with my collaborators, with people in the neighborhood, making this happen, and the people on the streets and sidewalks have lived to tell the tale as the videos whir on.

JUMP CUT to a MEDIUM SHOT of Seycon-Nadia Chea. She's standing in the parking lot of PALMS LIQUOR, her long legs in black leggings with boots, a scarf around her neck in the winter frost. She holds a large, opalescent shell in her hand. The shell is full of dried white sage. Chea lights the sage. The candy-salty aroma of the sage pushes up. She sets the sage down in the middle of the trash-littered parking lot. I train the CAMERA on it, PULLING UP to a TIGHT SHOT.

I hold it there. I think of the people of Saskatoon, and my collaborator Cole Blackstar, buying crystal methamphetamine after opioid addictions go untreated. I think of my brother, Josef Cadwell, hundreds of miles away in prison in Detroit's exurbs, fighting with every word he writes, with every word that we write together, in *Writing through Walls*. I think of the peo-

ple of McDougall-Hunt, whirling forward, as theory, method, and practice zoom into a single frame.

As explosive gentrification pops and sparks downtown, McDougall-Hunt forges ahead. I think of Greg Winters, living in and cultivating this gritty neighborhood with his family for more than sixty years now, whose refrain, "keep it moving," is the spirit of this city. I think of my dear friend Todd Stovall, sculpting and composing his having-sex-in-the-ocean dance tracks, and composing the LST music, in a McDougall-Hunt bank for the past decade, grinding out Detroit's art scene, day in and day out, since the early 2000s. I think of the people LST has reached, connected with, been in conversation with over the years, from museums, to pages, to streets, to kitchen tables, and back.

I think of twenty-two-year-old Derrick Conner, DeShawn Dumas and Ashley Conner's brother, killed by police officers in Elkhart. I think of twenty-one-year-old Juwan Lumpkin, also killed by a police officer, down the street, at Motor City Liquor. I ask myself every day—how can I trace, document, and interrogate this moment? Chea launches into a subtle choreographic sequence, machining rhythms on a whim, citing thousands of years of aesthetics with a calculated tremble of her shoulders. I stand at a portal and a crossroads, just watching.

The CAMERA PULLS BACK and we see GRATIOT AVENUE, rushing by with a light blur of Saturday afternoon traffic. A woman I speak with, Brenda Collins, tells me that "more black-owned businesses are opening up" and that "we've beautified our home, here in Detroit." She insists on possibility. She destroys death with her words. As I'm trying to understand how eight liquor stores could for decades on end benefit from antiblack violence and traffic licit and illicit drugs, gaining financial wealth and security for their families, in a 0.39-square-mile neighborhood for all these years, while the majority of people in the neighborhood lack access to quality employment, education, and amenities, the smell of burning sage and the echo of Collins's voice takes me over. Collins is proclaiming a corrective. For now, her words are perhaps the only corrective. I breathe in. I know the story is only beginning. I click the camera off and—for now—we

FADE
TO
BLACK.

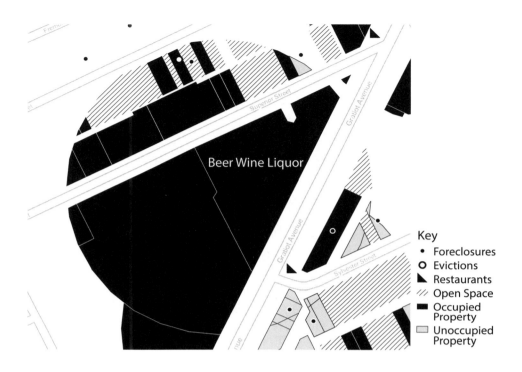

Key
- • Foreclosures
- O Evictions
- ◤ Restaurants
- ⁄⁄⁄ Open Space
- ■ Occupied Property
- ▢ Unoccupied Property

Maps 19.1–19.7 *Liquor Store Theatre* atlas. Maps by Alex B. Hill.

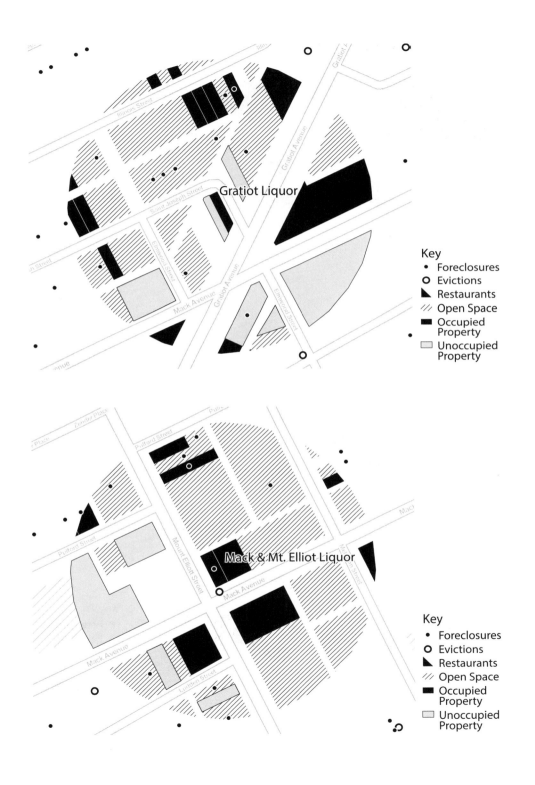

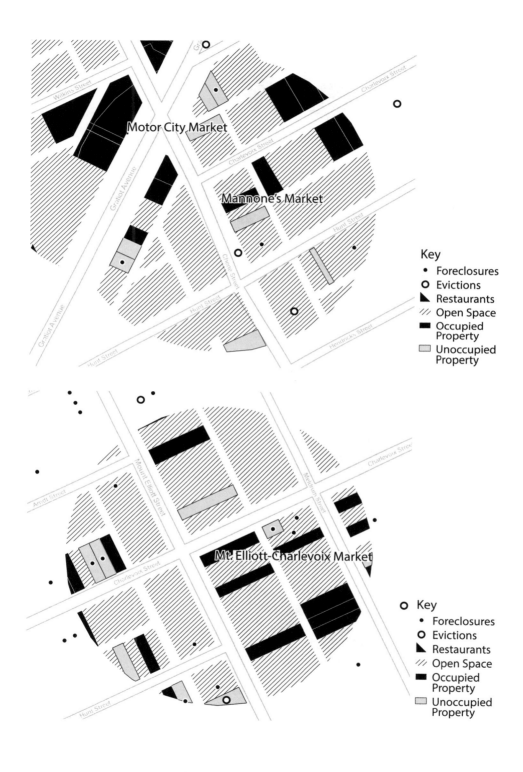

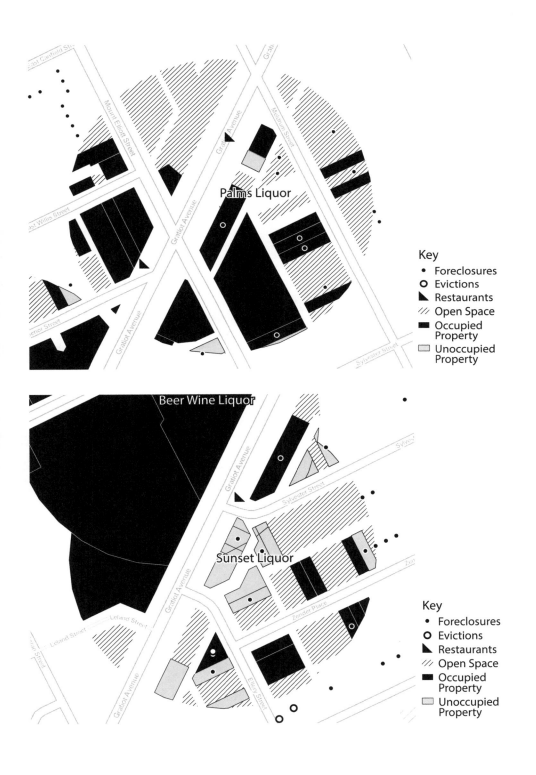

ACKNOWLEDGMENTS

Greg Winters—you make this book come alive. Your family breathes life into McDougall-Hunt. I am grateful for you, your family, and our neighbors. Our neighbors—the people of Detroit, where I grew up, and McDougall-Hunt, where I found a home: thank you for the glimpses into your lives, long after the *Liquor Store Theatre* cameras are turned off.

On the streets and sidewalks, Biba Bell, Seycon-Nadia Chea, Eric Johnston, Martha Johnston, Bana Kabalan, Mohamed Soumah, and Todd Stovall—you in particular help make the work move. Todd Stovall, your *Liquor Store Theatre* music compositions spin across the streets and sidewalks of McDougall-Hunt and beyond. Zander McGhee, Hector McGhee, and Faygo Wolfson—your expertise shines through the pages.

Ken Wissoker, thank you for your editorial brilliance, and for listening from the start. I am grateful to all of the Duke University Press colleagues who worked toward this book, with special thanks to Liz Smith and Josh Tranen. I am indebted and grateful to the anonymous peer reviewers who read drafts of this book and provided challenging and thoughtful comments along the way.

Andrew Blauvelt, Pat Elifritz, Bridget Finn, Thelma Golden, Matthew Higgs, Christopher Y. Lew, David Liss, Mia Locks, Laura Mott, Sara Nishi-kawa, Terese Reyes, Jessica Silverman, Frank Smigiel, Erin Somerville, Adam Weinberg, AKA Artist-Run Centre (Saskatoon), Cranbrook Art Museum, Detroit Artists Market, Fort Mason Center for Arts and Culture, Kalama-zoo Art Institute, Library Street Collective, the Museum of Contemporary Art Detroit, the Museum of Contemporary Art Toronto Canada, the Mu-

seum of Contemporary Art St. Louis, Reyes | Finn (Detroit), the San Francisco Art Institute, the Studio Museum in Harlem, White Columns (New York City), the Whitney Museum of American Art, and many others, thank you for supporting my work.

California State Polytechnic University (Cal Poly), Pomona, and the Department of Liberal Studies including all of the students, staff, and faculty—you provide the collegial department where I write this book. I am particularly grateful for my Cal Poly Pomona colleagues Estela Ballón, Christina Chávez-Reyes, Kimberly Deitrick, Keiry Ewing, Zeida Garcia, Hend Gilli-Elewy, Rodney Hume-Dawson, Karen Langlois, Teresa Lloro, Todd London, Cheryl Love, Reyes Luna, Christy Orgeta, Jeff Passe, Stephanie Rascon, Jeff Roy, Guy Zimmerman, the Cal Poly Pomona members of the Social Justice Advisory Board, and many more. I am grateful to all of the staff of the Cal Poly Pomona College of Education and Integrative Studies office of the dean, directed by Jeff Passe and Hend Gilli-Elewy, for their support of this work.

Lee D. Baker, whose intellectual generosity is unparalleled, Biba Bell, Stephen Chrisomalis, Andrew D. Newman, and Ariel Osterweis—I'm ever grateful for each of your contributions and advice over the years. I am grateful to the students, staff, and faculty of the Wayne State University Department of Anthropology, where I began research for this work. Special thanks to Allen Batteau and Susan Fisher, Stasia and Sergio Chávez, Mark Luborsky, Alex B. Hill, Andrea Sankar, and Suzanne Walsh. Katherine McKittrick and Loïc Wacquant—you provided brief yet generous thoughts from afar and I'm grateful for your input. DeShawn Dumas and Ra Dumas, thank you for being amazing.

NOTES

Prologue

1 Herbert Aptheker, *Negro Slave Revolts in the United States, 1526–1860* (New York: International Publishers, 1939).

2 Aptheker, *Negro Slave Revolts.*

3 Aptheker, *Negro Slave Revolts,* 16–17.

4 Herbert Aptheker, ed., *A Documentary History of the Negro People in the United States,* vol. 1 (New York: Citadel, 1969).

5 Aptheker, *A Documentary History of the Negro People,* 1–2.

6 Frantz Fanon, *The Wretched of the Earth* (New York: Grove/Atlantic, 2007); Paul Farmer, "An Anthropology of Structural Violence," *Current Anthropology* 45, no. 3 (2004): 305–325.

7 Cedric Robinson writes extensively on U.S. founding myths in the fine work *Black Marxism: The Making of the Black Radical Tradition* (Chapel Hill: University of North Carolina Press, 2000).

8 Robinson, *Black Marxism,* 226.

9 Mary Frances Berry, *Black Resistance/White Law: A History of Constitutional Racism in America* (New York: Penguin, 1995), xii; Robinson, *Black Marxism,* 226.

10 Robinson, *Black Marxism*; Nikhil Pal Singh, "Toward an Effective Antiracism," in *Dispatches from the Ebony Tower: Intellectuals Confront the African American Experience,* ed. Manning Marable (New York: Columbia University Press, 2000), 31–51; Berry, *Black Resistance/White Law*; Aptheker, *A Documentary History of the Negro People,* 226.

11 As well as that of Native Americans and numerous other groups present in the early days of the U.S.'s formation. However, this work centers on African American historiography and ethnography.

12 Berry, *Black Resistance/White Law.*

13 Berry, *Black Resistance/White Law,* 3.

14 Herbert Aptheker, *The Negro in the American Revolution* (New York: International Publishers, 1940), 5.

15 Aptheker, *The Negro in the American Revolution*, 5.

16 Aptheker, *A Documentary History of the Negro People*, 5–6.

17 Aptheker, *The Negro in the American Revolution*.

18 Aptheker, *The Negro in the American Revolution*, 20.

19 Berry, *Black Resistance/White Law*, 4.

20 Berry, *Black Resistance/White Law*, 4.

21 Benjamin Quarles, *The Negro in the American Revolution* (Chapel Hill: University of North Carolina Press, 2012), xix. "Maroons" refers to once-enslaved African Americans who escaped slavery and established independent communities on the frontier, at times linked with Native American communities (Aptheker, *Negro Slave Revolts*).

22 Quarles, *The Negro in the American Revolution*, xix.

23 Quarles, *The Negro in the American Revolution*, xix.

24 Quarles, *The Negro in the American Revolution*.

25 The Thirteenth Amendment states, "Neither slavery nor involuntary servitude, except as a punishment for crime whereof the party shall have been duly convicted, shall exist within the United States, or any place subject to their jurisdiction" (U.S. Constitution).

26 Berry, *Black Resistance/White Law*, 4.

27 Berry, *Black Resistance/White Law*; Angela R. Riley, "Native Nations and the Constitution: An Inquiry into Extra-constitutionality," *Harvard Law Review Forum* 130, no. 6 (2017): 173.

28 Riley, "Native Nations and the Constitution," 179–180.

29 Berry, *Black Resistance/White Law*, 6.

30 Berry, *Black Resistance/White Law*, 5.

31 Berry, *Black Resistance/White Law*, 6–7. The Fugitive Slave Clause required the return of escaped enslaved African American persons to the state from which the person escaped. It states, "No person held to service or labor in one state, under the laws thereof, escaping into another, shall, in consequence of any law or regulation therein, be discharged from such service or labor, but shall be delivered up on claim of the party to whom such service or labor may be due" (U.S. Constitution, art. IV, § 2, cl. 3).

32 Riley, "Native Nations and the Constitution," 180. The Treaty Clause gives the president the power "to make Treaties, provided two thirds of the Senators present concur" (U.S. Constitution, art. II, § 2, cl. 2). The Commerce Clause states that the United States Congress has power "to regulate Commerce with foreign Nations, and among the several States, and with the Indian Tribes" (U.S. Constitution, art. I, § 8, cl. 3).

33 Population figure from United States Census Bureau, QuickFacts, Detroit City, Michigan (2017), https://www.census.gov/quickfacts/fact/table/detroit citymichigan,US/PST045217.

34 United States Census Bureau, QuickFacts, Detroit City (2017).

35 David M. Katzman, "Black Slavery in Michigan," *Midcontinent American Studies Journal* 11, no. 2 (1970): 56–66.

36 David M. Katzman, *Before the Ghetto: Black Detroit in the Nineteenth Century* (Urbana: University of Illinois Press, 1973).

37 "Minutes of the State Convention of the Colored Citizens of the State of Michigan, for the purpose of considering their moral & political conditions, as citizens of the State" (Detroit, 1843). Copy in the Boston Athenaeum.

38 Aptheker, *A Documentary History of the Negro People*.

39 Aptheker, *A Documentary History of the Negro People*, 460.

40 Singh, "Toward an Effective Antiracism."

41 Singh, "Toward an Effective Antiracism," 40.

42 Thomas J. Sugrue, *The Origins of the Urban Crisis: Race and Inequality in Postwar Detroit*, updated ed. (Princeton, NJ: Princeton University Press, 2014).

43 Richard W. Thomas, *Life for Us Is What We Make It: Building Black Community in Detroit, 1915–1945* (Bloomington: Indiana University Press, 1992), 26–27.

44 Kevin Fox Gotham, "Urban Space, Restrictive Covenants and the Origins of Racial Residential Segregation in a US City, 1900–50," *International Journal of Urban and Regional Research* 24, no. 3 (2000): 620.

45 Gotham, "Urban Space, Restrictive Covenants."

46 Gotham, "Urban Space, Restrictive Covenants."

47 Gotham, "Urban Space, Restrictive Covenants."

48 Gotham, "Urban Space, Restrictive Covenants," quoting Stanley L. McMichael and Robert Fry Bingham, *City Growth and Values* (Cleveland: Stanley McMichael Publishing Organization, 1923).

49 Victoria W. Wolcott, "Defending the Home: Ossian Sweet and the Struggle against Segregation in 1920s Detroit," *OAH Magazine of History* 7, no. 4 (1993): 23–27.

50 "I Have to Die a Man or Live a Coward," *Detroit News*, February 11, 2001, http://blogs.detroitnews.com/history/2001/02/11/i-have-to-die-a-man-or-live-a-coward-the-saga-of-dr-ossian-sweet/.

51 Wolcott, "Defending the Home."

52 Wolcott, "Defending the Home."

53 Wolcott, "Defending the Home."

54 David Harvey, "The 'New' Imperialism: Accumulation by Dispossession," *Socialist Register* 40 (2004): 63–87.

55 Thomas, *Life for Us Is What We Make It*, 28.

56 Sugrue, *The Origins of the Urban Crisis*; Thomas J. Sugrue, *Motor City: The Story of Detroit* (New York: Gilder Lehrman Institute of American History, 2012).

57 Joe T. Darden, Richard Child Hill, June Thomas, and Richard Thomas, *Detroit: Race and Uneven Development* (Philadelphia: Temple University Press, 2010), 68.

58 Darden et al., *Detroit*, 68.

59 Janet L. Langlois, "The Belle Isle Bridge Incident: Legend Dialectic and Semiotic System in the 1943 Detroit Race Riots," *Journal of American Folklore* 96, no. 380 (1983): 183–199.

60 Ellis Cashmore and Eugene McLaughlin, *Out of Order? Policing Black People*, Routledge Revivals (New York: Routledge, 2013), 83.

61 Cashmore and McLaughlin, *Out of Order?*

62 Cashmore and McLaughlin, *Out of Order?*, 83.

63 Darden et al., *Detroit*, 68, 107.

64 Jeffery Shantz, "'They Think Their Fannies Are as Good as Ours': The 1943 Detroit Riot," *Studies in the Literary Imagination* 40, no. 2 (2007): 75.

65 Darden et al., *Detroit*.

66 Langlois, "The Belle Isle Bridge Incident."

67 Langlois, "The Belle Isle Bridge Incident," 189.

68 Langlois, "The Belle Isle Bridge Incident."

69 Darden et al., *Detroit*, 68.

70 Darden et al., *Detroit*, 68.

71 Colleen Doody, *Detroit's Cold War: The Origins of Postwar Conservatism* (Urbana: University of Illinois Press, 2012).

72 Doody, *Detroit's Cold War*, 57.

73 Doody, *Detroit's Cold War*, 57.

74 Coleman Young, quoted in Doody, *Detroit's Cold War*.

75 Doody, *Detroit's Cold War*, 58.

76 Doody, *Detroit's Cold War*, 58.

77 Doody, *Detroit's Cold War*, 58.

78 Doody, *Detroit's Cold War*, 58.

79 Singh, "Toward an Effective Antiracism," 38.

80 Singh, "Toward an Effective Antiracism"; Sugrue, *The Origins of the Urban Crisis*; Sugrue, *Motor City*; Darden et al., *Detroit*, 68.

81 Sugrue, *The Origins of the Urban Crisis*; Singh, "Toward an Effective Antiracism."

82 Darden et al., *Detroit*, 152; H. A. Thompson, *Whose Detroit? Politics, Labor, and Race in a Modern American City* (Ithaca, NY: Cornell University Press, 2004), 218.

83 Sugrue, *The Origins of the Urban Crisis*; Thompson, *Whose Detroit?*

84 Mike Davis, *City of Quartz: Excavating the Future in Los Angeles*, new ed. (New York: Verso, 2006); Edward W. Soja, *My Los Angeles: From Urban Restructuring to Regional Urbanization* (Berkeley: University of California Press, 2014); David Stradling and Richard Stradling, "Perceptions of the Burning River: Deindustrialization and Cleveland's Cuyahoga River," *Environmental History* 13, no. 3 (2008): 515–535; Dale A. Hathaway, *Can Workers Have a Voice? The Politics of Deindustrialization in Pittsburgh* (University Park, PA: Penn State University Press, 2010).

85 Darden et al., *Detroit*, 154.

86 Darden et al., *Detroit*, 158.

87 Darden et al., *Detroit*, 159.

88 Police department statistic from Darden et al., *Detroit*.

89 Darden et al., *Detroit*, 72.

90 Darden et al., *Detroit*, 72.

91 Darden et al., *Detroit*.

92 Darden et al., *Detroit*.

93 Darden et al., *Detroit*, 73.

94 The Detroit Police Department division called Stop the Robberies, Enjoy Safe Streets (STRESS) was purportedly started to reduce crime in the city. Decoy units used by STRESS directly targeted African American men. Actions by STRESS led to the deaths of twenty-four men, twenty-two of them African American, over the course of three and a half years. Doug Merriman, "A History of Violence: The Detroit Police Department, the African American Community and S.T.R.E.S.S. An Army of Occupation or an Army under Siege," *Doug Merriman*, November 17, 2015, https://dougmerriman.org/2015/11/17/a-history-of-violence-the-detroit-police-department-the-african-american-community-and-s-t-r-e-s-s-an-army-of-occupation-or-an-army-under-siege/.

95 Angela D. Dillard, "Religion and Radicalism: The Reverend Albert B. Cleage, Jr., and the Rise of Black Christian Nationalism in Detroit," in *Freedom North: Black Freedom Struggles outside the South, 1940–1980* (New York: Palgrave Macmillan, 2003), 153.

96 Dillard, "Religion and Radicalism," 154.

97 Martin Glaberman, "Dodge Revolutionary Union Movement," *International Socialism*, 1st ser., 36 (1969): 8–9.

98 Glaberman, "Dodge Revolutionary Union Movement," 8.

99 Laurence Ralph, *Renegade Dreams: Living through Injury in Gangland Chicago* (Chicago: University of Chicago Press, 2014), 14.

100 Craig Reinerman and Harry Levine, *Crack in America* (Berkeley: University of California Press, 1997).

101 Reinerman and Levine, *Crack in America*.

102 Chris Barber, "Public Enemy Number One: A Pragmatic Approach to America's Drug Problem," Richard Nixon Foundation, June 29, 2016, https://www.nixonfoundation.org/2016/06/26404/.

103 Reinerman and Levine, *Crack in America*, 60.

104 John Irwin and James Austin, *It's About Time* (Belmont, CA: Wadsworth, 1994).

105 Reinerman and Levine, *Crack in America*, 56.

106 Philippe Bourgois, *In Search of Respect: Selling Crack in El Barrio* (New York: Cambridge University Press, 2003); Singh, "Toward an Effective Antiracism"; Maya Stovall, "Liquor Store Theatre: Ethnography and Contemporary Art in Detroit" (PhD diss., Wayne State University, 2018).

107 Sarah Rahal. "Detroit Police Arrest 2 Men in $17M Drug Bust," *Detroit News*, October 23, 2018, https://www.detroitnews.com/story/news/local/detroit-city/2018/10/23/detroit-police-arrest-2-men-17-m-drug-bust/1741986002/.

108 Bourgois, *In Search of Respect*; Stovall, "Liquor Store Theatre."

109 "Prisocracy" after (linguistically and onto-legislatively) the term "Slavocracy" that Herbert Aptheker established in the fine work, *The Negro in the American Revolution*. Michelle Alexander, *The New Jim Crow: Mass Incarceration in the Age of Colorblindness* (New York: New Press, 2012).

110 Darden et al., *Detroit*.

111 Fernando Ferreira and Joseph Gyourko, *A New Look at the US Foreclosure Crisis: Panel Data Evidence of Prime and Subprime Borrowers from 1997 to 2012*, no. w21261 (Washington, DC: National Bureau of Economic Research, 2015).

112 Christine MacDonald and Joel Kurth, "Volume of Abandoned Homes 'Absolutely Terrifying,'" *Detroit News*, June 24, 2015, https://www.detroit news.com/story/news/special-reports/2015/05/14/detroit-abandoned-homes -volume-terrifying/27237787/.

113 Ben Henry, Jill Reese, and Angel Torres, *Wasted Wealth: How the Wall Street Crash Continues to Stall Economic Recovery and Deepen Racial Inequity in America*, Alliance for a Just Society, May 2013, http://allianceforajustsociety .org/wp-content/uploads/2013/05/Wasted.Wealth_NATIONAL.pdf.

114 Bill Mitchell, "In Detroit, Water Crisis Symbolizes Decline, and Hope," *National Geographic*, August 22, 2014, https://news.nationalgeographic.com /news/special-features/2014/08/140822-detroit-michigan-water-shutoffs-great -lakes/.

115 Mitchell, "In Detroit, Water Crisis Symbolizes Decline, and Hope."

116 Mitchell, "In Detroit, Water Crisis Symbolizes Decline, and Hope."

117 Joel Kurth and Mike Wilkinson, "I Hate to Complain, but I Haven't Had Water in a Year. A Detroit Story," Michigan Health Watch, *Bridge*, February 17, 2020, https://www.bridgemi.com/michigan-health-watch/i-hate-complain -i-havent-had-water-year-detroit-story. Water shutoff numbers provided by the Detroit Water and Sewerage Department.

118 Nina Lakhani, "Detroit Suspends Water Shutoffs amid Covid-19 Fears," *Guardian*, March 12, 2020, https://www.theguardian.com/us-news/2020 /mar/12/detroit-water-shutoffs-unpaid-bills-coronavirus.

119 Terrance L. Green, Joanna D. Sánchez, and Andrene J. Castro, "Closed Schools, Open Markets: A Hot Spot Spatial Analysis of School Closures and Charter Openings in Detroit," *AERA Open*, April 2019, 1–14.

120 Amber Arellano and John B. King Jr., "Michigan Lawmakers Have Ignored Inequities in Education for Too Long," *Detroit Free Press*, January 15, 2019, https://www.freep.com/story/opinion/contributors/2019/01/15/michigan -education-detroit-students/2575753002/.

121 John Gallagher, "Few Black People Get Home Mortgages in Detroit, Data Show," *Detroit Free Press*, March 21, 2019, https://www.freep.com/story /money/business/john-gallagher/2019/03/21/black-mortgages-detroit-real -estate-michigan/3165381002/.

122 Joe Guillen, "Detroit Leads the Nation in Reverse Mortgage Foreclosures," *Detroit Free Press*, June 14, 2019, https://www.freep.com/story/news

/investigations/2019/06/14/detroit-leads-nation-reverse-mortgage
-foreclosures/1442186001/.

123 Christine MacDonald and Mark Betancourt, "Detroit Homeowners Over-
taxed $600 Million," *Detroit News*, January 9, 2020, https://www.detroitnews
.com/story/news/local/detroit-city/housing/2020/01/09/detroit-homeowners
-overtaxed-600-million/2698518001/.

124 Moratorium Michigan, "Fact Sheet on City of Detroit Conditions," July 2018,
https://moratorium-mi.org/wp-content/uploads/2018/07/Detroit-fact-sheet
.pdf.

125 David Harvey and Mark Davidson, *Social Justice and the City* (London: Ar-
nold, 1973), 17.

Introduction

1 John L. Jackson Jr., *Thin Description* (Cambridge, MA: Harvard University Press,
2013), 14; Kathleen C. Stewart, *Ordinary Affects* (Durham, NC: Duke Univer-
sity Press, 2007), 2.

2 Clifford Geertz, *The Interpretation of Cultures* (New York: Basic Books, 1973), 17.

3 A square is a cigarette right out of the manufacturer's pack (in other words, with
no additional drugs or substances added—it's what a square would smoke).

4 David Harvey, "The Right to the City," *International Journal of Urban and Re-
gional Research* 27, no. 4 (2003): 939–941.

5 As of the 2010 U.S. Census.

6 Robin Runyan, "New Maps Compare Detroit's Population Density to Cities
around the World," *Curbed Detroit*, March 23, 2017, http://detroit.curbed.com
/2017/3/23/15038248/maps-detroits-population-density.

7 The term "Rust Belt" refers to the constellation of upper Midwestern states, ex-
tending to the Great Lakes, and broadly to cities and states experiencing eco-
nomic decline due largely to contraction of the manufacturing economy. Rust
Belt regions include western New York, Pennsylvania, West Virginia, Ohio,
Indiana, and the Lower Peninsula of Michigan and extend to northern Illinois,
eastern Iowa, and southeastern Wisconsin.

8 W. E. B. Du Bois and Isabel Eaton, *The Philadelphia Negro: A Social Study* (Bos-
ton: Ginn and Company, 1899); St. Clair Drake and Horace Cayton, *Black Me-
tropolis: A Study of Negro Life in a Northern City* (Chicago: University of Chi-
cago Press, 1970); Frantz Fanon, *Black Skin, White Masks* (New York: Grove,
1968; Fanon, *The Wretched of the Earth*; Frantz Fanon, *Toward the African Rev-
olution: Political Essays* (New York: Grove, 1969); Zora Neale Hurston, *Mules
and Men* (New York: Perennial Library, 1935); Katherine Dunham, *Island Pos-
sessed* (Chicago: University of Chicago Press, 1994); Audre Lorde, *Zami: A New
Spelling of My Name: A Biomythography* (Berkeley, CA: Crossing Press, 2011);
August Wilson, *Ma Rainey's Black Bottom* (New York: Penguin, 2019); August
Wilson, *Seven Guitars* (New York: Samuel French, 1996); August Wilson, *Ra-
dio Golf* (New York: Theatre Communications Group, 2007).

9 Ralph, *Renegade Dreams*, 16.

10 Ralph, *Renegade Dreams*.

11 Ralph, *Renegade Dreams*, 70.

12 Cass Technical High School is one of Detroit's public, elite, magnet high schools, noted for attracting youths from higher socioeconomic backgrounds.

13 John L. Jackson Jr., *Real Black: Adventures in Racial Sincerity* (Chicago: University of Chicago Press, 2005), 17.

14 Jackson, *Real Black*.

15 Jackson, *Real Black*.

16 Nathan Bomey and M. Helms, "Attorney: Detroit Won't Recover without Grand Bargain," *USA Today*, September 2, 2014.

17 Bomey and Helms, "Attorney."

18 Stuart Hall and Paul du Gay, eds., *Questions of Cultural Identity* (Thousand Oaks, CA: Sage, 1996).

19 Sarah Jane Cervenak, *Wandering: Philosophical Performances of Racial and Sexual Freedom* (Durham, NC: Duke University Press, 2014).

20 Stewart, *Ordinary Affects*.

21 Katherine McKittrick, "Wynter, Sylvia," in *The Encyclopedia of Postcolonial Studies* (New York: Wiley, 2016), 4.

22 James Boggs, *Pages from a Black Radical's Notebook: A James Boggs Reader* (Detroit: Wayne State University Press, 2011); Michael Hardt and Antonio Negri, *Empire* (Cambridge, MA: Harvard University Press, 2001).

23 Gilles Deleuze and Félix Guattari, *A Thousand Plateaus: Capitalism and Schizophrenia* (New York: Bloomsbury, 1988), 281.

24 Matt Reynolds, "Michigan High Court Asked to Review Detroit Foreclosures," *Courthouse News Services*, November 2, 2017; Rose Hackman, "What Happens When Detroit Shuts Off the Water of 100,000 People," *Atlantic*, July 17, 2014, https://www.theatlantic.com/business/archive/2014/07/what-happens -when-detroit-shuts-off-the-water-of-100000-people/374548/; Les Christie, "I've Been Priced Out of Downtown Detroit," *CNNMoney*, May 27, 2014, https:// money.cnn.com/2014/05/27/real_estate/downtown-detroit/index.html; Ida Byrd-Hill, "Detroit's Problem Is a Lack of Jobs, Not Too Much Gentrification," *Bridge*, May 5, 2017, https://www.bridgemi.com/guest-commentary/detroits -problem-lack-jobs-not-too-much-gentrification; Henry Graber, "Can America's Worst Transit System Be Saved?," *Slate*, June 7, 2016, https://slate.com /business/2016/06/detroit-has-americas-worst-transit-system-could-the -regional-transit-master-plan-save-it.html.

25 Marlon M. Bailey, *Butch Queens Up in Pumps* (Ann Arbor: University of Michigan Press, 2013).

26 Dwight Conquergood, "Performance Studies: Interventions and Radical Research," *TDR/The Drama Review* 46, no. 2 (2002): 145–156.

27 Deborah A. Thomas, *Modern Blackness: Nationalism, Globalization, and the Politics of Culture in Jamaica* (Durham, NC: Duke University Press, 2004), 26.

Urban Bush Women, an internationally performing dance company, was founded over thirty years ago by artistic director Jawole Willa Jo Zollar (see https://www.urbanbushwomen.org/).

28 Thomas, *Modern Blackness*, 269.

29 Thomas, *Modern Blackness*, 229.

30 Thomas, *Modern Blackness*, quotations Thomas's.

31 Thomas, *Modern Blackness*.

32 Thomas, *Modern Blackness*, 269.

33 Elizabeth M. Liew Siew Chin, *Purchasing Power: Black Kids and American Consumer Culture* (Minneapolis: University of Minnesota Press, 2001), 64.

34 Chin, *Purchasing Power*, quotations Chin's.

35 Chin, *Purchasing Power*.

36 Chin, *Purchasing Power*.

37 Randy Martin, *Critical Moves: Dance Studies in Theory and Politics* (Durham, NC: Duke University Press, 1998), 205, 218.

38 Jane Jacobs, *The Death and Life of Great American Cities* (1961; reprint, New York: Vintage, 1992); Henri Lefebvre, *The Production of Space*, trans. Donald Nicholson-Smith (Malden: Blackwell, 1991); Loïc Wacquant, *Body and Soul* (Oxford: Oxford University Press, 2004).

39 Jacobs, *The Death and Life of Great American Cities*, 54; Lefebvre, *The Production of Space*, 385; David Harvey, *Spaces of Global Capitalism* (London: Verso, 2006), 131.

40 Thomas F. DeFrantz and Anita Gonzalez, "Introduction: From 'Negro Expression' to 'Black Performance,'" in *Black Performance Theory*, ed. Thomas F. DeFrantz and Anita Gonzalez (Durham, NC: Duke University Press, 2014), 2.

41 André Lepecki, *Exhausting Dance: Performance and the Politics of Movement* (New York: Routledge, 2006), 46.

42 Barbara Browning, *Samba: Resistance in Motion* (Bloomington: Indiana University Press, 1995); Brenda Dixon Gottschild, *Digging the Africanist Presence in American Performance: Dance and Other Contexts* (Westport, CT: Greenwood, 1996); Brenda Dixon Gottschild, *The Black Dancing Body: A Geography from Coon to Cool* (New York: Springer, 2016); DeFrantz and Gonzalez, *Black Performance Theory*.

43 Browning, *Samba*, 15.

44 Martin, *Critical Moves*, 14.

45 Martin, *Critical Moves*, 183.

46 Gottschild, *The Black Dancing Body*, 296.

47 Rosalind E. Krauss, *Under Blue Cup* (Cambridge, MA: MIT Press, 2011), 19.

48 Li Zhang, *In Search of Paradise: Middle-Class Living in a Chinese Metropolis* (Ithaca, NY: Cornell University Press, 2012).

49 Zhang, *In Search of Paradise*, 138.

50 Zhang, *In Search of Paradise*, 138.

51 Edward W. Soja, *Postmodern Geographies: The Reassertion of Space in Critical Social Theory* (New York: Verso, 1989), 174.

52 Soja, *Postmodern Geographies*, 176.

53 Hudson-Webber Foundation et al., *7.2 SQ MI: A Report on Greater Downtown Detroit* (Detroit, 2013), https://detroitsevenpointtwo.com/.

54 Rebecca J. Kinney, *Beautiful Wasteland: The Rise of Detroit as America's Postindustrial Frontier* (Minneapolis: University of Minnesota Press, 2016).

55 There were indeed well-intentioned people who were simply uninformed or misinformed, white and nonwhite people alike, whom I came across during my fieldwork. The people I write of, for whatever reason, simply did not yet know or acknowledge that racism/capitalism was a single force in Detroit. I have seen firsthand such persons, who were naive to historical-political economy and its impact on urban process, change their perspectives on Detroit's development after learning historical-political economy and analyzing the city with fresh eyes. Urban ethnographers in our genealogy of historical materialism can do a lot of work on this transformation of thinking the world over.

56 Ida Susser, *Norman Street: Poverty and Politics in an Urban Neighborhood* (New York: Oxford University Press, 2012); Mitchell Duneier, *Slim's Table: Race, Respectability, and Masculinity* (Chicago: University of Chicago Press, 2015); Steven Gregory, *Black Corona: Race and the Politics of Place in an Urban Community* (Princeton, NJ: Princeton University Press, 1999); Mary Pattillo, *Black Picket Fences: Privilege and Peril among the Black Middle Class* (Chicago: University of Chicago Press, 2013); Andrew Newman, *Landscape of Discontent* (Minneapolis: University of Minnesota Press, 2015).

57 Hurston, *Mules and Men*; Stewart, *Ordinary Affects*.

58 Hurston, *Mules and Men*, 2.

59 Stewart, *Ordinary Affects*, 10.

60 Aimee Meredith Cox, *Shapeshifters: Black Girls and the Choreography of Citizenship* (Durham, NC: Duke University Press, 2015).

1. Liquor Store Theatre, Vol. 1, No. 1

1 Roderick A. Ferguson, *Aberrations in Black: Toward a Queer of Color Critique* (Minneapolis: University of Minnesota Press, 2004), 41.

2 Saidiya Hartman, "Venus in Two Acts," *Small Axe* 26 (2008): 1–14.

3 Manning Marable, *How Capitalism Underdeveloped Black America: Problems in Race, Political Economy, and Society* (Chicago: Haymarket, 2015), 62.

4 bell hooks, *Communion: The Female Search for Love* (New York: Morrow, 2002), 34.

5 Judith Butler, *Gender Trouble: Feminism and the Subversion of Identity* (New York: Routledge, 2011).

6 Sara Ahmed, *The Promise of Happiness* (Durham, NC: Duke University Press, 2010), 115.

7 2010 U.S. Census Data, Census Explorer, McDougall-Hunt, Detroit, accessed February 27, 2017, https://www.census.gov/newsroom/blogs/random-samplings/2013/12/discover-your-neighborhood-with-census-explorer.html.

8 The male gaze refers to the visual, performing, and literary art worlds' representation of women as objects of male pleasure. The male gaze is said to consolidate spectator, character, and cameraman: Laura Mulvey, "Narrative Cinema and Visual Pleasure," in *Visual and Other Pleasures* (Houndmills, UK: Palgrave, 1975).

9 Lisa John Rogers, "Maya Stovall," *Artforum* 56, no. 6 (2018): 195.

10 Patricia Hill Collins, *Fighting Words: Black Women and the Search for Justice* (Minneapolis: University of Minnesota Press, 1998), 211.

11 Terrion L. Williamson, *Scandalize My Name: Black Feminist Practice and the Making of Black Social Life* (New York: Fordham University Press, 2016); Hortense Spillers, interview with Tim Haslett for Black Cultural Studies, February 4, 1998.

12 Lefebvre, *The Production of Space*.

13 Lefebvre, *The Production of Space*, 73.

14 Lefebvre, *The Production of Space*, 73.

15 Lefebvre, *The Production of Space*, 73.

16 Michel Foucault, *Discipline and Punish: The Birth of the Prison* (New York: Vintage, 2012).

17 Setha M. Low and Denise Lawrence-Zúñiga, eds., *The Anthropology of Space and Place: Locating Culture* (Malden: Blackwell, 2003).

18 Katherine McKittrick, *Demonic Grounds: Black Women and the Cartographies of Struggle* (Minneapolis: University of Minnesota Press, 2006), xvii, quotations McKittrick's.

19 McKittrick, *Demonic Grounds*, xvii.

20 Elizabeth Grosz, *Becoming Undone: Darwinian Reflections on Life, Politics, and Art* (Durham, NC: Duke University Press, 2011), 89.

21 Lefebvre, *The Production of Space*, 73; McKittrick, *Demonic Grounds*, xvii.

22 Ferguson, *Aberrations in Black*, 78.

23 Ferguson, *Aberrations in Black*, 78.

2. Liquor Store Theatre, Vol. 1, No. 2

1 Browning, *Samba*; Gottschild, *Digging the Africanist Presence*; Judith Lynne Hanna, *Naked Truth: Strip Clubs, Democracy, and a Christian Right* (Austin: University of Texas Press, 2012); DeFrantz and Gonzalez, *Black Performance Theory*.

2 In this text, I use the terms "performance as prompt" and "dance as prompt" interchangeably. Performance includes a variety of actions from the quotidian to the staged; dance, of course, is a particular mode of performance. I use the terms interchangeably in referring to my LST work, knowing that they are certainly not the same in other situations. In the case of the way I used dance in

LST events (abstract, conceptual) and how I think of performance, this is appropriate for me here.

3 Cervenak, *Wandering*, 23, italics Cervenak's.

4 Cervenak, *Wandering*, 23.

5 Cervenak, *Wandering*, 23.

6 Deleuze and Guattari, *A Thousand Plateaus*, 281.

7 Deleuze and Guattari, *A Thousand Plateaus*, 281.

8 Deleuze and Guattari, *A Thousand Plateaus*, 498–499.

9 Hal Foster, *The Return of the Real: The Avant-Garde at the End of the Century* (Cambridge, MA: MIT Press, 1996), 177.

10 Foster, *The Return of the Real*.

11 Gloria House and J. Watson, *Mapping the Water Crisis: The Dismantling of African-American Neighborhoods in Detroit* (Detroit: We the People of Detroit, 2016).

3. Liquor Store Theatre, Vol. 1, No. 3

1 See Dunham, *Island Possessed*; Lila Abu-Lughod, *Veiled Sentiments: Honor and Poetry in a Bedouin Society* (Berkeley: University of California Press, 2016); Lila Abu-Lughod, *Writing Women's Worlds: Bedouin Stories* (Berkeley: University of California Press, 2008); Marla F. Frederick, *Between Sundays: Black Women and Everyday Struggles of Faith* (Berkeley: University of California Press, 2003); Zain Abdullah, *Black Mecca: The African Muslims of Harlem* (Oxford: Oxford University Press, 2010).

2 Deleuze and Guattari, *A Thousand Plateaus*, 353.

3 G. F. Kojo Arthur, *Cloth as Metaphor: (Re)Reading the Adinkra Cloth: Symbols of the Akan of Ghana* (Bloomington, IN: iUniverse, 2017).

4 Abdullah, *Black Mecca*, 64.

5 Abdullah, *Black Mecca*, 67.

6 Adagio movement refers to slow, fluid, expressive, and/or gradual movement qualities.

7 Wade Davis, *The Serpent and the Rainbow* (New York: Simon and Schuster, 2010).

4. Liquor Store Theatre, Vol. 2, No. 1

1 The term "deep east side" or "deep west side" merits explanation. In this sense, it is an AAVE-dialect geographical descriptive often used by Detroiters. The term has become popular and is used by Detroiters who do not generally use AAVE, as well. Detroit's large land area was conceptualized in relation to the north- and south-running artery of Woodward Avenue. Land east of Woodward is on the east side, and west of Woodward is the west side. Being far from downtown Detroit, areas far east or far west of Woodward, pressing toward

inner-ring suburbs, earned the description "deep east" or "deep west." Deep east and deep west areas and the way they were reckoned structured ideas of living, knowing, and belonging in the city.

2 James David Dixon, "On Mack and Bewick, a Detroit Councilwoman Tries to Save Her City," *Detroit News*, June 27, 2015, https://www.detroitnews.com /story/opinion/2015/06/26/dickson-occupy-corner/29379497/; Chin, *Purchasing Power*, 64.

3 Michael Taussig, *Law in a Lawless Land: Diary of a Limpieza in Colombia* (Chicago: University of Chicago Press, 2005), 11.

4 Gertrude Stein, *Everybody's Biography* (Cambridge, MA: Exact Change, 1993), 228.

5 Taussig, *Law in a Lawless Land*, 14.

6 McKittrick, *Demonic Grounds*, 53.

7 Thomas, *Modern Blackness*, 49.

8 Ralph, *Renegade Dreams*, 194–195.

9 Ralph, *Renegade Dreams*.

10 Ralph, *Renegade Dreams*.

11 Bourgois, *In Search of Respect*, 40.

12 Pierre Bourdieu, *Language and Symbolic Power* (Cambridge, MA: Harvard University Press, 1991), 167.

13 Bourgois, *In Search of Respect*, 106.

14 Bourgois, *In Search of Respect*, 183.

15 Bourgois, *In Search of Respect*, 228, 310.

16 Wacquant, *Body and Soul*, 67.

17 Wacquant, *Body and Soul*, 130.

18 Wacquant, *Body and Soul*, 242. I have chosen to change the grammatical accents for a more standardized English quotation of Wacquant's informant. The original grammatical accents, with regional shortening of words, would have seemed out of context here.

19 Taussig, *Law in a Lawless Land*, 47.

20 Taussig, *Law in a Lawless Land*.

21 Taussig, *Law in a Lawless Land*.

5. Liquor Store Theatre, Vol. 2, No. 2

1 Kinney, *Beautiful Wasteland*.

2 Kinney, *Beautiful Wasteland*.

3 Kinney, *Beautiful Wasteland*.

4 Lyrics written and performed by Lil' Foot, June 2015.

5 Walter Rodney, *How Europe Underdeveloped Africa* (London: Bogle-L'Ouverture, 1972), 13.

6 Marable, *How Capitalism Underdeveloped Black America*, 48.

7 Thomas, *Modern Blackness*, 157.

8 Thomas, *Modern Blackness*.

9 Robinson, *Black Marxism*, 213.

10 Robinson, *Black Marxism*.

11 Kevin Fox Gotham, "Racialization and the State: The Housing Act of 1934 and the Creation of the Federal Housing Administration," *Sociological Perspectives* 43, no. 2 (2000): 291–317; J. Paul Mitchell, ed., *Federal Housing Policy and Programs: Past and Present* (New Brunswick, NJ: Rutgers University Center for Urban Studies, 1985).

12 Gotham, "Racialization and the State"; Mitchell, *Federal Housing Policy and Programs*.

13 Gotham, "Racialization and the State"; Mitchell, *Federal Housing Policy and Programs*.

14 Gotham, "Racialization and the State"; Mitchell, *Federal Housing Policy and Programs*.

15 Gotham, "Racialization and the State," 300–301.

16 Gotham, "Racialization and the State"; Mitchell, *Federal Housing Policy and Programs*.

17 Gotham, "Racialization and the State"; Mitchell, *Federal Housing Policy and Programs*.

18 Douglas S. Massey and Nancy A. Denton, *American Apartheid: Segregation and the Making of the Underclass* (Cambridge, MA: Harvard University Press, 1993).

19 Reynolds Farley, Sheldon Danziger, and Harry J. Holzer, *Detroit Divided* (New York: Russell Sage, 2000).

20 Farley, Danziger, and Holzer, *Detroit Divided*.

21 Kevin Michael Kruse and Thomas J. Sugrue, eds., *The New Suburban History* (Chicago: University of Chicago Press, 2006).

22 Supplemental Security Income, or SSI, refers to a U.S. government assistance program that provides cash and health care coverage to low-income people who are either blind, disabled, or age sixty-five or older.

23 Section 8 of the Housing Act of 1937 authorized rental housing assistance payments to private landlords to supplement the rent for approximately 4.8 million households meeting income requirements for eligibility.

24 Joe Guillen, "Detroit Water Shutoffs to Begin Tuesday," *Detroit Free Press*, May 24, 2015, https://www.freep.com/story/news/local/michigan/detroit/2015/05/24/detroit-water-shutoffs-poverty-unpaid-bills/27852135/.

25 Alex B. Hill, "Map: Top 40 Delinquent Commercial Water Accounts in Detroit," DETROITography.com, July 14, 2014.

26 Hill, "Map: Top 40."

27 Mary M. Chapman, "Detroit Shuts Off Water to Residents but Not to Businesses Who Owe Millions," *Daily Beast*, July 26, 2014, https://www.thedailybeast.com/detroit-shuts-off-water-to-residents-but-not-to-businesses-who-owe-millions.

28 "The Great Lakes," U.S. EPA, June 28, 2006, https://www.epa.gov/greatlakes.

29 Tam E. Perry, Tim Wintermute, Brenda C. Carney, Donald E. Leach, Claudia Sanford, and Laura Quist, "Senior Housing at a Crossroads: A Case Study of a University/Community Partnership in Detroit, Michigan," *Traumatology* 21, no. 3 (2015): 244.

30 Comerica Park is the home stadium of the Detroit Tigers Major League Baseball team.

31 Pattillo, *Black Picket Fences*, 118.

32 John L. Jackson Jr., *Harlemworld: Doing Race and Class in Contemporary Black America* (Chicago: University of Chicago Press, 2001), 51.

33 Jackson, *Harlemworld*.

34 Gregory, *Black Corona*, 123.

35 Gregory, *Black Corona*.

36 Monica Davey and Julie Bosman, "Protests Flare after Ferguson Police Officer Is Not Indicted," *New York Times*, November 24, 2014, https://www.nytimes.com/2014/11/25/us/ferguson-darren-wilson-shooting-michael-brown-grand-jury.html.

37 United States Department of Justice, *Investigation of the Ferguson Police Department* (Washington, DC: United States Department of Justice, 2015).

38 The moonwalk is an original dance move created and made universal by the international pop star Michael Jackson. It consists of a pull-and-glide motion, progressing backward, that requires a blend of rhythm and musicality. (No one will ever do it like MJ.)

6. *Liquor Store Theatre, Vol. 2, No. 3*

1 Daniel Gilbert is an American businessman and founder of Quicken Loans and Rock Ventures, which were under federal investigation for mortgage fraud between 2015 and 2019. In 2019, the federal government reached a $32.5 million settlement with Quicken Loans, finding Quicken guilty of fraud. The Department of Justice initially sought $200 million. (Vince Grzegorek, "Feds Reach $32.5 Million Settlement with Quicken Loans in Mortgage Fraud Lawsuit," *Cleveland Issue Newsletter*, June 17, 2019, https://www.clevescene.com/scene-and-heard/archives/2019/06/17/feds-reach-325-million-settlement-with-quicken-loans-in-mortgage-fraud-lawsuit.) Gilbert's companies famously purchased hundreds of thousands of square feet of downtown real estate in Detroit during the mid-2000s. Gilbert is owner of several sports franchises, including the National Basketball Association's Cleveland Cavaliers, the American Hockey League's Cleveland Monsters, the Arena Football League's Cleveland Gladiators, and the NBA G League's Canton Charge. He operates Quicken Loans Arena in Cleveland, Ohio. Gilbert is a polarizing figure for his role in gentrification and the contentious role he plays as a relative newcomer to the Detroit scene, while receiving outsized publicity from national news outlets for his efforts.

2　Lodge, or M-10, Freeway connects downtown Detroit with northern and northwestern suburban areas of the metropolitan area. Interstate 94 connects downtown Detroit with eastern and western suburban areas.

3　Taussig, *Law in a Lawless Land*, 9.

4　Taussig, *Law in a Lawless Land*, 74.

5　Taussig, *Law in a Lawless Land*, 9.

6　Detroit's Seventh Police Precinct operations building was located at Gratiot and Mack for decades. The building sat vacant for ten years, then was razed in 2014. While the abandoned and vacant precinct was still standing, I had a public community garden in its front yard.

7　Taussig, *Law in a Lawless Land*, 100.

8　Taussig, *Law in a Lawless Land*.

7. *Liquor Store Theatre, Vol. 3, No. 3*

1　Lisa John Rogers, in "Maya Stovall," described Todd Stovall's LST music compositions as centering the project in Detroit's electronic dance music genealogy.

2　Jackson, *Thin Description*.

3　*Vol. 3* begins with episode number 3 because I chose not to include numbers 1 and 2 in the publicly available *Liquor Store Theatre* film series. I made choices about which films to include in the series across all volumes. For instance, in *Vol. 1* there were several films that I did not include in the series after *Vol. 1, No. 3*.

4　John Hartigan, *Racial Situations: Class Predicaments of Whiteness in Detroit* (Princeton, NJ: Princeton University Press, 1999); Pattillo, *Black Picket Fences*.

5　Delmos J. Jones, "Towards a Native Anthropology," *Human Organization* 29, no. 4 (1970): 258, quotations Jones's.

6　Jones, "Towards a Native Anthropology."

7　The streetcar, M-1 Rail, or QLine, is a trolley that runs from downtown to Midtown Detroit. It was completed in May 2017 with private and public funding at a cost of about $137 million. It continues to be controversial as Detroit's public transit system is inadequate for many riders and the QLine contributed a great deal of expense and novelty, but not much functionality.

8　Taussig, *Law in a Lawless Land*.

9　Shelby Township is a northern suburb of Detroit located in Macomb County.

8. *Liquor Store Theatre, Vol. 3, No. 4*

1　Low and Lawrence-Zúñiga, *The Anthropology of Space and Place*.

2　Conquergood, "Performance Studies."

3　Conquergood, "Performance Studies," 149.

4　Frederick Douglass, *My Bondage and My Freedom* (New York: Oxford University Press, 2019), quotations Douglass's.

5 Dwight Conquergood, "Rethinking Ethnography: Towards a Critical Cultural Politics," *Communications Monographs* 58, no. 2 (1991): 179–194.

6 Dunham, *Island Possessed*.

7 Dunham, *Island Possessed*, 109.

8 Sally Ann Ness, *Body, Movement, and Culture: Kinesthetic and Visual Symbolism in a Philippine Community* (Philadelphia: University of Pennsylvania Press, 1992).

9 Ness, *Body, Movement, and Culture*, 55.

10 Deidre Sklar, *Dancing with the Virgin: Body and Faith in the Fiesta of Tortugas, New Mexico* (Berkeley: University of California Press, 2001).

11 Sklar, *Dancing with the Virgin*, 228.

12 Browning, *Samba*, 103.

13 Bailey, *Butch Queens Up in Pumps*.

14 Bailey, *Butch Queens Up in Pumps*, 118.

15 Bailey, *Butch Queens Up in Pumps*, 65.

16 Hanna, *Naked Truth*, 33, quotations and abbreviations Hanna's.

17 "Streetcar" refers to the M-1 Rail, or the QLine, a trolley running from downtown to Midtown Detroit. See chapter 7, note 7.

9. *Liquor Store Theatre, Vol. 3, No. 5*

1 Known simply as the RiverWalk, the Detroit RiverWalk is a paved bike and pedestrian pathway network spanning over ten miles, including the east riverfront, west riverfront, and Dequindre Cut segments. The Detroit Riverfront Conservancy operated the RiverWalk through a mix of public and private contributions. Grosse Pointe is an affluent suburb east of Detroit, also just north of the river. Grosse Pointe overlooks the river parallel to Detroit's east-side neighborhoods just north of the river.

2 Detroit is directly across the river from Windsor, Canada. From the RiverWalk, you can look across the river at Canada, as McGhee describes.

3 For privacy, pseudonymous company names have been used instead of actual names.

4 Sugrue, *The Origins of the Urban Crisis*.

5 Farley, Danziger, and Holzer, *Detroit Divided*.

6 Sugrue, *The Origins of the Urban Crisis*.

7 Hastings Street was an economic hub of Detroit's east-side, majority–African American neighborhoods until it was demolished to make way for Interstate Highway 375 in 1945.

8 Ralph, *Renegade Dreams*.

9 Marable, *How Capitalism Underdeveloped Black America*, 111–112.

10 Ralph, *Renegade Dreams*, 70.

11 Ralph, *Renegade Dreams*.

12 Marable, *How Capitalism Underdeveloped Black America*, 111–112.

13 To freak, in this context, refers to sexually explicit social dance movements.

14 Detroit was 83 percent African American at the 2010 census.

15 Antonio Gramsci, *Selections from the Prison Notebooks of Antonio Gramsci*, ed. and trans. Quintin Hoare and Geoffrey Nowell Smith (New York: International Publishers, 1971).

16 Valeriano Ramos, "The Concepts of Ideology, Hegemony, and Organic Intellectuals in Gramsci's Marxism," *Theoretical Review*, no. 27 (1982): 34.

17 Alex B. Hill, "Detroit: Black Problems, White Solutions," *Alex B. Hill*, October 16, 2014, https://alexbhill.org/2014/10/16/detroit-black-problems -white-solutions/.

18 Alex B. Hill, "Map: The Detroit Design Festival and the Myth of the Blank Canvas," DETROITography, September 24, 2014, https://detroitography.com /2014/09/26/map-detroit-design-festival-and-the-myth-of-the-blank-canvas/.

19 Hill, "Map: The Detroit Design Festival."

20 Hill, "Map: The Detroit Design Festival."

21 Rebecca J. Kinney, *Beautiful Wasteland: The Rise of Detroit as America's Postindustrial Frontier* (Minneapolis: University of Minnesota Press, 2016).

10. *Liquor Store Theatre, Vol. 3, No. 6*

1 Gregory, *Black Corona.*

2 Gregory, *Black Corona*, 232–233, parenthetical references Gregory's.

3 Gregory, *Black Corona*, 233.

4 Gregory, *Black Corona.*

5 Gregory, *Black Corona*, italics Gregory's.

6 Gregory, *Black Corona.*

7 Gregory, *Black Corona.*

8 Taussig, *Law in a Lawless Land.*

9 The hustle is a form of African American social line dance based on patterns of steps, sequences, and pathways. The hustle has roots in Detroit black dance cultures and is often performed to electronic techno or house music that originated in Detroit, as well as Chicago and New York City.

11. *Liquor Store Theatre, Vol. 3, No. 7*

1 Sarah Klein, "Paradise Regained," *Detroit Metro Times*, August 3, 2005.

2 Klein, "Paradise Regained."

3 Jackson, *Harlemworld*, 158.

4 Karl Marx, *The Poverty of Philosophy*, trans Harry Quelch (Chicago: C. H. Kerr, 1913).

5 Mark Anthony Neal, *New Black Man* (New York: Routledge, 2015), xx.

6 Neal, *New Black Man*, xx–xxi.

7 Neal, *New Black Man*, 71.

8 Hardt and Negri, *Empire.*

9 Hardt and Negri, *Empire.*

12. Liquor Store Theatre, Vol. 4, No. 1

1 Martin, *Critical Moves*, 1–2.

2 Martin, *Critical Moves.*

3 In describing my approach as an artist, I often use the term "postminimalist." Postminimalism, in this context, refers to post-1960s movements of work centered by process, performance, seriality, and conceptual art. Postminimalism works with abstract, surreal aesthetics and uses readymade materials, with an interest in industrial and postindustrial materials. Postminimalism also has a tendency to be more emotive (although this is often coded or ironic) than minimalist work pre-1960.

4 Immanuel Kant, *Critique of Pure Reason*, trans. Norman Kemp Smith (1781; New York: St. Martin's Press, 1929); Jean-Luc Nancy, *The Inoperative Community* (Minneapolis: University of Minnesota Press, 1991); Angela Y. Davis, *Freedom Is a Constant Struggle: Ferguson, Palestine, and the Foundations of a Movement* (Chicago: Haymarket, 2016).

5 Davis, *Freedom Is a Constant Struggle*, 61.

6 Daniel Howes, "Gilbert Proposes to Build Wayne Co. Jail, Take Gratiot Site," *Detroit News*, February 7, 2017, https://www.detroitnews.com/story/business /columnists/daniel-howes/2017/02/06/howes/97571020/.

7 John Gallagher, "U.S. Sues Quicken Loans over Allegedly Improper FHA Loans," *Detroit Free Press*, April 23, 2015, https://www.freep.com/story /money/business/michigan/2015/04/23/quicken-fha-hud-lawsuit-mortgages -gilbert/26258541/; Christine MacDonald and Joel Kurth, "Foreclosures Fuel Detroit Blight, Cost City Millions," *Detroit News*, June 3, 2015, https:// www.detroitnews.com/story/news/special-reports/2015/06/03/detroit -foreclosures-risky-mortgages-cost-taxpayers/27236605/.

8 Vince Grzegorek, "Feds Reach $32.5 Million Settlement with Quicken Loans in Mortgage Fraud Lawsuit," *Cleveland Issue Newsletter*, June 17, 2019, https:// www.clevescene.com/scene-and-heard/archives/2019/06/17/feds-reach-325 -million-settlement-with-quicken-loans-in-mortgage-fraud-lawsuit.

9 Howes, "Gilbert Proposes."

10 Howes, "Gilbert Proposes."

11 Julie Creswell, "Quicken Loans, the New Mortgage Machine," *New York Times*, January 21, 2017, https://www.nytimes.com/2017/01/21/business /dealbook/quicken-loans-dan-gilbert-mortgage-lender.html.

12 Howes, "Gilbert Proposes."

13 Detroit Free Press Editorial Board, "In Math for Soccer Stadium, What Do Taxpayers Pay?," *Detroit Free Press*, February 7, 2017, https://www.freep.com /story/opinion/editorials/2017/02/07/gilbert-soccer-jail-wayne/97588742/.

14 Lauren E. Glaze and Danielle Kaeble, *Correctional Populations in the United States, 2013* (NCJ 248479) (Washington, DC: U.S. Bureau of Justice Statistics, December 2014).

15 Alexander, *The New Jim Crow.*

16 Glaze and Kaeble, *Correctional Populations in the United States.*

17 Cervenak, *Wandering*, 154.

18 Cervenak, *Wandering.*

19 Cervenak, *Wandering.*

20 Cervenak, *Wandering*, 155.

13. *Liquor Store Theatre, Vol. 4, No. 2*

1 Johanna Oksala, "Affective Labor and Feminist Politics," *Signs: Journal of Women in Culture and Society* 41, no. 2 (2016): 281–303.

2 Eduardo Viveiros de Castro, *Cannibal Metaphysics*, ed. and trans. Peter Skafish (Minneapolis: University of Minnesota Press, 2015), 40.

3 Taussig, *Law in a Lawless Land.*

4 John Langshaw Austin, *How to Do Things with Words* (Oxford: Oxford University Press, 1975).

5 Barbara Johnstone, Jennifer Andrus, and Andrew E. Danielson, "Mobility, Indexicality, and the Enregisterment of 'Pittsburghese,'" *Journal of English Linguistics* 34, no. 2 (2006): 77–104.

6 Johnstone, Andrus, and Danielson, "Mobility, Indexicality, and the Enregisterment of 'Pittsburghese,'" 81, quotations around "social meaning" the authors'.

7 Mary Bucholtz, "From Stance to Style: Gender, Interaction, and Indexicality in Mexican Immigrant Youth Slang," in *Stance: Sociolinguistic Perspectives*, ed. Alexandra Jaffe (New York: Oxford University Press, 2009).

8 Michael Silverstein, "Indexical Order and the Dialectics of Sociolinguistic Life," *Language and Communication* 23, no. 3 (2003): 193–229.

9 Silverstein, "Indexical Order and the Dialectics of Sociolinguistic Life."

10 Silverstein, "Indexical Order and the Dialectics of Sociolinguistic Life," 227, parentheses and quotation marks the author's.

11 Silverstein, "Indexical Order and the Dialectics of Sociolinguistic Life," 227.

12 Johnstone, Andrus, and Danielson, "Mobility, Indexicality, and the Enregisterment of 'Pittsburghese,'" 81.

13 James Q. Wilson and George L. Kelling, "Broken Windows," *Critical Issues in Policing: Contemporary Readings* (1982): 395–407.

14 McKittrick, *Demonic Grounds.*

15 Sugrue, *The Origins of the Urban Crisis.*

16 Ta-Nehisi Coates, "The Black Family in the Age of Mass Incarceration," *Atlantic*, October 2015, https://www.theatlantic.com/magazine/archive/2015/10/the-black-family-in-the-age-of-mass-incarceration/403246/.

17 Ta-Nehesi Coates, "Trayvon Martin and the Irony of American Justice," *Atlantic*, July 15, 2013, https://www.theatlantic.com/national/archive/2013/07 /trayvon-martin-and-the-irony-of-american-justice/277782/.

14. *Liquor Store Theatre, Vol. 4, No. 3*

1 Hartigan, *Racial Situations*.
2 Hartigan, *Racial Situations*, 16.
3 Hartigan, *Racial Situations*, 16–17, quotations Hartigan's.
4 Maya Stovall and Alex B. Hill, "Blackness in Post-bankruptcy Detroit: Racial Politics and Public Discourse," *North American Dialogue* 19, no. 2 (2016): 117–127.
5 Hartigan, *Racial Situations*, 17.

15. *Liquor Store Theatre, Vol. 4, No. 4*

1 Marcel Mauss, *The Gift*, trans. I. Cunnison (London: Cohen and West, 1925).
2 Mauss, *The Gift*, 38.

17. *Liquor Store Theatre, Vol. 4, No. 6*

1 James David Dickson, "Off-Duty Detroit Officer Shot, Kills Suspect," *Detroit News*, June 5, 2017, https://www.detroitnews.com/story/news/local/detroit-city /2017/06/05/off-duty-officer-shot-kills-suspect-attempted-robbery/102509334/.
2 The Big Four or Tac Squads were four-person police units that primarily patrolled black areas of Detroit during the 1960s. The Big Four was known for policing disparities, police brutality against black people, and perpetrating acts of degradation and humiliation toward black people in particular. STRESS, short for Stop the Robberies, Enjoy Safe Streets, was a Detroit police unit operating during the 1960s. The unit was known to use decoy strategies and targeted black men in particular. Over two years, the unit led to the deaths of twenty-four men, of whom twenty-two were black. For more on the Big Four and STRESS, see Sidney Fine, *Violence in the Model City* (Ann Arbor: University of Michigan Press, 1989).
3 Christian was close; Young was elected mayor in 1974.
4 Arjun Appadurai, *Fear of Small Numbers: An Essay on the Geography of Anger* (Durham, NC: Duke University Press, 2006), 40.
5 Ralph, *Renegade Dreams*, 5, quotations Ralph's.
6 Dickson, "Off-Duty Detroit Officer Shot, Kills Suspect."
7 Dickson, "Off-Duty Detroit Officer Shot, Kills Suspect."
8 Dickson, "Off-Duty Detroit Officer Shot, Kills Suspect."
9 Dickson, "Off-Duty Detroit Officer Shot, Kills Suspect."
10 Taussig, *Law in a Lawless Land*, 48, quotations Taussig's.

11 Hannah Arendt, *The Human Condition* (Chicago: University of Chicago Press, 2013), 203, quotations Arendt's.

12 Arendt, *The Human Condition.*

13 Appadurai, *Fear of Small Numbers*, 40.

18. *Liquor Store Theatre, Vol. 4, No. 7*

1 Elijah Anderson, *A Place on the Corner* (Chicago: University of Chicago Press, 2003), 1, quotations Anderson's.

2 Anderson, *A Place on the Corner.*

3 Anderson, *A Place on the Corner*, 119, quotations Anderson's.

4 Naomi Rea, "A Year Ago, Parker Bright Protested Dana Schutz at the Whitney. Now His Fans Are Flying Him to Paris to Protest Again," *Art World*, February 21, 2018.

5 De Castro, *Cannibal Metaphysics*, 47–48.

6 Anna Kisselgoff, "Dance Review: Bill T. Jones's Lyrical Look at Survivors," *New York Times*, December 2, 1994, https://www.nytimes.com/1994/12/02 /arts/dance-review-bill-t-jones-s-lyrical-look-at-survivors.html.

7 Arlene Croce, "A Critic at Bay: Discussing the Undiscussable," *New Yorker* 70, no. 43 (1994): 54.

8 Croce, "A Critic at Bay."

9 Croce, "A Critic at Bay."

10 Croce, "A Critic at Bay," 59.

11 Croce, "A Critic at Bay," 54.

12 Croce, "A Critic at Bay," 54, italics mine.

13 Croce, "A Critic at Bay."

14 Bill T. Jones, *Still/Here with Bill Moyers*, 1997, http://www.pbs.org/moyers /journal/archives/billtjones_stillhere_flash.html.

19. *Liquor Store Theatre, Vol. 5, No. 1*

1 Farmer, "An Anthropology of Structural Violence."

2 Estate of Conner by Conner v. Ambrose, 990 F. Supp. 606 (N.D. Ind. 1997), U.S. District Court for the Northern District of Indiana, December 23, 1997.

3 *Estate of Conner by Conner v. Ambrose.*

4 *Estate of Conner by Conner v. Ambrose.*

5 Maya Stovall, "Public Library: Crystal Meth, Choreography, Conceptual Art," *TDR/The Drama Review* 64, no. 2 (2020).

6 Jermont Terry and Kayla Clark, "Community on Detroit's East Side Remains on High Alert over Serial Killer," *Local 4/Click on Detroit*, June 12, 2019, https://www.clickondetroit.com/news/2019/06/13/community-on -detroits-east-side-remains-on-high-alert-over-serial-killer/.

7 Rahal, "Detroit Police Arrest 2 Men in $17M Drug Bust."

BIBLIOGRAPHY

Abdullah, Zain. *Black Mecca: The African Muslims of Harlem*. Oxford: Oxford University Press, 2010.

Abu-Lughod, Lila. *Veiled Sentiments: Honor and Poetry in a Bedouin Society*. Berkeley: University of California Press, 2016.

Abu-Lughod, Lila. *Writing Women's Worlds: Bedouin Stories*. Berkeley: University of California Press, 2008.

Ahmed, Sara. *The Promise of Happiness*. Durham, NC: Duke University Press, 2010.

Alexander, Michelle. *The New Jim Crow: Mass Incarceration in the Age of Colorblindness*. New York: New Press, 2012.

Anderson, Elijah. *A Place on the Corner*. Chicago: University of Chicago Press, 2003.

Appadurai, Arjun. *Fear of Small Numbers: An Essay on the Geography of Anger*. Durham, NC: Duke University Press, 2006.

Aptheker, Herbert, ed. *A Documentary History of the Negro People in the United States*. Vol. 1. New York: Citadel, 1969.

Aptheker, Herbert. *The Negro in the American Revolution*. New York: International Publishers, 1940.

Aptheker, Herbert. *Negro Slave Revolts in the United States, 1526–1860*. New York: International Publishers, 1939.

Arellano, Amber, and John B. King Jr. "Michigan Lawmakers Have Ignored Inequities in Education for Too Long." *Detroit Free Press*, January 15, 2019. https://www.freep.com/story/opinion/contributors/2019/01/15/michigan -education-detroit-students/2575753002/.

Arendt, Hannah. *The Human Condition*. Chicago: University of Chicago Press, 2013.

Arthur, G. F. Kojo. *Cloth as Metaphor: (Re)Reading the Adinkra Cloth: Symbols of the Akan of Ghana*. Bloomington, IN: iUniverse, 2017.

Austin, John Langshaw. *How to Do Things with Words*. Oxford: Oxford University Press, 1975.

Bailey, Marlon M. *Butch Queens Up in Pumps: Gender, Performance, and Ballroom Culture in Detroit.* Ann Arbor: University of Michigan Press, 2013.

Barber, Chris. "Public Enemy Number One: A Pragmatic Approach to America's Drug Problem." Richard Nixon Foundation, June 29, 2016. https://www.nixonfoundation.org/2016/06/26404/.

Berry, Mary Frances. *Black Resistance/White Law: A History of Constitutional Racism in America.* New York: Penguin, 1995.

Boggs, James. *Pages from a Black Radical's Notebook: A James Boggs Reader.* Detroit: Wayne State University Press, 2011.

Bomey, Nathan, and M. Helms. "Attorney: Detroit Won't Recover without Grand Bargain." *USA Today,* September 2, 2014.

Bourdieu, Pierre. *Language and Symbolic Power.* Cambridge, MA: Harvard University Press, 1991.

Bourgois, Philippe. *In Search of Respect: Selling Crack in El Barrio.* New York: Cambridge University Press, 2003.

Browning, Barbara. *Samba: Resistance in Motion.* Bloomington: Indiana University Press, 1995.

Bucholtz, Mary. "From Stance to Style: Gender, Interaction, and Indexicality in Mexican Immigrant Youth Slang." In *Stance: Sociolinguistic Perspectives,* edited by Alexandra Jaffe, 146–170. New York: Oxford University Press, 2009.

Butler, Judith. *Gender Trouble: Feminism and the Subversion of Identity.* New York: Routledge, 2011.

Byrd-Hill, Ida. "Detroit's Problem Is a Lack of Jobs, Not Too Much Gentrification." *Bridge,* May 5, 2017. https://www.bridgemi.com/guest-commentary/detroits-problem-lack-jobs-not-too-much-gentrification.

Cashmore, Ellis, and Eugene McLaughlin. *Out of Order? Policing Black People.* Routledge Revivals. New York: Routledge, 2013.

Cervenak, Sarah Jane. *Wandering: Philosophical Performances of Racial and Sexual Freedom.* Durham, NC: Duke University Press, 2014.

Chapman, Mary M. "Detroit Shuts Off Water to Residents but Not to Businesses Who Owe Millions." *Daily Beast,* July 26, 2014. https://www.thedailybeast.com/detroit-shuts-off-water-to-residents-but-not-to-businesses-who-owe-millions.

Chin, Elizabeth M. Liew Siew. *Purchasing Power: Black Kids and American Consumer Culture.* Minneapolis: University of Minnesota Press, 2001.

Christie, Les. "I've Been Priced Out of Downtown Detroit." *CNNMoney,* May 27, 2014. https://money.cnn.com/2014/05/27/real_estate/downtown-detroit/index.html.

Coates, Ta-Nehisi. "The Black Family in the Age of Mass Incarceration." *Atlantic,* October 2015. https://www.theatlantic.com/magazine/archive/2015/10/the-black-family-in-the-age-of-mass-incarceration/403246/.

Coates, Ta-Nehisi. "Trayvon Martin and the Irony of American Justice." *Atlantic,* July 15, 2013. https://www.theatlantic.com/national/archive/2013/07/trayvon-martin-and-the-irony-of-american-justice/277782/.

Collins, Patricia Hill. *Fighting Words: Black Women and the Search for Justice*. Minneapolis: University of Minnesota Press, 1998.

Conquergood, Dwight. "Performance Studies: Interventions and Radical Research." *TDR/The Drama Review* 46, no. 2 (2002): 145–156.

Conquergood, Dwight. "Rethinking Ethnography: Towards a Critical Cultural Politics." *Communications Monographs* 58, no. 2 (1991): 179–194.

Cox, Aimee Meredith. *Shapeshifters: Black Girls and the Choreography of Citizenship*. Durham, NC: Duke University Press, 2015.

Creswell, Julie. "Quicken Loans, the New Mortgage Machine." *New York Times*, January 21, 2017. https://www.nytimes.com/2017/01/21/business/dealbook/quicken-loans-dan-gilbert-mortgage-lender.html.

Croce, Arlene. "A Critic at Bay: Discussing the Undiscussable." *New Yorker* 70, no. 43 (1994): 54–61.

Darden, Joe T., Richard Child Hill, June Thomas, and Richard Thomas. *Detroit: Race and Uneven Development*. Philadelphia: Temple University Press, 1990.

Davey, Monica, and Julie Bosman. "Protests Flare after Ferguson Police Officer Is Not Indicted." *New York Times*, November 24, 2014. https://www.nytimes.com/2014/11/25/us/ferguson-darren-wilson-shooting-michael-brown-grand-jury.html.

Davis, Angela Y. *Freedom Is a Constant Struggle: Ferguson, Palestine, and the Foundations of a Movement*. Chicago: Haymarket, 2016.

Davis, Mike. *City of Quartz: Excavating the Future in Los Angeles*. New ed. New York: Verso, 2006.

Davis, Wade. *The Serpent and the Rainbow*. New York: Simon and Schuster, 2010.

de Castro, Eduardo Viveiros. *Cannibal Metaphysics*. Edited and translated by Peter Skafish. Minneapolis: University of Minnesota Press, 2015.

DeFrantz, Thomas F., and Anita Gonzalez, eds. *Black Performance Theory*. Durham, NC: Duke University Press, 2014.

Deleuze, Gilles, and Félix Guattari. *A Thousand Plateaus: Capitalism and Schizophrenia*. New York: Bloomsbury, 1988.

Detroit Free Press Editorial Board. "In Math for Soccer Stadium, What Do Taxpayers Pay?" *Detroit Free Press*, February 7, 2017. https://www.freep.com/story/opinion/editorials/2017/02/07/gilbert-soccer-jail-wayne/97588742/.

Dickson, James David. "Off-Duty Detroit Officer Shot, Kills Suspect." *Detroit News*, June 5, 2017. https://www.detroitnews.com/story/news/local/detroit-city/2017/06/05/off-duty-officer-shot-kills-suspect-attempted-robbery/102509334/.

Dillard, Angela D. "Religion and Radicalism: The Reverend Albert B. Cleage, Jr., and the Rise of Black Christian Nationalism in Detroit." In *Freedom North: Black Freedom Struggles outside the South, 1940–1980*, 153–175. New York: Palgrave Macmillan, 2003.

Dixon, James David. "On Mack and Bewick, a Detroit Councilwoman Tries to Save Her City." *Detroit News*, June 27, 2015. https://www.detroitnews.com/story/opinion/2015/06/26/dickson-occupy-corner/29379497/.

Doody, Colleen. *Detroit's Cold War: The Origins of Postwar Conservatism*. Urbana: University of Illinois Press, 2012.

Douglass, Frederick. *My Bondage and My Freedom*. New York: Oxford University Press, 2019.

Drake, St. Clair, and Horace R. Cayton. *Black Metropolis: A Study of Negro Life in a Northern City*. Chicago: University of Chicago Press, 1970.

Du Bois, W. E. B., and Isabel Eaton. *The Philadelphia Negro: A Social Study*. Boston: Ginn and Company, 1899.

Duneier, Mitchell. *Slim's Table: Race, Respectability, and Masculinity*. Chicago: University of Chicago Press, 2015.

Duneier, Mitchell, and Ovie Carter. *Sidewalk*. New York: Macmillan, 1999.

Dunham, Katherine. *Island Possessed*. Chicago: University of Chicago Press, 1994.

Estate of Conner by Conner v. Ambrose, 990 F. Supp. 606 (N.D. Ind. 1997). US District Court for the Northern District of Indiana, December 23, 1997.

Fanon, Frantz. *Black Skin, White Masks*. New York: Grove, 2008.

Fanon, Frantz. *Toward the African Revolution: Political Essays*. New York: Grove, 1988.

Fanon, Frantz. *The Wretched of the Earth*. New York: Grove/Atlantic, 2007.

Farley, Reynolds, Sheldon Danziger, and Harry J. Holzer. *Detroit Divided*. New York: Russell Sage, 2000.

Farmer, Paul. "An Anthropology of Structural Violence." *Current Anthropology* 45, no. 3 (2004): 305–325.

Ferguson, Roderick A. *Aberrations in Black: Toward a Queer of Color Critique*. Minneapolis: University of Minnesota Press, 2004.

Ferreira, Fernando, and Joseph Gyourko. *A New Look at the US Foreclosure Crisis: Panel Data Evidence of Prime and Subprime Borrowers from 1997 to 2012*. No. w21261. Washington, DC: National Bureau of Economic Research, 2015.

Fine, Sidney. *Violence in the Model City: The Cavanagh Administration, Race Relations, and the Detroit Riot of 1967*. Ann Arbor: Michigan State University Press, 2007.

Foster, Hal. *The Return of the Real: The Avant-Garde at the End of the Century*. Cambridge, MA: MIT Press, 1996.

Foucault, Michel. *Discipline and Punish: The Birth of the Prison*. New York: Vintage, 2012.

Frederick, Marla F. *Between Sundays: Black Women and Everyday Struggles of Faith*. Berkeley: University of California Press, 2003.

Gallagher, John. "Few Black People Get Home Mortgages in Detroit, Data Show." *Detroit Free Press*, March 21, 2019. https://www.freep.com/story/money/business/john-gallagher/2019/03/21/black-mortgages-detroit-real-estate-michigan/3165381002/.

Gallagher, John. "U.S. Sues Quicken Loans over Allegedly Improper FHA loans." *Detroit Free Press*, April 23, 2015. https://www.freep.com/story/money/business/michigan/2015/04/23/quicken-fha-hud-lawsuit-mortgages-gilbert/26258541/.

Geertz, Clifford. *The Interpretation of Cultures*. New York: Basic Books, 1973.

Glaberman, Martin. "Dodge Revolutionary Union Movement." *International Socialism*, 1st ser., 36 (1969): 8–9.

Glaze, Lauren E., and Danielle Kaeble. *Correctional Populations in the United States, 2013* (NCJ 248479). Washington, DC: U.S. Bureau of Justice Statistics, December 2014.

Gotham, Kevin Fox. "Racialization and the State: The Housing Act of 1934 and the Creation of the Federal Housing Administration." *Sociological Perspectives* 43, no. 2 (2000): 291–317.

Gotham, Kevin Fox. "Urban Space, Restrictive Covenants and the Origins of Racial Residential Segregation in a US City, 1900–50." *International Journal of Urban and Regional Research* 24, no. 3 (2000): 616–633.

Gottschild, Brenda Dixon. *The Black Dancing Body: A Geography from Coon to Cool.* New York: Springer, 2016.

Gottschild, Brenda Dixon. *Digging the Africanist Presence in American Performance: Dance and Other Contexts.* Westport, CT: Greenwood, 1996.

Graber, Henry. "Can America's Worst Transit System Be Saved?" *Slate*, June 7, 2016. https://slate.com/business/2016/06/detroit-has-americas-worst-transit-system-could-the-regional-transit-master-plan-save-it.html.

Gramsci, Antonio. *Selections from the Prison Notebooks of Antonio Gramsci.* Edited and translated by Quintin Hoare and Geoffrey Nowell Smith. New York: International Publishers, 1971.

"Great Lakes." U.S. EPA, June 28, 2006. https://www.epa.gov/greatlakes/facts-and-figures-about-great-lakes.

Green, Terrance L., Joanna D. Sánchez, and Andrene J. Castro. "Closed Schools, Open Markets: A Hot Spot Spatial Analysis of School Closures and Charter Openings in Detroit." *AERA Open*, April 2019, 1–14.

Gregory, Steven. *Black Corona: Race and the Politics of Place in an Urban Community.* Princeton, NJ: Princeton University Press, 1999.

Grosz, Elizabeth. *Becoming Undone: Darwinian Reflections on Life, Politics, and Art.* Durham, NC: Duke University Press, 2011.

Grzegorek, Vince. "Feds Reach $32.5 Million Settlement with Quicken Loans in Mortgage Fraud Lawsuit." *Cleveland Issue Newsletter*, June 17, 2019. https://www.clevescene.com/scene-and-heard/archives/2019/06/17/feds-reach-325-million-settlement-with-quicken-loans-in-mortgage-fraud-lawsuit.

Guillen, Joe. "Detroit Leads the Nation in Reverse Mortgage Foreclosures." *Detroit Free Press*, June 14, 2019. https://www.freep.com/story/news/investigations/2019/06/14/detroit-leads-nation-reverse-mortgage-foreclosures/1442186001/.

Guillen, Joe. "Detroit Water Shutoffs to Begin Tuesday." *Detroit Free Press*, May 24, 2015. https://www.freep.com/story/news/local/michigan/detroit/2015/05/24/detroit-water-shutoffs-poverty-unpaid-bills/27852135/.

Hackman, Rose. "What Happens When Detroit Shuts Off the Water of 100,000 People." *Atlantic*, July 17, 2014. https://www.theatlantic.com/business/archive/2014/07/what-happens-when-detroit-shuts-off-the-water-of-100000-people/374548/.

Hall, Stuart, and Paul du Gay, eds. *Questions of Cultural Identity*. Thousand Oaks, CA: Sage, 1996.

Hanna, Judith Lynne. *Naked Truth: Strip Clubs, Democracy, and a Christian Right*. Austin: University of Texas Press, 2012.

Hardt, Michael, and Antonio Negri. *Empire*. Cambridge, MA: Harvard University Press, 2001.

Hartigan, John. *Racial Situations: Class Predicaments of Whiteness in Detroit*. Princeton, NJ: Princeton University Press, 1999.

Hartmann, Saidiya. "Venus in Two Acts." *Small Axe* 26 (2008): 1–14.

Harvey, David. "The 'New' Imperialism: Accumulation by Dispossession." *Socialist Register* 40 (2004): 63–87.

Harvey, David. "The Right to the City." *International Journal of Urban and Regional Research* 27, no. 4 (2003): 939–941.

Harvey, David. *Spaces of Global Capitalism*. London: Verso, 2006.

Harvey, David, and Mark Davidson. *Social Justice and the City*. London: Arnold, 1973.

Hathaway, Dale A. *Can Workers Have a Voice? The Politics of Deindustrialization in Pittsburgh*. University Park, PA: Penn State University Press, 2010.

Henry, Bill, Jill Reese, and Angel Torres. "Wasted Wealth Report: How the Wall Street Crash Continues to Stall Economic Recovery and Deepen Racial Inequity in America." Alliance for a Just Society, May 2013. https://allianceforajust society.org/wasted-wealth-report/.

Hill, Alex B. "Detroit: Black Problems, White Solutions." *Alex B. Hill*, October 16, 2014. https://alexbhill.org/2014/10/16/detroit-black-problems-white-solutions/.

Hill, Alex B. "Map: The Detroit Design Festival and the Myth of the Blank Canvas." DETROITography, September 24, 2014. https://detroitography.com/2014/09/26/map-detroit-design-festival-and-the-myth-of-the-blank-canvas/.

Hill, Alex B. "Map: Top 40 Delinquent Commercial Water Accounts in Detroit." DETROITography.com, July 14, 2014. https://detroitography.com/2014/07/14/map-top-40-delinquent-commercial-water-accounts-in-detroit/.

hooks, bell. *Communion: The Female Search for Love*. New York: Morrow, 2002.

House, Gloria, and J. Watson. *Mapping the Water Crisis: The Dismantling of African-American Neighborhoods in Detroit*. Detroit: We the People of Detroit, 2016.

Howes, Daniel. "Gilbert Proposes to Build Wayne Co. Jail, Take Gratiot Site." *Detroit News*, February 7, 2017. https://www.detroitnews.com/story/business/columnists/daniel-howes/2017/02/06/howes/97571020/.

Hudson-Webber Foundation et al. *7.2 SQ MI: A Report on Greater Downtown Detroit*. Detroit, 2013. https://detroitsevenpointtwo.com/.

Hurston, Zora Neale. *Mules and Men*. New York: Perennial Library, 1935.

"I Have to Die a Man or Live a Coward." *Detroit News*, February 11, 2001. http://blogs.detroitnews.com/history/2001/02/11/i-have-to-die-a-man-or-live-a-coward-the-saga-of-dr-ossian-sweet/.

Irwin, John, and James Austin. *It's About Time*. Belmont, CA: Wadsworth, 1994.

Jackson, John L., Jr. *Harlemworld: Doing Race and Class in Contemporary Black America*. Chicago: University of Chicago Press, 2001.

Jackson, John L., Jr. *Real Black: Adventures in Racial Sincerity*. Chicago: University of Chicago Press, 2005.

Jackson, John L., Jr. *Thin Description*. Cambridge, MA: Harvard University Press, 2013.

Jacobs, Jane. *The Death and Life of Great American Cities*. 1961. Reprint, New York: Vintage, 1992.

Johnstone, Barbara, Jennifer Andrus, and Andrew E. Danielson. "Mobility, Indexicality, and the Enregisterment of 'Pittsburghese.'" *Journal of English Linguistics* 34, no. 2 (2006): 77–104.

Jones, Bill T. *Still/Here with Bill Moyers*. 1997. http://www.pbs.org/moyers/journal /archives/billtjones_stillhere_flash.html.

Jones, Delmos J. "Towards a Native Anthropology." *Human Organization* 29, no. 4 (1970): 251–259.

Kant, Immanuel. *Critique of Pure Reason*. Translated by N. K. Smith. 1781. New York: St. Martin's Press, 1929.

Katzman, David M. *Before the Ghetto: Black Detroit in the Nineteenth Century*. Urbana: University of Illinois Press, 1973.

Katzman, David M. "Black Slavery in Michigan." *Midcontinent American Studies Journal* 11, no. 2 (1970): 56–66.

Kinney, Rebecca J. *Beautiful Wasteland: The Rise of Detroit as America's Postindustrial Frontier*. Minneapolis: University of Minnesota Press, 2016.

Kisselgoff, Anna. "Dance Review: Bill T. Jones's Lyrical Look at Survivors." *New York Times*, December 2, 1994. https://www.nytimes.com/1994/12/02/arts/dance -review-bill-t-jones-s-lyrical-look-at-survivors.html.

Klein, Sarah. "Paradise Regained." *Detroit Metro Times*, August 3, 2005.

Krauss, Rosalind E. *Under Blue Cup*. Cambridge, MA: MIT Press, 2011.

Kruse, Kevin M., and Thomas J. Sugrue, eds. *The New Suburban History*. Chicago: University of Chicago Press, 2006.

Kurth, Joel, and Mike Wilkinson. "I Hate to Complain, but I Haven't Had Water in a Year. A Detroit Story." Michigan Health Watch, *Bridge*, February 17, 2020, https://www.bridgemi.com/michigan-health-watch/i-hate-complain-i-havent -had-water-year-detroit-story.

Lakhani, Nina. "Detroit Suspends Water Shutoffs amid Covid-19 Fears." *Guardian*, March 12, 2020. https://www.theguardian.com/us-news/2020/mar/12 /detroit-water-shutoffs-unpaid-bills-coronavirus.

Langlois, Janet L. "The Belle Isle Bridge Incident: Legend Dialectic and Semiotic System in the 1943 Detroit Race Riots." *Journal of American Folklore* 96, no. 380 (1983): 183–199.

LaReau, Jamie L. "General Motors to Close Detroit, Ohio, Canada Plants." *Detroit Free Press*, November 27, 2018. https://www.freep.com/story/money/cars /general-motors/2018/11/26/ontario-plant-closure/2112539002/.

Lefebvre, Henri. *The Production of Space*. Translated by Donald Nicholson-Smith. Malden: Blackwell, 1991.

Lepecki, André. *Exhausting Dance: Performance and the Politics of Movement*. New York: Routledge, 2006.

Lorde, Geraldine Audre. *Zami: A New Spelling of My Name: A Biomythography.* Berkeley, CA: Crossing Press, 2011.

Low, Setha M., and Denise Lawrence-Zúñiga, eds. *The Anthropology of Space and Place: Locating Culture.* Malden: Blackwell, 2003.

MacDonald, Christine, and Mark Betancourt. "Detroit Homeowners Overtaxed $600 Million." *Detroit News*, January 9, 2020. https://www.detroitnews .com/story/news/local/detroit-city/housing/2020/01/09/detroit-home owners-overtaxed-600-million/2698518001/.

MacDonald, Christine, and Joel Kurth. "Foreclosures Fuel Detroit Blight, Cost City Millions." *Detroit News*, June 3, 2015. https://www.detroitnews.com/story /news/special-reports/2015/06/03/detroit-foreclosures-risky-mortgages-cost -taxpayers/27236605/.

MacDonald, Christine, and Joel Kurth. "Volume of Abandoned Homes 'Absolutely Terrifying.'" *Detroit News*, June 24, 2015. https://www.detroitnews.com/story /news/special-reports/2015/05/14/detroit-abandoned-homes-volume -terrifying/27237787/.

Marable, Manning. *How Capitalism Underdeveloped Black America: Problems in Race, Political Economy, and Society.* Chicago: Haymarket, 2015.

Martin, Randy. *Critical Moves: Dance Studies in Theory and Politics.* Durham, NC: Duke University Press, 1998.

Marx, Karl. *The Poverty of Philosophy: Being a Translation of the Misère de la philoso- phie (a Reply to "La philosophie de la misère" of M. Proudhon).* Translated by Harry Quelch. Chicago: C. H. Kerr, 1913.

Massey, Douglas S., and Nancy A. Denton. *American Apartheid: Segregation and the Making of the Underclass.* Cambridge, MA: Harvard University Press, 1993.

Mauss, Marcel. *The Gift.* Translated by I. Cunnison. London: Cohen and West, 1925.

McKittrick, Katherine. *Demonic Grounds: Black Women and the Cartographies of Struggle.* Minneapolis: University of Minnesota Press, 2006.

McKittrick, Katherine. "Wynter, Sylvia." In *The Encyclopedia of Postcolonial Studies.* New York: Wiley, 2016.

Merriman, Doug. "A History of Violence: The Detroit Police Department, the Af- rican American Community and s.t.r.e.s.s. An Army of Occupation or an Army under Siege." *Doug Merriman*, November 17, 2015. https://dougmerriman .org/2015/11/17/a-history-of-violence-the-detroit-police-department-the -african-american-community-and-s-t-r-e-s-s-an-army-of-occupation-or-an -army-under-siege/.

"Minutes of the State Convention of the Colored Citizens of the State of Michigan, for the purpose of considering their moral & political conditions, as citizens of the State." Detroit, 1843. Copy in the Boston Athenaeum.

Mitchell, Bill. "In Detroit, Water Crisis Symbolizes Decline, and Hope." *National Geographic*, August 22, 2014. https://news.nationalgeographic.com/news /special-features/2014/08/140822-detroit-michigan-water-shutoffs-great-lakes/.

Mitchell, J. Paul, ed. *Federal Housing Policy and Programs: Past and Present.* New Brunswick, NJ: Rutgers University Center for Urban Studies, 1985.

Moratorium Michigan. "Fact Sheet on City of Detroit Conditions." July 2018. https:// moratorium-mi.org/wp-content/uploads/2018/07/Detroit-fact-sheet.pdf.

Mulvey, Laura. "Narrative Cinema and Visual Pleasure." In *Visual and Other Pleasures*. Houndmills, UK: Palgrave, 1975.

Nancy, Jean-Luc. *The Inoperative Community*. Minneapolis: University of Minnesota Press, 1991.

Neal, Mark Anthony. *New Black Man*. New York: Routledge, 2015.

Ness, Sally Ann. *Body, Movement, and Culture: Kinesthetic and Visual Symbolism in a Philippine Community*. Philadelphia: University of Pennsylvania Press, 1992.

Newman, Andrew. *Landscape of Discontent: Urban Sustainability in Immigrant Paris*. Minneapolis: University of Minnesota Press, 2015.

Oksala, Johanna. "Affective Labor and Feminist Politics." *Signs: Journal of Women in Culture and Society* 41, no. 2 (2016): 281–303.

Pattillo, Mary. *Black Picket Fences: Privilege and Peril among the Black Middle Class*. Chicago: University of Chicago Press, 2013.

Perry, Tam E., Tim Wintermute, Brenda C. Carney, Donald E. Leach, Claudia Sanford, and Laura Quist. "Senior Housing at a Crossroads: A Case Study of a University/Community Partnership in Detroit, Michigan." *Traumatology* 21, no. 3 (2015): 244.

Quarles, Benjamin. *The Negro in the American Revolution*. Chapel Hill: University of North Carolina Press, 2012.

Rahal, Sarah. "Detroit Police Arrest 2 Men in $17M Drug Bust." *Detroit News*, October 23, 2018. https://www.detroitnews.com/story/news/local/detroit -city/2018/10/23/detroit-police-arrest-2-men-17-m-drug-bust/1741986002/.

Ralph, Laurence. *Renegade Dreams: Living through Injury in Gangland Chicago*. Chicago: University of Chicago Press, 2014.

Ramos, Valeriano. "The Concepts of Ideology, Hegemony, and Organic Intellectuals in Gramsci's Marxism." *Theoretical Review*, no. 27 (1982): 34.

Rea, Naomi. "A Year Ago, Parker Bright Protested Dana Schutz at the Whitney. Now His Fans Are Flying Him to Paris to Protest Again." *Art World*, February 21, 2018.

Reinerman, Craig, and Harry Levine. *Crack in America*. Berkeley: University of California Press, 1997.

Reynolds, Matt. "Michigan High Court Asked to Review Detroit Foreclosures." *Courthouse News Services*, November 2, 2017.

Riley, Angela R. "Native Nations and the Constitution: An Inquiry into Extra-constitutionality." *Harvard Law Review Forum* 130, no. 6 (2017): 173–199.

Robinson, Cedric J. *Black Marxism: The Making of the Black Radical Tradition*. Chapel Hill: University of North Carolina Press, 2000.

Rodney, Walter. *How Europe Underdeveloped Africa*. London: Bogle-L'Ouverture, 1972.

Rogers, Lisa John. "Maya Stovall." *Artforum* 56, no. 6 (2018): 195.

Runyan, Robin. "New Maps Compare Detroit's Population Density to Cities around the World." *Curbed Detroit*, March 23, 2017. http://detroit.curbed .com/2017/3/23/15038248/maps-detroits-population-density.

Shantz, Jeffery. "'They Think Their Fannies Are as Good as Ours': The 1943 Detroit Riot." *Studies in the Literary Imagination* 40, no. 2 (2007): 75.

Silverstein, Michael. "Indexical Order and the Dialectics of Sociolinguistic Life." *Language and Communication* 23, no. 3 (2003): 193–229.

Singh, Nikhil Pal. "Toward an Effective Antiracism." In *Dispatches from the Ebony Tower: Intellectuals Confront the African American Experience*, edited by Manning Marable, 31–51. New York: Columbia University Press, 2000.

Sklar, Deidre. *Dancing with the Virgin: Body and Faith in the Fiesta of Tortugas, New Mexico*. Berkeley: University of California Press, 2001.

Soja, Edward W. *My Los Angeles: From Urban Restructuring to Regional Urbanization*. Berkeley: University of California Press, 2014.

Soja, Edward W. *Postmodern Geographies: The Reassertion of Space in Critical Social Theory*. New York: Verso, 1989.

Stein, Gertrude. *Everybody's Biography*. Cambridge, MA: Exact Change, 1993.

Stewart, Kathleen. *Ordinary Affects*. Durham, NC: Duke University Press, 2007.

Stovall, Maya. "Liquor Store Theatre: Ethnography and Contemporary Art in Detroit." PhD diss., Wayne State University, 2018.

Stovall, Maya. "Public Library: Crystal Meth, Choreography, Conceptual Art." *TDR/The Drama Review* 64, no. 2 (2020).

Stovall, Maya, and Alex B. Hill. "Blackness in Post-bankruptcy Detroit: Racial Politics and Public Discourse." *North American Dialogue* 19, no. 2 (2016): 117–127.

Stradling, David, and Richard Stradling. "Perceptions of the Burning River: Deindustrialization and Cleveland's Cuyahoga River." *Environmental History* 3, no. 3 (2008): 515–535.

Sugrue, Thomas J. *Motor City: The Story of Detroit*. New York: Gilder Lehrman Institute of American History, 2012.

Sugrue, Thomas J. *The Origins of the Urban Crisis: Race and Inequality in Postwar Detroit*. Updated ed. Princeton, NJ: Princeton University Press, 2014.

Susser, Ida. *Norman Street: Poverty and Politics in an Urban Neighborhood*. New York: Oxford University Press, 2012.

Taussig, Michael. *Law in a Lawless Land: Diary of a Limpieza in Colombia*. Chicago: University of Chicago Press, 2005.

Terry, Jermont, and Kayla Clark. "Community on Detroit's East Side Remains on High Alert over Serial Killer." *Local 4/Click on Detroit*, June 12, 2019. https://www.clickondetroit.com/news/2019/06/13/community-on-detroits-east-side-remains-on-high-alert-over-serial-killer/.

Thomas, Deborah A. *Modern Blackness: Nationalism, Globalization, and the Politics of Culture in Jamaica*. Durham, NC: Duke University Press, 2004.

Thomas, Richard W. *Life for Us Is What We Make It: Building Black Community in Detroit, 1915–1945*. Bloomington: Indiana University Press, 1992.

Thompson, H. A. 2004. *Whose Detroit? Politics, Labor, and Race in a Modern American City*. Ithaca, NY: Cornell University Press.

United States Census Bureau. QuickFacts, Detroit City, Michigan; United States.

2017. https://www.census.gov/quickfacts/fact/table/detroitcitymichigan,US/PST045217.

United States Census Bureau. QuickFacts; United States. Table. 2010. https://www.census.gov/quickfacts/fact/table/US/PST045218.

United States Department of Justice. *Investigation of the Ferguson Police Department*. Washington, DC: United States Department of Justice, 2015.

U.S. Census Data. Census Explorer, McDougall-Hunt, Detroit. 2010. https://www.census.gov/newsroom/blogs/random-samplings/2013/12/discover-your-neighborhood-with-census-explorer.html.

Wacquant, Loïc. *Body and Soul*. Oxford: Oxford University Press, 2004.

Williamson, Terrion L. *Scandalize My Name: Black Feminist Practice and the Making of Black Social Life*. New York: Fordham University Press, 2016.

Wilson, August. *Ma Rainey's Black Bottom*. New York: Penguin, 2019.

Wilson, James Q., and George L. Kelling. "Broken Windows." *Critical Issues in Policing: Contemporary Readings* (1982): 395–407.

Wolcott, Victoria W. "Defending the Home: Ossian Sweet and the Struggle against Segregation in 1920s Detroit." *OAH Magazine of History* 7, no. 4 (1993): 23–27.

Zhang, Li. *In Search of Paradise: Middle-Class Living in a Chinese Metropolis*. Ithaca, NY: Cornell University Press, 2012.

broken windows policing, 197
Brown, Michael, 97
Browning, Barbara, 39–40, 124–125
Bucholtz, Mary, 195–196
Bush, George H. W., 20
Butch Queens Up in Pumps: Gender, Performance, and Ballroom Culture in Detroit (Bailey), 36
Butler, Judith, 50–51

Cadwell, Josef, 248, 253
Cadwell, Martin, 254
camera politics, ethnography and, 101–106
Cameron, Simon, 10
Cannibal Metaphysics (Viveiros de Castro), 190–191
capitalism: class tensions and, 192–193; founding myths and, 4; racism and, 182–183, 274n55; role in Detroit of, 153–155, 274n55; surveillance and, 6; U.S. carceral system and, 181–183
casinos, economic impact in Detroit of, 79–80
Cayton, Horace, 30
Cebuano dance, cultural research on, 123
Cervenak, Sarah Jane, 34, 59–60, 185–186
Charlevoix Liquor, performances at, 156–158
Chea, Seycon-Nadia, 47, 51–52, 62, 70, 73, 233–234, 247, 256–257
Chic (music group), 149
Chin, Elizabeth, 37–38
choreography, xiii, 39–40, 65–67, 162; anthropology and, 124; cities and, 16, 32, 60, 170; conversation and, 63, 65–66; dance anthropology and, 123–132; ethnography and, 59, 60, 64, 69, 109; neighborhood strategies and, 61–62, 239–240; performance and, 52, 88–89, 234, 241; smooth space and, 63; spectacle and, 235; as strategy, 38–40, 41, 54, 61–62, 147
Chris, Lia, 94–96
Christian, Glen, 226–227, 232
churches, communities and role of, 71–75

citizenship, right to, 148
civil rights movement: growth of, 15–16; liberation and power movements and, 2, 16, 19–20, 30, 148, 236
Civil War, African American participation in, 10
Claiborne, Lottie "The Body" Graves, 1, 168, 176
claims: Detroit and, 153; legal intimidation and, 145; longtime Detroiters, newcomers, and, 192–200; memory and, 138–139
Clark, Trayvon, 80–83, 86
class: gender and, 53; intellectuals and role of, 153; neighborhood politics and, 100–106
Cleage, Albert B., Jr. (Rev.), 19–20
Coates, Ta-Nehesi, 199
collective forgetting, communities and, 180–181
Collins, Brenda, 257
Collins, Patricia Hill, 54
Colombian drug violence, Taussig's research on, 77–78, 84–85, 95, 103–104, 117, 162
colonization: hierarchies of value and, 89–90; law during, 3–5; racism and, 2
Commerce Clause (U.S. Constitution), 8, 266n32
communism, civil rights movement linked to, 15–16
communities: churches' role in, 71–75; liquor stores as hubs in, 21–22, 26–27, 67, 158; myth of, 180; neighborhood culture and, 134–141
concealed pistol license, fieldwork in research and, 74–75
conceptual art, xxii, 1; choreography and historiography, 30–31; Dumas, DeShawn, and, 249; multidisciplinary techniques in, 33; performance and ethnography, 36–44; Piper, Adrian, and, 253; Pope.L, William, and, 185; practice and anthropological research, 1; state terror and, 253
Conner, Derrick, 249–257

genocide: of African Americans, 4–5, 8; contemporary incidents of, 5; of Native Americans, 8; public health failures and, 22

gentrification, Detroit contexts and, 4–5, 9, 17, 35, 89, 92–95, 129–130, 153–154, 185, 255–257, 279n1

geographic apartheid (Singh), as segregation tool, 16

Gift, The (Mauss), 214–215

Gilbert, Dan, 181–182, 279n1

Giuliani, Rudolph, 160, 197

Gordy, Barry, 108

Gores, Tom, 182

Gotham, Kevin Fox, 11

Gottschild, Brenda Dixon, 40

Gramsci, Antonio, 153

Gratiot Avenue (Detroit), jail construction project, 180–184

Gratiot Liquor, 165–177

Gratiot redevelopment project (Detroit), 16–17

Great Migration (U.S.), 10–13, 90–91

Greening of Detroit, 60–61

Gregory, Steven, 43, 96–97, 159–161

Grosz, Elizabeth, 55

Guattari, Félix, 35–36, 61, 62–63, 72

gun violence: as economic violence, 227–232; power and control and, 74–75

Guyton, Tyree, 1, 27, 30, 150, 172, 199

Haitian Vaudun, 30, 123, 125

Hall, Stuart, 33

Hanna, Judith Lynne, 126

Harbor Square Ballet (Stovall), 234

Hardt, Michael, 35, 175, 188–189

Harper, Fran, 31–33

Harrison, John, 67

Hartigan, John, 113, 208–210

Hartman, Saidiya, 50

Harvey, David, 12–13, 27, 39

hate strikes, against African American workers, 13–14

health: behavioral and mental, 84, 205; ethnographic ethics and, 243; struc-tural violence and, 21, 22, 93, 228, 278n22

Heidelberg Project, 27, 30; critical geography and, 199; disputes about, 157–158; DIY aesthetic of, 130–131; neighborhood perspectives on, 135, 147, 149–150, 190, 237–238; readymades in, 27, 30

hierarchy, performance theory and, 123

highway construction, impact on neighborhoods of, 136–139, 149

Hill, Alex B., 153–154

hip-hop: Detroit and, 108; ethnographic encounters and, 1, 88, 149, 171; performance and, 60–61, 134

historical materialist analysis, 2; political ontology and, 4, 23; registers of space and place and, 34, 55, 61

history: neighborhood culture and, 140–141; urban anthropology and, 30–32

HIV/AIDS, narratives about, 241–246

Holzer, Harry J., 145

home equity wealth, racial disparities in, 91–92

Hooker, John Lee, 1, 108

hooks, bell, 50

House Committee on Un-American Activities (HUAC), 15

Housing Act of 1934, 90–92, 196, 199

Housing Act of 1937, Section 8, 278n23

housing discrimination: African American rebellion against, 11, 13–14; neighborhoods and, 192–193; political-economic consequences of, 91–98, 146–147; property rights and, 194–195; racist real estate covenants and, 90–91, 145–146; urban development and, 103–106

Hurston, Zora Neale, 30, 43–45, 74

identities, determinism and tensions and, 55–56; performances of, 37

immaterial labor, 188–189

incarceration rates: drug offenses and disparities in, 183; in international comparisons of, 148; War on Drugs and, 20–21

indexicality, linguistic anthropology and, 194–196, 197–199
innocence, politics of, 166
insider anthropology, 113–115

Jackson, John, Jr., 26, 32–33, 96, 168–169
Jacobs, Jane, 39
Jay, Ellen, 194–200, 208–209
Jay, Jared, 194–195, 199–200, 208–209
Jim Crow legislation, 10, 16, 270n109
Johnston, Eric, 62, 68–69
Johnston, Martha, 62
Johnstone, Barbara, 195–196
Jones, Bill T., 241–246
Jones, Delmos J., 113–115

Kabalan, Bana, 233–234
Keil, Chris, 194–196, 199–201, 208–209
Keil, Stella, 194–195, 208–209
King, Rufus, 7
Kinney, Rebecca, 41–42, 88, 154
Klein, Stacey, 213–214
Krause, Ben, 79
Krauss, Rosalind E., 40
Kroman, Jared, 225–226, 232
Kunming, China, 40–45

labor, theory of: African American experiences and, 174–176; perceptions and, 192–193
Lafayette Park redevelopment project (Detroit), 17
Lambert, William, 9–10
land commodification and privatization, segregation through, 12–13
language: bodily cues and, 118, 204; financialization and, 194; *Liquor Store Theatre* performers and, 65; quality-of-life discourse and, 160; strategy and, 195, 199; U.S. Constitution and, 8
Larson, Reggie, 184–185
Larson, Sandy, 184–185
Lawrence-Zúñiga, Denise, 55
Lefebvre, Henri, 39, 55
Lepecki, André, 175
Lewis, Tee, 205–208, 230–231

LGBTQ people: aesthetics and, 242; ballroom cultures and, 36, 125; ethnography and, 125–126
Lil' Foot, 88–89, 92–95, 97–98
linguistic anthropology, neighborhood culture and, 194–196
liquor stores: addiction and symbolism of, 81–86; churches and, 71–75; drug trafficking and, 146–147, 203–204; patriarchy and power norms and, 123; as public squares, 21–22, 26–27, 67, 158; racial, sexual, and gendered tensions in, 48–51; sex trafficking and, 203–208; space and race intersection at, 208–210; video camera systems in, 63–64; violence and dispossession at, 254–256
Liquor Store Theatre: approach to and development of, 1–2, 25; atlas of, 258–261; critique of, 255–257; in the Whitney Biennial, 188; overview, 26–28
Liquor Store Theatre, Vol. 1, No. 1, 47–57
Liquor Store Theatre, Vol. 1, No. 2, 58–69
Liquor Store Theatre, Vol. 1, No. 3, 70–75
Liquor Store Theatre, Vol. 2, No. 1, 76–86
Liquor Store Theatre, Vol. 2, No. 2, 87–98
Liquor Store Theatre, Vol. 2, No. 3, 99–106
Liquor Store Theatre, Vol. 3, No. 3, 107–119
Liquor Store Theatre, Vol. 3, No. 4, 120–132
Liquor Store Theatre, Vol. 3, No. 5, 133–155
Liquor Store Theatre, Vol. 3, No. 6, 156–164
Liquor Store Theatre, Vol. 3, No. 7, 165–177
Liquor Store Theatre, Vol. 4, No. 1, 178–186
Liquor Store Theatre, Vol. 4, No. 2, 187–201
Liquor Store Theatre, Vol. 4, No. 3, 202–210
Liquor Store Theatre, Vol. 4, No. 4, 211–216
Liquor Store Theatre, Vol. 4, No. 5, 217–223
Liquor Store Theatre, Vol. 4, No. 6, 224–232
Liquor Store Theatre, Vol. 4, No. 7, 233–246
Liquor Store Theatre, Vol. 5, No. 1, 247–257
Liquor Store Theatre, Vol. 5, No. 2, 255
Liquor Store Theatre, Vol. 6, No. 1, 256

plantation ethnography (Douglass), 122

police brutality: in Detroit, 13–14, 249–256; racial disparities in, 95–98; Rebellion of 1967 against, 17–19, 269n94

Police Strategy No. 5: Reclaiming the Public Spaces of New York, 160, 197

police surveillance, impact on neighborhoods of, 149

political economic racism: Great Migration and, 89–90; gun violence and, 229–232; housing segregation and, 91–98; origins of, 2–9

Poor People's Campaign, 22

Pope.L, William, 59–60, 185–186, 190–191

poverty: contextuality of, 89–98, 148; Detroit contexts and, 22, 30, 80, 197; spectacle of, 235

power: Detroit and, 14, 19, 23, 89, 108, 147–148, 159–160, 164, 179, 183, 209, 212, 214; ethnographic tensions and, 34, 215–216, 222, 230–231, gender, sex, sexuality, and, 48–50, 53, 65, 75, 121, 125, 161–162; paradox of place and, 89; U.S. slavery and, 4–8, 13, 122

predatory mortgage loans, 21–24

presence, in performance theory, 64–65

property rights: in Detroit, 41–45; neighborhood culture and, 194–195

Public Library (Stovall) exhibition, 253

Quicken Loans, 181–182, 279n1

Quinn, Gerald, 250

race: Detroit and, 14, 154, 192–199; ethnographic perspectives and, 33, 96, 151, 207–209; gender, sex, sexuality, and, 49, 51, 53–54, 125, 221; unjust policing and, 97; unjust real estate practices and, 11

racial sincerity (Jackson), in anthropological research, 32–33

racism: black dominance in Detroit and, 208–210; black women and, 53–54; Detroit Future City (DFC) plan erasure

of, 154–155; formalist structuralist framework for, 15; gender and sexuality and, 49–51; Great Migration communities and, 30; indexicality and, 193–196; law enforcement and, 97–98; legislated, neighborhood views and, 192–193; new black man and, 172–173; positionality of whiteness and, 193–196, 208–209; race riots, 14; role in Detroit of, 153–155, 274n55; space and place and, 199, 208; visual epistemology and, 125–126. *See also* critical race theory

Ralph, Laurence, 30–33, 147–149, 228–229

Rankin, Winston, 72–73

Reagan, Ronald, 20

real estate covenants, 90–92, 196; African American rebellions against, 13–14; development of, 11

real estate development, 103–106; impact of, 181–184

Rebellion of 1943 (Packard Automotive Manufacturing Plant), 13–14

Rebellion of 1967 (Detroit), 17–19

religion: in anthropological research, 71–75; in dance anthropology, 125–126

renegade dreamers, 80–81

rental market, housing segregation and, 93–98

representation, politics of, 50, 236–237

residential policies: class and, 101–106; geographic apartheid and, 16; Housing Act of 1934 and, 90–91; segregation using, 12–13; taxation of black homeowners, 41

restorative justice, linguistic anthropology and, 198–199

right to the city (Harvey), theory of, 27, 150, 152, 270n4

Robinson, Cedric J., 4, 90, 95

Rock Ventures LLC, 181–184

Rodney, Walter, 89, 95

Rust Belt, 271n7

Saunderson, Kevin, 108

Schumack, Tim, 99–100

Schutz, Dana, 236
segregation in Detroit: aquatic geography and, 138; government policies for, 12–14; Housing Act of 1934 and, 90–91; political-economic consequences of, 91–98, 146–147; white approval of, 16
Selections from the Prison Notebooks of Antonio Gramsci (Gramsci), 153
7.2 SQ MI, 41–42, 88
sex trafficking, 203–210
sexuality, performance intersectionality with, 50–56, 125–126
Shay's Rebellion, 7
Shrine of the Black Madonna (Detroit), 19–20
Silver, John, 237–239, 246
Silverstein, Michael, 196
simmering ethnographic choreography, 109
Sklar, Deirdre, 123–125
slavery. *See* U.S. slavery
Smigiel, Frank, 248–256
Smith, Blake, 171–173
Smith, Edward, 11–12
sociality, dynamics of, 157–159
sociocultural positioning, education and, 171
Soja, Edward, 41
Sojourner Truth Housing Project Rebellion, 13–14
Soumah, Mohamed, 122–123, 187, 189, 217–219, 224–226, 231–234
space and place: claims to and, 40–42; contemporary life and, 40–45; new ways of thinking and, 34; paradox of place and, 34; politics of, 84–86, 152, 159–160, 213–214; production of, 54–55; smooth vs. striated space, 62–64; spectacle of poverty and, 235–236; state-controlled and, 72–73; toponyms and, 138; urban anthropological research and, 96–97
spectator engagement, in performance, 65–66
state-sanctioned violence, 6

Stewart, Kathleen C., 26, 43–45
Still/Here (Jones ballet), 241–246
Stovall, Todd: collaborations and, 61–62, 69, 115–116, 157, 233–234, 172; electronica compositions of, 88–89, 108, 115, 123, 257; sculpture by, 217–219, 234
Stowall, Ericka, 70, 73, 76, 78, 99–100
STRESS officers (Detroit police force), 18–19, 269n94, 285n2
structural violence: economics and, 95; police violence as, 249–256
Studio Museum in Harlem, 115
Sugrue, Thomas, 145
Sunset Liquor, performance at, 108–119, 233–245
surveillance: of public space, 96, 103–106; structural-economic violence and, 95–96
Survival Workshops, 241
Susser, Ida, 43
Sweet, Henry, 12
Sweet, Ossian, 11–12

Talley, Norm, 108
Taussig, Michael, 77–78, 84–85, 95, 103–104, 117, 162, 229
taxation of black homeowners, 41
terrorism, gun violence as, 229–232
theatre: of the everyday, 48, 69, 208; as deployed in *Liquor Store Theatre*, 73; separation between reality and, 242–245
thick description in anthropology, *Liquor Store Theatre* and, 26
Thomas, Deborah A., 36–37, 89–90, 95
Thunderbird Immolation (art installation), 185–186, 190
Till, Emmett, 236
Torralba, Fabiola, 133–134, 137
Tortugas, New Mexico, dance ethnographic research in, 123–124
traditional intellectuals, Gramsci's concept of, 153
transportation, Detroit contexts and, 9, 27, 35, 38, 67, 85, 100–101, 110, 121, 131, 141, 164, 166, 169, 180, 183, 191, 197, 211, 214–215, 225, 234

Treaty Clause (U.S. Constitution), 8, 266n32

on research with, 115–117, 231; "keep it moving" mantra of, 35; neighborhood activism of, 44–45, 61, 108–110, 115, 257; properties owned by, 113–114; as research collaborator, 26–28, 33, 190

Wolfson, Faygo: art created by, 162–164, 172, 214–216; on casinos, 79–80; *Liquor Store Theatre* and, 26–28, 33–35, 44–45, 61–62, 239–241; as research collaborator, 190, 231, 233

women: drug trafficking impact on, 161–162; employment and, 14; presence in *Liquor Store Theatre* videos, 49–54, 101, 105–106, 163, 204, 230

Wood, John, 15

Young, Coleman, 15, 227

youth: Detroit contexts and, 80–82, 100, 139, 152, 168, 170–172, 174–175, 193, 198, 225, 272n12; ethnographic contexts and, 37–38, 95–96

Zane, Arnie, 242

Zhang, Li, 40